INTO EVERY GENERATION A

SLAYER
IS BORN

INTO EVERY GENERATION A
SLAYER IS BORN

HOW BUFFY STAKED OUR HEARTS

EVAN ROSS KATZ

NEW YORK

Hachette Books
Hachette Book Group
1290 Avenue of the Americas
New York, NY 10104

HachetteBooks.com

Twitter.com/HachetteBooks

Instagram.com/HachetteBooks

First Edition: March 2022

Published by Hachette Books, an imprint of Perseus Books, LLC, a subsidiary of Hachette Book Group, Inc. The Hachette Books name and logo is a trademark of the Hachette Book Group.

The Hachette Speakers Bureau provides a wide range of authors for speaking events. To find out more, go to www.hachettespeakersbureau.com or call (866) 376-6591.

The publisher is not responsible for websites (or their content) that are not owned by the publisher.

Library of Congress Cataloging-in-Publication Data

Names: Katz, Evan Ross, author.
Title: Into every generation a slayer is born: how Buffy staked our hearts / Evan Ross Katz.
Description: First edition. | New York: Hachette Books, 2022. | Includes bibliographical references and index.
Identifiers: LCCN 2021036939 | ISBN 9780306826689 (hardcover) | ISBN 9780306826702 (ebook)
Subjects: LCSH: Buffy, the vampire slayer (Television program)—Influence.
Classification: LCC PN1992.77.B84 K38 2022 | DDC 791.45/72—dc23
LC record available at https://lccn.loc.gov/2021036939

ISBNs: 9780306826689 (hardcover), 9780306826702 (ebook)

Printed in the United States of America

LSC-C

Printing 1, 2021

To Billy Jacobson, who taught me unconditional love through meticulous practice, and Charisma Carpenter, for everything… and everything in between.

Contents

I designed *Buffy* to be an icon, to be an emotional experience, to be loved in a way that other shows can't be loved... I wanted her to be a cultural phenomenon. I wanted there to be dolls, Barbie with kung-fu grip. I wanted people to embrace it in a way that exists beyond, "Oh, that was a wonderful show about lawyers, let's have dinner." I wanted people to internalize it and make up fantasies where they were in the story, to take it home with them, for it to exist beyond the TV show.

—Joss Whedon, 2001

Pre-Prologue

Can I start off a book about *Buffy the Vampire Slayer* with an anecdote about the Pulitzer Prize–winning rock opera *Rent*? On the one hand, who's going to stop me? On the other hand, must we? Verdict: We must. *Rent* made its Broadway debut in 1996, a year before *Buffy* premiered. The brainchild of composer/lyricist Jonathan Larson, it was hailed as groundbreaking from the outset for its depictions of queer people, the AIDS crisis, and the East Village arts scene, and as a result developed a cult following the likes of which were never before seen by a Broadway show. These Rentheads, as they came to be called, saw something in *Rent* that was bigger than just a Broadway musical. *Rent* became as much a lifestyle as a show.

Six years earlier, author Sarah Schulman published a novel called *People in Trouble*, based on a relationship she had with a married woman in the East Village during the advent of the AIDS crisis. Schulman alleged that the plot of her book and Larson's musical are eerily similar, with one noticeable difference: Larson reinterpreted the love triangle present in Schulman's novel, making the straight man the protagonist, whereas in Schulman's version, he was the secondary character. This bothered Schulman for a number of obvious reasons. "At base, it's the issue of taking authentic material made by people who don't have rights, twisting it so they are secondary in their own life story, and thereby bringing it center stage in a mainstream piece that does not advocate for them." She ultimately deemed it an "insidious but very American process."

Why are we opening a book about *Buffy* by talking about a musical

that had nothing to do with *Buffy*? Doubting me from the outset, I see you. *Rent* is a show that for many people allows them to feel seen for who they are or to gaze at a version of themselves that they longed to be. It was gay—*really gay*. It was sex-positive. It addressed the AIDS crisis in a substantive and meaningful way while dignifying story-lines around drug addiction and homelessness. It no doubt changed lives by exposing a subculture to the masses and introducing it through the tools of empathy and catchy melodies. And if Schulman is to be believed, it's also an example of one man seeking, gaining, and reaping credit for something that might not have been his, and something that may have caused great harm in its repurposing.

Buffy is not a direct parallel to *Rent* in this instance. Joss Whedon's concept for *Buffy*, both the series and the character, were not, to the best of our knowledge, in any way stolen—albeit admittedly derived from the amalgamation of characters seen onscreen before her. But there is an undeniable parallel at play here in how we try to untangle the emotions wrapped up in how we viewed something at a particu-lar moment in time—and the formative nature of these memories—with how we reexamine them through a new lens years, even decades, later. *Buffy* remains one of the best television series of all time to this day, period exclamation point. It's also a much different show now, twenty-five years later, than it was when it premiered. *Buffy* didn't so much break rules as create them. Much of the modern-day television landscape, particularly in the genre and teen space, is inspired by, grafted from, or, at minimum, a nod to the groundwork laid by *Buffy*.

It's a fact: *Buffy* changed lives. It changed my life. It's how I learned to quip. It gave me a sense of strength and certainty through-out a youth in which I often felt powerless; it even helped me come to terms with my sexuality. Perhaps you can relate.

It also ruined lives.

I set out to write a book about *Buffy the Vampire Slayer*, the historic and groundbreaking television series that altered and then reshaped the television landscape and, in its wake, created a phenomenon with

a still-beating heart nearly twenty-five years after the series debuted as a midseason replacement on a fledgling network. This will not be *that* book. It will contain remnants of the book I set out to write. But as Catherine sings in the Stephen Schwartz musical *Pippin*, "things *change*; *things* change."

So does context.

So with that, let the spell not be ended but, rather, recast.

Prologue

If you're reading this, first of all hi, and probably, likely, or most certainly you've loved something with your whole heart. I just have a hunch. Not a person—that provides reciprocation potential—but more like a *thing*. Something you can give over your energy to in a way that feeds you and leads you to a deeper understanding of self or the world around you. Maybe it was hockey cards or Pokémon, Pogs or Tamagotchi, or maybe you're among the tasteful set and it was Mandy Moore's *I Wanna Be with You* album. Something that found you, undid you, rewired you, and so much more, before you ever had the know-how, let alone the nomenclature, to understand.

For all of my adult life, and the majority of my kid life, too, that thing was a show I bet you're familiar with called *Buffy the Vampire Slayer*. "That's the one with the blond girl and the Dracula?" Yes, Nana, go to sleep.

There's a reason we're talking about *Buffy* twenty-five years after the show's debut and not *Veronica's Closet*. (Don't get me wrong, I would love to write a book about Kathy Najimy's criminally underrated portrayal of Olive Massery. But not here. And not now.) This longevity, in the form of regard and reverence, is not coincidental or happenstance. There's a reason, a *there* there, if you will. It's a reason we'll explore in-depth, and from varying angles, with the goal of understanding why this show continues to transcend the medium. Why *Buffy* harnesses the rare ability to bring people, particularly those on the margins, closer together as a result.

But this book isn't just for *Buffy* lovers. (Not to worry, y'all will

be fed.) This book is a celebration of the culture vultures, those who do not like but who *love*. Some might know this mode of being as "stanning." That term derives from the 2000 Eminem song "Stan," which tells the story of the fictional Stanley "Stan" Mitchell, a man who claims to be Eminem's biggest fan. He writes letters to Eminem and grows angry when he doesn't hear back, ultimately being drawn to violence over his unrequited obsession. The term took on a life of its own afterward with many perceiving, perhaps by design, it to be a portmanteau of the words "stalked" and "fan." Hyperbole gave way to irony, and the term reiterated over time to mean obsessed... in a good way. Stan armies were amassed online, and even artists themselves began acknowledging their stanbases. Lady Gaga and her Little Monsters. Beyoncé and her Beyhive. Rihanna and her Navy. Soon, one couldn't just like a thing, they had to *love* it and be willing to defend their fav against the haters.

At first I could relate. I, too, love a thing. But then a meaninglessness started to percolate. In 2011, Britney Spears tweeted, "Does anyone think global warming is a good thing? I love Lady Gaga. I think she's a really interesting artist." More than 200K fans favorited this unintelligible non sequitur. "@tpa@y#m##@nyhn," Oprah tweeted in March of 2014, generating thousands of Likes from fans for no discernible reason. When Lady Gaga tweeted the letter *f* in 2019, a quarter million people gave it a heart. Make it make sense. I couldn't. Over time, standom gave way to unquestioning devotion and meritless defending. Rose-colored spectacles became the accessory du jour and suddenly to love something meant you could not question it, for to question it would put your love into question. To question it, you would be dubbed a "fake fan."

That was never for me when it came to *Buffy*. I love the show but could never—and still can't ever—wrap my head around Buffy's love for Spike, a man who both stalked her and sexually assaulted her, or why my favorite characters (namely women) were constantly killed off for no good reason, or the enactment of the Bury Your Gays trope,

the slut-shaming, the tokenism...you want me to go on? So yes, my fav is problematic. And therefore I do not stan blindly. I will not push that aside in examining the profound and lifelong impact this show has had on how I, and many others, exist and function within the world outside of the show. In that sense, there will be a lot of gray area: something blue and seeing red and all kinds of other strokes worth coloring in. And though there won't be blood, there will be referencing.

From my POV, to love *Buffy* is to both contextualize and reexamine it. So that's what we're gonna do: something that's one part oral history, including interviews with the cast and crew; one part critical analysis, examining the show for what it got right and when it missed the mark; and one part fan notes, giving voice to the show's devotees who are the lifeblood of *Buffy*'s ongoing legacy.

And throughout we'll be examining the problematic figurehead who created this show. I set out writing this book knowing we'd need to unpack several stories about Joss Whedon that had made the rounds over the years, including two big ones from August 2017 and July 2020 (we'll get into both in detail). I had completed about half of the book's interviews when a cavalcade of accusations came out of the Buffyverse, beginning with actor Charisma Carpenter and followed quickly in succession by actors Amber Benson and Michelle Trachtenberg. Their stories and allegations are nuanced, but the gist has a through line: this workplace, to some, felt unsafe. As a result, much of the way we, the fans, view this show is with the understanding that it seems to have caused a great amount of torment for many of those who worked on it. It's not a coincidence that these stories come mainly from the women of *Buffy*. There were a number of interviews for this book that were confirmed and then canceled in the wake of the recent allegations against Whedon. There's a more complete version of this book that I set out to write that was, at one time, within my grasp. Things *change*; *things* change. We'll get into all of that in the most unflinching way I know how.

There's a lyric in the Tears for Fears song "Mad World" that I keep coming back to: "The dreams in which I'm dying are the best I've ever had." Curt Smith presents that rather arresting concept as both "funny" and "sad." And that's how I understand the story of this show. Funny at times, sad at others, sometimes a little bit of both and in some instances a lot of bit of both.

One other important note before the train departs the station: I wasn't there for any of this. I do not know conclusively, nor do you, what happened all those years ago. There's been a lot of "he said," hoping to add some more "she said," but ultimately this is not *my* story to tell. I did my best to listen diligently, to ask follow-up questions, to source from as many people who were there as possible. And so I am telling a version of the story to the best of my ability.

And so we cannot begin this book, conceived as a celebration, without acknowledging the pain that some endured in making this series. This book is a tribute to the women of *Buffy*: the actors, the writers, the costumers, the stunt performers, the PAs, and every non-male on set or behind the scenes who helped make this show mean something. As Harmony once told Cordelia: "You reign."

So put on a pair of your comfiest yummy sushi pajamas and let's get it done.

A Conversation with Stacey Abrams

Leader Abrams, what do you think it is about *Buffy the Vampire Slayer* that makes us not only love it some twenty-five years later but want to discuss and dissect it still?

Buffy centers on a young woman who is incredibly powerful in a supernatural sense, but we also have the opportunity to watch her grapple with the contours of power. What does it mean when you have the ability to do something no one else can and watch how that isolates you from others, but how it also draws people to you? One of the most fantastical relationships on the show is her relationship with Joyce, her mother, and watching her navigate the fact that one of the closest relationships she has is one where she cannot tell her mother the whole of who she is. And yet she has to continue to be embraced by and renewed by her mom. And so I think the complexity of that navigation of power, the intersections of who she is and who she wants to be, the friendships she builds, the friendships she loses, all of those pieces come together to be just this remarkable meditation on power and powerlessness in the same person.

I absolutely agree. I think the character of Joyce is particularly unique in how fleshed out she is and how much emotional complexity she has, especially for a teen show. They really made her more than just "the mom who never understands her wacky daughter's teenage

antics." Let me ask about your origin story of how you first discovered the show. I believe you were in law school at the time ...

I was. I lived in Atlanta for my internship, and I was staying with friends. They were out at an event, and I didn't go out. So I turned on the TV and there was *Buffy* and I got hooked and became a faithful watcher from the very first episode.

And I believe you were already a fan of Sarah Michelle Gellar's from *All My Children* ...

Absolutely. She played Kendall Hart, and she was fantastic.

An Emmy-winning performance, no less. Had you ever seen anything quite like *Buffy* before?

I had seen the movie, which was ... it was cute. But it was not my taste. And so I was surprised by how effectively they melded the ethos of a sort of *Beverly Hills, 90210* or *Dawson's Creek*, that sort of teen vibe, but muted it with this supernatural overlay. That's what was so fascinating to me.

The show, especially when it first aired, tended to be looked down upon by a lot of folks, especially critics. Maybe it was the name, maybe it was the premise, the network, a combination. Did you ever receive any flak from friends, family, or other law students for not just liking, but it sounds like *loving* this show?

No, because my friends understand how much I love television and I never permitted denigration of good TV to enter my space. People that know me know that I love TV, and I don't understand the point of being ashamed of good stories.

Was there a character who you immediately telegraphed your own experiences onto or who you really connected with?

Not exactly. I think the narrative arc of the story was exceptional and you can pick out different pieces that relate to your own

experiences. One of the dynamic pieces of *Buffy the Vampire Slayer* was how it took very regular teenage and young-adult experiences and not only made them relatable to monsters and demons but also helped you contextualize your own experience. So it was less about individual characters and more about their experiences.

Agree. Is there an example of that that comes to mind?

So there's the episode with Xander and his teacher and that notion of wanting to be liked even if it is [*laughs*] going to kill. The characters are so well drawn that there was a universality to each of their experiences that didn't depend on gender or race or direct connection. It was, "Oh my God, I know what that feels like." And that I think was the most important part of *Buffy*.

I just have to tip my hat to you for referencing Season 1, Episode 4. That is definitely a niche reference that I appreciate.

I could do this all day, I promise. When it comes to *Buffy* and *Star Trek* I'm a deep-cuts kind of person.

Do you have a favorite Big Bad? I tend to waffle between the Mayor and Glory.

The Mayor for me. The dichotomy between his old-fashioned persona, especially with the moment where he is, like, insisting that Faith drink her milk before she goes out to fight, and his courtliness, but also just the absolute carnage that he's willing to wreak in order to hold on to power. I found it amusing and [*chuckles*] not that distant from some experiences that I've had. I've never worked with a mayor like that, but it was a Big Bad that wasn't *all* bad. And I think that that's what was so terrifyingly effective about him. He wasn't just this evil marauder. He was someone who could be kind and thoughtful and assumed he was doing what was right, even if it meant killing everyone to do it,

until of course he wanted to ascend to the absolute power, and we all know what happened there.

I particularly like the details the writers inserted about him caring about his job as mayor. He met with the Boy Scouts, spoke at a town vigil after two kids were murdered, and famously told Faith, "There's nothing uncool about healthy teeth and bones." In addition to, you know, all of his evildoing and mass murder.

Kendra the Vampire Slayer comes into the picture midway through Season 2. She is the first multi-episode Black character to appear on the show. I've spoken to Bianca Lawson, who played Kendra, for this book, as well as a number of Black female fans of the show who cited Kendra as a triumph for powerful Black female representation *and* a failure in how the show both depicted and treated her. How did you see Kendra?

At the time Kendra first appeared, I was just happy to see her exist. The reality is that as someone who has loved television since the first time that I got to watch it, you become accustomed to not seeing a direct representation of yourself. And it meant a great deal to see a Black Slayer. It was of course disappointing that her tenure was so short-lived, but at least the nod was there. And I see things from an arc of not only this being nearly twenty-five years ago but as a writer who faced challenges because my characters were Black, the industry resistance to that kind of multicultural approach, it was always going to be a mark against it. But I think it was an important moment in the show. And I still celebrate the work that she did.

You've spoken about your affection for Spike as Buffy's true love...

I didn't. I did not say that.

Oh my God! I apologize. Correct me, please.

I said Angel was her first love and the right person for her to love when she was coming into her power. She was with the right

person. And I don't believe in this notion that you are allowed to have only one true love. I think he was the absolute right person for Buffy as she was becoming the Slayer and, with the time they had together, was absolutely the right person. I think Spike was absolutely the right person when she became a powerful, independent woman on her own. And as somebody who actually watched every episode of *Angel*, I think the split was opportune and I think that the way they developed his character was also important, because he had to become someone else once he reconciled with his curse. And so I think that they actually did the right thing for *Buffy*, but I resist the notion that one was better. I think that at different parts of our lives we are different people. And for the person she was, Angel was absolutely the right person and for the person she became, Spike was absolutely the right person.

I'm wondering your thoughts on the in-between man, Riley, who was really pummeled by the fandom at the time. There was a lot of pushback to Riley on the show, especially given him coming in so soon after Buffy had parted ways with who many believed to be her soul mate. What were your thoughts on that character and his relationship with Buffy?

I liked Riley, but Riley was the rebound guy. And he was destined to be the rebound guy. You come after an epic love story like Angel and Buffy, you were there while she was in the beginning of college where she's trying to figure out who she is in this new realm, and so I think Riley from the very beginning was a bridge relationship and he served that purpose well. Marc Blucas did a great job. It is a hard job too. I would say as an actor I think he did the best job possible of being someone who's appealing, but not so iconic that his loss would devastate the show. And that is exactly what she needed. She needed someone who loved her before he knew everything about her and who was never her adversary.

Everyone else, Angel and Spike, were her adversaries. He was someone who was just a guy who really cared about her. And that I think was important for her, and I always liked Riley.

I did too. I'm curious for your opinion on *Buffy*'s most controversial season, Season 6, which dealt with much more adult themes like addiction and sexual assault. Curious if you had any reaction to the tonal transition of the show that followed Buffy's resurrection?

As a writer, I can appreciate how hard it is to take a story to that peak where she finally does die in a way that feels permanent and irrevocable, and when she comes back, darkness necessarily followed. And I think it was an important season. It was a hard season to watch; it can be an awkward and uncomfortable season to watch, and I think they did a fairly deft job of trying to navigate it. But when you literally lost everything and your return is not just a violation of the natural order but a destabilization of everything and everyone, that's a perfect time to really start to think about what does it mean to be beyond the cocoon of college and ask what does it mean to really enter the world where there are no safety nets and where you've got to grapple with adulthood in all of this unapologetic goriness? And I think for a show that always tried to explore the dark themes using a deft hand with both humor and allegory, it was probably the best way to tell that story in that moment.

And speaking of goriness, Tara's death is easily considered the show's biggest mistake; even the creator has gone on record and said this. What was your reaction to Tara's death?

It was tragic. She was so sweet. There's no other way to think about it. She was the sweetest character. When you remember Tara's beginning with her weird family, she deserved the happily ever after. And so to not only not get it but for her to be knocked out so remorselessly was sad and tragic.

And unnecessary.

People don't really talk about the series finale very often within the canon of great episodes that get dissected. What are your thoughts about how the show ended?

I think it was one of the best series finales that I've seen. Those are hard to do. It is hard to end a story in a way that feels resonant and that meets the nature of the show. And when you remember how the show began, there was an irreverence to that ending where, yes, they win one more time, but they know it's just temporary. And the best part of it is how remarkably reminiscent it is of those early Scooby moments where they were all hanging out in the library with a bemused Giles, and they're sort of ready for the next thing to happen but hoping it won't happen for a minute because they need to go home and change. That kind of moment was a perfect moment. And I juxtapose it with how they ended *Angel*, which was one of the best last lines of a show: "I've always wanted to fight a dragon." Angel needed to go out in the middle of the battle; Buffy needed to have completed the battle and just be really exhausted and annoyed knowing that something else was going to come but she wants to go to the mall first.

The good ol' Sunnydale Mall, where "the clerks are rude and everything in the food court is sticky."

For someone who has never seen the show before, what would you say are the biggest reasons now, in 2022, to watch the show?

Buffy is clever. It's fun. It has action, adventure, romance, and an endless well of sarcasm. And it's just one of the best shows ever written and ever performed.

I love Sarah Michelle Gellar's multifaceted and layered performance as Buffy. I think it is criminally underrated. What is it about her portrayal of the character of Buffy that you think takes this show from a nine to a ten?

I had the opportunity recently to do an event with Sarah Michelle Gellar, and that was just delightful. And it confirms what as a fan I'd always hoped to be true: She is someone who loves her craft but never takes herself more seriously than the role that she's in. And that's what we needed from Buffy. We needed someone who appreciated the story and understood that the story was the point—not Buffy, even though she was the titular character. Buffy was a vehicle for these amazing stories. And as an actress, whether she's playing the calcitrant Kendall on *All My Children* or . . . I actually loved her in all of her movies too; she never forgets the joy of being able to tell these stories through acting. And she's someone who appreciates the role and she respected who she was and what she was doing. And that comes through in every single scene, none more so than "The Body."

(Spoiler Alert: "The Body" is Episode 16 of Season 5, in which Buffy finds her mother's body lifeless, having suffered a brain aneurysm. While we're here, let's just address the fact that this book will unavoidably contain a lot of spoilers. For example: Buffy dies twice. See, I warned you!)

Besides "The Body," "Innocence," and "Hush," which I know are three of your favorite episodes—taste!—are there any other episodes that really stand out for you as favorites?

I actually liked the Season 4 episode "The I in Team," when Riley finally discovers all that Buffy can do. That far into the show we're so used to it, and to see his amazement is just hilarious to me. It's probably one of my favorite ones that people don't talk about too often.

Definitely a good one. And I think you get the flex of Sarah Michelle Gellar's comedic chops in that one.

Exactly.

Are there any lessons that you take from the series that you bring with you to the work that you do today?

This goes back to your first question. The work that I am privileged to do, whether it's in politics or in activism, it's about empowerment in a very specific way, meaning my job is to create the space so that I can get out of the way and people can live their best lives. And ultimately that's what Buffy was doing. She was doing it for herself. She had to get out of her own way so that she could be the best version of herself, but she never forgot that the work that she did was not for gratitude. In fact, most people would never know about it and wouldn't care if they knew, but that doesn't absolve you of the responsibility. And I think that's the most important piece for me that, regardless of the outcome, the responsibility to act is always present.

The Slayer in Me

Our story begins with Sarah Michelle Gellar, as any good story should. Ask anyone who has ever had contact with me—distant relatives, teachers, childhood bullies, my rabbi, even SMG herself, they'll all affirm the same stalwart truth: Some, albeit few, might like *Buffy the Vampire Slayer* as much as I do, but nobody loves Sarah Michelle Gellar as much as I do. I am, after all, the world's preeminent Sarah Michelle Gellar historian, a self-bestowed title I take very seriously.

"My sister was a real *Buffy* fan and I sort of knew about it more through her," actor Olivia Wilde told me during a 2020 appearance on my podcast. "I remember at one point they were teaching a *Buffy* class at Harvard—which of course you could now go and teach—and I remember at that point thinking this is a big deal. This is a cultural phenomenon that is important. And [Sarah Michelle Gellar] is an important person. But in terms of my own deep knowledge of her oeuvre, it's not as deep as I would like it to be, but I trust you to help me out and educate me."

"I live-tweeted *Buffy*," the actor Retta told me during a 2020 appearance on my podcast shortly thereafter. "I'd never watched it. I watched *Angel* in syndication and was obsessed with it. And people were like 'How have you not watched *Buffy*?' So I bought the box set and I started live-tweeting it, and thoroughly enjoyed it and was shooo-ook by the silent episode. That was the scariest shit ever, I was like 'God bless,' because this ain't just camp right here."

"Evan, I know that you love her," Anna Faris told me during a

2021 appearance on my podcast (yes, if you haven't already guessed, I ask every guest about their knowledge base of the SMG oeuvre). "Can I ask you a question? Can you sum up in three sentences your love for Sarah Michelle Gellar?"

I can. And I will throughout this book. But in three sentences? I'll need more than that. For this, here, is my love language. When Tom Cruise tells Renée Zellweger "You complete me" in *Jerry Maguire*? It's very *that* steez for *Buffy* and me, but objectively less reciprocal. Before stanning became a culturally ubiquitous term, there was eight-year-old me in the childhood bedroom I shared with my older brother in a suburb eight miles south of Pittsburgh, meticulously and methodically cutting up pages of *BB* and *Bop* in search of new glossy stills to hang on my wall mere inches from his posters of Mario Lemieux and Jaromír Jágr.

It became my "thing," intrinsic to my being years before my homosexuality or Judaism came to dominate my cultural identity. Before I was an American, I was a *Buffy* fan, I would joke. But I wasn't joking. I loved this show. I loved *to* love this show. And I loved how much people seemed to love my love *for* this show ("seemed to" being the operative words). Nobody I knew loved *Buffy* like I did. It was mine. I didn't have to share it. Other eight-, nine-, and ten-year-olds were into Nintendo 64, Furbys, the Spice Girls, or *Titanic* if you were deep, but not me. How could I devote my energy to Bowser and Wario when characters like Willow and Ms. Calendar existed?

In the summer of 1999, weeks after *Cruel Intentions* hit theaters, I sent Sarah Michelle Gellar a handwritten letter in the mail in which my ten-year-old self lied about having seen the film (no chance my mother was allowing that). "You are my Meryl Streep," I told her, a refrain I'd continue echoing into adulthood with growing certitude. I followed up weeks later with another letter, this one apologizing for the lie and promising not to do it again. (She didn't answer either time, thankfully.) All I knew then was that she was my universe and I was a constellation in orbit.

So how did it begin? Really I owe a big thank-you to Calista

Flockhart. It was October 27, 1997, around eight forty-five p.m., when I first discovered *Buffy the Vampire Slayer*. I was in my parents' bed watching *Ally McBeal* when destiny decided to stunt upon me. Flipping through the channels during a commercial break, I happened upon a helpless young frizzy-haired brunette girl about to be eaten by a man with a very poor dye job. Scared but enthralled (the title of my forthcoming memoir), I put down the remote.

"Look at you. Shaking. Terrified. Alone. Lost little lamb. I love it," the attempted blondie told the young damsel in distress as he zeroed in for the kill. Suddenly the frizzy-haired brunette sprung back into frame (now blond herself) with a menacing smile, her assailant holding the wig she had been wearing. "Honey . . . I'm home," she quipped. Right punch to his gut, left hook to the face, a right hook, and then a kick sent him flying.

"Evan, turn that off right now," my mom rudely interrupted, breaking what had begun to percolate into a spiritual experience for me. I made a run for it—"Gotta pee!"—to the basement television, heart racing, my nose pressed to the glass, where I concluded watching my first episode, the eighteenth of the series. I wouldn't miss a single episode after that. But more important, I had discovered the icon, the legend, the perennial moment: Sarah Michelle Gellar.

Twenty-one years later, when I'd enter the Mandarin Oriental hotel in Times Square to interview her for a story for *O, the Oprah Magazine*, she'd greet me by facetiously (I think?) asking if the restraining order was still in place. They say never meet your idols, but clearly "they" have never met SMG. I'm a creature of desired knowledge. If I seek to know a subject, I need to know it in its entirety and be able to formulate an opinion that's born of holistic understanding. My love for *Buffy* began with and always goes back to her. *Buffy*, and Sarah Michelle Gellar's performance in the titular role, isn't a relic so much as it is the blueprint. It certainly deserves celebration; it also warrants scrutiny. More than anything, it deserves immortalization. Let's do that now.

Rhonda the Immortal Waitress

"*Buffy the Vampire Slayer* is uh...well, it's about a girl, she's a mall doll, and she basically uh...she...she...she loves shopping, she loves boys. Everything pretty much is materialistic to her. And then one day comes along Merrick, played by Donald Sutherland, who tells her that she is the chosen one, that she bears the mark—which is a big hairy mole. She bears the mark to slay vampires. Of course, it's a big hairy mole but Buffy had it removed so um...he wants her to come to the graveyard and slay these vampires and she's not into it at all. And uh basically things start to happen. Strange things start to happen."

That was Kristy Swanson wearing a cream-white pantsuit, her legs tucked under and to the side, fumblingly detailing the plot of *Buffy the Vampire Slayer*, a film she was promoting on *The Arsenio Hall Show* in 1992. If you're going off that description alone, you can understand, perhaps, why this is a book about *Buffy* the television series versus *Buffy* the film. *Buffy* the film is pleasant. Like a Yankee Candle in the bathroom at a mid-tier Midtown Manhattan restaurant: you're glad it's there, all things considered. I have little bad to say about *Buffy* the film. I also have little to say about it in general. That said, upon entering the *Buffy* wing of the Metropolitan Museum of Art that I hope one day will be a towering reality, a *Buffy* film room would most definitely greet you.

Mostly, *Buffy* the film just seems unsure of who or what it is. It's a bunch of ideas, many of them good ideas, but without a real POV.

There's a Season 7 episode title of *Buffy* the series that sums up the film quite well: "Potential."

At twenty-six, Joss Whedon had two credits under his belt before writing *Buffy the Vampire Slayer* the script: four episodes of *Roseanne* (or *R*seanne* as we call it today) and three episodes of *Parenthood*, a sitcom based on the Steve Martin film of the same name, which featured a young Leonardo DiCaprio and David Arquette, among others. "He was a baby," Kristy Swanson recalled during a talkback at the Calgary Comic & Entertainment Expo in 2015 in which she and Luke Perry answered fan questions about the film. "He was just a very unassuming, quiet, nice guy," Perry added.

But it's always the quiet ones, isn't it? Whedon may have been green, but he was nothing if not the product of generations of writers. John Whedon, Joss's grandfather, wrote for *The Donna Reed Show*, *The Andy Griffith Show*, *The Dick Van Dyke Show*, and *Leave It to Beaver*. Tom Whedon, Joss's father, was a writer for *Captain Kangaroo*, *The Electric Company*, *The Dick Cavett Show*, and *The Golden Girls*.

So he had the pedigree, clearly. After majoring in film studies at Wesleyan University under the tutelage of film historian Jeanine Basinger and cultural critic and scholar of American mythology Richard Slotkin, Whedon made the cross-country trek to Hollywood in the hope of becoming the next great auteur. It was his strong, eyebrow-raising concept—a self-absorbed California high school cheerleader chosen against her will to defend humanity against vampires—that ultimately caught the attention of Dolly Parton's production company: Sandollar Productions. You'll see headlines spring up every few years like "You Can Thank Dolly Parton for *Buffy the Vampire Slayer*," and like, sure, but it was really Parton's business partner, Gail Berman, who made the deal. Plus, we should be thanking our patron saint Dolly Parton habitually anyway.

Still, eager to get Parton's thoughts all of these years later, I submitted a question to the *Watch What Happens Live* producers ahead of Parton's August 2021 appearance on the show.

Andy Cohen: Evan K emailed, "Dolly I've always been so fasci-
nated by the fact that you were an uncredited producer on
Buffy the Vampire Slayer. Were you a fan of the show and what
was your favorite part about being involved with it?"

Dolly: Well, actually I thought *Buffy the Vampire Slayer* was a won-
derful little show. Actually, my Sandollar Company, again
with Sandy Gallin, my manager, we had a company called
Sandollar and we were a small part of that and I was very, very
proud to be a part of that.

"A wonderful little show." Arguably my favorite boilerplate ever
uttered.

Vampire stories had a proven track record, from Bram Stoker's
Dracula to Mario Bava's *Planet of the Vampires* to Dan Curtis's *Dark
Shadows* to Anne Rice's *The Vampire Chronicles.* But these stories tend
to have an inevitability in that vamp's "survival" is dependent upon
the killing of the innocent—often women, often young ones, often
blondes. Whedon wanted to overturn that. "The first thing I ever
thought of when I thought of the movie was the little girl, the little
blond girl who goes into a dark alley and gets killed in every horror
movie," Whedon explained. "The idea of *Buffy* was to subvert that
idea, that image, and create someone who was a hero where she had
always been a victim. That element of surprise, that element of genre-
busting, is very much at the heart of both the movie and the series."

As Whedon would go on to explain, he felt bad for "that blond
girl," and wanted to give her the opportunity at a second life. "I
thought, It's time she had a chance to take back that night. So the idea
of *Buffy* came from the very simple thought of a beautiful blond girl
walks into an alley, a monster attacks her and she's not only ready for
him, she trounces him."

He'd go on to reference the "blond girl in the alley" for years, with
slight alterations to the story over time. "I felt bad for her, but she was
always more interesting to me than the other girls," he told *Rolling*

Stone in 2000. "She was fun, she had sex, she was vivacious. But then she would get punished for it. Literally, I just had that image, that scene, in my mind, like the trailer for a movie—what if the girl goes into the dark alley. And the monster follows her. And she destroys him."

At that point, Buffy was gestating as Rhonda the Immortal Waitress, a seemingly insignificant character who turns out to be extraordinary, in the brain of Joss Whedon. "I wanted to make a somewhat, you know, low-key, funny, feminist horror movie," he says of the film, citing his own mother, Lee Stearns, a teacher, political activist, and aspiring novelist, as inspiration for the film's protagonist. A manuscript soon took shape and was rushed into production by 20th Century Fox, with the belief that the film could be a crowd-pleaser at the summer box office.

"The first iteration of *Buffy* occurred in 1992 with a movie that most fans of the TV series like to pretend didn't exist," wrote *Screen-Rant*'s Robin Burks in what has long been a popular refrain about the film that views it more as a springboard than a precursor. The film had many big names among its cast: Luke Perry, two seasons into *Beverly Hills, 90210*; Donald Sutherland, fresh off of Oliver Stone's *JFK*; *Blade Runner*'s Rutger Hauer; Pee-wee Herman himself, Paul Reubens; plus Academy Award nominee Candy Clark as Buffy's absentminded mom. It also had a string of up-and-comers, including David Arquette, as well as eventual two-time Oscar-winner Hilary Swank. "Get out of my facial," Swank famously quips in one of the film's many bizarre-yet-memorable utterances. It's a line that doesn't quite land, but it signifies Whedon's desire to stand out from the pack. Why say something forthright when you can twist it for no reason other than that?

Notable cameos in the film include Ricki Lake as a waitress and Ben Affleck in one of his first onscreen roles. "Apparently, I am so bad in that movie," Affleck said in a 2020 interview in which he was asked about the film. "I'm holding a basketball and another basketball

player turns into a werewolf and I get scared—naturally, as you might, if you see a werewolf. And I give him the ball and say, 'Take it.' I thought it was fine and the director seemed happy. I went to the movie—I didn't get premiere tickets or anything—and I was like... that is not my voice. That is not me. Apparently the director hated my performance so much that she looped the entire performance, which was one line." Regardless of the withholding of what could have been one of Affleck's career-defining line readings, the film had a stacked cast across the board.

Twenty-two-year-old Kristy Swanson, best known for her roles in *Ferris Bueller's Day Off*, *Flowers in the Attic*, and *Hot Shots!*, was a slam-dunk Buffy of the time. Swanson was friends with 90210 star Jason Priestley, who introduced her to Perry, who had a three-picture deal with 20th Century Fox at the time. Perry encouraged Swanson to audition for the film, telling her she was perfect for the part. "You could say she's kind of ditzy, [but] I looked at her more as a typical teen," Swanson said about the role. This rings true to one of the film's final scenes, where at the senior dance Luke Perry's Pike tells Swanson's Buffy that she's "not like other girls." Buffy pulls him in closer, holds him, and whispers in his ear: "Yes, I am." This would remain a tenet of the series as well. "But you're...you're just a girl," one kid remarks after Buffy saves his life in the Season 5 finale of the series. "That's what *I* keep saying," she responds, mirroring, tonally, the Buffy of the film.

Though Pike's name can be found within Spike's (a main antagonist and later protagonist-ish of the series), the two characters do not exist in the same cinematic universe, and Pike's entire existence is never once referenced beyond the film. Pseudo-coincidence, or Whedon having a penchant for names ending in *-ike*? Guess we'll never know.

But despite an all-star cast, a unique premise, and a budget so small failure seemed impossible, a plagued production ensued. "I pretty much eventually threw up my hands because I could not be

around Donald Sutherland any longer," Whedon said in a 2001 interview. "It didn't turn out to be the movie that I had written. They never do, but that was my first lesson in that. Not that the movie is without merit, but I just watched a lot of stupid wannabe-star behavior and a director with a different vision than mine—which was her right, it was her movie—but it was still frustrating. Eventually, I was like, 'I need to be away from here.'" Asked if it was a personality conflict versus incompatibility with the role, Whedon added this: "[Donald] would rewrite all his dialogue, and the director would let him. He can't write—he's not a writer—so the dialogue would not make sense. And he had a very bad attitude. He was incredibly rude to the director, he was rude to everyone around him, he was just a real pain."

But it wasn't just Sutherland with whom Whedon butted heads. It was also director Fran Rubel Kuzui. "I watched the movie the night before my network test and happened to see Joss as I was going through the door at Fox, and said, 'Oh! Oh! I watched the movie last night.' And he looked at me as if I had just thrown him an insult," recalls actor Anthony Stewart Head, who would be cast as Sutherland's successor in the series. "The problem for him was that [director] Fran Rubel Kuzui said, 'Leave it to us, we know how to make this,' and they took his humor, which can be dark, and sharp—it's so human—and they made it into schlocky horror. I love Donald Sutherland, but he seemed to be in another film, it was very strange."

It's hard to get a real sense of how many permutations *Buffy* went through from page to screen. "We actually didn't get to shoot the whole script because of budgetary concerns and things like that," Perry revealed at the 2015 Calgary Expo.

Couple Whedon's squandered vision with the film's uneven tone and what was left did not a pop cultural phenomenon make. To quote Christina Aguilera referring to her album *Bionic*, "Maybe it was too ahead of its time." But a flop it was not, despite often being remembered as such. "Our movie got sunk by *Death Becomes Her* in the movie theaters, so it really didn't do as well as it hoped," Swanson said during the

2015 Calgary Expo, failing to consider *Death*'s $55 million budget in comparison to *Buffy*'s modest $7 million. The film grossed double its production budget and received pleasant, if not memorable, accolades.

"A slight, good-humored film that's a lot more painless than might have been expected," Janet Maslin of the *New York Times* wrote in her slightly shade-filled review. Kenneth Turan at the *Los Angeles Times* called it a "light and diverting romantic comedy that is as high-spirited, undeniably silly, and not particularly deep as its teen-age protagonist," praising the film for not taking itself too seriously. And when the film was greeted with criticism, it was often through the lens of wasted potential. *Time* called Fran Rubel Kuzui's directing "frenzied mistrust of her material," while the *Chicago Tribune* noted that the film "never treats its material with much respect." This is important to note in deconstructing the myth that the series was based off of a failed movie. If anything, most reviews were keen to distinguish the work of Whedon's latent talents.

"I had seen it," says Sarah Michelle Gellar, who would go on to carry the baton of the titular heroine in the series. "I think it's totally fun and I love the concept. I wasn't quite sure how they were going to make a show of it, like it sounded very odd. But I think the movie is fun. My favorite line was always, 'All I want to do is graduate from high school, move to Europe, marry Christian Slater, and die.' It's a great plan." I concur.

"I went on opening day," recalls writer Douglas Petrie, who would join the *Buffy* writers' room in Season 3 and stay with the series to the end. "Because I had to see a movie called *Buffy the Vampire Slayer*. I wanted it to be what the show was. I wanted it to be great. But tonally it was different. To me it felt silly when it wanted to tighten up. To me they seemed to be saying, 'this is campy and therefore fun,' and I was like, 'No, I want the emotional stakes to be high and I want the fights to be tense and thrilling and important and meaningful.'"

Still, he saw something in Whedon's script, the same way he had when he saw *Speed* years later. "*That*, I want to do *that*. That's what I

want to see and that's what I want to make," he recalls after seeing the Keanu Reeves–led action thriller, noting how much fun could be had with attention to detail. He saw those same glimmers in *Buffy*.

Famed fashion casting director James Scully saw *Buffy* in theaters as well and, like Petrie, saw promise. "It was a mock on a horror flick that we hadn't seen before," he says. "It was sort of that same thing as what *Avenue Q* became years later: taking the story you knew from childhood and bringing it up into a Gen-X, '90s kind of ironic way. The humor was just so quick and so fast, and I still listen to that soundtrack today."

Though the film wasn't a hit by any means, it developed a following who saw something in its quirks. "The people who saw it loved it," Scully says. How does it compare to the series? "You got the warnings that the show was going to be nothing like the movie," he says. "And then the TV show came and blew the movie out of the water. It was its own thing. And unfortunately the fact that Kristy Swanson turned out to be some crazy Trumper has basically tarnished the whole movie, unfortunately. But I watched it recently and can confirm that it still holds up."*

It can be difficult to dissect something that ultimately middles, as our tendencies are to go to what is more easily digested or rewarded (read: hyperbole). "It was the best film *ever*" or "I would rather gouge my eyes out than watch this film again." *Buffy* the film is neither. It would never be my go-to, but I would certainly watch it if it came on while flipping through channels. I laugh out loud quite a bit: "Are there any good sicknesses that aren't too depressing?" one of Buffy's friends asks as they sit around brainstorming possible themes for the

* Swanson was an adamant and outspoken supporter of Donald Trump throughout his presidency. "If cancel culture is really going to have Donald J. Trump removed from the John Hughes movie Home Alone, then in support of my president I'd like to have myself officially removed from the John Hughes films Pretty in Pink and Ferris [Bueller's] Day Off," she tweeted in January 2021, spelling it "Buhler" instead of "Bueller."

school dance. "Guys, the environment," Buffy responds. "I'm telling you, it's totally key. The Earth is in terrible shape, we could all die. And besides, Sting's doing it." Moments later, a friend of Buffy's chimes in with a well-thought-out suggestion: "Okay, guys, how about the ozone layer?" Buffy's convinced. "We gotta get rid of that."

But those sort of blink-and-you-miss-it retorts weren't the only flavor of humor. "I can't believe I'm in a graveyard hunting for vampires with a strange man...on a school night," Buffy remarks early in the film. "They had fangs. They were biting people. They had this look in their eyes—totally cold. Animal. I think they were Young Republicans," another character remarks after evading death by vampire bite.

And then, my personal favorite:

[Buffy's mom bids farewell to Buffy and her boyfriend.]
Buffy's Mom: Bye-bye, Bobby.
Jeffrey: Bye! [to Buffy] She thinks my name's Bobby?
Buffy: It's possible she thinks my name's Bobby.

Still, no one would have expected this rather unremarkable film to have a second life as a series—most of all Joss Whedon. But as any loyal *Big Brother* viewer will attest, expecting the unexpected is critical. "You know, honey, maybe a few years from now, you'll get to make it again, the way you want to make it," Whedon's wife, Kai Cole, told him at the time. She'd prove to be an oracle of sorts.

Whedon's response was telling: "Ha ha ha, you little naïve fool. It doesn't work that way. It'll never happen."

Buffy Will Patrol Now

"I saw the movie when it came out—I mean, of course I wanted to *be* Kristy Swanson—and I remember when I met Joss at my audition for the show he was like, 'Don't even think about that movie. That movie doesn't exist,'" recalls actress Julie Benz, who played recurring vampire Darla. "And I was like, 'Oh good,' because I thought the movie was kind of cheesy...although I love Luke Perry, don't get me wrong. So I was happy to hear that that wasn't what they were trying to do."

A television show based on a movie that wasn't terribly successful, that's the boilerplate often cited when speaking about the weird circumstance of events that explain *Buffy*'s jump from the big to small screen.

"I think it's not inaccurate to say that I had a perfectly happy childhood during which I was very unhappy," Joss Whedon said, reflecting on his childhood in a 2001 interview. "It was nothing worse than anybody else...I was not popular in school, and I was definitely not a ladies' man. And I had a very painful adolescence, because it was all very strange to me. It wasn't like I got beat up, but the humiliation and isolation, and the existential 'God, I exist, and nobody cares' of being a teenager were extremely pronounced for me. I don't have horror stories. I mean, I have a few horror stories about attempting to court a girl, which would make people laugh, but it's not like I think I had it worse than other people. But that's sort of the point of *Buffy*,

that I'm talking about the stuff everybody goes through. Nobody gets out of here without some trauma."

Joss Whedon is credited with creating *Buffy the Vampire Slayer*, but had it not been for his ex-wife Kai Cole's prodding, *Buffy* would have remained a forgettable film from the early '90s. "I was with him when his *Buffy the Vampire Slayer* script was adapted, and the resulting movie released," she wrote in a 2017 essay for *The Wrap*. "It was painful to see how his vision was interpreted by the production team and on our honeymoon to England in 1995, I urged him to figure out how to turn it into a TV show. He didn't want to work in television anymore, following in his father's and grandfather's footsteps, but I convinced him it was the fastest way to get the experience he needed, so he could direct his own films someday."

Fortunately, or serendipitously, depending on how you look at it, he wasn't the only one with the hope of giving *Buffy* a second life. Whedon got the phone call in 1995. Sandollar Television owned the rights to the film, and president and CEO Gail Berman thought *Buffy* would make for a good TV series. "There were no young women on television at the time—certainly not young, empowered women—and that's what was basically the pitch for the television show: to take this young teenage woman and turn her into a kind of superhero," recalled Berman. "They called me up out of contractual obligation," Whedon said. " 'Call the writer, have him pass.' And I was like, 'Well that sounds cool.' "

Whedon was intrigued by the concept, seeing this as an opportunity to project his own high school experiences onto the series, something he had not done in the film version. He also saw the series as a rare opportunity to enact his original vision for the film. As creator, executive producer, and showrunner, Whedon would have control, something he felt he had earned in the years following the film's middling success. Whedon had made a name for himself as a script doctor, reworking the dialogue in films including *Speed* and *Twister* and

receiving an Academy Award nomination for Best Original Screen-play for co-writing *Toy Story*.

But it wasn't an immediate greenlight. "There were lots of sets of rolling eyeballs when we left the room," Berman said. NBC passed, as did 20th Century Fox's own network, Fox. It was an upstart two-year-old network called the WB that first showed interest. Without an established audience or a breakout hit, the network saw *Buffy* as an opportunity to target and carve out a younger demographic with par-ticular attention toward young women.

But revisiting *Buffy* meant reworking, and in many ways undo-ing, the world of the film. For starters, Buffy the character would regress from being a senior in high school in the film to a sophomore in high school in the series. The series would pick up with Buffy mov-ing from Los Angeles, where the film was set, to the fictional town of Sunnydale, California. She'd be joined by her mother, Joyce, who would be radically reconceived to be both more present and a more maternal figure in Buffy's life. Buffy's dad would appear briefly in the series, but unlike in the film, Buffy's parents would be divorced. And most notably, the series would begin with Buffy being expelled from Hemery High for burning down the gym, an event that was to take place in the original film but was ultimately scrapped.

"The show had to be designed so that if you saw the movie it didn't reiterate what the movie had done, because I wasn't interested in doing that again, but if you hadn't seen the movie, it had to bring you in," Whedon explained. "So we did a show that explained to every-one who hadn't seen it what was going on but if you had, it's sort of worked as a sequel—i.e., Buffy is already a vampire slayer, has already been on that journey, she already knows her destiny, she's sort of rejected it, she's moved to a new town and is trying to make a new start but she's still haunted by her past."

Though her time at Hemery is eventually seen in a flashback dur-ing the Season 2 finale of the series, the lapse in the timeline is never addressed. And though Buffy's original Watcher in the film, Merrick,

does appear, Donald Sutherland was recast for the series—much, I'm sure, *not* to Whedon's chagrin.

"I was just tickled," Swanson said of the film being turned into a series during a 2017 interview. Though tickled, she'd never make an appearance in the Buffyverse despite being a regular presence on the convention circuit. She wasn't alone, though. None of the original film actors would appear in the series, save for actors Chi Muoi Lo, who played an unnamed vampire in the movie and appeared in an uncredited, nonspeaking role in one of the show's finale episodes twenty-one years later, and Seth Green (whose brief appearance in the film as Wally Bessel, a nerdy vampire who feeds on a jock near the beginning of the film, was relegated to the cutting-room floor).

"There's moments in pop where something that's campy or something that's that original just can't time it right; it hits culture at just the wrong moment and nobody appreciates it," says Seth Green, who likens the film to the cult hit *Heathers* in its subversion of high school tropes. "My tastes are weird, so I tend to like what isn't popular, but then somehow people catch on to what was cool about it and it becomes more popular. And I felt that way about the movie. I was like, 'Oh, this is a movie that people might not get, but it's really worth being a part of.'"

Swanson would meet Sarah Michelle Gellar years later, according to Swanson, but they never talked about Buffy. "In a way it's almost like two totally separate things," she remarked. She's not wrong. I ask Gellar if the two Buffys have ever discussed their shared role in the ensuing years. "It's funny, we had dinner once quite a few years ago and I'm trying to think…I don't know if we did," she says. I tell her how crazy I find that, but she counters me: "It's pretty common. Lots of people play the same role and I don't know that they always get together and discuss it."

For many, me included, Swanson lies outside of the canonical line, since her Buffy and the Buffy in the series have little to nothing in common. "Sarah Michelle Gellar is and was the ONLY Buffy the

Vampire Slayer," I somewhat facetiously tweeted in August 2019 after Kristy Swanson defended former president Donald Trump on Twitter (as she was wont to do throughout his tenure in office). "Amen and repeat," Tony-winning actress Kristin Chenoweth responded to me in agreement, making some diehard *Buffy* film loyalists sweat.

But before *Buffy* would begin taping its first season, a pilot presentation was needed to convince the WB. What's a pilot presentation? "Sometimes if a network doesn't wanna commit to picking up a pilot, but they believe in the project and want to spend a little money, they'll shoot a pilot presentation," explains writer/producer Eric Charmelo, who would go on to work with Sarah Michelle Gellar on the CW's *Ringer*. "It's like a 'soft' commitment and gives the network a very specific idea of what the show would look like as a series." And so, in 1996, what is now known as "The Unaired Pilot of *Buffy*" commenced filming on a budget even a shoestring would find paltry.

Oh shoot, I didn't give SMG a proper entrance to the story! Let's fix that. Sarah Michelle Gellar was fresh off of her Daytime Emmy win for *All My Children* when she headed west to pursue bigger opportunities. She was in Queensland, Australia, wrapping production on Disney's *Beverly Hills Family Robinson* when she got a call from Fox to meet with Joss Whedon and test for the part of Cordelia, a popular cheerleader with whom Buffy would often spar (the non-butt-kicking kind). They met shortly thereafter, it went well, and she was offered the role. Feeling like she had little to lose in signing on for the pilot, Gellar accepted the role of Cordelia. It came, however, with a unique offer. Whedon and company still hadn't found the right Buffy and offered Gellar the opportunity to test for the leading role despite already being cast as a series regular. She came in for four days of readings before the prophecy fulfilled itself and Gellar was cast in the role that would be forever affixed to her identity within the zeitgeist of popular culture.

That's one neatly wrapped way of telling the story. According to Gellar, it was far less painless. "I'm sure you've heard this story," she

starts off during our interview. I have, of course, but I want to hear it from the legend's mouth. "The audition process was extremely brutal," she says. "It was my first pilot season that I'd come out to Los Angeles for. I kept being told I was too green, I wasn't ready, all those kinds of things that an actor loves to hear, especially a young actor. And I read the pilot and I loved it and I was like, 'Great Cordelia, it's perfect for me.' I had just come off playing Kendall Hart on *All My Children*. I knew that world. I went in, I had an audition, I had a callback, I screen tested [and] I got the job. It was a very... not simple—it was certainly stressful—but normal."

Things turned not-so-normal quickly. "That night I got a call saying that they still couldn't find Buffy, and they saw something in me and would I have any interest in coming back and reading for Buffy. It was a very split decision among my reps at the time, because there's always that risk that then they don't really see you as Cordelia, but they don't see you as Buffy. And maybe they see someone else, and they go in a different direction. So some people said, 'Don't do it.' And other people said, 'You should try.' And I went with my gut, which was to try."

According to Gellar, she went in to meet Joss ten or eleven more times. She passed the studio test. Then it was time for the network test. She went in, read, and then stepped outside to wait. "And then they finally said the other girl could go home and, 'Sarah, would you like to come back in?' And [before we went in] I broke down to the casting director and I said, 'I can't do this again. I'll be Cordelia. I'll be happy. I love this project. I want to be a part of it, but I just can't do this anymore.' And snot is dripping down my nose. And they walked me back into the office, and it was like thirty people in there, and they all started clapping and said, 'Congratulations, Buffy.'"

"I remember the brownish-orange carpet in the casting office for *Buffy*," recalls actor Selma Blair, who would go on to co-star with Gellar in 1999's *Cruel Intentions*. "I had auditioned for the part of Buffy as well. I remember the audition being pleasant, and that I was not

asked to do any part of it again." She laughs, then continues: "There was no response to me at all and I don't remember how I read. But of course I remember Sarah Michelle Gellar being the iconic Buffy. I was a fan, of course. My friend Rachel and I watched her on *All My Children*. I could picture myself in that other iconic role of hers, that of Kendall Hart, but not Buffy. That was all Sarah."

"You hear these stories about 'so-and-so auditioned for Buffy,' but obviously the role was meant to be Sarah's from the very beginning," says actor Clare Kramer, who played Glory in Season 5. "You can't imagine anyone else playing that role." She's, of course, not wrong. Even Seth Green, who had first met Gellar when the pair starred in a 1985 Duncan Hines commercial and would go on to join the cast in the show's third season, was convinced by her casting alone. "I was like, 'Oh, they're making a show out of this?' But then I heard it was Sarah, and I was like, 'Oh, that could work. Who knows? What is this WB network anyway?'"

For the pilot presentation, Gellar would be joined by Riff Regan and Nicholas Brendon as her best friends Willow Rosenberg and Xander Harris. Regan wasn't an acting newbie, having appeared as young Georgie on the NBC family drama *Sisters*, but this would be her first series-regular role. Brendon was even greener, having only one major acting credit to his name as Guy in Ray-Ray's Gang in a 1993 episode of *Married…with Children*.

"I had no right booking that fucking TV show," Brendon recalls after getting the phone call from Whedon, noting that he had only been formally pursuing acting for two months. Brendon says he was the last person cast "because Joss was casting himself." But Gellar had a unique vantage point from that of being a young person *and* a television veteran. She could relate to her co-stars in age while also recognizing the unique leadership role that the eponymous part demanded. Buffy was the Chosen One, but so was Gellar.

"I remember the first time we ever met was at Joss's house, it was me, Tony [Head], Sarah, and Riff, and we did a read-through before

we shot the presentation," Brendon says, recalling how Whedon had to interrupt the read-through to take a call from Steven Spielberg, who had sought out Whedon to help him do rewrites on the script for *Twister*. "It was a very sort of gentle way of plunging into it," recalls Head. This would eventually become a tradition, that of gathering the cast at Whedon's house, first on Monday nights and later on Tuesdays, where the cast and creatives would huddle together to watch the episodes as they aired.

The early days would prove to be challenging, especially to those greener to set life. "I didn't know what anything was," says Brendon. "I didn't know what a mark was. I didn't know what camera left was, or camera right. I didn't know anything technical. And [Sarah] held my hand and got me through those things. I couldn't have done it without her."

He takes a long pause. "And I'm going to start crying talking about it," he says as tears begin to well. "But, um...then things got a little fractured." More on that later.

Former San Diego Chargers cheerleader Charisma Carpenter assumed the role of Buffy's nemesis, Cordelia, the part originally offered to Gellar. ("I didn't know that," Carpenter revealed when Gellar told her this during the 2017 *Entertainment Weekly* cast reunion.) "I was already on this Aaron Spelling show *Malibu Shores*, but the word on the street was that it wasn't doing well," Carpenter recalls. "You could feel it. NBC was on the set. They were in the makeup and hair chair. They were kind of breathing down the throats of everybody, trying to turn it into something, but it wasn't working. So I think that my talent people were trying to find another vehicle for me, unbeknownst to me." It would prove a savvy move. *Malibu Shores* was canceled after ten episodes. Carpenter would book *Buffy* immediately thereafter.

"The thing that's very important about this show is that we are all Willow, and all Cordelia, and Buffy and Xander," Whedon explained. "Cordelia obviously stops being the evil one and becomes a part of the group. That was very deliberate because one of the things I wanted

to say with this high school show is that we don't have categories like 'The Nerd,' 'The Cool Guy,' 'The Popular Guy.' Everything is fluid, everything changes. Alliances change. We're all cruel, we're all heroic, we're all everything."

Rounding out the cast was Anthony Stewart Head, best known to American audiences for his role in a twelve-part Taster's Choice coffee commercial, who was cast as Rupert Giles, Buffy's Watcher, a guardian-like figure who would serve as a successor to Donald Sutherland's Merrick, who was killed in the film. A Watcher's job was to teach Slayers hand-to-hand fighting skills as well as teach them to use traditional Slayer weapons such as crossbows, axes, swords, and quarterstaffs. They would have regular training sessions with their dedicated Slayers either to learn new skills or to maintain their physical well-being. Giles would daylight as the school librarian, thus ingratiating himself in the lives of the characters beyond Buffy.

Whereas Buffy was distinctly a California teen girl, Giles was older, British, stuffy. But he wasn't a foil to Buffy so much as a hybrid mentor/father/confidant. "Giles read to me a bit like Prince Charles or, because *Robin Hood: Prince of Thieves* had come out around that time, like Alan Rickman as the Sheriff of Nottingham," recalls Head. "I said to Joss, 'Which way would you like me to go?' and, classically, Joss said, 'Um, a bit of both.'"

Of course Anthony, or Tony as he was affectionately referred to by the cast, had his reservations. "From where I was standing, the crew were not taking it terribly seriously. They were sort of pulled together off the street, it felt; they were sort of a bit like 'meh.'" Still, he was stricken by Whedon's tenacity and resoluteness in the show's upward trajectory. "During setups on the unaired pilot, Joss said, 'The suits aren't going to get this, but it's going to go from word of mouth, from person to person; people are going to be talking about it, and it's going to be huge.'" Call it egomaniacal or self-possessed, Whedon was determined to make sure this *Buffy* would work.

With his cast assembled, cameras went up.

"Making the pilot presentation was nothing but excitement," Gellar recalls. "I remember making that drive to Torrance High School every day and knowing there was something there." That's not to say it was an easy shoot. "Joss did not have a lot of experience or any directing, and what he wasn't surrounded by at that point was people that would support him, that would explain shots that were needed or missed, and so it was a difficult process in terms of filming because you need that as a first-time director; you need people that want to see you succeed. I'm not saying that people wanted to see him fail, but there was certainly an 'Oh, great, another boy wonder' kind of thing coming in. And you're based on a failed movie on a network most people didn't know about at that point. It wasn't like people thought this was going to be their best job. So I felt for him, and I remember talking at length [and] trying to build him up during that process, while at the same time being nervous myself."

Clocking in at just over twenty-five minutes, the unaired pilot is a condensed version of what would later become "Welcome to the Hellmouth," the show's actual pilot. "I don't think you'll have any problem adjusting, Bunny. Just remember our personal rules: No gang colors, no fur, no hanging from the rafters in the cafeteria screaming 'meat is murder' on sloppy joe day. That became very popular last month. Had to put my foot down." That was Stephen Tobolowsky as Principal Flutie, uttering a line of dialogue that would have felt as much at home in the film as it would have on the series. Nevertheless, it was cut—as was Tobolowsky, who would be replaced by Ken Lerner for four episodes before the character was unceremoniously eaten by a pack of hyenas.

Another small cameo came from Danny Strong, who would go on to win two Emmy Awards, including Outstanding Writing for a Miniseries, Movie, or a Dramatic Special for HBO's *Game Change* as well as co-creating and executive producing the Fox series *Empire*. "I was there for one night for a few hours," he recalls of filming the unaired pilot. "I had one line of dialogue in it and that was it: 'Are you the

new girl?' And she said, 'Yeah.' And then I looked at her like I don't know what else to say. And then I turned away and I tried to do a little comedy bit with it. Joss comes over laughing, Sarah Michelle Gellar is laughing, everyone's laughing. And they just kind of loved this little moment. It just cracked everyone up. It was very exciting to book that one line. I think I was twenty-two. I just graduated from theatre school. So any job I got was quite thrilling."

Soon after, Strong ran into Sarah Michelle Gellar and Nicholas Brendon at Century City Mall. "They ran over to me and they said, 'You were in the *Buffy* pilot!' I said, 'Yeah, how are you guys doing?' And they said, 'Oh my God, you were so funny. Joss is writing a part for you. He's writing a role for you because he thought you were so funny.' And I couldn't believe it. I mean, I was like, 'Oh my God, is this real?' So now I'm incredibly nervous. No one had ever written a part for me. And lo and behold, the show gets picked up and I get a call that I have an audition and that it's a pretty big part. This is the part that Joss Whedon had written for me that Sarah Michelle Gellar had told me is *my* part. So I show up for the audition, Joss Whedon comes out. He's beaming. He's so excited to see me. He couldn't be friendlier. I go in for the audition and I tank it. I was just terrible. I was so nervous because everyone kept telling me that Joss had written this part for me. And I saw on his face in the audition this disappointment. And then I didn't get the part."

It ended up being a disguised blessing. That part, the role of Xander's best friend, Jesse, ended up going to Eric Balfour. Jesse, Xander and Willow's best friend, would be killed off in the pilot episode and never referred to again. Jonathan, the role Strong eventually landed in the show's second season, would appear in twenty-eight episodes throughout the run. But at the time, not knowing the trajectory that would soon follow? Yeah, it stung. "I was devastated because I couldn't book a part that was written for me, and now *Buffy* is getting a massive release and there are billboards all over Los Angeles. And it's becoming

kind of the coolest thing in town. And I have to tell you the pain I had every time I would drive by a *Buffy* billboard because it would remind me of the part that was written for me that I couldn't land."

Another minor character introduced in the pilot who would go on to become much more significant over time was Darla, portrayed by actor Julie Benz. Benz would be the first actor to appear onscreen, and in doing so, would fortify the metaphor of the show. Darla and a Sunnydale High student break into the school at night. She appears as the damsel about to be in distress, only to then be revealed as a vampire herself, who then goes in for the show's very first kill. It was an immediate signal to audiences that subversion was going to be the name of the game.

"My wardrobe was hideous, that's what I remember," recalls Benz. "I remember the costume designer wanted me to look like my clothes were old and dusty and like they were pulled out of an old suitcase. That is not Darla at all. Darla kills for wardrobe." Benz, who was not just the first actor but also the first vampire to appear onscreen, also recalls being a test monkey for the vampire makeup. What was finessed down to about an hour and a half on and off started as anywhere from a three- to four-hour process. "It was a little traumatizing for me. It was my first time working with a prosthetic and I developed allergies to every kind of adhesive and remover. My face was just getting red and inflamed like I was burned. But I do remember after they put the prosthetic on me for the first time, I had to go pee, and so I went back into my little honey wagon trailer to use the bathroom. And I was nervous thinking, How am I going to play this super-evil vampire character? And I looked in the mirror, and I smiled, and then I was like, Ohhh, that's creepy! And that's how, in that exact moment, I discovered Darla."

Ultimately, the presentation was successful in that it got the series picked up. Still, Whedon would rather its existence in the nether reaches of the Internet be washed.

IGN: Is the presentation ever going to make it to DVD?

Whedon: Not while there is strength in these bones.

IGN: Well, I mean, it's one of the most heavily bootlegged things on the Internet.

Whedon: Yeah. It sucks on ass.

IGN: Yeah, it does, but it's sort of that archival, historical perspective...

Whedon: Yeah, I've got your historical perspective.

IGN: It would take it off the bootleg market...

Whedon: Ah, I don't—what are you going to do?

IGN: Put it on the DVD.

Whedon: Not me.

But like I said, the presentation was a means to an end ultimately achieved. And though the WB would pass on a full-season order in May 1996, just four months later, the network did an about-face and revived the series for a twelve-episode midseason pickup with one major caveat: They wanted Riff Regan out. "You must make her more hip, more cool." Whedon recalls the network suits saying. "I was determined that we wouldn't have the 'supermodel in horn rims' that you usually see on a television show. I wanted someone who really had their own shy quirkiness."

"Originally when Joss was envisioning Willow, he was envisioning Melanie Lynskey," says Gellar. Lynskey, who would go on to do a number of films and a role on *Two and a Half Men*, had just come off *Heavenly Creatures* and was unable to be considered for the role due to issues with her visa.

"That was a difficult role to cast," admitted casting director Marcia Shulman. "It just didn't work, so when we got picked up, we always felt like we were going to start again and look for another Willow. The qualities that Willow had to have are the exact opposite qualities of what actresses have to have: insecure, shy, self-effacing." Alyson Hannigan, best known for her role opposite Dan Aykroyd and Kim Bassinger in *My Stepmother Is an Alien* and in the short-lived sitcom *Free Spirit*, assumed

the role of Willow, and would go on to become the only cast member outside of Sarah Michelle Gellar to appear in every single episode of the series. "They made the right decision to recast," says Brendon. "It's almost a boring show with Riff. Alyson took it and ran."

"I really loved Riff, and I enjoyed working with her," says Gellar. "And to put her through that process of finding out that the series didn't get picked up, then it does, and then she's not [going to be on it], it was very heartbreaking." Gellar was called in to read with other potential Willows, but she knew immediately that the part was Hannigan's. "Alyson will tell the story and jokes that she just bombed the final test. And yes, she got some of the lines wrong, but it was just so obvious that the way we saw Willow was going to change with Alyson and that that was the right direction to go."

It simply cannot be denied how much the role of Willow is meant for Hannigan. It could be an easily won argument that no character has a more substantial arc on the show than Willow, and Hannigan's portrayal takes you through every machination from bookish, insecure, and uncertain to self-reliant, self-possessed, and empowered. It's the subtleties, the humanity, the emotional dexterity, the making what's dramatic feel real, the way she can catch her voice—I could go on and on.

Still, at this stage in the game, the network expressed distaste with the character, particularly her nerdy clothes seen in the pilot episode. "The character threw them because she isn't the TV-glow, big-hair sort of star that they would usually expect," says Whedon. "And I very much kept saying, 'I don't think you understand this character.' This actress is going to have a fanbase that is more rabid than anybody else's, because she brings so much to it, and that's the character that people think, That's somebody that I might have known, that I might have gotten along with. But at the same time she's the ideal of that. And I knew that they would respond to her on a level that they couldn't even respond to Buffy, because Buffy has an unobtainableness. She is such a hero."

So, with our new cast finally assembled...Oh wait! There was one other small but seismic addition, a young actor with only one major acting credit to his name (a guest appearance on *Married...with Children*): David Boreanaz, who was cast as Angel, a darkly handsome vampire cursed by gypsies to suffer the torment of having a soul. "They described me as a street-smart prizefighter who if knocked down would always get up," Boreanaz explained. "This guy was a two-hundred-and-forty-two-year-old vampire with a conscience."

"The idea that the man Buffy would clearly fall in love with would turn out to be a vampire, to me seemed like it might be a bit of a cliché," Whedon said. "But it was so perfect for this—that the wrong-side-of-the-tracks romance, the one person she could categorically never be with, the one person she'd spend her life learning to hate was the person she fell in love with—it was just too good to pass up." Plus, the pair had an undeniable chemistry. Look up on-screen chemistry in the dictionary and you'll see two pairs: Spencer Tracy and Katharine Hepburn, and SMG and DB. It's a scientific fact.

"David and I had one of the best working relationships," says Gellar. "We weren't best friends. Like, we didn't hang out on the weekends. But we never had so much as a disagreement. We made each other laugh, but it was never heavy, and we would fall back into old patterns. There's a reason why they call it chemistry, because there's no actual answer for it. It's not like we have these crazy passions in common. He loves ice hockey. I like basketball. It just worked. And we always had a good time."

"They have an energy together that's hard to define," Whedon said. "But it's very clear, and it's very tangible, and very gratifying." It was this love story, which began in earnest in the show's first season, that would anchor the show's first three seasons and capture the zeitgeist. "It was the glue," Charisma Carpenter said. "That love story and the themes around call of duty, forbidden love, the hope against all odds...the relationship is how we learned so much about who Buffy was, who Angel was—who he wanted to be. Couldn't be."

Boreanaz would bring a levity to the atmosphere on-set as well. "He was so charming, and so fun and he's actually kind of a big dork…but he's so hot, too, at the same time," says Julie Benz, whose character, Darla, would go on to give birth to a child with Boreanaz's Angel on *Buffy*'s spin-off series years later.

Boreanaz was a known on-set prankster who, along with Gellar, would eat tuna fish and pickles before their kissing scenes. But that's not all: "David started making a habit where he got to set before I did, he'd go shit in my trailer—and he wouldn't flush it," recalls Seth Green. "And it's like a huge turd. I'm like, 'Did you save that? Who is this? Who's doing this?' And then and at one point I arrived and he was walking out of my trailer zipping his pants up and I go, 'You motherfucker!' and we both burst out laughing."

But he was also a hard and dedicated worker. "He really has an amazing screen presence," says Benz. "He never took himself too seriously. He threw himself into the work. We would get the giggles looking at each other in our vampire faces. It's that thing called chemistry that they always talk about. We danced really well together. And I trusted him one thousand percent. It's magic when that happens. And I think he realized what a gift it was to do two or three episodes and then all of a sudden continue and then the next thing you know you're a series regular before moving on and getting your own show. It's a huge gift. That's not normal."

But that would come later. For now, Boreanaz would appear in a recurring capacity on *Buffy*, joining Kristine Sutherland (no relation to Donald), who was cast as Buffy's mom, and Mark Metcalf, who was cast as the Master, the show's first Big Bad, with whom Buffy would eventually square off to the death. With a cast finally complete, production began on Season 1 of *Buffy the Vampire Slayer*.

"You know, we had people like David [Boreanaz] and Nick Brendon who had done virtually nothing before they did these jobs," said Whedon. "And putting them up against people like Tony, Sarah, and Alyson, who'd been working for over a decade, each of them, and

everybody holding their own. Everybody coming up to a very intense professional level—that was very gratifying."

Brendon immediately felt at ease with Whedon, seeing a bit of himself in Joss, who had cast him, Brendon, to play a fictionalized version of Whedon himself. It was all very meta. "Joss gave me this direction once—which is the worst direction that you can give—but I knew exactly what he meant. He's like, 'Nicky, faster, but slower.' And I knew immediately what he meant: a little faster at the beginning, a little slower at the end. We just had a symbiotic relationship. And that's why I feel that this show was supposed to be made. There was a higher power to it."

In many ways, I see Season 1 of *Buffy* as table setting for the meal eventually served beginning in Season 2. With a few exceptions, namely "Angel" (Season 1, Episode 7) and "Prophecy Girl" (Season 1, Episode 12), *Buffy*'s first twelve episodes are more about establishment and world-building. Whenever I convince a friend to begin their *Buffy* journey, I always add the caveat that they need to stick out Season 1 and get midway into Season 2 if they're going to (wrongfully) choose to tap out. And if they do, there's a word for people like that: loser.

Now, on to the show.

CHAPTER 5

Beep Her

Humiliation. Alienation. Confusion. "I don't think you ever get over high school," Whedon said of his experience, which he seemed to (shrewdly? assumptively?) perceive as the universal one. He'd telegraph that experience, as mentioned, through the character of Xander. "Xander I've always identified as the figure I most was like, because he did have that inability to talk to the girl and come through in the big moment. And he does make an idiot of himself a lot. Of course, he's a lot prettier and more muscular than anybody who acts like that should be, but this is television, so get over it."

I want to pause here briefly because it's within this quote from the Season 1 DVD commentary that I think one of Whedon's greatest secret weapons is deployed: his masterful conversational skills. I'd conjecture that a lot of the reason that people first started wearing shirts emblazoned with the phrase "Joss Whedon Is My Master Now" (in *Star Wars* font, no less) has as much to do with his interviews *about* the work as the work itself. "As a DVD commentator, for example, a mostly improvisational form, the consistently hilarious, reliably insightful, frequently moving Whedon has no real rival known to us," noted David Lavery and Cynthia Burkhead in their book, *Joss Whedon: Conversations.*

Part of this came from Whedon's ability to posture himself as a lifelong outcast. *Buffy* was about high school, but Whedon spoke to the residual damage we carry into adulthood. And in Whedon's world, the misfits held the power. It's within this worldview—the

normalization of the "othered" by belief that the "othered" is the real normal—that a critical foundation point of the series is first established. "The idea of this band of outcasts being the heart of the show and creating their own little family is very much the mission statement," Whedon said. And thus was built the *Buffy* paradigm in which outcast often signified a refusal of the sheeplike tendencies of American youth. In other words, the cool factor of being a cheerleader or a star football player was easily usurped when held up against kicking demon butt and the occasional saving of the world.

How did Buffy, a beautiful, blond former cheerleader fit the mold of "othered"? In her case, it was a decision. When Cordelia, the popular girl, tries to welcome her to her elite social circle, Buffy rejects her after learning from Willow, the nerd, that she can't have it both ways. At least "not legally," according to Willow. That would be another major shift in serializing the concept: Buffy *and* friends.

"Buffy kind of mourns her lost popularity that she had at her school in LA before she went to Sunnydale but also realizes that that's not her priority anymore; that's no longer important to her, and there are much bigger problems to worry about," says food writer, chef, YouTube personality, and noted *Buffy* superfan Claire Saffitz. "I think that was a positive message for me: There are more important things to worry about than being popular in high school. I mean, she had to save the world a bunch of times!"

Both the character and the series were less interested in hammering home Whedon's clever conceit—blond girl goes into dark alley, gets attacked by big monster and kills it—and instead adopted a "been there, done that" attitude that forced the viewer to catch up. So in Episode 4 ("Teacher's Pet"), when it's discovered that the substitute biology teacher is a She-Mantis, the characters cycle past a gobsmacked "Wait...what?"; quickly work their way through "She's a demon!"; and land with astounding alacrity on "How do we kill her?" It's this accelerated thought pattern that helps swiftly indoctrinate viewers into the world of the show.

One holdover from the movie that was quickly phased out was the use of California-isms. For one, the show was intended to be more universal than the film. And for two, it was just plain weird.

Girl #3: Well, the chatter in the caf is that she got kicked out and that's why her mom had to get a new job.
Girl#1: Negly.
Girl#3: Pos. She was starting fights.

"You'll hear in [the first episode] a lot of, really, California-speak," Whedon says. "We toned that down, as people didn't really respond to it, and they didn't know what we were talking about. We still speak in a very strange pattern, but it's more based on the way I and the writers speak than on anything we think teenagers might want to say."

Sunnydale High, the fictional high school that (what's the opposite of serendipitously?) sat atop the mouth of hell, was based on "every high school in America." According to Whedon, he and his friend Tommy were sitting around, trying to come up with a reason why all evil forces would be drawn to Sunnydale. That's how they came up with the Hellmouth, "because it allows us to get away with anything." Placing it beneath the high school? Why not!

This kind of logic, the "It is this way because I say it's this way," became one of the creative team's best utilized tools in terms of how much it freed them from the tethers of exposition or explanation for that pesky logic thing's sake. "Some shows, *The X-Files,* for example, [are] very much into the realism, the science behind whatever the horror is. Explaining it, really justifying it in the world," Whedon said. "We are so much more about the emotion resulting from this. Not why there might actually be vampires, but how you might actually feel in high school if you had to fight them. And as a result, we tend to gloss over the really intense details about how we might go through procedure, how we might find something, how we might kill something, how something might exist. We tend to say, 'It's on the

computer' and 'It's 'cause we're on the Hellmouth,' and just get away with it."

I'll watch the show sometimes with smarty-pants types who triumphantly point out a gap in logic of an episode's plot. "Yup," I'll tell them, gently tapping them on the knee to affirm their perceptiveness while also telling them, wordlessly of course, to STFU and enjoy.

Now, let's (finally) start the show.

Sunnydale High School. Night. We open on a shot of the school with a twist on the classic blond girl in peril. Not only is she not in any kind of peril, but rather she is that which *causes* peril. The "she" in question is the great Julie Benz as Darla. And though she appears in only five episodes of the series, she is both a prominent fixture in the show's lore and in the spin-off series, *Angel*. Benz begins what is practically a tradition on the show: an actor coming on for a single or multi-episode arc and somehow sticking around for much longer (see: Angel, Spike, Oz, Faith, Anya, and Tara, just to name half a dozen).

In the case of Benz, Whedon saw a practical need to keep her around beyond the pilot. "Originally she had been supposed to die," Whedon admitted. "Willow confronts her with holy water at the end of this episode, and as originally written she croaked. But while we were shooting this we were working on upcoming stories, and I thought the story for Episode 7, when we revealed Angel to be a vampire when he and Buffy were really starting to fall in love, would be much more interesting if there were a triangle. If we saw some darker side of Angel, somebody who represented a rival for Buffy who represented his evil leanings. And Julie was doing such a great job for us on these shows that we quickly decided to have her run out in pain rather than die, because we knew we could use her."

And use her they did. Benz would return for several episodes in flashback form before being brought back to life in human form in the Season 1 finale of *Angel*, where she'd continue on as a recurring character. I asked for any memories she had of filming Season 1 of *Buffy*,

at which point she joked that I should have asked her this a decade ago instead of now, nearly a quarter century later. Then, after parsing her brain, a big smile came over her face. "David [Boreanaz] and I weren't series regulars at the time, and we were both older than most of the cast, so we would laugh at the fact that we got to run around and be these vampires. We just thought it was the funniest thing ever that we got paid to do this. We laughed at the ridiculousness of it, but also recognized how cool it was that this was an actual job."

Benz's multi-episode villain arc would prove to be rare for the series, which would adopt a hybrid model of the monster-of-the-week format popularized on *The X-Files*, while introducing what is colloquially known as the "Big Bad," a supervillain that would face ongoing battles with Buffy throughout the season until ultimately being defeated in the finale. For the first season, the Master, played by Mark Metcalf (known largely for his appearance as Maestro on *Seinfeld*) was introduced as Buffy's major foe and helped cement and fortify the construct that evil was not always easily defeated. That, and it suggested an idea more gainfully explored in Season 2: that of evil having wants and needs all its own, and sometimes, even scarier perhaps, evil isn't so easily discerned. "The best kinds of villains are the people that you know and love," co-executive producer David Greenwalt explained.

Upon my most recent rewatch, what stands out most about Season 1 is the budget... both for better and for worse. "You'll see a great number of examples of me, who had worked mostly in movies, trying to do things that I physically can't, and having no idea actually how to run a television show," Whedon explained. "A lot of my expectations had to be brought down. Usually to the benefit of the show, because the less elaborate I could be, the more I just had to make things matter. So that I couldn't hide things with the dog and pony show because I couldn't afford the pony; I only had the dog."

Perhaps the most canonical example of the limited budget is the fact that every hallway walk-and-talk (of which there are many) is shot

in the exact same hallway. At best, you never notice, and at "worst" it makes for a pleasant Easter egg. The stunts were practical. The makeup was detailed, using no special effects outside of the vampire dustings. Though they became more intricate as time went on, starting from the pilot episode, vampires would poof into dust once killed. Though this detail was a slight post-production cost for a show on a shoestring budget, it was practical to not have to deal with vampire corpses popping up all over Sunnydale. Everything felt very thought through, no strays or flyaways.

One big advantage that the series had in being ordered as a mid-season replacement was that all twelve episodes were shot before any of them aired. As a result, there are scenes in the first episode, for instance, that were shot months after the episode had wrapped filming. "We didn't have that luxury of like, 'is this show doing well?'" says Nicholas Brendon. "When we said goodbye after 'Prophecy Girl,' we didn't know if we were going to see each other ever again." Still, there was some inclination among the cast that they were sitting on something special. "I remember it was me, Aly, and Sarah, and we all watched ['The Witch'] one day in the edit bay. And I remember we walked out and Sarah looks at me and Aly and she was like, 'Guys, I think we have a job for a while.'"

Gellar was confident in the series, but as a television veteran, she was keen to get her performance calibrated just right. Whedon felt the same and decided to do reshoots after the season had wrapped. My favorite example of this happens about midway through the pilot when Buffy, having rejected her fate as a vampire slayer, returns to the library and confronts her new Watcher with her feelings of trepidation. Whedon felt the performance was slightly too "pissy." Gellar's own senses told her the same. "I have a feeling that I was too angry," she went and told Whedon. Eight months later, they re-created her side of the scene and stitched it in with Anthony Stewart Head's original take remaining intact.

I asked Gellar about these reshoots. "[Joss] is talking about the big

scene in the library, right?" That's one of them, I tell her. "No, I didn't remember that until you just told me. See, this is what happens. You can prompt me and sometimes I'll come up with them." This proved to be a fun little game of sorts throughout my interview with Gellar and many of the other cast members, helping color in memories that had over time faded to black and white.

Head recalled his own frustrations at his early portrayal of Giles. After filming the unaired pilot and all the tests with various TV executives, by the time he got on set he recalls losing confidence in the aspects of his performance that the network responded best to, and thus began overthinking his choices as an actor. "When we shot the last scene [in the pilot], I overplayed it—very, very pushed, and pompous. Thank God the editing bay was next to my dressing room up the stairs. I just heard my voice the next day, and I popped my head through the door and watched what we had shot. It was shit. It was *such* shit. So, thankfully, I was able to just wind it all back in when we shot the important stuff, like when I meet Buffy in the library. The scene at the end is all there, as you can see, but thankfully, it's little, and I got the chance to make the rest of it okay."

Gellar agrees that finding Buffy was a process rather than an outcome. "As you shoot a season, you get your footing, you find the character, you find your confidence, and there were things that I felt more capable of doing by Episode 12 of Season 1 that I wasn't [at the outset]. A lot of people have said that with great scenes [sometimes] you have these ideas afterwards and every so often you're lucky enough to get that chance at it."

That's going to be a common thread we'll continue to explore: Just how underrated Sarah Michelle Gellar's performance is throughout this show. Sure, she earned a Golden Globe nomination in Season 5, but to quote Joyce Summers after Buffy tells her mother that she's the Slayer: "I just don't accept that."

It's actually a scene minutes earlier that convinced Whedon of the star power he had at his disposal in Gellar. It's a rather innocuous

scene early on in the pilot between Buffy and the school's principal in which she pleads that the Buffy who was expelled from her last school is a Buffy of the past. It's a rather unremarkable scene from the viewer's perspective, requiring little emotional dexterity from Gellar. And yet Whedon saw something. "This was one of the times when I was really watching Sarah on the monitor, and realized what an enormous television star I had on my hands," he recalled. "The subtlety of her acting, a lot of which would go completely unnoticed. Just the reactions, the expressions. I realized you could play this entire scene on her and she tells you everything that's going on. That's the reason I think Sarah works so well in this role. What is great about her as a television actress is she takes the audience with her everywhere she goes. Everything she feels, very specifically, because everything she does is specific. There's nothing vague, there's nothing un-thought-out. Very precise. So she's an open book. She brings you with her."

The pilot mostly plays out like a movie-of-the-week: Buffy, our hero, finds evil, defeats evil, and makes friends along the way. Hooray! And does she quip? Oh, how she quips. Part two of the pilot, "The Harvest," ends with an open-ended denouement, thus setting up the remainder of the series, both tonally and episodically. Put simply: She defeats the bad guy. "Yay." But there will be more coming. "Oy."

> **Giles:** We've prevented the Master from freeing himself and opening the Mouth of Hell. That's not to say he's going to stop trying. I'd say the fun is just beginning.
> **Willow:** More vampires?
> *[They stop walking.]*
> **Giles:** Not just vampires. The next threat we face may be something quite different.
> **Buffy:** I can hardly wait!
> **Giles:** We're at the center of a mystical convergence here. We may, in fact, stand between the Earth and its total destruction.

Buffy: Well, I gotta look on the bright side. Maybe I can still get kicked out of school!

[The three students continue to class. Giles stays behind and watches them go.]

Xander: Oh, yeah, that's a plan. 'Cause lots of schools aren't on Hellmouths.

Willow: Maybe you could blow something up. They're really strict about that.

Buffy: I was thinking of a more subtle approach, y'know, like excessive not studying.

[Giles turns to go back to his library.]

Giles: The Earth is doomed!

"I like the scene a lot just because I think everybody's good in it," Whedon said. "And it's nice to have established the group that well. And to go off on Giles's statement, 'The Earth is doomed'...it says everything is not perfect. It's a nice little way to go. Tony's excitement at all the monsters we're going to face is always a source of amusement for us. He's always having just a little too much fun in the midst of all this direness."

Buffy's friends were not only accepting of her slayer status, they were allies in the fight. They also serve as fundamental, albeit accidental, agents of chaos, especially in Season 1. In "Teacher's Pet" (Episode 4), Xander falls for the aforementioned She-Mantis and must be saved by Buffy. In "I Robot, You Jane" (Episode 8), Willow falls for a mysterious man online who turns out to be a demon spirit trapped in cyberspace and must be saved by—you guessed it—Buffy. In "Out of Mind, Out of Sight" (Episode 11), Cordelia is targeted by a mysterious invisible spirit out for blood and must be saved by...well, you get it.

Writer Drew Z. Greenberg, who joined the writers' room in Season 6, cites Episode 11 as his first "aha moment" of watching the show and realizing *Buffy* wasn't good, it was great. "I related in a big way to

that thing of not feeling seen. And making the metaphor literal was just so smart. The neurons in my brain just went, 'Oh, that's it. This is something on a different level where they are taking it and making you feel the thing in a genre context.'"

The paradox was clear: Buffy's friends connected her to her humanity, and more specifically her teenagedom, but also made her more vulnerable to attack, and thus her own humanity became both her secret weapon and Achilles' heel, something that would be explored more deeply down the line. "No friends. Just kill. We are alone." Those are the words the First Slayer, Sineya, would tell Buffy when the two face off in Season 4.

The pilot also establishes Buffy's intelligence in the fight. When Buffy defeats her first major foe, Luke, by tricking him into thinking he's dying from sunlight only to stake him from behind while letting him know that the sunlight in question was nothing but a streetlamp, she proves her capabilities go beyond the physical, allowing her to outwit *and* outmatch her opponents. She'll be painted as a less-than-extraordinary student throughout the series, but Buffy's intelligence, particularly her emotional intelligence, never wavers, only growing stronger through the trials and tribulations of life as both a teen and as the Slayer.

By Episode 3 ("The Witch") the show already feels familiar. That's one of the things I love so much about it: Thanks perhaps to the film or the unaired pilot or Whedon's world-building or the cast's chops or some alchemy of all of the above, the show feels extremely certain of itself from the jump. Buffy is the fearless leader. Willow is the doe-eyed brains. Xander is the loveable goofball. Cordelia is the mean girl. Giles is the father figure. By Episode 6 ("The Pack"), the school principal was already getting eaten by a group of hyena-spirit-possessed students.

"I loved the audacity of the storytelling, and the sense of humor, but the thing that really hooked me was the way the show got the experience of high school—and that age—correct," says writer Jane Espenson, who joined the writers' room in Season 3. "That age, those

experiences—it's all so painful that it's hard to look at it directly. Using the metaphorical structure, turning inner demons into outer demons, made it possible to explore all that stuff *and* have fun. And there's something truer-than-true about it. There is a kind of teenager that is very much a hyena, and making that literal brings them more into focus."

But I think it's the midway point of the season that we'd need to explore to suss out the first wafts of the series firing on all cylinders, and it has everything to do with the unanticipated chemistry between Gellar and Boreanaz. If you look up "brooding" in the same dictionary that has their image next to "chemistry," you'll find David Boreanaz's performance as Angel from Season 1, partly because that is the character and partly because the character was missing critical development that was not yet required. The mystery was written to be alluring for Buffy, but it cast a spell on audiences as well. The overwhelming response from viewers following Season 1: More Angel.

He has but one scene in the show's pilot, but one scene is all he needs.

Angel: Is there a problem, ma'am?

Buffy: Yeah, there's a problem. Why are you following me?

Angel: I know what you're thinking. Don't worry, I don't bite.

[She backs off and lets him get up, but keeps her fighting stance.]

Angel: Truth is, I thought you'd be taller, or bigger muscles and all that. You're pretty spry, though. *[He massages his neck.]*

Buffy: What do you want?

Angel: The same thing you do.

Buffy: Okay. What do I want?

Angel: To kill them. To kill them all.

Buffy: Sorry, that's incorrect. But you do get this lovely watch and a year's supply of Turtle Wax. What I want is to be left alone!

Angel: Do you really think that's an option anymore? You're standing at the Mouth of Hell. And it's about to open.

[She stops, turns to him, and looks at him with a wide-eyed gaze. He reaches into his jacket and pulls out a small box.]

Angel: Don't turn your back on this. *[Tosses her the box.]* You've gotta be ready.

Buffy: What for?

Angel: For the Harvest.

Buffy: Who are you?

Angel: Let's just say . . . I'm a friend. *[He starts to leave.]*

Buffy: Yeah, well, maybe I don't want a friend.

Angel: *[Turns back]* I didn't say I was yours.

He pops up briefly again in Episodes 4 and 5, hinting at the possibility of love, but it's in Episode 7, aptly titled "Angel," that the character's backstory is filled in, thus paving the way for his future on the show. It's in this episode that a three-season-long arc is born. "A vampire in love with a Slayer? It's rather poetic," Giles will admit just a few episodes later. It's hard to remember a reality in which I didn't know Angel was a vampire, but it takes half a season for this big reveal, instigated, poetically, by their first kiss. It's due to this kiss that Angel experiences a pang of true happiness—that we'll later learn he is cursed to never have the opportunity to feel without dire consequences—and thus we are given our first look at vamp Angel. (Still pretty sexy, to be honest.)

It's a fun *Romeo and Juliet*–esque trajectory from here forward in which the pair agree to keep their burgeoning relationship a professional one, despite sealing this decision with a goodbye kiss by the episode's end.

Angel: If I can go a little while without getting shot or stabbed I'll be all right. Look, this can't . . .

Buffy: . . . ever be anything. I know. For one thing, you're, like, two hundred and twenty-four years older than I am.

Angel: I just gotta . . . I gotta walk away from this.

Buffy: *[Nods]* I know. Me too. *[Whispers]* One of us has to go here.
Angel: *[Whispers]* I know.
[They look at each other a moment longer and then close in to kiss. Their kiss becomes passionate. Buffy reaches her hands up to Angel's neck. Finally, they separate.]
Buffy: You okay?
Angel: It's just...
Buffy: ... painful. I know. See you around?
[Buffy walks away. Angel watches her go. The camera pans down to his chest, where her cross has left a deep burn.]

You'd think this would be the beginning of the great romance that many know it to have become. You'd be wrong. Angel doesn't appear again until the season's penultimate episode and won't come face-to-face with Buffy again until the finale. Further proof that Season 1 is more of a means to an end. But what an end it is.

There's a particularly notable scene that happens midway through the season finale that accomplishes quite a bit, both within the world of the show and in establishing the show's greater legacy. Giles and Angel are in Giles's office talking when Buffy wanders into the library. Buffy hears indistinct chatter and is immediately enthralled by the unexpected presence of her crush. She lingers to listen in. "Tomorrow night Buffy will face the Master, and she will die," Giles tells Angel. A stunned Buffy, who has snuck in unnoticed, begins to laugh, catching the attention of both men, before resigning from the position she never chose to begin with.

Buffy: I quit!
Angel: It's not that simple.
Buffy: I'm making it that simple. I quit! I resign, I-I'm fired, you can find someone else to stop the Master from taking over!
Giles: I'm not sure that anyone else can. All the... the signs indicate...

Buffy: The signs? *[Throws a book at him]* READ ME THE SIGNS! *[Throws another one]* TELL ME MY FORTUNE! YOU'RE SO USEFUL SITTING HERE WITH ALL YOUR BOOKS! YOU'RE REALLY A LOTTA HELP!

Giles: No, I don't suppose I am.

Angel: I know this is hard.

Buffy: What do you know about this? You're never gonna die.

Angel: You think I want anything to happen to you? Do you think I could stand it? We just gotta figure out a way…

Buffy: I already did. I quit, remember? Pay attention!

Giles: Buffy, if the Master rises…

Buffy: *[Yanks the cross from her neck]* I don't care! *[Calms down]* I don't care. Giles, I'm sixteen years old. I don't wanna die.

There's going to be a lot of moments that I wish I could just roll tape and have us all collectively sit together in a room and watch a scene (or scenes, or hell, the whole series) together. This is the first of those instances. I think this scene is masterful in a lot of different ways. For starters, it shows us the depth of feeling both Angel and Giles have for Buffy. I think it's particularly resonant to have these emotions play out in this triangular dynamic because it's the first real showing of Giles as a fatherlike figure to Buffy and not just her Watcher. When Giles responds to Buffy by admitting his inadequacy, it also sets up a major theme throughout the series: Buffy's solitude. "Into every generation, there is a chosen *one*. *One* girl in all the world. She *alone* will wield the strength and skill to stand against the vampires, the demons, and the forces of darkness." Despite the chosen family she amasses, at the end of the day, the battle is hers and hers alone.

"That was her struggle, right?" says Gellar. "And that's what every sixteen-year-old goes through. Your body's going through these terrible changes, all of your relationships are changing, you're not an adult, you're not a child, you don't have the skill set to really survive.

And it was manifested as actual physical demons. And that to me was the beauty of the show. Plus, there weren't shows about female empowerment then. The girls were the girlfriend or the sidekick. We weren't superheroes. The *Wonder Woman* movie didn't get made then. They were trying to, but they'd been trying to for forever."

I let Gellar know that I'm among a faction of fans who believes she would have been a great Wonder Woman. "I'm too short. Plain and simple. She was an Amazon. I am a little person."

But back to reality, or rather, the Buffyverse. I suppose now is as good a time as any to start to *really* dissect Sarah Michelle Gellar's performance, which, hoo-boy... Can we talk? The stunted laugh her character lets out upon hearing that she'll die. The way she vacillates from calm to angry to resigned to hurt to scared. There's a phrase I'm gonna pull out from my undergraduate days at NYU theatre school: moment-to-moment work. This scene allows us, the viewer, to see the toll that this sacred birthright has taken on Buffy. She entered the series with the burden of trying to find her footing at a new school: not get kicked out, get good grades, and maybe make a friend or two. And now she's got to die? Frustrating! Spoiler alert: She'll be okay... until she dies again... and another spoiler alert: she'll be okay!

And all of those swirling emotions, the sadness about missing your prom on account of dying combined with the confusion, anger, resentment, and despondency? You, the viewer, feel all of that. This show is specifically crafted, maybe by design, maybe by chance, maybe both, to put you in the driver's seat of the character of Buffy. To feel all of her feelings. "You can sort of pick your poison, but the loudest invitation is 'Step into Buffy's life,'" says Jenny Owen Youngs, co-host of the popular podcast *Buffering the Vampire Slayer*. "And for me, the highlighting of Buffy's experience of otherness and the idea that great capability and great power can coexist along with a beautiful, strong chosen family slash community? That general vibe is a spicy meatball." Couldn't have said it better.

All of that groundwork is laid out in Season 1, but nowhere more

specifically than in the season finale, which ups the stakes from *feeling* like life or death to *being* life or death. Unlike future seasons, which feel like a slow build toward an ultimate final showdown, Season 1 gave us very little arc. Because the Master was relegated to being belowground in his lair, he and Buffy were never given the opportunity to meet face-to-face before the final battle. His right-hand man is dusted in the second part of the season premiere and then the Master does not show up again until a brief appearance in Episode 5 ("Never Kill a Boy on a First Date"). He resurfaces (albeit belowground) again in Episode 7 ("Angel"), but again, it's mostly his pained reaction to the loss of his right-hand woman, Darla. He pops up in Buffy's nightmares in episode 10 ("Nightmares") and then isn't seen again until the finale.

Still, despite his limited screen time, I quite like the Master in terms of blueprinting the archetype that will continue on in the series in characters like Spike, the Mayor, Glory, and more. This idea, that the bad guy has characteristics outside of just villainy—a sense of humor, for instance—is one of the ways that the series is subversive beyond just the character of Buffy.

"You tried," the Master tells Buffy upon their first meeting. "It was noble of you. You heard the prophecy that I was about to break free and you came to stop me. But prophecies are tricky creatures. They don't tell you everything. You're the one that sets me free. If you hadn't come, I couldn't go. Think about that." He then sinks his teeth into her neck. "Oh, God...the power!" Then: "By the way, I like your dress." He then disposes of her body in a shallow pool, leaving her to drown.

In the end, though, Buffy defeats the bad guy in time for her and her friends to attend the prom. Oh yeah, and she dies. I've never been too clear on the logistics of this. The Master feeds off of her and then leaves her to drown. Minutes later, with the Master and his henchman finally going aboveground, Xander and Angel find Buffy and Xander resuscitates her with CPR. I don't know much about CPR, but

I'm pretty sure it doesn't work on a dead person. What's clear is that she survived the Master's bite, seeing as the CPR was for her loss of breath, not her loss of blood. I'm famously not a vampire but wouldn't you want to maybe snack a bit longer, considering the quality free meal before you? I guess one could argue that Buffy's blood was his gateway out, and therefore he wanted to waste no time in getting above soil. I guess? Just seems more like Buffy passed out than *died*. That said, in addition to famously not being a vampire, I've famously never died, so maybe I'm not the best authority. Nonetheless, this is canonically believed to be Buffy's death, and who am I to argue? And thus a new Slayer is called. More on that in the following chapter.

Oh! Maybe this is a good time to introduce some of the rules of the world according to *Buffy*. "We picked and chose our vampire lore based on lots of different myths, in *Dracula*, *Lost Boys*, everything we'd seen we sort of took whatever we wanted," Whedon said. According to Buffy herself, "to make you a vampire they have to suck your blood and then you have to suck their blood, it's a whole big sucking thing." Becoming a vampire is allegedly great. "I feel good, Xander! I feel strong! I'm connected, man, to everything! I can hear the worms in the Earth!" a recently slain guy named Jesse tells Xander in the show's second episode. A one-off character Holden Webster would repeat this sentiment almost verbatim in the show's seventh and final season. "No, it feels okay. Strong, and I feel like I'm connected to a powerful all-consuming evil that's gonna suck the world into fiery oblivion."

In order to survive, vampires require mammalian blood to maintain strength. Preferably human blood, but rat or pig blood will do in a pinch. A vampire will reveal their "vampire face"—pronounced brow ridges, yellow eyes, elongated upper canines, and pointed upper incisors. They generate no body heat, have no reflection, do not require oxygen, and are unable to receive direct sunlight. If they do, they burst into flames. It's that simple. Holy water is another way to kill them, but you better douse them. A cross pressed up against the

body will make them smoke, but no fire. And of course, the tried-and-true wooden stake through the heart. As for bullets? Won't help. Once dead (again), a vampire goes poof. "That was a very conscious decision, that they would turn into dust, clothes and all, because I didn't think it would be fun to have fifteen minutes of 'let's clean up the bodies' after every episode," Whedon explained.

Perhaps my favorite detail is the invitation-only policy. Vampires can only enter a private residence if invited; otherwise, they hit an invisible barrier. However, one invite grants the vampire unlimited entry. Public spaces are a free-for-all. I think that about covers it! We might need to revisit this at a later point because I'm pretty sure the rules are a bit, how shall we say...malleable. "We spent a long time explaining the rules to people during this show because I wanted them to understand," Whedon said. "The rules are very important in a horror movie. You can't just make them up...You have to have very specific rules—so that when you break them it means something. And the audience always knows on that level what to expect even if they don't on a story level."

But back to the show! "We saved the world, I say we party," Buffy tells the Scooby Gang (that's what they come to be called, a nod to *Scooby-Doo*'s Fred, Velma, Daphne, and Shaggy, after "Slayerettes" fails to stick) as they head to the prom, and thus as they exit we get the camera slowly tilting down to the bones of the Master. "That guy ain't dead," I remember rightly thinking. But dead or not, *Buffy* had critics clamoring. "There are more than 320 Web sites devoted to her every aspect," the *New York Times* wrote in their Season 1 review as proof of its immediate status as a cult hit. (If 320 doesn't seem like a lot, remember, this was 1997.)

But even the *Times* was of more than one mind. A review of the fifth episode of the season skewered the show: "With the cult suicides in California, these aren't the best of times for television entertainments to be peddling supernatural fantasies.... What then to make of

Buffy the Vampire Slayer, the new Monday-night series on the fledgling WB network? Not to worry. Nobody is likely to take this oddball camp exercise seriously, though the violence can get decidedly creepy."

Thankfully, the negative reviews were the outliers. *People* gave the season premiere a B+, while the *Hollywood Reporter* was similarly glowing: "It's undeniable fun to see Gellar's self-assured Buffy go through Bruce Lee moves as she wipes out the nosferatu brigade." The *Chicago Tribune*, too, seemed smitten: "The performances are generally strong, but the devilishly clever, culturally hyper-attuned dialogue (by executive producer Joss Whedon, who wrote the original and worked on *Speed* and *Toy Story*) is what makes this stand out."

One thing was immediately clear from any review you read from that time—the ones loving it and the ones that poo-pooed—is an undeniable desire to muse about this show. Even the critics who didn't connect to it felt a need to talk at length about why. Whether it was being compared to the existing television landscape, or the changing milieu of American teens, or simply dissecting the show's near-constant genre-bending, *Buffy* was inescapable fodder.

"It wasn't a massive ratings hit, but it was considered very cool," says Danny Strong, who despite appearing in the "Unaired Pilot" was not yet part of the show and would not begin his recurring role as Jonathan until Season 2. "It was a hip show right out of the gate."

But is *Buffy* Season 1 good?

I decided to poll fans of the series, those who watched upon first airing, those who found the show on DVD in the early aughts, and those who freshly viewed the series for the first time by streaming it. I have to tell you, one of the most unexpectedly fun parts of writing this book has been putting polls up on Instagram or simply posing questions about the show and receiving hundreds of deeply thoughtful and remarkably cogent responses.

"Yes, unequivocally. High camp. Plus, Queen Charisma at her A game. She sang Whitney Houston, for crying out loud."

"As a whole, no. Bits and pieces, yes. Key moments, yes."

"Yes! It's a fun monster-of-the-week, establishes the universe, and people are too hard on it."

"It's good but hasn't aged as well as the other seasons."

"Yes. Because it's the start of something excellent. It's very dated now, but still beautiful."

"Eh, it's cute."

"It's fun, campy, still funny as hell, and the FASHUN. I mean! Also, the premiere/finale still slap."

"It's foundational. Necessary."

"You have to start somewhere, and there's maybe four good episodes."

"Every season is good. It's fucking *Buffy.*"

"Yes. The tone is different, but we wouldn't appreciate the later seasons without Season 1's levity."

"Fuck everyone, the Master's character design is iconic."

"Compared to the rest? No. But like the first *Harry Potter* movie, major props for casting and tone establishment."

"Yes. Controversial, but I think it's the best. Campy, goofy, Sarah shines and the fashion reigns."

"Xander is at his hottest."

"I think we're terrified to critique her because it starts it all. I would say good but not best. Too monster-of-the-week."

And there you have it. The range! I'd say that outside of Season 7, Season 1 receives the least amount of examination for a number of obvious reasons. Primarily, it's the oldest and the shortest (no offense!). I've always wondered how a full, twenty-two-episode Season 1 would have influenced the show's overall trajectory. Would we have gotten more time with the Master? Would the show have been forced to figure out what to do with Cordelia sooner?

With Season 1 a definitive success, the landing strip was cleared for a Season 2; one that would go deeper and fill out nearly twice the span of Season 1 with a twenty-two episode pickup. In order to do

this, the show would need to fill out its universe even more. David Boreanaz, who had only signed a six-episode deal for Season 1, was recruited to the main cast for Season 2. Side characters like Buffy's mom, Joyce (Kristine Sutherland), and Giles's maybe love interest, Jenny Calendar (Robia LaMorte), would see their roles bolstered moving forward. Juliet Landau and Seth Green would both make their series debuts as Drusilla and Daniel "Oz" Osbourne, respectively. But perhaps the biggest impact was made with the casting of James Marsters as Spike, a character nearly as indelible in the series lore as its title star.

Buffy Season 1 had stuck the landing, and now that it had hit the ground, it was time to start running.

You're 16 Years Old. I'm 241.

We open, appropriately, on a graveyard. But unlike the graveyard from Season 1, shot on location in Hollywood, Season 2 afforded set designer Cary Meyer (promoted from his role as art director in Season 1) the budget to build a graveyard in a parking lot on set—"which made our lives a whole lot easier, but doesn't give you the scope that you get from [the real graveyard]," Whedon remarked. In many ways, this decision underscores the contrast between seasons. Whereas Season 1 required ingenuity and was therefore granted grace in seeing how big they went with so little, Season 2 had polish, aka budget. "I remember I was the last one to get a new car," Gellar says. "I got a new car the second season of the show . . . Everyone else had gotten [one]."

Buffy returned in September 1997 with a new look, quite literally. Sarah Michelle Gellar's hair had been shorn and a new, fresher wardrobe would accompany the changeup. "I think they just wanted fresh eyes, and I remember [the producers] sharing that they wanted less of a vintage look and wanted everything to look a little bit more hip and a little bit more cool," says costume designer Cynthia Bergstrom, who was fresh off of costuming Wes Craven's *Scream*. The show's Season 1 costumer, Susanna Puisto, exited the series, and Bergstrom was brought in to breathe some new life into our heroine. Buffy had quite literally been reborn and resurrected in the Season 1 finale and was now taking ownership of her status as the Chosen One, and so her style needed to reflect this and be, as Bergstrom puts it, "less little girlish."

"In season one, we found that we had a show that people liked," Whedon said. "I really thought people were going to laugh at the Buffy/Angel thing and say, 'Well, he's a vampire. This is so hokey.' But they couldn't get enough of it. It definitely made me realize the soap opera aspect of it; a continuing story of the romance and the people and their emotions was really what was fascinating. The monsters were all very well and good, but in the first season we were like, 'Let's take our favorite horror movies and turn them into high school stories.' By the second season, the horror movies were gone and the horror came from the story, the high school, and the emotion."

According to James Marsters, Season 2 was when Whedon really honed his skill set. "The first season was his education. He was a writer before that, but he wasn't a director or a producer, and there's a bit of a learning curve. I think Season 1 is gloriously good, but he started hitting his stride in Season 2."

It wasn't just Whedon. The cast, too, began to feel the effect of the show finding its groove. "I don't think we felt any kind of real impact until Season 2," says Charisma Carpenter. "Sarah was doing *SNL* and on the cover of *Rolling Stone* and we were doing photo shoots for *People*. It was just such a neat thing to have this show called *Buffy the Vampire Slayer*—which seems so vacuous and silly and stupid—become this little show that could, and dominating on this teeny-tiny network with a dancing frog with a top hat and cane. It was filling this thirst for all these craving teens of something that was identifiable and all the Shakespearian themes being invisible and Halloween where you literally turned into your costume...just all of these wonderful, imaginative things were really resonating and still today [are] resonating."

Carpenter got to embody what many fans would come to regard the show for: the frustrations of not being taken seriously throughout your teens. "I remember being in love with a boy and being told that I was going to fall in love nineteen times over again. 'This is just nothing, this is just a blip on the radar, move on,' or made to feel as

though what I was feeling was just insignificant. One of the things that I loved about being on the show was that I identified and could remember times when, in my own life, my feelings were not being validated or taken seriously. And to see a show cope, deal with, and acknowledge that fact felt very satisfying. It resonated with me. And if it's going to resonate for me in my twenties playing this teenager, I'm sure it's just what every teenager needed."

When you encounter a *Buffy* fan in the wild, their stake-to-the-heart answer on the best season of all time will more than likely be Season 2. There's something about the alchemy of this season that just undeniably works. It might not be *your* favorite season (it's not mine!), but I have yet to hear a substantive argument from anyone against Season 2's undeniable appeal. It takes a few episodes to get the engine revving—don't get me started on Episode 2 ("Some Assembly Required"), actually, let's, but in a bit—but once the cylinders get firing, it's an all-hands-on-deck situation.

Even for some of the show's die-hard fans, Season 2 is considered the real starting place for the series. "My then-girlfriend tried to get me to watch Season 1 for the first time in 2010 and I couldn't make it through," says *Buffering the Vampire Slayer* co-host Kristin Russo. "And then a couple of years later, she said, 'You kind of know the premise. You know the touchstone pieces of this thing. So what if we just skipped Season 1 for your first watch through and started with Season 2?' And that really changed the game." Six years later, Russo and her then-girlfriend, Jenny Owen Youngs, launched their podcast in which the pair meticulously comb through and dissect the series. (This here book grazes the surface; if you want the nuance, and you should, I encourage you to check out their very fabulously quirky podcast.)

I think Season 2 helped to crystalize *Buffy* as not being like anything else out there, not just in the teen or genre space, as it had been categorized, but in all of the television landscape. "At the time, television was something you listened to," says writer Doug Petrie. "You

would see a movie, you would watch TV. And Joss destroyed that convention in a lot of ways that I loved. There was a Valentine's Day episode where a love potion is floating around and Xander gets too much of what he wanted and Buffy is maniacally in love with him. And it was one of the best sight gags I'd ever seen, which again you didn't do sight gags on TV at the time because it's TV. So Xander is hiding in the library and he barricades the door. He puts a desk and a chair and a lamp—everything he can possibly find—up against the door. And she opens the door because it opens out the other way. Nobody wants to get poked in the ribs and told 'You get it? You get it?' And *Buffy* never did that."

It's been called the quintessential season and the season where the show started to really cook with gas. It's bigger. It's deeper. It's faster. "As assured and well-realized as any in TV history," writer Noel Murray stated in his review for the *AV Club*. "Don't underestimate Buffy even when she's dressed like a damsel in distress," writer David Bianculli said in his review of "Halloween" (Season 2, Episode 6) for the *New York Daily News*.

As was the case for me, "Halloween" was Petrie's first glimpse of the series. "I just flipped," he says. "I loved it so much, and Xander's line 'I got a strange sense of closure beating up that pirate' just was everything I ever wanted. It was a very funny line; it was not breaking the fourth wall but pressing up against it, and more importantly I was so thrilled to see Xander beat up the bully who was tormenting him. I was so emotionally taken in."

But we're getting ahead of ourselves, aren't we? (A theme.) Season 2, Episode 1 ("When She Was Bad") served as a bridge between seasons. Buffy, fresh off of a summer spent with her dad in Los Angeles, returns to Sunnydale with a bit of sass in her step. She's distant. She's moody. Teenage hormones or something deeper? "Whatever is causing the Joan Collins 'tude, deal with it," Cordelia, who is still at the beginning of her frenemy-to-friend journey, tells Buffy outside of the Bronze, the town's most popular (and only) club. "Embrace the pain,

spank your inner moppet, whatever, but get over it. 'Cause pretty soon you're not even gonna have the loser friends you've got now."

In the end, Buffy's post-traumatic stress reveals itself, she slays—she always does—and the "Joan Collins 'tude" is put to rest along with the Master's bones, which she cathartically crushes with a sledge-hammer. We have one more episode before the fun begins. About that episode, "Some Assembly Required": Houston, we have a filler. There's a number of episodes that serve no real function plot-wise or character-building-wise, and this is the first real example. Others: Season 2, Episode 18, "Killed by Death" (my least favorite episode of the series); Season 4, Episode 5, "Beer Bad"; and Season 4, Episode 18, "Where the Wild Things Are." I think "Some Assembly Required" clunks particularly loudly because of where it falls in the series: We just got Buffy back, and back to normal by the end of the season premiere, and so we're ready for the games to begin in Season 2. Instead, we get a B-plot turned A-plot with Buffy saving the day against a foe that doesn't deserve her slay. Thankfully, by Episode 3, the games can really, finally, begin.

As we discussed in Chapter 1, the Master wasn't really a major foe for Buffy in that he was sequestered underground and had no significant allies to conspire with. This was a practical decision for Whedon. "The idea that he was stuck down there was so that he was not out for twelve episodes constantly trying to kill Buffy and failing. We knew we wanted them to confront each other in the last episode. We also knew that if for twelve episodes he spent every week going, 'This time I will destroy Buffy!' and she beat him up, people would get tired of it really quickly."

Where the Master was bad, Spike and Drusilla would be, to quote Swedish pop musician Tove Lo, "sadder, badder, cooler." Cast as the deranged Sid-and-Nancy-inspired vampire lovers were James Marsters and Juliet Landau ("I was Sid—and he was Nancy!" Landau once said). James Marsters was a seasoned theatre actor, having attended the Juilliard School and having worked onstage for a

decade playing roles like Ferdinand in *The Tempest* and Robespierre in the six-hour drama *Incorruptible: The Life, Death, and Dreams of Maximilien de Robespierre*. With a few minor guest spots on television, Marsters was less enticed by the fame industrial complex than he was by the paycheck—and for good reason.

"I came down to Los Angeles basically to prostitute myself for money," Marsters says. "I had been doing professional theatre for about a decade. Did very well, I was successful, but made very little money. And then I became a dad and it became very apparent to me that I needed to try to do that. I was watching my son get wiped off on the birthing table and I had read somewhere that when a man sees their firstborn child his brain rewires and his frontal lobes come online and he's better at planning ahead, his impulse control improves, et cetera. I experienced this as the voice of God telling me, 'Go to Los Angeles, whore yourself out if you have to. You are having so much fun being an artist, a poor, starving artist, and this little human being did not make that choice. You have to try to make money.' So I came down, told my agent, 'I am not here for awards. I'm not here to prove myself as an actor. I did that in theatre. I'm here for diaper money. I'll be the new Urkel, I don't care.' And I ended up being on a show that frankly was better written than a lot of the theatre that I was doing before I came."

Marsters describes his entrance onto the series through the metaphorical lens of a cherry on top of an ice-cream sundae. "The cherry is just useless. If you ever eat a maraschino cherry on its own, it's not that great, y'know? But if you have a really good sundae and you put that cherry on top, it just pops and everything works and it's not really a sundae until that cherry is put on top. I think in some ways Spike was that little extra pop."

Landau, meanwhile, had a pedigree that preceded her. Her father is Academy Award–winning actor Martin Landau, and her mother is Emmy Award–winning actress Barbara Bain. Landau portrayed actress Loretta King in the Tim Burton film *Ed Wood* (which won

her father his first Academy Award, after two previous nominations) and starred opposite Whoopi Goldberg in the critically maligned film *Theodore Rex*. (In a 2015 interview with the Brazilian newspaper *Folha de S.Paulo*, Goldberg stated that this is the only film she regrets ever having done: "Don't ask me why I did it, I didn't want to.")

Marsters was immediately drawn to the writing. "The scripts were genius, and when you read something that good, it carries you. I would always kind of check the script when we finished filming a scene and I'd always notice that we missed something. There was always one bit of described action or a beat or a reaction that we just fluffed over because there was just so much good stuff to try and get that you'd miss something." And it was from this constant aspiration toward greatness that a frustration began to build for Marsters and others. "I was so focused on how good the scripts were and how hard everybody was working on that show. Everyone was really bringing it. And everyone was a little frustrated at the same time. I think that was the delicious pain of working on this show: we all knew we couldn't quite live up to the scripts. It's tragic. It's a little sad. I'll be honest, to this day it's a little sad because I feel like in some ways I constantly failed those scripts."

But that frustration, which eventually congealed into sadness, was hardly present in the work from the audience perspective. The two had immediate and undeniable chemistry from the moment they first appeared onscreen. It was different from the chemistry of Gellar/Boreanaz in that it felt far more sinister and enjoyably sadistic. Spike is a chaotic drunk hellbent on inciting mayhem. His entrance sets an immediate jolt of adrenaline through the series when he crashes his 1958 Dodge DeSoto Fireflite through the "Welcome to Sunnydale" sign. Then he exits the vehicle, lights a cigarette, and declares, "Home, sweet home." This moment signals to the audience that Spike isn't new here, it's just we, the viewer, who are new to him. It gives immediate main character energy.

From the outset, Spike is a bubble burster. When a vampire brags

about having attended the crucifixion, Spike appears from the shadows. "*You* were there?" he says with a malevolent chuckle. "Oh, please! If every vampire who said he was at the crucifixion was actually there, it would have been like Woodstock." Immediately he is established as an evil who mocks his own. Of course, Spike then admits he *was* at Woodstock. The vampire, enraged, rushes Spike from behind. Without looking, Spike swings his fist up, hitting him in the face and knocking him to the floor. "So! Who do you kill for fun around here?" he asks with glee. And thus the paradox of Spike is introduced within seconds. You, the viewer, should hate him. He's evil, after all, and will tell us this throughout the series. "And you're, what, shocked and disappointed? I'm evil!" he reminds us a few seasons later. But he's funny and buoyant. And he's sexy.

And he comes equipped with an Achilles' heel in the form of Drusilla, his sire. Wait...what's a sire?

Holden: You know, my girlfriend at college, she's so sweet. We have this great thing, but that doesn't mean I'm gonna go vampify her just so we can be together forever.
Buffy: Sire.
Holden: What?
Buffy: The word—when you turn a human into a vampire—it's you "sire" them.
Holden: Cool.
Buffy: It's a noun too.

Great, now back to Drusilla. Drusilla, or Dru as Spike calls her, is the Rachel to Spike's Ross, the Big to Spike's Carrie, the Topanga to Spike's Corey, the [insert other '90s to mid-aughts television lovers]. Where Spike was hostile, Drusilla was soft, ethereal, and mostly insane. Her own grand-sire, Darla, described her as a lunatic. Together the two would wreak havoc on Buffy's life, with Drusilla representing the first in a string of female Big Bads. Her presence alone was a

subversion on Whedon's original premise. Remember, Whedon earlier set the scene: "A beautiful blond girl walks into an alley, a monster attacks her, and she's not only ready for him, she trounces him." But Drusilla was no "him." In fact Drusilla, like Buffy, was once an ordinary young woman for whom fate, destiny, or whatever you want to call it had other plans.

The characters were fleshed out on the page, but it was Marsters's and Landau's performances, so keyed-in from the onset, that made the characters immediately unforgettable. "I don't think I understood how brilliant those two were together until I rewatched it now and saw every nuance," says Gellar. "You know, for me, that was just, 'Oh good, a day off.' Like that's all that was to me at the time. They were amazing and such original unique characters and portrayals." So amazing and unique that Spike would stick around until the series finale and Drusilla would appear sporadically on the show all the way into Season 7. Unlike the Master, Buffy would face Spike and Drusilla on multiple occasions in the lead-up to the finale. Also, unlike the Master, both would survive. That's because the real Big Bad, which you probably already know, but let's give it a few more graphs for proper exposition, was there all along in waiting.

So what's going down in Season 2? Let's check in on the Scooby Gang:

- Giles has the feels for Jenny Calendar, a computer science teacher first introduced in Season 1. Turns out, surprisingly— or not surprisingly given this is *Buffy*—she's a technopagan sent by the Kalderash tribe to watch over Angel. Giles, a staunch technophobe, feels something akin to a schoolboy crush on Calendar, who is acerbic and the perfect ying to Giles's stuffy yang.
- Willow still has feelings for her childhood best friend, Xander, who still has feelings for Buffy (even after being rejected by him in the Season 1 finale). That begins to change midway

through the season when Willow meets Oz, portrayed by Seth Green, her co-star from the 1988 film *My Stepmother Is an Alien*. ("I came in with a weird take," says Green. "I had these big glasses on. It was toward the end of the '90s, it was just post the grunge era, MTV's *Cribs* was on the rise, there were all these very intentionally folksy musicians with weird facial hair and the beginning of the resurgence of ska, so I was like, 'All right, if this guy's in a band, I'm going to give him a point of view.' If you look at the first episode, I've got that little goatee, my hair's bright white, I've got all my earrings and shit in. We edged him into a different territory, but in those first couple of episodes, I looked like I could have been in the Bosstones.") Willow will also begin dabbling with magic this season, a practice that will affect her arc until the end of the series.

- Xander's crush on Buffy starts to simmer early on when he finally accepts (better late than never?) that Buffy sees him only as a friend. Freed from the throes of his one-sided love affair, Xander begins hooking up with Cordelia in secret. Their "I hate you so much I love you" sweaty, broom-closet sessions soon turn into a fully bloomed romance.

- Cordelia becomes further integrated into the Scooby Gang with her blossoming relationship with Xander and her slow-burgeoning friendships with Buffy and Willow. Cordelia struggles with maintaining her vapid popularity while becoming a part of a group she once identified as "downward mobility."

- Angel, now promoted to a series regular, is no longer keeping his feelings for Buffy close to the vest. The two finally begin dating, which . . . well, it doesn't go *very* well.

About that Seth Green casting . . . Green was already a bona-fide star when he first appeared as Oz in Season 2, Episode 4 ("Inca

Mummy Girl"), having appeared in Woody Allen's *Radio Days*, *Big Business*, *Airborne* in his youth and having just played Scott Evil in *Austin Powers: International Man of Mystery*. But it wasn't a hard sell. "I'm real used to that gypsy lifestyle of just making movies on locations for several months at a time and then maybe never seeing those people again for another ten or fifteen years, but this was an easy one for me," he says. "The writing was so great, Sarah is such a good friend of mine, Aly's somebody I'd work with anywhere or anytime. When I got offered that part, it was just a recurring, but they were like, 'What we're working towards is you and Aly as a couple, and the idea of her as the unpopular girl that gets a very cool boyfriend. And the reason the boyfriend's cool is not because he's tall and handsome, it's just because he's cool, he's at ease with himself, and he likes a girl like Willow.' And so that offer, I was like, 'Yeah, this would be fun.'"

That Bosstones look became refined over time, but Oz still had an edge. In fact, one of the most recurring questions I got asked when I told people I was interviewing Seth Green were questions about his ever-changing hair colors. "With Oz, because he's a teenager in a band, I could do anything I wanted. I was like, 'What if I paint my nails? Like, what if I wear all this jewelry? I'm going to dye my hair. What do you think about that?' And they were so cool. They made any of that character based. And so I felt like I had a tremendous amount of freedom."

In the Whedonverse it should come as no surprise that a new character would be introduced with an atypical backstory, and Oz was no exception. "I was about three episodes in and Joss was like, 'I had an idea.' He said, 'I wasn't going to do it unless we cast somebody that I thought could do it but I always wanted that maybe Oz was a werewolf.' And I was like, 'Go on.' He said, 'I've always loved the idea. I love the duality. I love the concept of human man struggling against animal instincts. I love the concept of control, the responsibility, and I wanted to make a character that people love dangerous.' And I was like, 'Yeah, I'm in, I'm in for whatever this becomes.'"

Oz would prove dangerous at times, but controllable when caged on a full moon. Plus, he loved Willow and Willow loved him. "You're nice and you're funny and you don't smoke," Willow told him upon learning that he's a werewolf. "Yeah, okay, werewolf, but that's not all the time. I mean, three days out of the month I'm not much fun to be around either." Angelus, meanwhile, would prove dangerous in a way we'd never before seen from a character. He was reckless, unrelenting, and out for blood.

"I think the Angelus arc really let the audience know that we were interested in change," Whedon said. "That we were interested in shaking things up as much as possible and interested in just making things as grown-up and complex as we could get away with. As it grew and the more we thought about it, the bigger it got until it became a really complex, adult kind of show."

Writer Marti Noxon was brought on for Season 2 with little experience under her belt—a theme. She sold a project really young and, as she puts it, "thought the doors would swing wide open," but then waited another seven years before getting her first big break as a writer on *Buffy*. "I remember driving down Hyland and seeing the billboard for the series and thinking, What a bad idea. That was a failed movie and it sounds so lame." She watched the entirety of Season 1 at her agent's behest. "By Episode 12, I was weeping."

Noxon met with Whedon and didn't think he liked her. She had good reason to think so. "At one point he threw chocolate at me, just sort of started lobbing chocolate kisses at me." But despite this odd professional courtship, Whedon was charmed and called Noxon, convincing her that by joining the *Buffy* writers' room, she'd be a better writer. "Which was a pretty ballsy thing to say, but I bit," she said. Noxon accepted the offer and promptly called her family to tell them the news. "When I told my mother I got a job on *Buffy*, she said, 'I'm sorry, honey, I'm sure you'll get on something better next year,'" Noxon recalled. (I tried and tried and tried again to get Marti Noxon interviewed for this book and didn't receive so much as a "no thank you.")

Noxon made her episodic debut co-writing Season 2, Episode 9 ("What's My Line? Part One"). She then wrote Season 2, Episode 10 ("What's My Line? Part Two"); Season 2, Episode 12 ("Bad Eggs"); and Season 2, Episode 13 ("Surprise") nearly back-to-back.

Noxon helped introduce a small but major character to the Buffy-verse, that being Kendra the Vampire Slayer, played by actress Bianca Lawson, then best known for her roles on *Saved by the Bell: The New Class* and *Sister, Sister*. I'd be remiss not to mention that she is also the stepsister of Beyoncé and Solange Knowles. Kendra was activated as the next Slayer after Buffy's death in the Season 1 finale. See, that's how the Slayer lineage works: One dies, and the next one is activated. Only, Buffy didn't die. Errr, she did (according to the show, anyway), but she was brought back to life. Whatever! And thus we have two Slayers.

"I originally auditioned for Cordelia when they were casting the pilot, but I was committed to another show at the time," recalls Lawson. "I'd worked with the writers of that show before and they wrote a part specifically for me on their new show, so when I received an audition for Kendra I thought it was a great opportunity to still be able to be a part of the *Buffy* universe."

Lawson detailed her audition process as follows: "There was only one other actress there, whom I knew and was far more well known than I. After my reading for the producers, I booked the job on the spot and was immediately walked down to wardrobe for a fitting. The majority of my look that I came into the audition with remained the same: the hairstyle, hoops et cetera. I even wore my same shoes. It all happened very quickly. She was a very different character for me at that time. I just had an instinctive understanding of her that I connected with."

Kendra emerges from the cargo hold of a plane in her opening scene on the show, signaling the character's reticence to embrace her humanity. Like Slayers past, Kendra sees herself as a protector of a humanity she does not allow herself to live among. Not only is the

character not given a last name, Kendra herself says she has no last name.

According to Lawson, there wasn't much to go on about Kendra's origin story. "I think it was maybe one scene, so I just made it my own. There was no accent or anything at that time. I think they were still toying with specifically where she was from. But obviously I knew that she would be a new Slayer that was activated when Buffy 'died' and her dialogue lended itself to a juxtaposition of personalities between them based on the differing ways they were raised and trained. Her perspective and temperament seemed very clear to me even without the details or specifics."

"I was initially underwhelmed by Kendra as a character," says Lowery Woodall, an associate professor at Millersville University who coauthored the 2016 book of critical essays *Joss Whedon and Race*. "Her accent felt almost cartoonish in the way it was presented. It was also hard to become emotionally invested in Kendra because it seemed that the writers gave up on the character relatively quickly. I saw the introduction of Faith as the producers of the show rebooting the Kendra idea. I don't believe that this is Bianca's fault. She did the best job she could with the material she was given, but it was not as strongly written a character as I would have hoped for."

In her brief appearance on the show (she appears in three episodes), Kendra stood in great contrast to Buffy's ideals, with both women ultimately imbuing the other with a greater sense of self through a shared destiny.

[Kendra picks up the crossbow]
Buffy: Be careful with that thing!
Kendra: Please. I'm an expert in all weapons.
[The bolt flies off of the crossbow and breaks a lamp.]
Kendra: Sorry! Dis, uh, trigger mechanism is different. Perhaps when dis is over you can, uh, show me how to work it.

Buffy: When this is over I'm thinking pineapple pizza and teen video movie fest. Possibly something from the Ringwald oeuvre.

Buffy considers retiring and letting Kendra take over but ultimately realizes (thanks to Kendra, no less) that slaying is not a job, it's part of who she is. Kendra leaves town having given Buffy a newfound understanding that she is no longer alone in her sacred birthright.

Buffy: Thank you. For helping me save Angel.
Kendra: I am not telling my Watcher about that. It is too strange that a Slayer loves a vampire.
Buffy: Tell me about it.
Kendra: Still, he is pretty cute.
Buffy: Well, then, maybe they won't fire me for dating him.
Kendra: You always do that.
Buffy: Do what?
Kendra: You talk about slaying like it's a job. It's not. It's who you are.
Buffy: You get that from the handbook?
Kendra: From you.
Buffy: I guess I can't fight it. I'm a freak.
Kendra: Not the only freak.
Buffy: Not anymore.

Kendra's exit really stung at the time, especially for Black female viewers, some if not many of whom were projecting their experiences onto the character. "Love my Kendra," says Emmy, Grammy, and Tony Award–winning (and Oscar-nominated!) actress Cynthia Erivo when I ask her to choose her favorite character. "It was just so empowering to see a Black vampire Slayer. Like, what?! Honestly, and I've met Ms. Lawson before, but even still I get a little starstruck because she really is part of my growth, my kid-hood, and one of the first women I saw

demonstrate that you can be powerful and clever but make no bones about it or have to apologize for it."

I'm reminded of the first time I met another gay person in my youth, having previously held the belief that I was the only one, the only freak, out there. It fundamentally undid and rewired me at the same time. Kendra was also the first Black female to ever appear on the show (took them a season and a half) and the first Black character to ever appear for more than one episode. To have her depart initially was a bummer, but to then have her return and be killed off immediately after felt unusually cruel. (More on that—much more on that—later.)

According to Lawson, Kendra's death was not intended to happen. "From the beginning she was intended to stick around," she says. "When I auditioned, the plan at that time was for her to be a more permanent fixture. Sure I was bummed when I read the script where she was killed, but that's just how things go sometimes."

Once Kendra departs (she'll return briefly to try to help save the day in the season finale), we're cleared for takeoff on *Buffy*'s most significant arc to date. In the last of Noxon's first four episodes, we are given our first glance at Angelus. If Buffy had to grow up quickly in the Season 1 finale with the realization that her death at sixteen was prophesied, she had to do it again here, on her seventeenth birthday, going toe-to-toe with her lover.

"Surprise" awakened the beast that is Angelus, revealing the evil that lay dormant within Angel. Buffy knew of him, but now she would have to *know* him and the way he reveled in systematically torturing his victims. What had begun as Buffy and Angel versus Spike and Drusilla collapsed quickly, with Angel tapping out and in his place Angelus rising up and joining the ranks of his evil comrades. In an instant Buffy lost a lover and a crucial ally. She also jumped time slots.

Part of the conceit of the "Surprise"/"Innocence" doubleheader, which would see Noxon pass the baton to Whedon to conclude the two-part arc, was moving the show from its original time slot of Mondays at nine p.m. to Tuesdays at eight p.m., the show's eventual permanent

time slot. "Monday, it's the television event you've been waiting for," said a promo trailer. "Everything you know about Buffy and Angel is about to change. It's a story so powerful, it takes two nights to tell." This time-slot shift was a signal of confidence from the WB in positioning the series as one of its tentpole prime-time shows and showed a commitment to helping the show reach a broader audience.

In part one, Buffy and Angel finally consummate their relationship, with Buffy losing her virginity. The climax, however, was short-lived, as Angelus emerged at the top of part two. What had been at first perceived as the best night of her life would quickly descend into the worst. "After that momentous night, Angel lost his soul and turned into a blood-lusting killing machine, a frightening metaphor for how your first time can often be more traumatic than romantic," writer Ira Madison III wrote in a year-twenty retrospective.

Buffy has three key scenes in "Innocence" that I feel outline both her depth and resolve. The first: Confusion and disbelief. Buffy, worried by Angel's disappearance after their night together, seeks him out at his apartment. She's meek, asking Angel if she was "not good." He's dismissive and snide and she begins immediately spiraling.

> **Buffy:** Angel! *[He stops and faces her] [Teary-eyed]* I love you.
> **Angelus:** *[Points coolly at her]* Love you, too. *[Turns away]* I'll call you.

The second: Hope for resolve. Angel's got Willow by the throat and is trying to use Buffy's friends to get to her. Buffy, having now learned that Angel is now Angelus, tries to reason with him.

> **Angelus:** *[To Xander]* I got a message for Buffy.
> **Buffy:** *[Appears behind him]* Why don't you give it to me yourself?
> *[Angelus spins around with Willow to face her.]*
> **Angelus:** Well, it's not really the kind of message you tell. It sort of
> involves finding the bodies of all your friends.

[He tightens his grip on Willow even more, and she lets out another pained yelp.]

Buffy: This can't be you.

Angelus: Gee, we already covered that subject.

Buffy: Angel, there must be some part of you inside that still remembers who you are.

Angelus: Dream on, schoolgirl. Your boyfriend is dead.

The third: Acceptance. She's not quite there yet, still in the thick of the trauma, but just as she accepted her prophecy a season earlier, at seventeen years old Buffy recognizes a kind of strength in herself that isn't just physical. It's this characteristic of Buffy's, the ability to work through trauma without retreating, that is one of her most magnetic and less called-out qualities. She's a pillar of strength not just in her physical prowess but in her ability—even at such a young age—to grin, bear it, and fight back.

Angelus: You know what the worst part was, huh? Pretending that I loved you. If I'd known how easily you'd give it up, I wouldn't have even bothered.

Buffy: *[Gets up]* That doesn't work anymore. You're not Angel.

Angelus: You'd like to think that, wouldn't you? It doesn't matter. The important thing is, you made me the man I am today!

[He smiles evilly. Buffy kicks him in the face. He blocks her next swing and punches her in the face and in the gut. He grabs her and swings her around to throw her, but her footing is good and she regains her balance. He kicks her in the face and this time she falls to the floor. Angelus grabs Buffy as she tries to get up and heaves her over onto her back again. She rolls around to her feet and comes at him. She swings, but he blocks and hits her instead. He follows up with a backhand punch and she hits the floor again.]

Angelus: Not quittin' on me already, are ya? *[She looks up at him]* Come on, Buffy. You know you want it, huh?

[She leaps up and kicks him in the face. He arches backward and then snaps forward. Buffy knees him in the chin and then delivers a series of punches to his gut. She ends with a punch to his face. He isn't fazed, and lunges at her. She grabs his arm and diverts him into a display case. He crashes through the glass, but immediately straightens back up. She kicks him in the face and again in the chest, and he staggers backward into a potted tree. She pulls out a stake and stands ready to finish the job. Angelus straightens up and faces her. Buffy doesn't move, but instead lowers the stake and just stares at him.]

Angelus: You can't do it. You can't kill me.

[Her anger takes over and she kicks him extremely hard in the crotch. Angelus grabs his groin and moans in extreme pain. He collapses to his knees. Buffy turns her back on him and walks away.]

Buffy: Give me time.

I particularly love the way Whedon crafts that final bit of dialogue in that it underlines Angelus's power over Buffy—and his awareness of that power, something he'll deploy in his emotional torture of her moving forward. She doesn't yet have a plan on how to combat him. She's only just coming to the realization that he is that which needs combatting. That final admission is less an "I'm not ready" and more "when I'm ready." And it's in Gellar's delivery of that final line of dialogue that you, the audience, begin to fear for him. The stakes lie not in whether she can defeat him but what emotional toll it will take on her when she does. We've spent eighteen episodes building this love affair, and within one forty-four-minute block it's mercilessly ripped from us. Imagine how Buffy must feel. It's not so hard, thanks to the craftsmanship of the storytelling.

Later, in a curbside denouement where Giles drives Buffy home, Giles comforts his fragile charge. "Do you want me to wag my finger

at you and tell you that you acted rashly?" he asks her. "You did. And I can. I know that you loved him. And he has proven more than once that he loved you. You couldn't have known what would happen. The coming months are gonna be hard. I suspect on all of us. But if it's guilt you're looking for, Buffy, I'm not your man. All you will get from me is my support. And my respect."

This is one of the most pronounced moments of Giles as father figure to Buffy, a role Tony Head was reluctant to claim. "When people called Giles Buffy's father replacement, at the time, I was like, 'No, no, no, no, I'm not old enough for that, I'm her uncle,'" Head recalls. "And I remember the photo shoots and things and seeing a few photos where I pursed my lips." He puts his forehead in his palms and chuckles. "Looking back on it, of course I was her dad."

As Buffy's eyes begin to well, she allows herself to display weakness toward a person who only sees her strength. And thus, the season's arc really begins its path to overdrive. But not without a nod to Buffy the human, Buffy the teen, Buffy the girl. Buffy and her mother are curled up on the couch in pajamas watching the 1936 movie musical *Stowaway*. Alice Faye sings "Goodnight, My Love."

"Goodnight, my love, my moment with you now is ending."

Her mother brings out two cupcakes, one with a single candle sticking out of its top. Buffy looks withdrawn as her mom asks about her birthday. "I got older," Buffy responds. "You look the same to me," Joyce tells her before lighting the candle, wishing her a happy birthday and telling her to make a wish. "I'll just let it burn," she tells her mother, expressionless. Joyce doesn't visibly react but stares deep into her daughter's eyes in search of clues. Buffy offers none, simply curling up atop her mother's breasts as Joyce gently strokes her hair.

"Remember that you're my sweetheart."

The psychological and emotional torture happens quickly from there. Angelus tries to kill Xander as a Valentine's Day "gift" to Buffy. He doesn't succeed. He goes to Buffy's home and scares Joyce with his intensity, telling her of his obsession with her daughter and

revealing that the two made love. He then goes after Jenny Calendar, aware that she possesses the Orb of Thesulah, a spirit vault for rituals of the undead. It's useless without a translation of the Ritual of Restoration. No problem for a technopagan, am I right? Jenny successfully decrypts the ritual and saves it onto a floppy disk, but Angelus finds her before she's able to do anything with it. He chases her throughout the school before finally catching her, snapping her neck, and killing her. She's the first Scooby Gang member to die, and the gravity of a life lost is felt for the first time on the series. It won't be the last.

Giles calls Buffy and Willow at Buffy's house to tell them the news. Buffy falls to the floor and hands the phone to Willow, who immediately bursts into tears. "[Director] Michael Gershman had the genius idea that when I phone Willow and tell her Jenny's dead—mind you, this was before cell phones, a long way before cell phones—he arranged for a phone line on set so that I actually spoke to Alyson, and oh, she cried," recalls Anthony Stewart Head. "It was absolutely gutting."

The floppy disk containing the ritual is accidentally bumped off of Ms. Calendar's desk the next day and falls into the space between the desk and a filing cabinet. *Bum-bum-bum.*

But I want to zero in on a moment that happens a few minutes earlier in the episode, one of my favorite moments ever on the series and one that encapsulates both the premise and the power of the show's message. Buffy is facing off against the Judge, an ancient demon sent to wipe out the human race. The Judge has teamed up with Angelus, Spike, and Drusilla, and it's now four against one. Buffy tracks him down at the Sunnydale Mall...'cause when you're gonna take out civilization, best to start with food court patrons. She shoots a crossbow his way to get his attention. He pulls it out from his chest and crushes it without effort. "You're a fool," he tells her. "No weapon forged can stop me." Buffy, undeterred, responds accordingly: "That was then." She then switches out the crossbow for a rocket launcher. "This is now."

"I was so emotionally taken in," says Douglas Petrie, who was at

that time not yet a writer on the series, but merely a fan. "I remember watching that moment and thinking, 'that's everything I want to see.' And she was the hero. Of course she has a rocket launcher. And of course she's a badass."

And that about takes us to our finale. Xander tells an unconscious Willow that he loves her (despite the fact that she is now dating Oz and he is dating Cordelia). Kendra returns. Drusilla kills her. Spike, jealous of Drusilla's affection for Angelus, switches sides, teaming up with Buffy in a bid to leave town with Drusilla. Buffy and Willow discover Jenny's disk containing her translation and Willow, having briefly joined a coven earlier in the season, is able to successfully restore Angel's soul. All is kumbaya? Not so much.

Acathla, a demon that was once sent to bring about the end of the world, has been awakening. Just as Angel's blood was the key to awakening the demon, it's also the only way to close off the vortex to hell. Buffy raises her sword to dispatch Angelus, but when he gasps for air, those once-familiar puppy dog eyes are now staring blankly up at her. "Buffy?" he asks. "What's going on? Where are we? I-I don't remember."

Buffy quickly starts to realize what's going on. Should she be worried that it's a fake-out? Yes. Could she? She couldn't. "Angel?" she asks in a way that's part question, part surrender.

[She looks down at her wound and feels his gentle touch on her arm. She ignores her cut, looks back up at him and steps closer. He embraces her tightly.]

Angel: Oh, Buffy . . . God.

[She still isn't completely sure that it's true, but accepts the hug.]

Angel: I . . . I feel like I haven't seen you in months.

[Finally she accepts it, closes her eyes and breathes out a deep sigh.]

Angel: Oh my God, everything's so muddled. I . . .

[He holds her even more closely. He sighs deeply and kisses her on the shoulder.]

Angel: Oh, Buffy...

[She cries into his shoulder and hugs him back. Behind him Acathla lets out a low rumble. Buffy opens her eyes and stares in shock as Acathla's face contorts. His brows angle down, his eyes glow red, his mouth opens grotesquely and the swirling vortex to hell opens, small at first, but growing steadily in size and emanating a deep, red glow. Buffy lets go of Angel and looks up into his face.]

Angel: What's happening?

Buffy: *[Whispers reassuringly]* Shh. Don't worry about it.

[She brushes her fingers over his lips and across his cheek. She lays her hand on his cheek and kisses him softly. He returns the kiss, and it becomes more passionate. Behind them the vortex has grown and continues to get larger. Buffy breaks off the kiss and looks deeply into Angel's eyes.]

Buffy: *[Whispers]* I love you.

Angel: *[Whispers]* I love you.

[She touches his lips with her fingers again.]

Buffy: Close your eyes.

[She nods reassuringly, and he closes his eyes. She tries hard not to start crying, and kisses him again gently. She steps back, draws back her sword and thrusts it into his chest. His eyes whip open in surprise and pain, and a bright light emanates from the sword. She steps away from him. He reaches out to her and looks down at the sword thrust completely through him. He looks at her imploringly, completely bewildered by this turn of events. She can only stare at the sword protruding from his chest, and slowly steps further back.]

Angel: Buffy...

[Behind him the power of the sword begins to swirl into the vortex. Buffy steps further back, still looking only at the sword in his chest and not into his face. Angel still holds out his hand to Buffy. When the vortex finally meets him it suddenly closes into Acathla's

mouth without so much as a spark, taking him with it. Buffy
stares at the stone demon for a long moment, a light of awareness
dawning in her eyes as she truly realizes what she has done, what
she has lost. She begins to sob, her heart breaking.]

The Sarah McLachlan music begins as Buffy weeps. She doesn't cry often on the series, and this particular sob-fest is the release of so much pent-up emotion having lost the man she loved not once, but twice. She cries, goes home, packs her bags, and gets on a bus as the camera pans down to a sign that says NOW LEAVING SUNNYDALE, COME BACK SOON.

(Random but important side note: I'll never forgive Xander for not telling Buffy that Willow was planning to try the curse again to re-ensoul Angel before she went in to kill him. And though the show attempted to acknowledge it during Season 7, it was never properly resolved.)

It was during Season 2, Episode 19 ("I Only Have Eyes for You") that Whedon began to notice something in his brooding good guy turned bad. In the episode, Buffy and Angelus unwittingly are inhabited by the ghosts of two former lovers. Buffy is possessed by a former Sunnydale High student, while Angelus is taken over by a former teacher. The scene provided a reprieve from the action of the season, and thus gave Boreanaz a rare opportunity to play emotions nonexistent in the Angelus wheelhouse: warm, compassionate, openhearted. "I watched David very emotionally, unabashedly, and poetically playing a woman, and in that moment was like, 'This guy can anchor a show,'" Whedon said. And thus the wheels began turning between Whedon and co-executive producer David Greenwalt to spin off the character into his own series. But not just yet.

As *Buffy*'s ratings were rising, so too was Sarah Michelle Gellar's star after back-to-back commercial hits in 1997's *I Know What You Did Last Summer* and *Scream 2*. "I still remember, I was making *Scream*

2 in Atlanta and I went out one day with Neve Campbell, Courteney Cox, and all of these people that to me were big superstars. And I had just come from doing *I Know What You Did Last Summer* in Wilmington, North Carolina, which at the time didn't even have a WB station there, so *Buffy* wasn't even on there. And then when someone came up and recognized me before Courteney and Neve, I was like, 'wait... what?' Like it was such a shocking moment for me. And I think that you just don't realize when it's happening."

During her summer break between seasons 2 and 3, Gellar shot *Cruel Intentions*, a modern adaptation of the novel *Les Liaisons Dangereuses*. The film would reunite her with her former co-star Ryan Phillippe and have her sharing the screen with Reese Witherspoon and Selma Blair.

"I visited the *Buffy* set right after we shot *Cruel*, once we had really established a friendship," recalls Blair. "It was at an older hospital. Creepy. Nighttime. And this teenage beauty is walking onto set in the middle of the night, a fog machine starting up, and her blond hair was truly gold in the light. Like Eva Perón. I was so impressed by her presence, always."

Less impressive were the reviews of their film, *Cruel Intentions*. Though critic Roger Ebert called the film "smart and merciless," the *New York Times* called the film "faintly ridiculous," while *Rolling Stone*'s Peter Travers wrote that "rarely has a film elicited more raucous unintended laughter." Not so much a critical darling, fans, particularly teens (who were probably a bit too young to comprehend the film's very adult themes) and young adults propelled the film to cult status. The commercial success of the film helped earn Gellar an MTV Movie Award for Best Female Performance and a Teen Choice Award for Choice Movie: Villain.

Whedon wasn't quick to heap praise upon his star's work outside of the show. At the 1999 Television Critics Association press conference, Whedon described the film as "porny." "I did what I think is

my best work to date in that movie," Gellar told *Premiere* magazine in response. "Brushing it off by calling it 'porny' is unbelievably hurtful to me. He owes me flowers. And that's on the record."

I ask Gellar about this moment during our interview. I can hear the diplomacy weaving its way through her pregnant pause. "I am really, really proud of *Cruel Intentions*. I'm proud of the performance, proud of the movie, and I always will be. I stand by everything that I said. I'm not the person that ever says things to be hurtful. I was raised if I don't have something nice [to say] that I just don't say anything at all."

It was an unusually callous and dismissive comment from a show-runner about his leading lady. It would prove to be a breadcrumb about Whedon's seeming respect—or lack thereof—for the female stars on his show. But it wasn't just Whedon who may have been causing tensions behind the scenes. With an increased audience comes increased scrutiny, greater demands, an ever-present pressure to be the best. "We were all in it together. That was the thing. We were a team," says Nicholas Brendon about filming Seasons 1 and 2. "And then...then that went away with the success of the show. We remained a team, but that closeness, that unity [changed] once everyone got an entertainment lawyer, a publicist, all that. It went away. Our photo shoots went from like a very intimate affair to all of a sudden it's a thousand people."

Brendon described nights spent watching the series live at Whedon's house or driving to Santa Barbara with Whedon and Hannigan to see Nerf Herder (the band who wrote and performed the show's theme song) as moments that began to become more infrequent. "As success often does, it fractures sometimes. I remember having the thought that those days are gone and now this is where we are now."

He wasn't alone in this thinking. "In retrospect, the *Buffy* set was definitely pettier than other sets," recalls Danny Strong. "You had

young cast members. Sarah Michelle Gellar had become extremely famous and I felt that some people were jealous of her and that there was a little bit of a hierarchy because she was literally on the cover of magazines nonstop and starring in these huge movies—they weren't small indies—and so I sensed that, but it seemed pretty typical and natural that people would feel this way as opposed to some atypical set. Little did I know that there was this thing going on underneath."

Will You Be Slaying? Only
If They Give Me Lip.

Season 3 of *Buffy*? Ah, that's history. They say not to choose a favorite amongst your children, but they have clearly never seen *Buffy*'s third season, a season with no skips that proved there could be a life beyond the *star-crossed-lovers-gone-sour* storyline that captured the hearts of fans and critics alike. "Season 3 is the 1927 Yankees," says Douglas Petrie, who joined the writers' room along with Jane Espenson and Dan Vebber for the show's third season. According to Rotten Tomatoes, the season has a 100/100 rating. Makes sense to me! "The third season got off to a sensational start," wrote *Entertainment Weekly* in their 1998 review. "Give series creator Joss Whedon credit: No other show balances so many elements as deftly, without a trace of corniness or melodrama."

But that's not to say it was all smooth sailing for the powers that be. "Season three was a struggle, because I was so happy with the year before," said Joss Whedon. "I was like, 'Can we do it again? Is the magic gone?'"

Even the newbies were feeling the pressure to keep the spell alive. "At that point we were like, 'But they've done everything; there's nothing left we could possibly do,'" recalls Petrie. And so, to set the tone for the season, Whedon called a meeting for all of the writers and told them that there was going to be a new Slayer—"and she's going to be psycho." Enter Faith, a Slayer who zips where Buffy zaps.

Faith is Buffy's shadow self, the embodiment of the dark side that lives within a Slayer. Buffy has family and friends and is surrounded by love; Faith, in contrast, is lonely and isolated, but also untethered. "Instantly I just felt like, 'Boy am I in the right place. This is going to be so much fun.' And it was," says Petrie.

Knowing that this would be the show's last high school season and its last with David Boreanaz (who had committed to one more year after Season 2), the show was able to take bigger risks, something the writers did not shy away from. If the theme of Season 2 was lost innocence, Season 3 was about exploring the dark side of being a Slayer by introducing Faith, the Jungian shadow figure to Buffy. She would join forces with the evil mayor of Sunnydale in an effort to rule the world, again, as one does.

There are some clues about what's coming sprinkled throughout Season 2. At the end of Season 2, Episode 3 ("School Hard"), after a gang of vampires led by Spike overtakes Parent-Teacher night, the police chief approaches Principal Snyder. "I need to say something to the media people." "So?" asks Snyder, not understanding the question. "So? You want the usual story? Gang-related? PCP?" He asks. "What'd you have in mind? The truth?" Snyder responds.

Later in the season, we're given a similar iteration, this time with more detail.

Chief: Schoolboy pranks?
Snyder: Never sell.
Chief: The sewer got backed up.
Snyder: Better. I can probably make that one fly. But this is getting out of hand. People will talk.
Chief: You'll take care of it.
Snyder: I'm doing everything I can, but you people have to realize…
[Two men arrive.]
Man: Snyder, what's going on here?

Snyder: Backed up sewer line. Same thing happened in San Diego just last week.

[The two men continue into the building.]

Snyder: We're on a Hellmouth. Sooner or later, people are gonna figure that out.

Chief: The city council was told that you could handle this job. If you feel that you can't, perhaps you'd like to take that up with the Mayor.

And in the finale, after Buffy is mistakenly blamed for Kendra's death and therefore expelled from Sunnydale High by Snyder, we get one last nugget when he takes out his cell phone and says, "It's Snyder," with a menacing smile. "Tell the Mayor I have good news."

This continues into Season 3. "This isn't over. If I have to, I'll go all the way to the Mayor," Joyce tells Snyder after he rejects her plea to readmit Buffy to the school. "Wouldn't that be interesting," he says under his breath as she exits. We'll get other instances of this down the line, like how Buffy's sister Dawn's entrance into the show is foreshadowed well before her arrival, as is Buffy's second death.

Though the Mayor shared a sense of humor in common with the Master, he was the first Big Bad to live (and breathe) among people. He was also, notably, the first non-vampire Big Bad. Playing the role of the Mayor was Broadway veteran Harry Groener, best known for his role on the NBC sitcom *Dear John*, and for his Tony-nominated performances as Will Parker in the 1979 revival of Rodgers and Hammerstein's *Oklahoma!* and as Bobby Child in the Gershwin musical *Crazy for You*.

Season 3 had a lot of resolution that needed to take place, like getting Buffy back from Los Angeles (where she'd spent the summer waitressing after dodging town) and getting Angel back from hell. Whedon solved the former problem quite simply. When attacked by a demonic cult leader who tells Buffy she's "so pathetically determined

to run away from whatever it is [she] used to be," you see Buffy's appreciation of her own strength start to regenerate...and quickly. Having faced her demons (always literal and figurative), she's ready to return home.

With her Ginger Spice hair (my favorite of the series...I think!), she leaves behind the identity she'd adopted—a waitress named Anne (her middle name)—and heads back to Sunnydale ready to again be Buffy the Vampire Slayer.

There's a detail that I think encapsulates the greatness of the performances and the depth of the characters which is found in the final scene of the Season 3 premiere. Joyce is tinkering at the dishwasher when she hears a knock at the door. She starts to move toward it, matter-of-factly, and as she reaches the dining room and steps toward the door, her face shifts ever so slightly. She realizes what we, the audience, already knew—that it's Buffy at the door. It wasn't the knock at the door, it happened in the space between, that kinetic force of a child reaching out to their mother. Door swings open. And that look in Buffy's eyes conveys forty thousand emotions, namely regret, but also an "I'm sorry," a "do you forgive me?" and an "I had to go." Joyce hurdles past anger and they embrace. And let me just tell you that no one does on-camera hugging with as much force as Sarah Michelle Gellar. An Emmy for that hug alone!

Angel's path was a bit less linear. Like bringing back Buffy from the dead at the start of Season 6 (we're doing spoilers, that's been made clear, yeah? Oh right, I mentioned Dawn!), Angel's return was not an *if* but rather a *how*. After finally accepting Angel's death, Buffy goes to the mansion (Angel's former home, 'cause, y'know, abandoned mansions conveniently make for great vamp dwellings) to finally say goodbye in her own way. She takes the Claddagh ring given to her by Angel on her birthday (hours before Angelus took over his body), sets it down in the spot where she killed Angel, and leaves. The camera sticks around in darkness. The ring suddenly starts to quiver on the floor as a bright-white light appears. Out of the light drops a very naked Angel,

shivering and confused and…oh yeah, back from hell. How? It's never quite explained on the series. The following year, on *Angel*, it is implied that the "powers that be" brought him back to fulfill his destiny. Destiny or not, that still image of a nude David Boreanaz stayed on perpetual pause. Formative for a young gay like me, to say the least.

In that same episode we are introduced to the Slayer who was called after Kendra's death: Faith Lehane, a loudmouthed straight shooter who fled from Boston to Sunnydale after her Watcher was killed by an especially aggressive ancient vampire. From the outset, in every way possible, from the hair to the clothes to the accent, Faith is established as the anti-Buffy. Where Buffy was methodical, Faith was instinctual. "Slaying's what we were built for; if you're not enjoying it, you're doing something wrong," she'd tell Buffy, who up till then still saw slaying as a job. In many ways, Faith helped Buffy to see a world—and therefore a life—outside of Sunnydale. Where Buffy felt imprisoned, Faith saw only freedom.

Faith would take on a theme of darkness, allowing her most carnal desires for the kill to lead her into the hands of the Mayor, joining him as an ally in his fight toward ascension, where he would transform from human into the embodiment of an Old One, a purebred demon. But Faith was no Big Bad, for she contained too much good, however far beneath the surface. Eliza Dushku's performance as Faith remains one of the series' high points. She, along with the writers, injected Faith with a sense of vitality that attracted all those who came into her orbit.

"I think whatever intimidation I felt as a new writer on the series could go into Faith because she's like this badass but she's really insecure and really hungry for a family and community and love and safety," says Petrie, who wrote three of the biggest Faith-centric episodes of the season. At first glance, Faith's arrival offered Buffy a chance to expand her horizons, providing her the rare opportunity to rely on another. Upon closer examination, Faith's modus operandi was far more skewed and reckless. She unsettled Buffy.

Faith was like that senior you meet in your freshman year of high school who bestows you with your first cigarette, showing you how to block the wind with your hand and light it in one fell swoop. She unlocks something in you that is so unknown, but her surety convinces you—and quickly—that she knows who you *really* are. She's disarming in how she moves through the world without fear of consequence. Until consequence rears its inescapable head. And you, her unwitting accomplice, are caught in the crosshairs.

Such was the case for Buffy, who felt a tie to Faith both because of their shared identity as Slayers, but on a deeper level, their shared identity as outcasts. But Buffy, too, unlocked something in Faith: a desire for connection. "You know, I come to Sunnydale. I'm the Slayer. I do my job kicking ass better than anyone," says Faith. "What do I hear about everywhere I go? Buffy. So I slay, I behave, I do the good-little-girl routine. And who's everybody thank? Buffy." Faith lusted for the kill, but she also longed for the adulation bestowed upon Buffy by her peers.

"I loved Buffy and Faith," says Gellar, who had known Dushku for years and notes how this made it easier to establish a rhythm among the actors. "She's just a firecracker. And I think that what Faith brought out in Buffy was so much self-exploration. And that's at that age where you think you're one thing, but [then you start to wonder if] there's untapped parts of you that you want to explore. If I'm a good girl, is there a wild side of me that wants to come out? And sometimes it's not about a love interest as a foil. Sometimes it's an archnemesis. And sometimes an archnemesis is also a friend, and that line gets extremely blurred. And I think that's exactly what Faith represented."

Buffy wasn't the only character experiencing a crisis of identity. Xander and Willow, now paired off with Cordelia and Oz respectively, began a lust-fueled affair. Though the two had dated before, they broke up at the time because Xander stole her Barbie. They were five. And though Willow had pined for Xander in Season 1, she had lost interest due to his romantic obsession with Buffy and because she had met Oz. When Cordelia and Oz found out about the affair, both

couples disbanded, with Cordelia's social status plummeting even further now that she was seen as not even dateable by the school's biggest loser. On top of that, Cordelia was struggling after her father was found guilty of tax evasion, forcing her family out of their home and eliminating any prospects of her going to college.

"It's about as good as it can get," Charisma Carpenter says of being able to develop a character slowly over time. "You really get a chance to stretch your legs and get comfortable in a role and make new discoveries—and to be able to change so much and not be one note or have one point of view. Occasionally you find out that she's smart. Occasionally you find out that she's neglected at home. Occasionally you find out that she's very much alone even though she's in a room full of people. Occasionally you get little tastes of these things and her self-awareness. That is one of the most beautiful things that I look back on and was completely obtuse to in the moment: she was really self-aware. She is so freaking aware that people are using her for her status and she's going along with it. She's allowing it to happen because, honestly, it's better to be alone surrounded by people than it is by yourself."

For Seth Green, his promotion from a recurring player in Season 2 to a full-time cast member was a bittersweet bargain. "That was the hardest part about that third season for me, because I suddenly had to be on set every day and I didn't have any time to do anything, like make a dentist appointment," says Green. "There's seven main characters on the show, so it's a lot of group scenes in a library where they're trying to give you a line, but there's no reason for your character to be there. Anybody that talks about how fucking renegade pirate independent we produced this show will tell you that it was just all the time, all the time. It was an enormous production on a shoestring budget. And as a result, you couldn't plan more than a day in advance, and you always had the knowledge that that day could get fucked. So I spent that whole season making what I still believe is a great show, but as an actor, as an individual, I was being woefully underutilized."

Green called a meeting with Whedon in an effort to level with him. "I was like, 'Hey, listen, man, I'm getting crazy feature opportunities. I got offered this movie with everybody from John Cleese to Whoopi Goldberg. I got offered this movie with a post–*Saving Private Ryan* but pre-*XXX* Vin Diesel.' I was like, 'I want to make these movies. These are the roles that I have liked. I've been dying to play.'" But Green wasn't throwing in the towel, instead hoping to renegotiate his contract back to how it had been in Season 2. "I was like, 'Look, Oz was always best served as a recurring character. Look how successfully we were able to put this into episodes when it is necessary. I don't need all episodes produced. I'm not concerned with getting salaried across twenty-two episodes. I want to be here when it means the most and I want to go make these movies." Whedon agreed, but it ultimately didn't come down to what either of them wanted. More on that in a bit.

Buffy's third season, like the previous two, was well reviewed. In 1998, *Entertainment Weekly*, an early and stalwart supporter of the show, named *Buffy* the number one show of the year. "We all just flipped out," says writer Douglas Petrie.

"I think Season 3 is not only when the show really found its footing, but is this sort of emotional culmination of what the show had been and of the groundwork that it had been laying in seasons one and two," says writer Claire Saffitz. "It's her last year of high school and you really feel the emotional weight of what's happening. She's thinking about college and leaving home and that's terrifying enough, not to mention Faith and the Mayor and then everything with graduation. For someone watching the show in real time and really being someone close to that age, I really felt how scary Season 3 was."

But the season was not without controversy. In April 1999, executives at the WB decided to pull Episode 18 ("Earshot") before it hit the airwaves. The Columbine High School massacre, at the time the deadliest school shooting in U.S. history, had just taken place a week earlier and executives felt that the episode, which centered on a student bringing a gun to school, was in poor taste.

"If I'm not mistaken, we started with the idea of Buffy being able to read minds, with the very simple idea that what seems like a superpower would actually be a huge blow to the ego of a teenager," recalls Jane Espenson, who wrote the episode. "But Joss pointed out that that was hardly an original or surprising revelation. He thought it would get interesting if you could read minds and then you heard 'by this time tomorrow you'll all be dead.' That's how it started. So that, of course, meant that we structured it as a whodunnit and made it impossible to identify the voice, so that Buffy had to figure out who the potential killer could be."

The episode did not actually center on a school shooting, or even an attempted one, but rather was focused on one character, Jonathan, who intended to kill himself with a gun in the school's clock tower. "There had been a number of high-profile school shootings already, and that ended up being part of the resolution of the episode—and provided a sort of springboard for the character of Jonathan," says Espenson. "In the end, our would-be school shooter, Jonathan, wasn't the voice Buffy had heard, but the sweaty, rifle-wielding, confessional confrontation between the two of them was the best part of the episode. I wrote a draft of the scene, but Joss rewrote every word for the better. He found real adolescent pain in that scene."

The episode would air five months later, in September. It wasn't the only episode to be preempted in the wake of Columbine. Two hours before part two of the season finale was set to air, the WB pulled it, replacing it with a monster-of-the-week episode from earlier in the season. "Given the current climate," WB network president Jamie Kellner told the Associated Press, "Depicting acts of violence at a high-school graduation ceremony, even fantasy acts against a 60-foot serpent and vampires, we believe, is inappropriate to broadcast around the actual dates of these time-honored ceremonies." He went on to say that the network was acting "out of sympathy and compassion" for everyone affected by the recent shootings and out of a sense of responsibility to the WB's younger audiences.

"Is Kellner implying that it has suddenly become irresponsible to expose younger viewers to a show that's been aimed at them for three years now?" Charles Taylor wrote in a story for *Salon* at the time, in which he questioned what he felt was the network's attitude toward its viewers. "It's shoddy enough treatment to leave an audience hanging by postponing the concluding half of a two-part episode. There's something particularly appalling about a PR stunt like this being pulled by a network whose programs (*Felicity*, *Dawson's Creek*, *Charmed*) are geared to young people. The WB's decision has an inescapable air of Big Daddy condescension. The network acted like a parent who suddenly decided that maybe the kids were too young for that shiny toy they'd given them after all."

"I agreed with the postponement of 'Earshot,' but not 'Graduation Day,' but I respected their motivations for doing it," Whedon told *Science Fiction Weekly* in 2000. "I didn't think they needed to, but I didn't hate them for it either."

Actor Seth Green spoke out in an interview with *Entertainment Weekly* at the time. "It would have seemed really callous and inappropriate," he said about the possibility of airing "Earshot." "But the actual episode has nothing to do with school violence. It's a red herring in the story...The simple fact is, this is a topical issue. It's a growing problem, and Colorado isn't the only place it's happened. We just don't want to think these things happen, but they happen all the time...Instead of focusing on the real issues and the fact that guns are so easily and readily available to kids and that people aren't watching their kids carefully enough or monitoring the emotions of their students, they'd rather say, 'Ooooh, that guy's got a Mohawk,' or 'That guy's got a leather jacket on, and *Natural Born Killers* is a film I don't like, and Marilyn Manson scares me,' so all that shit should be put on a funeral pyre. I think that's the wrong way to go. You can have 10,000 kids watch *Natural Born Killers*, and only one or two is going to go shoot people, and you can guess they had mental problems to begin with." (I asked Green about this during our interview

and he said this: "My positions on this are still the same. I think we still have the same trouble because kids are still sick. Kids are still getting raised without enough information to feel okay. And the example of being seen and heard by all the people that don't see or hear you with a machine gun, it's become too common. And so people are just going to keep improving on that until they feel like they've been heard or seen.")

Still, coming off one of the darkest moments in American history, the idea of an episode centered on teens and guns didn't sit well with network executives. "The episode was a week away from airing, and we were in the writers' room working on whatever was going on, some much-later episode, when Marti [Noxon] came into the room and said, 'it happened again,'" recalls Jane Espenson. That was Columbine. "We got word pretty quickly, I think, that the episode wouldn't air, which was a relief. For one thing, it just wasn't the episode that you'd write if you knew it was going to land on a country in shock and mourning. It was too breezy. For another thing, that Buffy-Jonathan scene was important, full of empathy, and it deserved to be heard with some perspective." In September, five months after the episode was set to air, it finally made its network debut.

"It's not my place to agree or disagree with what the network did," Gellar told *The Vancouver Sun* at the time. "I'm not a program executive. I don't have all their issues. I don't have their responsibilities. I think that the network's decision was right for them, and I understand their reasons for doing it. It's a very, very touchy subject. I'm just one person. I have no real say. And I have no real right to comment about it. In my opinion, though, I do believe that there is a tendency to look for a scapegoat in situations like this."

She continued: "You know, I was out of the country when [Columbine] happened. And it was very interesting to watch the news in London and in Paris and see what they had to say about it. Because they truly didn't understand it. What I came to realize when I was there is that they have the same television shows, the same movies, the same

songs on the radio, and yet this problem seems unique to here. Which means we need to stop blaming the broad spectrum and look closer to home."

"In the end it was probably a smart move to delay the finale until now," wrote the *New York Times* critic Anita Gates in her 1999 review. "It's not only the sight of scores of students wielding swords, baseball bats, and bows with flaming arrows; it's that under the circumstances of the plot and the show's fantasy premise, they're absolutely justified in resorting to violence. But the members of the Trenchcoat Mafia may have thought they were battling demons, too."

In many ways, Season 3 felt like a coda to the series as the characters readied for their next chapter. Buffy would defeat the Mayor, putting Faith in a coma in her efforts. She, Willow, and Oz would head off to the fictional University of California, Sunnydale. Xander would begin his mission to evade college by going on a fifty-state road trip. "He said he wasn't coming back until he had driven to all fifty states," Willow tells Buffy at the start of Season 4. "Did you explain about Hawaii?" Buffy asks. "Oh, he seemed so determined," Willow responds. Cordelia would head to Los Angeles to pursue her acting career, and thus Charisma Carpenter's time on the series would come to an end. With the high school blown up, Giles would enter a period of unemployment. "Okay, remember before you became Hugh Hefner when you used to be a Watcher?" Buffy quipped upon discovering him with a lady friend, or an "orgasm friend," as one member of the Scooby Gang called it.

And then there's Angel. Buffy and Angel began Season 3 in the friend zone, trying their best to keep the relationship strictly business. Alas, it's never that easy. "You'll be in love till it kills you both," Spike tells the pair during his brief stint in Sunnydale midway through the season. "You'll fight, and you'll shag, and you'll hate each other till it makes you quiver, but you'll never be friends. Love isn't brains, children, it's blood. Blood screaming inside you to work its will. I may be love's bitch, but at least I'm man enough to admit it."

By mid-season, with the artifice of friendship buckling, Buffy and Angel resumed their romantic relationship. (I guess it was a sexless relationship, but to be honest that never got addressed.) That was Episode 10 ("Amends"). By Episode 19 ("Choices"), there was trouble in the paradise-adjacent something they had found themselves in. "Do you get the feeling that we're kind of in a rut?" Buffy asks Angel. He doesn't understand. Nor does she, as she's only beginning to get a sense of the inevitability of the "won't they" side of their three-year "will they/won't they."

Then a funny, very *Buffy*-like thing happens. During their final meeting before the big showdown, the Mayor lays it all out. He's not doing it as a tactic. It's just the humanity that still lies dormant within him calling it how he sees it. Buffy is not yet ready to hear it. Angel, meanwhile, finally has his inkling validated.

Mayor: God, you kids, you know. You don't like to think about the future. You don't like to make plans. Unless you want Faith to gut your friend like a sea bass, show a little respect for your elders.

Angel: You're not my elder. I've got a lotta years on you.

Mayor: Yeah, and that's just one of the things you're going to have to deal with. You're immortal, she's not. It's not. I married my Edna May in ought-three and I was with her right until the end. Not a pretty picture. Wrinkled and senile and cursing me for my youth. Wasn't our happiest time. And let's not forget the fact that any moment of true happiness will turn you evil. I mean, come on. What kind of a life can you offer her? I don't see a lot of Sunday picnics in the offing. I see skulking in the shadows, hiding from the sun. She's a blossoming young girl and you want to keep her from the life she should have until it has passed her by. My God! I think that's a little selfish. Is that what you came back from Hell for? Is that your greater purpose?

Buffy attempts to dismiss this. "We'll be okay," she tells Angel later, explaining that her dorm will be close to his place. "We will," he responds, looking 99 percent stoic and 1 percent despondent. The seed of doubt planted in Angel's mind by the Mayor is watered in the following episode, when Buffy's mom pays Angel an unexpected visit. "When it comes to you, Angel, she's just like any other young woman in love. You're all she can see of tomorrow. But I think we both know that there are some hard choices ahead. If she can't make them, you're gonna have to. I know you care about her. I just hope you care enough."

And then comes the inevitable, but no less heart-wrenching, breakup. It happens in a sewer tunnel, because... *Buffy*.

Buffy: Every time I say the word "prom," you get grouchy.
Angel: I'm sorry. I'm just worried that you're getting too...
 invested in this whole thing.
Buffy: What whole thing? Isn't this the stuff that I'm supposed to
 get invested in? Going to a formal, graduating, growing up.
Angel: I know.
Buffy: Then what? What's with the dire?
Angel: It's uh, it's nothing.
Buffy: No, you have "something" face.

And once again, Buffy is forced to grow up very quickly. Not just because she's being broken up with, but because he must understand the mechanics. He's not breaking up with her because he doesn't want to be with her. Quite the opposite. He's breaking up with her because he wants her to have a life he cannot provide.

Buffy is used to seeing the world as binary: good/evil, love/hate, strong/weak. "Is this about what the Mayor said?" she asks. "Because he was just trying to shake us up." He was right, Angel tells her. "No, he wasn't," she pleads. "He's the bad guy." But that's the thing: Even the bad guy can be right. And so Angel hatches a plan to leave. Where

he's going, he does not yet know. (Spoiler: He's going to Los Angeles, where he'll meet up with Cordelia and start Angel Investigations, a detective agency specializing in supernatural cases.)

And then, just like it happened when Angel lost his soul, Buffy's strength and emotional maturity propels her to a state of acceptance. She goes from asking "Is this real?" at the start of the episode to understanding not only that it's real, but why it has to be this way. At the eleventh hour, a forlorn Buffy stands alone at her senior prom. Angel enters, looking like a cross between James Bond and Marlon Brando.

Buffy: I never thought you'd come.
Angel: It's a big night. I didn't want to miss it. It's just tonight. It doesn't mean that I . . .
Buffy: I know. I mean . . . I understand.
Angel: Dance with me?

And so they dance for the last time as the Sundays' cover of "Wild Horses" hits pause on their love story. It's a song so inextricably tied to the series in musically underscoring a moment that feels devastating, comforting, and inevitable all at once. "Faith has been broken and tears must be cried/Let's do some living after we die," Harriet Wheeler croons as Angel and Buffy hold each other close one last time (for now).

Another big moment that occurs is Buffy being given an honorary Class Protector Award from Jonathan. "We're not good friends. Most of us never found the time to get to know you, but that doesn't mean we haven't noticed you. We don't talk about it much, but it's no secret that Sunnydale High isn't really like other high schools. A lot of weird stuff happens here. But, whenever there was a problem or something creepy happened, you seemed to show up and stop it. Most of the people here have been saved by you, or helped by you at one time or another. We're proud to say that the Class of '99 has the

lowest mortality rate of any graduating class in Sunnydale history. And we know at least part of that is because of you. So the senior class offers its thanks, and gives you, uh, this." He hands her a gold umbrella with a plaque that reads: "Buffy Summers, Class Protector."

"I feel like that moment in particular has gone down as one of the major moments in sort of the mythology of the series," says Danny Strong. "I remember after it aired someone told me that the monologue had made a friend of theirs cry, and I was like, 'Oh my God.' I was so overwhelmed. Because I was never a hot actor—physically hot nor hot in demand. It was never easy for me. It was always a struggle— and by struggle, I don't mean the work, I mean, getting work. And so anytime anyone would say 'Oh I saw you on *Buffy* and really liked it,' it always was so meaningful to me." Gellar cites this episode, along with "The Body," as her favorites of the series. Fun fact: So too does Stacey Abrams, as we know.

"The episode I tell people to watch if they want to understand why it's such an amazing show is 'The Body,'" says Abrams. "It is this moment where you understand Sarah Michelle Gellar's extraordinary behavior as an actor, you understand the connections and the complexity of all of the relationships. It is just so heart-wrenching and so perfectly done."

Behind the scenes, big changes were in order as David Boreanaz and Charisma Carpenter exited the series to launch *Angel*. Asking Gellar if she was apprehensive about how an Angel-less *Buffy* would fare elicits a rare and coveted "I don't think I've ever been asked that before."

She thinks, then explains: "Joss told me early [on] and coming from soap operas, you know that there's nothing worse than a happy couple. And at a certain point it gets very hard to sustain that. I was just really happy for David and excited to see what the next chapter was. And as David and Joss and I used to joke, if *Angel* doesn't work, he'll just come back. It was never such a closed door."

Gellar even surprised Boreanaz while taping the pilot for *Angel*,

showing up while cameras were rolling on the streets of LA. "Welcome to Hollywood! What's your dream? Everybody comes here. This is Hollywood, land of dreams," Gellar pronounced, referencing the film *Pretty Woman* to a stunned and delighted Boreanaz.

Carpenter, meanwhile, was flattered...but apprehensive. "I didn't know what was going on, on the message boards. I didn't really know until one time I was protesting a Cordelia moment and the producers said something like 'Calm down, this is why America loves you,' and you're going, Oh, America loves me? It was like new information for me. So to hear that I was being invited to go onto the spin-off show and have the opportunity to just be on a cast of three people instead of five plus, I was very terrified by that responsibility. I was kind of insecure and not sure that I would live up to the task. I had a lot of anxiety. I still am a pretty anxious person. And I was simultaneously in a lot of fear because I didn't know what kind of economic responsibility or insecurity that it could bring on [if it wasn't a hit]. My first response was, 'Thank you so much. If it fails, can I come back?' [Joss] said yes, and I said, 'Great, let's go.'"

Meanwhile, Nicholas Brendon was sad to lose his primary love interest, and was flummoxed at the concept of a spin-off altogether. "CC [Charisma Carpenter] is such an amazing person and interesting character," he says. "The thing I love about CC most of all is that you might think she's coming off as abrasive or whatever, but she's telling you exactly what she wants and nothing more. She won't talk shit behind your back. She is who she is. And there were times where she would get thrown by things, like if somebody was moving behind cameras, 'Please don't move.' I remember there was one episode where I was off-camera and Joss was over my right shoulder and it was between ten and thirteen takes and then you'd just see it in her eyes. And Joss would pinch my leg and I'd be like 'I know.' It might take five or it might take thirteen, but there would always be that take where she'd just glow and you'd know she was in the zone. And it was weird that she left the show. It was weird that *Angel* got a

spin-off. Because how does the most boring character in TV history get a spin-off?"

He wasn't done. "Why don't we break down Angel? Uh, no, there's nothing to break down. It's just a brooding little guy. Angel, in my opinion, is worse than those *Twilight* fuckers. I'm not sure if I'm talking about David or Angel at this point now."

I think—and just a hunch—it's fair to say these two aren't best friends for life.

As Boreanaz and Carpenter exited the series, preparations were in order for Seth Green to depart as well, dwindling the main cast down from seven to four. And it wasn't just the actors. Co-executive producer David Greenwalt, who had been with the series from the outset, would depart with Boreanaz and Carpenter to be the showrunner for *Angel*. Joss Whedon's time would be split between *Buffy* and *Angel*. Ch-ch-changes were in order as the show outgrew its high-school-as-horror premise and looked to find a new mission statement. And so began *Buffy*'s true second of what I consider three acts: the college years.

Well, You Were Myth-Taken

"[The show is] about adolescence, which is the most important thing people go through in their development, becoming an adult, and it mythologizes it in such a way, such a romantic way—it basically says, 'Everybody who made it through adolescence is a hero,'" Whedon said about the series. And then what? *Buffy*'s fourth season meant that the road map the show was built upon had to be revised. The prophecy had been fulfilled. In the words of Madonna on her hit single "Justify My Love": So now what?

Freedom. Terror. And the search for identity. "In season four, the loss of Angel actually made things easier, because it meant new places to go," said Joss Whedon. "What had become tough was wringing new changes out of that relationship. By season four we were into mission statements. What we said was this is the first year of college. The first year of college is about being able to do whatever the hell you want and completely losing yourself, trying on new identities and changing. Exploring sexuality, exploring freedom to screw your boyfriend all day long, which Buffy did do for a while."

"Buffy in particular finds herself adrift," said Marti Noxon. "We wanted to really convey her sense of insignificance compared to this big experience," that of leaving home and starting collegiate life. "We thought a lot about the fact that even though she's the Slayer, this isn't a situation that a Slayer necessarily has the skills to take on ... The character of the Slayer is only interesting when she's human and

when she has human emotions and frailties." And it wasn't just the titular character feeling adrift.

As Buffy's fourth season prepared to leave the departure gate, so, too, did Whedon's other child, his new one, *Angel*. As showrunner for both series, Whedon's time was split between the two shows, and as any parent knows, a baby needs outsized attention. "Part of the difficulty for me was that not only did Charisma and David leave, but also Joss did, because he was going to take on this new show," says Anthony Stewart Head. "Marti was great as a co-showrunner, but she was quite young. She was quite scared. But Joss had been the core, and the balance of the core had shifted. Now it was a little bit more of a who was friends with who, and how we all sat in the great scheme of things. I think that's where it changed."

With Angel, Cordelia, and soon thereafter Oz all out, the show needed a re-zhuzh. Why lose a third cast member six episodes after losing two of the seven? Contracts, but of course. "The deal that we were able to craft was that I would do those first six episodes of the new season, which ran right up until I went to film *Knockaround Guys*. I still posited that I could keep this contract, they could simply not pay me for the episodes that I wasn't on. And the suits were like, 'Well, this is against corporate precedent.' And I was like, 'Guys, none of that matters. What do you want?' *They* want me to do episodes. *I* want to do episodes. I also want to make these movies. Why can't we do this?"

A deal could not be struck, and Green concluded his run as Oz in Episode 6. "I was like 'I'm not trying to make enemies. I actually love everybody here and would do this forever. But I know that we could do both.' So the fact that I was being fought at a corporate level about some theoretical precedent of their future negotiations with someone else in a similar position felt idiotic."

Still, Green left on a good note. "Joss and I, we got square right away and I said, 'Literally, anytime, anywhere, any part, any price, you know what I mean?'" As a result, Green appeared in two episodes later in the season, but never appeared after that. I asked if he wished

he would have been brought back at a later date considering he made his willingness clear. "All those writers, they are such storytellers and you really fall for those characters as you're writing them, so I can only imagine that they were inspired by what was in front of them."

Is he bitter? Not in the least. "They gave us such good material, so many moments for the underserviced nerd to thrive and feel special and be inspiring. And for me as an actor, most of the characters I play are the loser, the misfit, the awkward guy, the guy who has no skills. And Oz was good at stuff, so I focused on making that true. And especially because Aly and I know each other so well, like, we have such easy chemistry that I think we can play any emotion together. We really boost each other's willingness because there's no fear, it's all trust. The writers were generous enough to give us such stuff to work with. And we were both shameless and fearless about where we could take it."

I mention his final scene with Alyson in Oz's van in which Willow and Oz agree that now is not the time for them to be together and comment on the nuance of both of their performances—deeply emotional but never overwrought. "She's just got an access and she can get there," he says. "And then when we're there together, she'll get me there or I'll push and we'll both be there. It's just, it's...it's like the best kind of partner."

The loss of Green took a particularly hard toll on Gellar, considering their decades-long friendship. "That was really hard for me," she says. "I lost David and then so soon thereafter I lost Seth. Those were hard transitions for me. Even though Seth wasn't there all the time, for me, that was like a piece of home and someone that I knew I could always count on. But I knew he'd always be in my life."

Green wasn't the only cast member hankering for projects outside of the show. "I was *Sex and the City*–obsessed and had been friends with [*Sex and the City* creator] Darren Star for years. And so I said to Darren, 'I just want to be on the show.' And he was like 'Great, I'll write it for you.' But each time we tried to do it, *Buffy* wouldn't let me go to New York to do it." Then, during shooting for Season 4, Gellar

got a call from Star letting her know that production was flying out to Los Angeles to shoot two episodes. "And as it happens, *Buffy* was in the throes of it, our schedule was way behind, and *Buffy* still wouldn't give me the time off to do it. And I get it: It's another show on another network, it's not their obligation to do that. So we finally landed on an agreement where *Buffy* would wrap at a certain point during the day and I could go and do *Sex and the City* at night. *Buffy* ended up going until eight p.m. and I had a ten p.m. call for *Sex and the City*. And they were kind enough, the teamsters from *Buffy* took my trailer over there. So I get there at ten and I don't think they called me out of my trailer until four or five in the morning. And then I worked on that until eight thirty in the morning. But it was totally worth it because I just wanted to be a part of the canon and the history of the show and I would do it again in a heartbeat."

But back to *our* show. With Angel, Cordelia, and Oz out, new blood arrived, and hastily, in the form of Emma Caulfield, best known for her role as Susan Keats, a love interest of Brandon Walsh's on the television series *Beverly Hills, 90210*, who was brought back into the fold after making several appearances in Season 3 and was promoted to a full-time cast member by mid-season. Her character, Anya, a reformed vengeance demon turned fish-out-of-water human, would be Xander's new love interest.

"I think because I had a good experience doing *90210*, going into the second 'Hey, we're a hit show, welcome,' kind of vibe was fairly okay," says Caulfield. "I don't remember coming back home thinking, Oh God, everyone hates me or this is going to be a long one. I think I just went with the flow. When I started [in Season 3] I was just supposed to be there for a week, so I didn't have any expectations other than: Well, I hope this comes off well. As I started to do more episodes, I wanted to continue to do more. I was having a good time and I liked the people. I was really enjoying myself. And then after I kept returning, then it became more of a psychological thing for me, like, How do I make them want to keep bringing me back?"

At one point during filming of Season 4, Caulfield was offered a series regular role on another show. Therein was a choice: Take a regular role on a not-yet-established show or stay with a show that can't seem to commit to you. "And at that point, I wouldn't have gone back recurring. It was one of those things like, 'Make it real baby,' 'put a ring on it or I'm not coming back.' So I had a very real potential of having no jobs at all. But luckily at that eleventh hour they made the call to bring me on full-time."

Rounding out the fresh faces were Amber Benson, who was brought in mid-season as a recurring character, Tara, a new love interest for Willow, and Marc Blucas as Riley, a college TA and new love interest for Buffy who had ties to the Initiative, a secret government agency that captured and researched demons for military purposes. Last but not least came the return of a fan-favorite character: Spike.

"I thought, They're going to call me and make me a cast regular for sure," James Marsters said after filming for Season 2 concluded. "And then, you know, Eliza Dushku happened," he jokes. Though Marsters had made a one-off appearance on Season 3, he assumed Spike's journey on the show had come to an end. "I think at that point it was very apparent that the show was continuing just fine without the character." Feeling resentful, Marsters started to tune out. "I did not see all of Season 3 because I was so angry that it was so good."

But with Faith in a coma and Cordelia off in Los Angeles, Buffy no longer had a frenemy to squabble with. "Buffy lost that character that says, 'Buffy, you're stupid, and we're all about to die.' And there was a conversation about if there was an existing character that they could bring in to fill that role and I think it was Sarah who said to Joss, 'Why don't you try Spike?' And Joss was like, 'Yeah, maybe we could try Spike. Didn't think of that.'"

And so Spike returned, still evil, but no longer a threat thanks to a chip implanted in his brain by the Initiative, which rendered him unable to harm humans. As the character describes it: "Spike had a little trip to the vet and now he doesn't chase the other puppies

anymore." At first, for a few episodes, he fulfilled the "Buffy, you're stupid" role, even expanding to "You're *all* stupid." But as Marsters points out, this wasn't really working for two reasons: One, the Scooby Gang are daytime characters, so trying to get Spike in the room so that he could tell Buffy that she's stupid proved difficult. "You see Spike running in underneath a smoldering blanket constantly, and they quickly realized that that just wasn't going to work."

And two: Emma Caulfield's Anya proved highly adept at making the Scooby Gang feel like bibbling idiots. Marsters noticed this too. "One time Joss was like, 'I just realized you're funny.' And I'm like, 'Oh, thank you, Joss. You know, I can play different styles and stuff.' And he's like, 'No, no, no. You're, like…*funny*. You're like *Emma Caufield funny*,' which for him was like the highest praise. And so at that point, I thought that I would be killed off because there wasn't really a place to fit me into the show." Well, James, you thought wrong.

Anya, a new fan favorite, in many ways was the show's real otherized character. In the Buffyverse, vampires and demons were the norm, even queer people were free to exist without unjust scrutiny, but Anya's status as ex-demon trying to make sense of life as a human was the show's best attempt at spotlighting marginalization. "Anya, for me, felt like the story of the immigrant," says Cynthia Erivo. "She was the woman who was out of place, didn't really feel like she belonged, had what felt to everyone else like a strange name and was trying to change how she spoke to people and how she was reacting. That's often what immigrants do, what we as kids of immigrants do: we're trying to find ways to fit in and be a part of the bigger design, and I think that's what she was, only instead of coming from a different country, she was a demon."

Another character who would have a hard time fitting in was Buffy's second boyfriend, Riley. In his case, however, it was less within the world of the show and more within the fandom, a fandom with the power to steer the show's ship. Though there had been a few other ships passing in the night (Owen Thurman in Season 1, Scott

Hope in Season 3, and Parker Abrams early in Season 4), Riley was Buffy's second "I love you." Marc Blucas, a former collegiate and professional basketball player—a senior at Wake Forest when Tim Duncan was a freshman—was new to Hollywood and looking for work after a bit part in *Pleasantville*. At the suggestion of his agent, he was told to watch *Buffy* in preparation for his audition.

"I had just finished playing pro sports and suddenly I'm in my apartment with the blinds down, watching episodes of a show called *Buffy*," he recalls. "And then I'm two or three episodes in and I'm like 'This is really good.' Like, I can't tell anyone, but I actually think it's great."

He went through several rounds of auditions before finally landing in front of Whedon. "At this point, it narrows down to two actors. And again, I'm taking acting class every night. I truly don't know how to break down a script, create a character. I had a full scholarship to law school. I was a business major in college. This all just kind of happened, which makes a lot of actors sick, and I realize how lucky I was, like *truly*, but I just think they saw potential talent because I certainly didn't have the craft. There was no mastery of it at all—not that I have it now," he says with a self-deprecating laugh that endears me to him. "But at least now I can set an intention and work with a filmmaker to accomplish what we both want to take away from the scene. But back then I just didn't have the vocabulary."

But that was hardly his biggest obstacle in the audition process. Blucas was in a summer basketball league. The night before his chemistry read with Gellar he found himself on the court and on his back, knocked out after taking an elbow to the head that left him concussed. "By the next morning, I couldn't walk," he recalls. He made it to the audition the next day in flip flops ("I couldn't bend over to put shoes on"). He performed his scenes with Gellar with his back against the wall. "I'm like, 'Hey guys, really sorry.' And I just did it. Then I apologized and headed for the door. I'm like, 'Good luck, sorry for wasting everybody's time.'"

He left and later that day received a phone call from Joss. "When are you going to get better?" Whedon probed. Never having been injured before, Blucas threw out a date: Two weeks. "And he was like, 'Great, Sarah's on vacation for two weeks and I'm going to have you back and do it again.' And look, second chances don't happen that much in life—and they certainly never happen in Hollywood—and I will always be grateful for that phone call from Joss giving me a second chance." And so, true to his word, Whedon called Blucas in two weeks later and even held the camera for the screen test between his two new romantic leads. "And the rest is history?" I ask. Ish. Whedon offered him the part, with an ominous caveat: "One of the very next lines he said to me was, 'Don't go on the Internet, because they're going to hate you.'"

What he meant was that fan attachment to the Buffy/Angel romance was strong, and any new love interest for Buffy was going to face an uphill battle in convincing an intensely invested fandom to have her start a relationship that wasn't with her soul mate. Still, Whedon rationalized this warning by explaining that *any* prospective love interest would be hated by fans. Comforting, no? "Joss had a quote: 'You don't follow a banjo act with a banjo,' which I thought was a great quote because I think David and I have similarities, but we are obviously different between the broodiness and the more high-energy, boy-next-door of Riley."

It's true, both the characters and actors had little in common outside of their hunk-like status, but Whedon was verbalizing an inevitability that would make Blucas's time on the show seem somewhat doomed from the start. "A Hate Letter to Riley Finn, Worst Man in the Buffyverse," reads the headline of one article. There were and are multiple forums and message boards online dedicated to hating Riley Finn. Some arguments hold water, like how Riley was immediately judgmental of Willow dating a "dangerous guy" like Oz without any true depth of understanding that Oz is only a werewolf three nights of the month. Others, less so: "I hate Riley too," read one response on

fanpop.com. "He has stupid hair and a weird voice." That comment alone feels like dialogue extracted from a *Buffy* script, delivered with Buffy's signature pouty voice.

"At the end of the day, because the Buffy/Angel relationship was so interesting, well thought out, well acted, well set up, and so dramatic and so intense, as Joss said, 'Nothing and no one is going to stand up to that.' That's what he said. 'We're going to do everything we can. A guy is going to try something with her and you're going to punch him out, like we're going to try it *all*, we're going to do all the devices, but listen, none of it's going to work. They're all just going to want her to be with Angel.'"

He wasn't wrong entirely, but there was a perhaps-less-vocal-on-the-message-boards faction of us who were very pro-Buffy placing her Angel relationship in the rearview. "I would just like to say that Angel stalked her and also murdered her Watcher's girlfriend…but Riley's definitely the *worst* boyfriend she ever had, definitely the *worst*," Jenny Owen Youngs states with brimming sarcasm. (And this isn't even factoring in her love affair with Spike, who *also* stalked her, had a robot version of her built to have sex with, and then attempted to rape her. I'm getting redundant at this point, but we'll get to *all* of that in time.)

I ask Gellar if she was aware of fan loyalty toward Bangel's romance, and their reluctance to embrace Briley (Bangel and Spuffy are fan-generated portmanteaus for Buffy/Angel and Buffy/Spike; Briley, on the other hand, is not one but I'm making it one now, haters be silent!). "Luckily for me, because there was no social media at that time, I was able to tune a lot of that out," she says. "Some of our cast members went on message boards, and I know Joss did too, but I never looked at that stuff because I know how hard it is. I know that for every good review, there's gonna be the bad ones, and so for me, it was best to just stay away. [Plus] Marc and I became closer off-camera as well and spent a lot of time together, and he was friends with my husband—they'd worked together [on *Summer Catch*]—so I think I was lucky and I didn't really know about it until afterwards."

Blucas largely avoided the message boards, too, and says that because of his background in sports, he wasn't too rattled by being set up for failure (or, in this case, perceived failure by some). What he says was the most upsetting was feeling like he hadn't yet come into his own as an actor. I can't help but be a bit confused as to why Riley existed in the first place. The character seemed not only built for failure but with the acknowledgment that nothing could be done to avoid such failure.

Thankfully, the cast was welcoming and set his mind at ease—especially Gellar. "Were there times where it was middle school with money? Well sure. But I think that I got really lucky because Sarah was open and welcoming and really helpful." Gellar speaks similarly about Blucas. "I got extremely lucky that I also adored Marc and we became very good friends. And while I don't think Buffy and Riley were ever meant for each other long-term, I do think that there was something there. And it was another experience for her, which only made her grow, which gave me as an actor more to do."

I ask Blucas to dispel any rumors of tensions between him and Gellar on set. "Look, I could be a basketball player and if a freshman fucked up, I would be pissed off. Like, this is my livelihood here, you know what I mean? But it was never taken out on me. Did it create problems for her? I would say I caused frustrations for her and she handled it the right way. She was patient with me. She would go to Joss and be like, 'Hey, we need to build in more time for rehearsal.' I think that she saw someone who was genuinely trying, who was a nice guy, who was never late, who never didn't know their line, and I think those things all help balance out the fact that I just wasn't a refined actor yet. So there's no ill will. It's ironically the opposite of that. I feel bad that I created more stress and drama. There's enough on those kinds of TV shows, especially for a number one on the call sheet like she was."

When Riley makes his debut in Season 4, Episode 1 ("The Freshman"), he's a bit bumbling, a bit shy—everything Blucas isn't. "I

remember Joss saying early on, 'For these first few episodes, I need you to just be wallpaper. I don't want to telegraph this. We just got to set it up right. It's going to be very vanilla and very plain. And then there'll be some reveals. Then this relationship will start and it'll start to turn dark and different and we'll have fun and do different things.'" In other words, his two directives were "Be wallpaper" and "Don't go on the Internet."

But like many people I interviewed for this book—more often the men—Blucas was deferential toward Whedon's perceived genius. "Joss was so smart about dropping all these things in from different seasons and setting things up that he was going to pay off four years later. There was a moment I remember asking him, 'Joss, what does this line mean?' And he was like, 'I just need you to say it like that because I'm going to pay it off in Season 7.' That was probably his way of saying 'Shut up and just say what I wrote.' But he was constantly thinking ahead and setting things off to pay off later. It's one of the things that make him a great writer."

I'm reminded of a comment that Whedon makes in the "Season 4 Overview" DVD featurette. He's describing a scene in Episode 16 ("Who Are You?") in which Faith, who has swapped bodies with Buffy through a magical device, seduces Riley, who senses something is off with the Buffy that stands before him but dismisses it as nothing too concerning. "A lot of people were surprised that Riley actually slept with her even though he senses something is up with her emotionally. Of course he's not going to get that it's not her, and the fact that he slept with her seems so un-Riley cause he's so the noble guy, but let's face it: he's just a guy." In other words, in Whedon's worldview as could be surmised from this assessment, men are simply slaves to their sexual desires.

Would Blucas do it all over again? "I'm not interested in having zero creative input," he says. "But back then I didn't know that creative input was even an option. I didn't know what I was doing, and probably had nothing valuable to add. But the whole 'Stand here, say

this' doesn't allow you to be as free to make a role your own. I'm sure you've had people talk about the dictatorship of Joss, and that's what it was. And listen, it was a success, so you can't judge him too much for it."

That's a through line in so many of these interviews: the work environment being deprioritized to give way to the work itself. Is that how it ought to be? The destination in spite of the journey? I don't believe that's how Ralph Waldo Emerson was thinking about it, but who am I to say conclusively?

I press further—a theme—asking Blucas if he had any experiences with Whedon or witnessed any on-set behavior that felt abnormal. "Joss, at that time, I felt was uncomfortable in his own skin. He was a writer who was probably more comfortable sitting at a desk, in a room, with a computer than being a people person. I'm coming from a small-town, sports, academic background and Joss is coming from a comic book...I don't mean the words 'geeky' or 'nerdy' to have a negative connotation to it, but...we almost had nothing to talk about. We had no similarities. We didn't have common interests. We were both kind to each other. There was never anything like *that*. I think he was highly intelligent. I think he's a brilliant writer. But that was the only thing I noticed: that I didn't think he was a people person. Like you wouldn't say that he was a quarterback in that way."

I can't help but feel a bit sorry for Blucas (and he doesn't give off the vibe of wanting pity, mind you), feeling like he got dealt a big opportunity and a bad hand at the same time. "I did what they said. I did it to the best of my ability at the time. I wish it would have been better. I haven't seen the show. I don't watch myself, so I don't know for sure."

For twenty years Blucas declined every convention opportunity that was directed his way. That changed in 2017. "I kept getting invited and I just never went. And it wasn't out of fear or pain or 'fuck them.' I just never had any interest. I wasn't the show, you know? I finally did one for the twentieth anniversary, thinking, All right, well

maybe now I won't get rotten fruit thrown at me. And I had an amazing time. And at the end of the day, it's one of those things on your résumé that you end up being really proud of, regardless of how judgmental I am on myself. I mean, I think every actor has a dream to be a part of a culture-changing seminal show. Like, we all want to be a part of a story that stands the test of time, and this one does."

He continues: "But I don't think Joss or anybody looks at me as a big part of the show and a big part of the storytelling. Like, that twenty-year thing that *Entertainment Weekly* did with the cast, like, I wasn't invited to that. And look, I don't know if Joss even liked me as a human being, so it could have been like, 'No, we don't want Marc.' Like, who knows where that got killed along the way, but I think I was there [on the show] enough that it wasn't an oversight. And so it felt like an active decision. And again, I didn't care. That was fine. I just don't think I'm viewed as a big part of the show . . . and that's okay."

I ask Blucas to recall a smaller memory of triumph on the show. He pauses for a while to think. "One moment I remember as a personal moment more than I do about the arc and story of Riley is when Riley went down the road of getting his blood sucked. That was my first time doing a dark scene. It's the whole crew. And I think they liked me. We all got along. And I remember trying that scene, and the crew clapped for me. It wasn't fucking brilliant. Ain't no fucking awards going on there. But it was just a moment where I think that they saw that this kid's working his ass off, and we see it and we've seen some growth and he's trying hard. And you've got seven or eight people clapping, which just doesn't happen on sets. That was what I remember. That meant a lot to me at that moment."

When Riley made his unceremonious exit in the middle of Season 5, Blucas was unfazed, ready to move on to the next chapter of his career. "I was sick of the middle school component of it," he says. "I didn't buy into the fandom. I didn't subscribe to the 'I'm a star.' It was awesome to be a part of a cool show. I made a little bit of money for the first time in my life, and that validated it for me."

We know he didn't watch himself on the show, but did he watch the show after Riley's departure? "I have no idea how Season 5 ended or how the series ended. I know they did a musical. I heard about it and was like, 'Thank God I wasn't in that.' I think I did see part of the episode I came back in [in Season 6], because I do have this image in my mind of Sarah wearing some ridiculous hat at a fast-food place, but that's it."

Will he ever watch the show? "Listen, I have two daughters and I'm a girl dad. And do I think that there's elements of female empowerment and some themes of that show that I think would be interesting with them when they're of age and older and they're ready to see it? But my kids have never seen me on a TV screen. Like, we live on a farm in Pennsylvania. Like, I have no interest in my kids seeing me sign an autograph or see any component of fame or seeing people treat me differently or on a television show. My nine-year-old knows what I do for a living. Um, but that's it, she hasn't been to a set. Like, I...we don't need that. And there's all kind of time for them to see and learn that. And when that all happens and at the appropriate age, I'll be like, 'Hey, you want to see something that I did that's pretty well known as a seminal, culture-changing show? Here, check this out.' And I'll show an episode of it. And if they like it and want to watch the series, then good for them. That'll be their choice, but that's the only time I really see me considering revisiting it."

More than anything, I'm bummed after talking to Blucas that he isn't given more regard by the fandom after the fact. I'm bummed that *Entertainment Weekly* or Joss or whoever didn't deem Blucas important enough to invite for the twentieth anniversary. But I'm grateful to have chatted with him for this book. "I wish it would have happened when I was more experienced and more mature so I would have been able to recognize how good the material was. On paper, it was a dream job because I came into an existing show that already had the wheels greased and an amazing track record and a tone and a cast and all things were hit out of the park before I even came on. But

I was so green and so bad on the show. I was just trying to make it. I was just trying to keep my head above water."

Buffy's new love interest might not have won fans' hearts over, but the opposite couldn't have been more true for Willow's new love interest: Tara, played by actress Amber Benson, who was best known at the time for her role as Ella McShane in Steven Soderbergh's *King of the Hill*. For the first three seasons of the series, Willow had had two great loves: Xander, on whom she'd had a crush since they were five, and Oz, her first and only boyfriend. I always noticed a lack of physical affection between the two. They rarely kiss and don't have sex for the first time until thirty episodes into Oz's arc on the series. "I think the characters almost have negative chemistry between the two of them," notes Ian Carlos Crawford, host of the podcast *Slayer-Fest '98*. "For me, it feels like when I dated girls in high school. It feels very closeted-person, being like, 'Yeah, I love this person,' but they're just functioning as friends."

According to Whedon, he and the writers had considered the idea of someone exploring their sexuality in college, as is fairly typical. "We talked about Willow and her being a witch because it's a very strong female community and it gives her a very physical relationship with someone that isn't necessarily sexual," Whedon told *Fresh Air*'s David Bianculli in 2002. "And then when we decided to go that way, part of it was because Seth Green wanted to step out and do movies and we knew that he was going to be out of the picture and someone had to be with Willow and it seemed like a good time for her to be exploring this, and the question became: How much do we play in metaphor and how much do we play as her actually expanding her sexuality? You're walking a very fine line there. The network obviously has issues. They don't want any kissing—that's one thing that they've stipulated—and they're a little nervous about it. They haven't interfered at all with what we've tried to do and yet they've raised a caution about it."

As is often the case on *Buffy*, there were hints: In Season 3,

Episode 16 ("Doppelgängland"), a spell gone awry brings a vampire Willow to Sunnydale. "That's me as a vampire?" Willow asks, when the two come face-to-face. "I'm so evil and skanky. And I think I'm kinda gay!" When Buffy responds, "Just remember, a vampire's personality has nothing to do with the person it was..." Angel interjects with a pointed "Well, actually..."

Later, in Season 6, Episode 8 ("Tabula Rasa"), when the Scooby Gang has their memories temporarily wiped, Willow, who believes she is dating Xander because she awoke wearing his jacket, realizes she is attracted to Tara and declares once again: "I think I'm kinda gay."

To be clear: Willow didn't turn gay. She fell in love with a woman. Much has been written and discussed over the years about Willow's sexuality, with some feeling like calling Willow a lesbian is bisexual erasure ("I was always of the mind that Willow was bisexual and Tara was a lesbian," says Amber Benson).

If we're going by the text alone, Willow does refer to herself as gay in several instances. "Well, hello, gay now," she says in Season 5, Episode 11 ("Triangle"), when Anya worries about Willow trying to steal Xander from her, which is my favorite instance. And maybe Willow is, as she said, gay *now*. But some would argue that the text as it is written fails to adequately reconcile the very real possibility that she's attracted to more than one gender. Never is it spoken about, let alone considered, that Willow was bisexual, or pansexual, all along. But maybe, as some have argued, her sexuality was fluid. "While some people, such as Buffy, or Tara, or even Vampire Willow, might have a permanent understanding of their sexuality as fixed, Willow does not," argues author Nicole Grafanakis in her essay "The Queer Influence of *Buffy the Vampire Slayer*." "And in many ways, that makes her even more dynamic, queer, and progressive."

The complexities of this conversation were certainly not present when Whedon brought the idea down from on high. "I knew that I was going to have a friend and that we'd do witchcraft together and cast spells, and I'd always asked if there was 'something more' to the

relationship," Alyson Hannigan said in a 2000 interview. "Joss would always say, 'Well, maybe there's some subtext there' and then Amber and I would see some of the spells and we'd be like, 'Joss, this is going way beyond subtext.'"

Most queer people watching saw the subtext as text almost immediately. In the show's arguably most famous episode, "Hush," Tara is running through the hallways being chased by a group of demons known as the Gentlemen when she quite literally stumbles upon Willow, who joins her in fleeing for safety. They find temporary refuge before they are discovered with a pounding on the door. Willow attempts to use her magic to move a vending machine across the room to barricade the entrance. She's not yet strong enough. Tara, inferring what she is doing, clasps Willow's hand and delicately laces their fingers together, generating enough power between them to force with great precision the vending machine across the room. The text was witchcraft; the subtext was queerness.

Whedon was not initially sold on Amber Benson. "I think [Joss] had in his mind an image of what he wanted the character to physically look like," Benson says. "I think originally she was going to be like a woodland sprite of some kind, and when you think of fairies and sprites, you think of a very lithe, petite kind of pixie-looking…looking more like an Alyson Hannigan versus a curvy, feminine, Mother Earthy kind of Amber Benson. When you're a writer and you're writing a character, sometimes you get things in your head and that's what you see. But luckily for me, Marti didn't have that image in her head. And I think she felt that I would be good for the part and she pushed for me."

She continues: "We were still coming out of that Kate Moss, androgynous, very, very thin, no hips, no breasts—almost antifeminine in a way—body type. I think that was the industry at the time also. And I think that it still holds true. I feel like there have been inroads made around body image and self-love of body, but Hollywood is about selling someone a fantasy. And so what do you want for your fantasy? You want people that adhere to the sort of fantasy

measurements. And I am not that; I am curvy. I have breasts. I have hips. I'm not anorexic. I don't want an egg-white omelet with no butter and no oil for breakfast—which a lot of my castmates would have every morning. And to each their own and everybody should do what's best for them, but for me, that just wasn't it."

Benson, like so many actors before her, was only intended to be brought in for a multi-episode arc. "There was no mention at all of this being a possible love interest for Willow. I guess in retrospect when the breakdown said something like, 'This is going to be a new friend for Willow,' I should have put it together," she says with a laugh. A few episodes in, the crew began approaching Benson on set to tell her how great the chemistry was between her and Hannigan. She shrugged it off, thinking, "That's so kind."

"And then Joss took each of us aside and was like, 'Hey, this is kind of my intent with this. I want you guys to be a couple.' To my understanding, the relationship was very much kind of a mash note to some friends of his who were a lesbian couple. I think he saw and loved them and was like, 'I really want to represent what I see. I feel like they don't get that. And so I want to give them that.' And I think that was sort of the impetus for the relationship that he created with Willow and Tara."

Fans quickly embraced the duo, particularly the show's burgeoning lesbian fanbase, who noted the authentic development and depth of the relationship, and how it challenged traditional gender notions of lesbian relationships. As Grafanakis points out in her essay on the queer influences of the show, both Willow and Tara are "femme." "The significance here is that their relationship resists the idea that lesbian women are innately masculine," she writes. "Further, Willow and Tara's hyper-feminine gender presentations emphasize that there is no 'man' in their relationship, as their love for each other is grounded in the acknowledgement that they are both women, and they both share roles of dominance and submission. This challenges the stereotype that lesbian couples follow the structure of butch/femme."

While viewers seemed immediately taken, the network was less

on board. Though Tara and Willow first meet in Season 4, Episode 10 ("Hush"), they would not share an onscreen kiss until Season 5, Episode 16 ("The Body"). "It rankled everybody," says Benson. "It was an edict that came down from on high that we were not allowed to [kiss]. Because this wasn't just a flash-in-the-pan 'Oh, two ladies making out for ratings,' this was an actual relationship. And I think it scared the absolute shit out of the network. And Joss really did push for [that kiss] to happen. He really did fight the fight."

"I remember when we got the Tara and Willow kiss," says James Marsters. "We had the first interracial kiss on *Star Trek*, and *Star Trek* fans like me will forever brag about that one. And I remember when we got our kiss I was like, 'Oh my God, we got our kiss!' I was so proud."

That kiss was both groundbreaking and polarizing.

"Are we forced to cut things between Willow and Tara? Well, there are things the network will not allow us to show," Whedon wrote in 2000 on a *Buffy* message board, "The Bronze," which he frequented. "For example: kissing. Does this bother me? Actually, no, and I'll tell you why. Restrictions are often a writer's best friend—they force him to be creative. The spell scene in [Season 4, Episode 16 ("Who Are You?")] was on one level a sex scene, on another level not. It was (barely) subtle compared to smoochin' and rompin'. The blowing out of the candle was lovely and poetical, as opposed to the more pedestrian smoochies. Look at Buffy and Riley. All their sheeted shenanigans leave most people cold compared to the tension between Willow and Tara (not *everyone*, but...)...Buffy and Riley get to have an active sex life, we get to (tastefully) show it, and it's not as compelling. So go, censors. We love working harder. Makes us better writers."

Benson says it was frustrating watching other characters given quite explicit sex scenes, whereas Willow and Tara were left blowing out candles. There's an entire episode, for instance, Season 4, Episode 18 ("Where the Wild Things Are"), where Buffy and Riley can't stop having sex. That frustration began to temper one day on set. "One of the crew took [Alyson and me] aside—and he was gay—and he said,

'Look, I know it feels frustrating for you. But what you have to understand is this is not about the physicality. This is about a couple who are in a loving, positive relationship who happen to be of the same gender. And you were going into homes in America, in middle America, every week, and showing people that being LGBTQ+ is normal. You are normalizing it. You're making it okay for them to go, Oh yeah, the lesbians on the show, I really liked them. I think I like lesbians. It wasn't about the kiss. It was about the normalization of LGBTQ+ relationships in our society.' "

Still, the kiss was a pivotal moment on the series that can be deemed quite progressive or relatively safe—or both—depending on your lens. "Looking back at it from where we are today it's easy to say, 'Ugh, straight couples don't have to wait that long to get their kiss. Why do we have to wait?' " says *Buffy* writer Drew Z. Greenberg. "The thing that is hard to remember is that it was not 2021. It was not where we are today. It was 2001. It was the WB."

Just a year earlier, *Dawson's Creek* aired a same-sex kiss between two of its characters, but not without much chagrin. "I had to threaten to quit [*Dawson's Creek*], basically because they wouldn't let us have the characters kiss," out, gay showrunner Greg Berlanti said. "At the time…there were shows that were fine to show lots of violence in network, but they wouldn't allow a kiss between two gay characters."

A few years before that, in 1994, Fox cut a gay kiss from airing on an episode of *Melrose Place*. The reason why? Money, of course. "The bottom line is, we're in a business," Fox's Sandy Grushow said at the time, after facing an onslaught of questions about the unaired kiss at a Television Critics Association meeting. "We would have lost up to $1 million by airing that kiss."

Whedon followed Berlanti's blueprint, and, according to him, threatened to quit the show. "[The network] called me and said, 'You know, we got a lot of gays here. On *Dawson's* and this other…and I'm like, 'I don't know, I don't watch those shows.' We're going to do this thing. It's true to character, it's what we're going to do. And then they

were like, 'Do you have to have the kiss?' I was like, 'Okay, I'm packing up my office.' I never pulled that out, except that one time."

It's important here to remember the context of where we were societally with regard to queer representation in media. There was no *Sex Education* or *Euphoria* or *Orange Is the New Black* or *Modern Family* or *Glee* or *Queer as Folk* or *The L Word* or *RuPaul's Drag Race*. Ellen DeGeneres had only come out four years earlier both on her show and on the cover of *Time*. The very first prime-time same-sex kiss (on *L.A. Law*) was less than a decade old. And it was hardly the watershed moment many queer people were hoping for.

"Eminently visual; cheap, provided the actors are willing; controversial, year in and year out; and elegantly reversible (sweeps lesbians typically vanish or go straight when the week's over), kisses between women are perfect sweeps stunts," the *New York Times* wrote at the time. "They offer something for everyone, from advocacy groups looking for role models to indignation-seeking conservatives, from goggle-eyed male viewers to progressive female ones, from tyrants who demand psychological complexity to plot buffs."

This trope, which would become known as the "lesbian kiss episode" would pop up everywhere in the '90s: *Picket Fences* (1993); *Roseanne* (1994); *Party of Five* (1999). It's a trend that would stick around into the twenty-first century, see: *Friends* (2001), and would even outlast *Buffy* on shows like *The O.C.* (2005) and *The Simpsons* (2012).

Willow and Tara's first kiss was not confined within a "lesbian kiss episode," however, and would be followed by many more lesbian kisses on the show (although there could always have been more). It was something Whedon was thoughtful about, both within the storytelling and the ripples he knew it would have culturally. "The first criticism we got was, 'She's not gay enough, they're not gay enough,'" recalled Whedon. "We were playing it as a metaphor, and it was like, 'Why don't they come out? They're not gay enough!' And eventually we did start to say, 'Well, maybe we're being a little coy. They've got good chemistry, this is working out, why don't we just go ahead and

make them go for it?' And, of course, once you bring it out in the open, it's no longer a metaphor. Then it's just an issue. But we never played it that way. Ultimately, some people say, 'lesbian chic,' I say, 'Okay, whatever.' Those criticisms don't really bug me. You look at shows like *Ally McBeal* and *Party of Five*, which both did lesbian kisses that were promoted and hyped for months and months, and afterwards the characters were like, 'Well, I seem to be very heterosexual! Thank you for that steamy lesbian kiss!' Our whole mission statement was that we would bury their first kiss inside an episode that had nothing to do with it, and never promote it, which I guess caught people off-guard at The WB. The reason we had them kiss was because if they didn't, it would start to get coy and, quite frankly, a little offensive, for two people that much in love to not have any physicality. But the whole mission statement was, 'We'll put it where nobody expects it, and we'll never talk about it.'"

"In my mind, of course, it would have been great if it happened sooner," says Drew Z. Greenberg. "But Joss did something really strategic. He had it happen in a moment where it wasn't really about the kiss. 'The Body' was an episode of pure emotion. It's grief. And it's solace. And it's love. And it made sense in the context of the show. Sucks that we had to be that calculating about where we put our kisses, but that's the way the world was at that point and I am grateful that it happened. And I'd like to think that if the show were being made today it would have happened sooner."

In many senses, Whedon and the writers, as well as Hannigan and Benson, had a job much bigger than writing or acting these characters. There was a responsibility, whether recognized or not, to represent an underserved part of society. "It is an atypical experience where you're doing something that feels like you're not just a performer but you're actually making social commentary," Benson says. "I definitely felt the onus was on me to really do her justice and be the best I could be for her, for Tara."

Best achieved. It's a kiss that even today holds significant weight

for so many people. "There are things that I didn't notice then that I notice now," says author Kristin Russo. "Like in 'The Body' when I watched it the first time, I was hit by all the things that when you Google 'The Body' and read any think piece touch on. But that's the episode where we first see Willow and Tara kiss. And *that* moment. And *that* choice. I was not aware of it like I am now."

Even without a kiss, Buffy's fourth season accomplished what the writers set out to do: It forced the characters to grow up. It also proved to its audience that the show could move past its original premise (high school is hell); sunset beloved characters like Angel, Cordelia, and Oz; and come away from it all stronger than ever. But some characters began to feel sidelined, and so did the actors portraying them.

"I was beginning to feel a bit like a standby," says Anthony Stewart Head. "We'd left the school and it was just Giles's apartment people would come to, always with problems. I didn't feel as core as I did before. And Joss said, 'Well, it's not called Giles, it's called Buffy. But leave it with me, let me have a think.' That's what gave him the idea with Giles having a midlife crisis because he was feeling left out." But even with those standalone episodes, characters like Giles and Xander began to feel backgrounded within the larger story arc of the season: one that served as a huge turning point in the discovery that the government and the world of science is not only aware of, but has invaded, the world of vampires, demons, and all things mystical.

Did Season 4 contain the show's least beloved Big Bad in the form of Adam, a biomechanical demonoid that we're gonna politely pass on analyzing in depth? Yes. Did it contain some of the least beloved episodes of the series, namely "Beer Bad" and "Where the Wild Things Are"? Also yes. But it also gave us some of the show's loftiest highs (Episode 10, "Hush," Episode 16, "Who Are You?" and the finale, Episode 22, "Restless"). "Restless" upended the series format as we previously knew it, reminding viewers never to get too comfortable. The season arc concluded an episode earlier (Buffy defeats Adam, extracting, with the help of the Scoobies, his uranium core power source), so

we were left with an episode that essentially serves as an appetizer for what's to come on the back half of the series.

With Adam now out of the picture, the Scooby Gang gathers at Buffy's home sans Tara and Anya. Riley kisses Buffy goodbye at the top of the episode, Joyce heads upstairs, and the remaining core four settle in with popcorn to watch *Apocalypse Now*.

> **Giles:** Still feel a little bit too wired.
> **Willow:** Mm. Yeah, that spell, that was, that was powerful.
> **Buffy:** Don't think I *could* sleep.

Within seconds, everyone is asleep. And so begin four dream sequences, starting with Willow, then Xander, then Giles, and finally Buffy. If you ever want to feel what it feels like to take a bunch of drugs without taking said drugs, watch this here episode. There's slow-motion kittens stalking the camera; Oz is back (!) and flirting with Tara (!!); there's a production of *Death of a Salesman* starring Buffy as Velma Kelly from *Chicago*; there's a random bald man who keeps cropping up out of nowhere and offering up cheese slices; Joyce is inviting Xander into her bedroom in one scene and living in the dormitory walls in another, allowing the mice to play with her knees; Spike's in a tweed suit on a swing set while Buffy plays in a sandbox; Giles and Anya are speaking in Spanish; Principal Snyder is back; Anya is performing stand-up at the Bronze, where Giles is also performing (and he can carry a tune!); Tara's in Buffy's room telling her, "You think you know...what's to come...what you are...you haven't even begun"; and there's the introduction of Sineya, the First Slayer.

"The Slayer does not walk in this world," Sineya tells Buffy via Tara (more on that choice, say it with me: later). Ever the antagonist, Buffy pushes back at her foremother. "I walk. I talk. I shop, I sneeze. I'm gonna be a fireman when the floods roll back. There's trees in the desert since you moved out. And I don't sleep on a bed of bones." Sineya is not convinced, assured of their prophecy. "No...friends! Just

the kill. We...are...alone." They tussle until Buffy finally chooses to wake up. But what did it all mean? Buffy goes upstairs to shower and passes by a bedroom we've never seen before in her home. She pauses. We hear Tara's voice once more, this time understanding it to be Sineya's: "You think you know...what's to come...what you are... you haven't even begun."

"Most people sort of shake their heads at it," Joss Whedon said in a 2003 interview citing "Restless" amongst his ten favorite episodes. "It was different, but not pointless."

In many ways, Season 4 can be seen as the least cohesive season, but it can also be viewed as a representation of the chaos, experimentation, and uncertainty of life after high school. "I think Season 4 was really challenging," says Claire Saffitz. "I think Season 4 mirrored the actual struggle of transitioning to college, which meant finding new challenges and bringing in new characters. I still like the season, but I think that that was probably the weakest one." I concur, but Saffitz and I both agree that *Buffy*'s weakest is what most shows would consider their pinnacle achievement.

"It was sort of a chaotic season and a lot of people say it's the season where we fell apart and they don't like it," Whedon remarked. "I actually think it's the season where we did our best shows. But it did have a weird sort of coherence...A lot of things didn't come together in the big picture. Episode by episode the strength was pretty unmatched, but as an arc I understand why people were like 'It didn't get me there.' So [the finale] in a way is a way of saying, 'Just look at the pieces. Look at the characters and what they've been through.'"

That finale, with influences of *Twin Peaks* and *Mulholland Drive* and *The Cell*, amongst others, planted the seed not just for Season 5 but the rest of the series. Sure, some stuff made absolutely no sense at all (see: the Cheese Man), but other themes explored in "Restless" would unlock character journeys yet to come, as well as characters yet to come. Insert bulging-eyes emoji.

There are three specific clues laid out that point more directly at

the *what* of what's to come. Clue #1: Season 3, Episode 22 ("Graduation Day, Part Two"). A dream sequence.

> **Buffy:** There's something I'm supposed to be doing.
> **Faith:** Oh yeah. Miles to go. Little Miss Muffet counting down from 7-3-0.
> **Buffy:** Great. Riddles.

730 days is exactly two years.

Clue #2: Season 4, Episode 15 ("This Year's Girl"). Buffy and Faith are making a bed in a bedroom we've never before seen. Another dream sequence.

> **Buffy:** I wish I could stay, but...
> **Faith:** You have to go.
> **Buffy:** It's just, with...
> **Faith:** ...little sis coming. I know. So much to do before she gets here.

Clue #3: Season 4, Episode 22 ("Restless"). By now you get it, a dream sequence.

> **Buffy:** Faith and I just made that bed.
> **Tara:** For who?
> **Buffy:** I think I need to go find the others.
> *[Buffy leaves]*
> **Tara:** Be back before dawn.

And so, with the stroke of Joss Whedon's pen, Buffy's sister, Dawn, was soon to arrive. A sister that had been there all along. We just hadn't noticed.

Who's Going to Take Care of Us?

This one starts with Britney Spears, and as Julie Roberts's character Isabel once proclaimed in the seminal film *Stepmom* after her soon-to-be-stepdaughter Anna told her that she wasn't her mother: "Thank God for that." "There is a rumor," I tell Gellar, that Britney was intended to guest star as April the Robot midway through the show's fifth season, and that it did not work out because of scheduling. "Please, put some truth where there are rumors," I beg her.

"I do vaguely remember that," says Gellar, who introduced Spears as a musical guest on *Saturday Night Live* in 2000, portrayed Britney in a sketch on the show, and hung out with her a few times socially. "I think there might've been an early discussion, but I don't think it was ever really going to work." Had that happened, I would have gone into cardiac arrest. Thankfully, I suppose, it did not, and the role eventually went to actor Shonda Farr. But Season 5 did not need big-name guest stars (though they did get Oscar-, Grammy,- and Tony Award–winner Joel Grey) to keep viewers on the edge of their cushions. Instead there was the introduction of Buffy's kid sister, Dawn, and an evil god in a red Prada dress named Glory.

About that kid sister, here's an excerpt from Season 3 of *The Magicians.*

Eliot: Ugh, God. What a cliché.
Margo: The baby that becomes a teenager practically overnight?
Eliot: Right? *Angel.*

Margo: *Twilight*.

Eliot: *Buffy*.

Margo: Technically, Buffy's sister was never a baby. She just appeared out of nowhere.

It's true, Dawn would show up in the final beat of the Season 5 premiere ("Buffy vs. Dracula") without explanation. Her backstory would remain an unaddressed mystery for several episodes, with her presence implanted as though she'd been there all along and it was us, the viewer, who had missed her.

Dawn would be portrayed by fifteen-year-old Michelle Trachtenberg, an industry vet in her own right, having starred as the titular Harriet in 1996's *Harriet the Spy* opposite Rosie O'Donnell; 1998's *Richie Rich's Christmas Wish*; and 1999's *Inspector Gadget*. Like Gellar, she appeared on *All My Children*, as well as Nickelodeon's *The Adventures of Pete & Pete*, and she was a regular guest on the popular kids' game show *Figure It Out*.

Fans did not take to Dawn. There are articles—"The 10 Most Annoying Things Dawn Ever Did," for instance—with the sole purpose of hating on this character, a fourteen-year-old girl. The character routinely pops up on "most annoying television characters ever" lists, while characters like Xander exist scot-free. According to *Vice*, the most shared opinion within the *Buffy* fandom is "Dawn is the worst." My argument in her defense: What fourteen-year-old isn't? Mostly, I think Dawn was given an underbaked interior life, especially later in her trajectory on the series. Even Whedon has admitted he didn't quite know where to go with the character. "I had wanted to go further with Dawn's character," Whedon later admitted shortly after the series wrapped.

I just don't think she warrants the hatred that the fandom often has for her. "I'm with you on that," Gellar says. "I think it's because a lot of shows before us had jumped the shark when they brought in the new kid." Examples of this include *Growing Pains* and *Family*

Ties. "I think people wanted to hate on it, but the way they did it with Dawn was so cool and so innovative. She also was a petulant teenager because she *was* a teenager. I loved some of the stuff that Dawn got to play and seeing that other, more maternal side of Buffy as a result. And I loved Dawn's relationship with Tara and Willow or even her relationship with Spike. I'm with you. I don't get it."

Clare Kramer, meanwhile, a television newbie, had just finished filming *Bring It On*, co-starring *Buffy* alum Eliza Dushku. She knew of the series but had only seen some Faith-centered episodes over at Dushku's house during *Bring It On* filming. She went in to audition for the part of Cherry, which at the time had little description. Wanting to impress with her ability to make bold choices, she decided to base the character off of Jack Nicholson in *The Shining*. She got a call to come back in the next day and read once again and was offered the part on the spot. Cherry would become Glory, one of the most havoc-wreaking baddies on the show.

"I was really excited when I got the role, obviously," recalls Kramer. "I had done two TV pilots before this and I had just finished filming *Bring It On*, but it had not come out yet. And I remember Eliza [Dushku] telling me, 'You gotta check out the message boards.' And then my episode aired and I went on and I had never been so heartbroken in my life. Everyone was like 'She's terrible. It's the worst overacting I've ever seen. What are they doing to this show?' And here I am, this NYU-trained actor, thinking I was going to have my big break, and the first wave of news I received was not accolades but horrible reviews from the fans." From there and in that moment, Kramer made a decision to trust her gut, know that she was playing the character the right way, and trust in the connection she had to the character. "The directors and the writers seemed to think it's going well. They hadn't killed me off yet, which I also was warned about. So I decided to stop reading the message boards...although I wanted to."

Like Faith before her, Glory was hellbent on going after Buffy through the people she loved most. Unlike Faith, however, there

wasn't an ounce of humanity to tether her back to any kind of morality. Whereas other Big Bads were fixated on destroying the world, achieving omnipotence, or some combination of both, Glory had a much simpler mission: She just wanted to go home. "I'm the victim here," she complains to her minions at one point. "First off, I don't even want to be here. And I don't mean this room, or city, or state or planet, I'm talking the whole mortal coil now. You know, it's disgusting. The food, the clothes, the people. I could crap a better existence than this."

Douglas Petrie recalls, "Each season would begin with an initial meeting of Joss saying, 'Here's the Big Bad this year and here's why this is the Big Bad.' And for me, Seasons 3 and 5 were the ones where we were going, 'Oh man, we're going to go to town.'" It began in Episode 5 ("No Place Like Home"). The episode opens with a group of monks rushing to perform a ritual while being chased by a powerful, unknown entity. The episode picks up two months later, back at the scene of the ritual, where one of the monks is scribbling over a blueprint when a pounding at the door begins. The powerful, unknown entity makes herself known by kicking through a metal door. She's in a skin-tight red Prada dress and heels, not a strand of her dirty-blond curly hair out of place from the impact of the, y'know, kicking down a metal door in heels. She dusts herself off, looks around, sees a monk and says, "There you are. I have been looking *all over* for you."

"I think more time was spent on my hair that season than actually talking to me about the character," says Kramer about the character's signature golden locks.

Glorificus, or Glory for short, was revealed episodes later to be a god not at all concerned with Buffy, whom she perceived to be nothing more than a nuisance, until she figured out that Buffy knows the whereabouts of the thing she wants most: the Key. What is the Key? The Key is an ancient mystical energy with the power to unlock the gates between all existing dimensions. Duh. Fearing Glory would use

the Key, the monks gave it form by molding it into flesh and sending it to Buffy in the form of a sister, Dawn.

Buffy: You put that in my house?

Monk: We knew the Slayer would protect.

Buffy: My memories...my mom's?

Monk: We built them.

Buffy: Then *un*-build them! This is my life you're—

Monk: [*Slowly fading into unconsciousness*] You cannot abandon.

Buffy: I didn't ask for this! I don't even know...what is she?

Monk: Human...now human. And helpless. Please...she's an innocent in this. She needs you.

Buffy: She's not my sister?

Monk: She doesn't know that.

Buffy would gain a sister and lose her mother within months. "Our mission statement for season five was family," Whedon said. "When you think you've moved on and grown up and moved out of the house and are living your life, family comes back. You realize that they're always a part of your life. Also a very strong message with me is you make your own family, or sometimes it's made for you by monks. So the introduction of Dawn, the death of Buffy's mom, the meeting of Tara's family—all of that stuff was very deliberate."

But along with family came the development of another plot that would become a focal point for the series until the end: the relationship between Buffy and Spike. Hoo-boy, buckle up. "Season 2 had the most epic love story and Season 3 was a lot of fun, but I gotta go with season 5," writer Jane Espenson replies when I ask her what the best season of the series is. The first in her laundry list of reasons why: Spike falling in love with the Slayer.

They were mortal enemies in Season 2. By Season 4 they were fighting side-by-side. And by Season 5, Spike discovered, and was

plagued by, an obsession with Buffy. Some, frustratingly so, will boil the series down to being about Buffy's two great romances: Angel and Spike. They'll ask, "Are you team Bangel or Spuffy?"

"For years I was a Spuffy shipper," says writer DW McKinney, who adds that she was decidedly anti-Bangel. "I never liked the idea of this older, brooding, slightly creepy man hanging out in crypts waiting for this high school girl. And then they fall in love, have sex, and he becomes a raging abuser? No, thanks. I liked Spuffy because I had a major crush on James Marsters and I loved his bad-boy energy. I think he was the love interest that Buffy needed when she was learning how to truly wield her power. He wasn't trying to keep her from being herself. He wanted her to fully be the badass that she always had been."

I've never been able to wrap my mind around this debate, choosing instead Buffy and her friends. I was pro-Bangel but also held a strike against him for skipping town. In Season 5, Spike stalks Buffy, rejects her pleas to be left alone, and creates both a sex doll in her image and a robot version of Buffy to have sex with. By the following season, Spike would attempt to sexually assault her. Both Spike and Angel may have loved Buffy, but in my mind only one was deserving of her love in return.

But my real disdain for Spike is informed by something James Marsters said in a 2001 E! special titled *Buffy's Back*, which was shot during production of Season 6. "The first time Spike saw Buffy, he was hunting her, which has a very sexual undertone," he says. "And I played that very heavily. It's kind of the same thing [as] some man hunting a woman at a bar, looking at her dancing, walking across the bar, and just noticing her. It's both sexual and violent. And I played that." I get that a vampire has no soul, and for them, violence isn't just palatable, it's tasty. But the comparison to real life, and the use of the words "hunting" and "violent" spoke volumes about Marsters's worldview at the time, which, if we're keeping it 100, feels grossly misaligned with the show's themes of female empowerment.

It's here I want to pivot slightly to talk about the complex professional relationship between Joss Whedon and James Marsters, one that could be viewed as something of a pissing contest. During a 2020 interview, Marsters shared details of an on-set squabble between the two. "I wasn't designed to be a romantic character. But then the audience reacted that way to it. And I remember [Joss] backed me up against a wall one day, and he was just like, 'I don't care how popular you are, kid, you're dead. You hear me? You're dead. Dead!' And I was just like, 'Uh, you know, it's your football, man.' He was angry at the situation I think."

When the interviewer asked him if Joss had ever apologized, Marsters gave a telling response, saying, "No. And why should he? If it had been me in his shoes I would have killed him off immediately... He resented a situation where he had to deal with another romantic vampire when his theme was that vampires are the problems you have to get over in high school." Is it okay for a boss to back a coworker up against a wall? It's not. Even if the coworker is okay with it? Still no.

I asked Marsters about this incident during our interview, trying to gain clarity on what sounds like a complex dynamic. "One of the things I think that one gets used to when you're working collaboratively with artists is there is passion," he says. "Looking back on it, I think Joss was actually talking to himself, reminding himself that he needed to kill this character. If it had been me, and Spike came along and was imperiling the theme of the show to the extent that Spike was doing that, I would have just murdered him right away. I think he was kind of at war with himself over whether to kill him off or not. Otherwise, he never would have backed me up against the wall. I would have just gotten a script and then I'd be dead."

I'm confused, wondering why Whedon ever brought Spike back at all if he felt this much torment over fan adoration for the character. Also, isn't fan adoration a...good thing? Marsters's response contains a lot of subtext, a lot of places where the delineation between Spike

and James seems translucent, and a lack of clarity around whether Joss's anger was caused by Spike, James, the fandom, or, as Marsters pointed out, Whedon himself.

"He told me that I was a soulless vampire and that I cared for nothing and nobody. And that *that* was the point of the show: Vampires are metaphors for the challenges that people face in adolescence, and that they are there to be overcome. And he said, 'The only reason that you're not going to be killed off after one episode is I don't want this to become a *Scooby-Doo* type show where there's always a new villain and at the end of each show it always wraps up neat and clean. You'll be around for a little while, but then you're dead. So don't get your hopes up.' And I said, 'You got it, boss.' And he turned his back and I thought, 'Fuck that, I'm not going to play it that way.' If I play it that way, he *will* kill me off quickly. And I need the money. It was as simple as that. And when you're a dad, you're on a mission from God: I'm going to make money. And you kind of get a little mercenary about that. Maybe I'm rationalizing. Maybe I did the wrong thing. Maybe that was not a moral choice, because it was a really good theme. And it was being seen by a lot of people. And it probably was selfish of me to undercut that, to try to get a few extra paychecks, but that's what I did. And he was right to want to get rid of that character."

This tension was no secret among the cast and crew. "Joss was upset, not with James but with Spike, because he was written to die. And Joss does not like having to change," says Nicholas Brendon.

So does Marsters hold on to any anger over having seemingly been physically intimidated by his boss on set? Not at all. In fact, he not only justifies it, he empathizes. (I suddenly find myself googling Stockholm syndrome to refresh my memory.) He buttons that portion of our chat, unprompted, by complimenting Whedon's genius: "Fortunately, [Joss] is imaginative enough to rework the character, to get his claws into him and turn him into a sweating morass of guilt and pain, like every other good character in the Joss Whedon universe."

Buffy's family would grow at the outset of Season 5, but would

shrink mid-season when Joss Whedon decided to kill off Buffy's mother, Joyce, in what is usually regarded as one of the most famous episodes of the series, "The Body." Buffy returns home, walks into the foyer, and spots flowers given to her mother on a date. She calls out to her mom, "Hey, flower-getting lady." She steps inside to see her mother lying on the couch. When Buffy realizes that her mother is motionless, she stops cold in her tracks, and her expression immediately shifts. "Mom?" she asks. Then, more urgently: "Mom." Then, quieter: "Mommy?"

What follows is a forty-four-minute meditation on the awkwardness, discomfort, and shock of grief. The episode gave us one of Gellar's best performances, the first kiss between Willow and Tara, and instilled in us, the viewer, that some deaths aren't supernatural.

> **Xander:** They should have checked her over, they should have had her in. Well, don't we have enough monsters in this town, the doctors gotta help 'em out?
>
> **Willow:** Xander, I-I don't think it was … any … it just happened.
>
> **Xander:** Things don't happen! I mean … they don't *just* happen. Somebody … I mean, somebody's got …
>
> **Willow:** Okay. *[Puts up her fists]* Let's go. Come on, you and me. Come on.
>
> *[Xander stares at her, then sighs. He walks over to her, kisses her on the forehead. Tara watches sadly.]*
>
> **Xander:** You know I can't take you.

"I was heartbroken," says Gellar about the decision to lose Joyce, and by proxy actor Kristine Sutherland, after five years on the show. It's Joyce, in fact, who had the very first line in the series premiere and was a constant presence in Buffy's life throughout the series. She was one of Buffy's biggest tethers to a "normal" life. The mother-daughter onscreen bond was felt offscreen as well. "She wasn't old enough to be my mom in real life, but she was just always such a

calming presence to me," says Gellar. "And I was dreading working up to that episode on every level: emotionally as a person and understanding that it meant losing Kristine. And Joss would keep saying to me, 'It's *Buffy*. We can bring anybody back. They all come back from the dead. Don't worry. It's not forever.' But I was really sad. She grounded the character of Buffy. And at times on-set, she grounded me because she was a mother in real life. And there were times where she could see me and the mom instinct kicks in: 'You just need a hug. You just need to talk. Or, you need to take a nap.' Whatever those things were, instantly my world would settle when Kristine was around."

The episode would be held up as a high point for the series by critics and fans alike. "'The Body' is one of the most sophisticated analyses of the impact of death ever produced on television, and it remains a testament to why *Buffy* was so unique," writer Sophie Gilbert said in an essay for *The Atlantic,* paying homage to the episode. It's also a great episode to reel in those on the bubble about whether to commit to watching the show.

The episode is an outlier to so much that we know. The camera goes to handheld. There's no music. Single scenes take up almost the entire act. "This episode was one that I did because I wanted to show—not the meaning, or catharsis, or the beauty of life, or any of the things that are often associated with loss, or even the extreme grief, some of which we do get in the episode," said Joss Whedon. "But what I really wanted to capture was the extreme physicality, the extreme—the almost boredom of the very first few hours. I wanted to be very specific about what it felt like the moment you discover you've lost someone."

For many reasons, Whedon is at his best in this episode. It can get convoluted even with the mere mention of his name to recognize the genius of Whedon, but there's no finer display than here. Take, for instance, him describing what he refers to as one of his favorite shots he ever composed: It's Buffy talking to a paramedic who is only visible from the nose down. "Very simply, it's an over [the shoulder

shot] where I squeezed [Sarah] in the frame as much as possible. It's just like she didn't have room to maneuver. And then the shot of [the paramedic] talking, which is just his mouth again. Just to say, not to call attention to itself so much, just to say this is her reality. She can't get the big picture, she's not having a normal conversation. A normal over would have been her with a tiny slice of his shoulder; instead, I let his shoulder own the frame. I took his eyes out of the frame. To show her experience of, literally, being trapped, being blocked off from reality. It's an obvious thing, not great filmmaking. But when I did it on the day, when I saw the over and thought, Oh, he's a little too much in-frame. Oh! Keep pushing it, keep pushing it, give her less room. Give her less room. It excited me. It made me realize that something, yeah, not particularly clever but useful, could just appear on the day."

The episode is a meditation on the banality of grief, how the world in all of its insignificance keeps on spinning, how death is frantic and confusing and sometimes tears people further apart rather than bringing them closer together. As a viewer, it's visceral and heart-wrenching to watch. Slaying demons is fantasy; watching loved ones succumb to health issues is real. It just hits you differently. Buffy can save the world from unspeakable evil, but she can't save her own mother. One (likely) can't relate to Buffy's status as the Chosen One, but this . . . this is different.

"I was gutted that we were losing Kristine," says Anthony Stewart Head, who had been somewhat of a surrogate husband to her, in having both Giles and Joyce playing a role in raising Buffy. "But Joss had planned it for some time, the massive sideswipe of losing her mother, affecting Buffy irretrievably. It was huge."

But even Whedon didn't quite understand the impact of the episode on people's lives (a specter of things to come), saying he was surprised how many people gained comfort from it, and a kind of catharsis. "People emailed and wrote and said that they had suffered a loss—sometimes their mother—and it had either been concurrent

with, or it had happened years before, and they had never been able to deal with it until they saw this episode," he said. "Which moves me more than I can say. It surprised me, though, because I really was after that feeling when, in the first few hours, when there is no solution, catharsis or anything else. That was a lovely revelation—that just finding a moment and expressing it, and expressing human behavior at this time without drawing any grand conclusions about it—was enough. That to me is . . . well, it's pretty much why I'm here."

Six episodes later, in "The Gift," the Summers family would face yet another loss, when Buffy sacrifices her life to save the world. It was a significant episode beyond just that, as not only a season finale but the 100th episode of the series. "Nobody was phoning it in," recalls Clare Kramer. "For the hundredth episode everybody in every department was really caring about the product and the content." The result was one of the show's crowning achievements, underlining the show's core theme while adding a postscript in the form of Buffy's wisdom gained over the course of the five-year journey that was the show.

"The Gift" begins with a distinct change in feel. "You are the Slayer," Giles tells Buffy in a "previously on" that cycles through the entire series up to that point in thirty-eight seconds. Suddenly, we're thrust into an alleyway and witnessing a boy being chased by an unknown. "Don't hurt me," the kid cries out once he's backed into a corner, and the pursuer is revealed to be a vampire. At this point Buffy steps out into the alley with a casual "Hey, what's going on?" The kid tells her to call the police, but the vampire appears unconcerned with Buffy. "Get outta here, girl," he tells her. "You guys havin' a fight? 'Cause, you know, fighting's not cool," she tells them. Resigned, the vampire decides he'll have Buffy as an appetizer. "Have you ever heard the expression 'biting off more than you can chew'?" she asks. The vamp shakes his head. "Okay. Um . . . how about the expression 'vampire slayer'?" He's entirely confused. "Wow. Never heard that one. Okay. How about 'Oh God, my leg, my leg'?"

The vampire growls and lunges at her. He goes to grab her, she ducks, punches him in the face, and kicks his leg. His knee buckles and he falls to the ground and like clockwork: "Oh God. My leg!" They fight. Buffy finds a makeshift stake from a broken piece of a wooden box. With minimal effort, Buffy turns him to dust.

Buffy: Wow. Been a long while since I met one who didn't know me. *[To the kid]* You should get home.
[She begins walking back toward the door she came out of.]
Kid: H-How'd you do that?
[Angle on Buffy's back as she walks toward the door. She doesn't turn or stop as she replies.]
Buffy: It's what I do.
Kid: But you're … you're just a girl.
[Buffy pauses in the doorway.]
Buffy: That's what I keep saying.

Buffy ends up never having to square off with Glory face-to-face. Instead, it is Giles who kills Glory when she mutates into Ben, the mortal prisoner she is forced to share a body with while on Earth. Giles suffocates Ben, and thus Glory is also killed off. It's … well, it's anticlimactic if we're being honest. Was Kramer pleased with her demise—or lack thereof? Not so much. "Obviously, I expected the story to culminate in some way. I was disappointed that they had to do it through the killing of Ben. I have a theory, though, that Glory body-jumped into Giles and that she is ready for resurrection at any point in time, in the comics or in her own new series."

By the episode's end, Buffy makes the ultimate sacrifice, her life, to save Dawn and, by proxy, humanity. As we watch her leap off a tower, we hear the final words she whispered to Dawn moments earlier. "Dawn, listen to me. Listen. I love you. I will always love you. This is the work that I have to do. Tell Giles I … Tell Giles I figured it out, and I'm okay. Give my love to my friends. You have to take care of

them now. You have to take care of each other. You have to be strong. Dawn, the hardest thing in this world is to live in it. Be brave. Live... for me."

"When we were watching 'The Gift' I remember thinking, I have been watching this woman be this character for five complete seasons and I have *never* seen these expressions *ever* on her face before," says Kristin Russo. "She has embodied this so deeply that when the character is changing we are seeing things that we have literally never seen. It's not just different because the lighting is different or she's delivering the line differently. It's a full-body experience to witness that. And that's really what we're meaning when we say that so many people created this show. Sarah Michelle Gellar's soul is in that character, and it is such an important piece of how we understand her."

The final beat of the episode would be a soft zoom in on Buffy's tombstone, which read: "Buffy Anne Summers. 1981–2001. Beloved sister. Devoted friend. She saved the world...a lot."

The loss of two Summers women, including the show's titular character (for a second time, no less) wouldn't be the only goodbye taking place in Season 5. Sarah Michelle Gellar was in Australia filming *Scooby-Doo* (she'd do two weeks in Australia then fly back to LA and do two weeks of *Buffy* shoots throughout Season 5) when she got the call letting her know that *Buffy* would be moving from its original home, the WB, to UPN, a network best known for *Star Trek: Voyager* and World Wrestling Federation's *Smackdown*. Up until then, the relationship between Whedon and the WB had been tenuous at best. "I think there was a small number of executives who understood how special this was and how letting Joss run his show was the smartest way to keep their jobs," Douglas Petrie says. "My educated guess is that overall the show was, at first, too small to bother with and then all of a sudden too big to mess with."

But mess with it they did. The WB was not thrilled at the prospect of losing one of their tentpole shows at the conclusion of Season 5, when the show's contract had lapsed, and thus began a very public

feud. "20th Television has made an inauspicious decision for the television industry by taking one of their own programs off of a nonaffiliated network and placing it on a network in which they have a large, vested interest," the WB said in a statement at the time.

Twentieth Century Fox, the studio that produces *Buffy*, fired back: "If News Corporation didn't own a single UPN station we would have made the exact same deal," said Sandy Grushow, the chairman of the Fox Television Entertainment Group. "We believe that there is enormous upside potential at UPN and given their passion for the show, given their commitment for the show, we believe they have every opportunity to raise the bar for *Buffy*."

Ultimately it came down to money. The WB was ponying up $1 million per episode at the time. Fox wanted to double that figure to $2 million for Season 6. WB's chief executive at the time, Jamie Kellner, offered somewhere between $1.6 million and $1.8 million (sources vary on the exact number). As the *New York Times* reported, Mr. Kellner appeared to have Fox painted into a corner. "The most likely place for the program other than WB appeared to be the Fox broadcasting network. But if the Fox television studio had sold the program to its direct corporate sibling, it could have sent a message that it would be willing to steal a show when it became a success. That could make the rival networks wary of doing business with the studio."

Kellner made sure all the dirty laundry was aired out. At the Television Critics Association winter press tour, Kellner threw shots. "In all likelihood, where we will come out is that we will say, 'We will take all the revenue we can generate with *Buffy* and we'll give it to you in a giant wheelbarrow. And if that's not enough, then take it to somebody else, and you've demonstrated that you're not the kind of partner we should be doing business with."

Gellar did not mince words at the time, airing her disdain for the prospect of *Buffy* moving homes. "I will stay on *Buffy* if, and only if, *Buffy* stays on the WB," Gellar told E! Online at the time. "And you know what? Print that. My bosses are going to kill me, but print that.

I want them to know...I don't want the show to move, because I feel that we belong on the WB. It's where our fans are. If *Buffy* leaves the WB, I'm out." Non-spoiler alert: She stayed. And in fact, soon after, she offered up an about-face. "Fox has been very good to me," she told the *Los Angeles Times*. "I intend to stay with *Buffy* no matter what."

I ask Gellar about this moment with two decades of hindsight, specifically as it seemed like a very out-of-character comment for the particularly tight-lipped star. "It was out of character. I normally choose not to say stuff. It was just that the WB had been so good to me and it felt like family and it just came out, and it was unprofessional. I just didn't like the politics of what was happening. Most networks would have canceled us in the first twelve episodes and the WB believed in us and they let us fly, and that's why we were still there. I didn't have a piece of the show. I was a young kid. I didn't understand the business behind it. We do things out of love and art, not out of commerce, right? So my comment came from love and defensiveness of the people I felt had supported us."

Then, in signature SMG fashion, she buttoned her statement with a laugh line: "I'm sure I would've thought differently if I was part of the people that got a big cut from that. Maybe I would have kept quiet."

Hindsight is 20/20, but at the time, even into the eleventh hour, negotiations seemed strained. Things came to a head when Kellner ripped the show in an interview with *Entertainment Weekly*. "Nobody wanted the show; it didn't perform [at first] but we stuck with it. It's not our No. 1 show," he argues. "It's not a show like *ER* that stands above the pack." Whedon responded, saying, "For [the WB] to be scrambling to explain why it's not cost-efficient—it's their second-highest-rated show. They need to step up and acknowledge that financially."

Kellner felt...differently. "Our audience is a younger audience. Maybe what we should be doing is to not stay with the same show for many years, and refresh our lineup."

In the end, UPN swooped in with an offer of $2.33 million per

episode and a two-season order. And thus, a deal was struck. "I've been dumped by my fat old ex and Prince Charming has come and swept me off my feet," Whedon said at the time. "I'm mostly very excited because I now have a network that cares about my show as opposed to one that insults it."

He wasn't done. "As long as I live, I'll never understand why Jamie Kellner said the things he said. I know he's a businessman, but to insult your best show…is unfathomable. They didn't exist (before *Buffy*). It sounds wicked braggy, 'cause it is, but it's not entirely untrue."

"In my head, I never thought *Buffy* was going to be anywhere but the WB," Gellar says now. "I'd had such support and such a positive experience that it just sort of didn't occur to me. I was heartbroken that it was going to leave the WB, the place that I felt had supported and nurtured [us] and having to understand that that decision was purely financially motivated. I didn't understand that at the time. That wasn't in my vernacular. So it was really hard, but I knew we would still be making the show. I don't think I ever thought the show was going off the air. Was that a possibility?"

It doesn't appear to be the case, though many have argued that the Season 5 finale could easily have been perceived as (although not written as) a coda to the series. If I had it my way, it would have been. Fortunately for many fans, my way was not up for consideration. "I was hoping that it was [the series finale], because I certainly knew that I wasn't coming back if it did continue and of course, selfishly, I would like to be the one to end it all," says Clare Kramer. "All I knew was the show had not been picked up, so this is being written much like I had heard the end of Season 1 was written so that if the show did not continue there was a resolution."

As for a resolution between Joss and the WB? Not so much. But the very public feuding among the top brass didn't trickle down to the day-to-day production, according to Gellar. "I wasn't a producer, so I didn't have to have those kinds of conversations and involvement. So for me it didn't change what I was doing every day."

Season 5 would prove to be a high point for the series. If Season 4 was perceived to be a bit all over the place narratively, Season 5 offered finesse, growth, and a very well-paced arc. Glory would prove to be a particularly beloved character within the fandom and would in effect change the trajectory of actor Clare Kramer's life. "I didn't know I was a big character. I didn't even know how big the show was. My parents lived in Ohio. They didn't get the WB. I really didn't have a concept at the time of what weight this role carried, and what weight it would carry two and a half decades later in my life. I didn't understand then, call it naïveté, and that was probably a good thing."

If the series is broken into three acts—the first being the high school years (Seasons 1–3), the second the college years (Seasons 4–5)—we are about to enter the final act: the "where do we go from here?" years. First order of business: resurrecting our heroine.

Several months after the finale aired, UPN rolled out their first campaign. It was bloodred with only Gellar's eyes peering out and two words scrawled across the top: BUFFY LIVES.

Ask Me Again Why I Could
Never Love You

"Season Sex." "Season Sucks." Season 6 has carried a lot of nicknames throughout the years. "It's crystal clear, in retrospect, that *Firefly* got most of the fun Whedon (that show is wall-to-wall memorable quips), while *Buffy* made do with the grim leftovers," read a 2017 *Vanity Fair* story with the headline: "How *Buffy the Vampire Slayer*'s Most Hated Season Became Its Most Important." (Most important? Hope the writer of that story stretched before that reach.)

"Season 6 is going to be tricky," Gellar says about watching the show throughout quarantine with her daughter, Charlotte (who is eleven at the time of this writing), and son, Rocky (who is eight at the time of this writing). "I just don't think that six is really appropriate for them, but I think seven would be amazing. So I'm deciding about whether just to wait or whether to cherry-pick certain episodes of six and fill them in. I haven't totally made that decision yet." One hundred episodes down and the show is suddenly inappropriate? Frankly, yes. *Buffy*'s sixth season is by far its most controversial and polarizing, both thematically and within the fandom. Nobody feels wishy-washy when it comes to Season Sucks, err...Season 6. Ugh, is my bias showing?

I was twelve years old when the sixth season began, practically a zygote, but at that point a card-carrying viewing veteran of the series. Season 6 devastated me at the time. I thought I'd go back to it in adulthood with a different gaze, realizing all that had gone over my head at

the time and the mature themes being explored. But not really. *Buffy*'s themes had been mature from the outset. And the show certainly never shied away from darkness (remember when Willow and Cordelia walked into a room full of their murdered classmates in the finale of Season 1?). But Season 6 felt and feels now gratuitous, at times directionless, and most of all unrelenting. I'll be honest in admitting that there's a part of me that wishes the last two seasons never happened. Fortunately, I'm not Cordelia, so it is not I who gets granted wishes. That said, there's a large swath of the fandom who think Season 6 was the *high point* of the series. Ah, the joys of discourse.

"Season six was basically about, 'Okay, we're grown-ups,'" said Whedon. "We have no mentor, we have no mother, we have no parental figures. We're dealing with marriage and alcoholism and a really abusive relationship. We're dealing with someone who is practically suicidally depressed. It's weird, but people didn't respond to that so much. Also, the metaphor of sex has become very graphic and real. The idea was to break down the mythic feeling of the show, because there is a moment at childhood when you no longer get that. Everything isn't bigger than life; it's actual size. It's real loss. At the same time, there's the darker side of power and Buffy's guilt about her power and her feeling about coming back to the world. And her getting into a genuinely unhealthy relationship with Spike that was all about dominance, control and, ultimately, deep misogyny. How lost did we get? Well, our villain turned out to be Willow."

Gellar has made her frustrations with Season 6 known before. "I've always said that Season 6 was not my favorite," she told *Entertainment Weekly* in 2017 during the twentieth-anniversary reunion. "I felt it betrayed who [Buffy] was." She elaborated on that more during our interview: "Darkness? That part was exciting to play. It's one thing to go through a bout of depression and to make poor choices, but it's another thing…" She pauses to think, saying she could pinpoint what, exactly, bothered her had she rewatched it now. "It felt like some of it was done for shock value and not authentic to who she

was. Joss was gone a lot—he was creating *Firefly* at that point—so he wasn't there to guide it. And when it got to Season 7 and he came back to help, it just felt like it all sort of got back on track." But that's glossing over where things went off-course.

The move to UPN came with a bigger budget and bigger paychecks for the cast and creatives, but it wasn't all hugs and puppies. "For me, it felt like a perception of failure, like a step down," says Emma Caulfield. "Like, 'We're not willing to really invest that much more, but we're not going to get rid of you either.' It was not that prestigious of a move by any means, but the show went on for another two seasons and that's . . . where it went."

New network. New rules. Cast shake-up. Season 6 was about growth and change, both onscreen and off. But first, Buffy needed to be brought back to life. "I think we earn it," Whedon said when pressed about Buffy's return between seasons. "There's no alternate-universe Buffy. It's not going to be neat. Bringing her back is difficult, and the consequences are fairly intense. It's not like we don't take these death things seriously. But exactly how she comes back, I can't reveal."

Buffy's resurrection felt inevitable, but Giles's exit from the principal cast was far less foretold. "When Tony told me that he was not going to be a regular anymore, that was the first gut shock," Nicholas Brendon says, recalling the exit of original series star Anthony Stewart Head while talking through tears. "For the first three seasons Sarah had her own trailer, but we had two bankers, and Tony was my neighbor. That was the beginning of the change. I wasn't concerned about where my character was going to go, but I did know that . . . that it felt different."

Buffy would be resurrected through a spell cast by her friends. Once back, and readjusting to life as she knew it, Buffy reveals first to Spike and then to her friends that she was not brought back from hell, but rather torn out of heaven. "Buffy's change in personality was just so gentle," says Cynthia Erivo. "We all knew *something* was wrong, but we couldn't quite figure it out. And then the rage that came with

what she had worked so hard for, which was a little bit of peace." A lot of Buffy's torment came from losing her mother and the second love of her life just a year earlier, coming back to a world she no longer wanted to be a part of and having to contend with a chosen family that suddenly felt unfamiliar. She'd face yet another loss almost immediately after her return, when Giles decided his time in Sunnydale had elapsed. The real reason for Giles's exit had little to do with the character and everything to do with Anthony Stewart Head.

Head cited his desire to be closer to home in the U.K. and to be closer to his daughters, both of whom were in their preteens at the time. That was entirely true. But there's more to it. "Aly[son] and Nicky [Brendon] were just signing an upgrade for the last two seasons, and I went, 'Oh, I thought it was five seasons, not seven,'" recalls Head with a laugh. "I looked in my contract, and it was seven seasons. Holy fuck! I'd been away from my children for five years and [my daughter] Daisy turned to me at the party at the end of Season 5 and said, 'Wow, you've been away for more than half my life.' I thought, Oh my God. She was nearly ten. And I went to Joss and said, 'Sorry, mate, I really apologize, I thought this was a five-year contract. Do you mind if I leave?' And he said, 'Well, I'd rather you didn't, but would you consider staying on in a recurring role?' 'Yes, that would be perfect!' So it was not me thinking, Oh my part needs to be this or that; it was me getting my contract wrong."

"Change is a mandate on the show," Whedon explained at the time about Head's exit. "And people always complain. [But] if we didn't change, you would be bored. The kids [on *Buffy*] are old enough now that they don't really need a mentor figure, and this is a period in your life when you don't really have one. So it made sense for him to go back [to England], and he chose to be on the show as a recurring character. But change is part of the show, and people always have a problem with it. But I think it's why they keep coming back."

Makes sense. How he exited? Less so. Giles does not announce his exit—instead we're made to believe that everyone already knows

and has made peace with his decision. Meanwhile, in a conversation with the Buffy-bot (a robot form of Buffy built by Warren with the intention to serve as a sex-bot for Spike but later repurposed for combat), Giles admits his own blame in Buffy's demise. "I just can't help but wonder if... she would have been better off without me." The next day, after mentoring this group and fighting in countless battles side by side for years, Giles leaves without a goodbye. "I've gone," he writes in a letter left behind. "Not one for long goodbyes. I thought it best to slip out quietly. Love to you all, Giles."

They follow Giles to the airport, forcing a real goodbye from him. We see the plane take off for England and thus the runway is cleared for the Scooby Gang to perform the ritual to bring Buffy back from the dead. Willow justifies not telling Giles about the plan, letting the group know that he "wouldn't understand." Did they think through the logistics of how they'd go about telling him once she returned? It seems not. Willow tells Buffy that she called him and he's coming back soon after Buffy, herself, has been brought back. An episode later, he returns. Yay, right? Not on Season 6's watch. Angered at Willow's decision to bring Buffy back, and without seeking his consultation, he calls her an "arrogant amateur."

Willow: Giles, I did what I had to do. I did what nobody else could do.

Giles: Oh, there are others in this world who can do what you did. You just don't want to meet them.

Willow: No, probably not, but... well, they're the bad guys. I'm not a bad guy. I brought Buffy back into this world, and maybe the word you should be looking for is "congratulations."

Giles: Having Buffy back in the world makes me feel... indescribably wonderful, but I wouldn't congratulate you if you jumped off a cliff and happened to survive.

Willow: That's not what I did, Giles.

Giles: You were lucky.

Willow: I wasn't lucky. I was amazing. And how would you know? You weren't even there.

Giles: If I had been, I'd have bloody well stopped you. The magicks you channeled are more ferocious and primal than anything you can hope to understand, and you are lucky to be alive, you rank, arrogant amateur!

[Giles angrily grabs his towel and turns to leave.]

Willow: You're right. The magicks I used are very powerful. I'm very powerful. And maybe it's not such a good idea for you to piss me off.

It's not our first taste of what would later become Dark Willow. We'd first meet an iteration of her in Season 5, after Glory attempted to brain-suck Tara. But this moment, Willow's willingness to spar with her own ally, one whose only intention is to look out for her, is foreshadowing her descent into chaos. A few episodes later, having wrung out every drop of the "Giles feels inconsequential plot line," Giles leaves once again. He returns in the penultimate episode of the season to face off against Willow. But his absence throughout can be felt in a big way. With Joyce dead and Giles out of the picture, there's no one from whom Buffy can seek solace. And I suppose that's the justification for what led her into the arms (and other regions) of Spike. I get it. I hear the arguments, loud and clear. It's just not where I wanted the show to go. Good thing *you* weren't a writer on the show, you might be thinking. Harsh, but I get that too.

I ask what's making Brendon so visibly emotional in talking about Head's departure. "There's just such a reverence," he says. "It felt like a show that was supposed to happen," he says, zooming out to describe the series as a whole. He pauses for a long time, and I deploy an interview method that I picked up from Oprah, which is to live in the pause. He'll continue, I'm sure of it. I sense we're nearing a previously unspoken *there* there. Finally, he speaks. "I have that perspective to look back on who I was then and ... I'm not sure if I was proud

of myself. When I do sense memory and I go back to it, there's a lot of things I'm missing and a lot of things I would change. Outside of CC, I don't have any relationships with anybody [from the show.] And that's sad."

He continued: "I have a recurring dream that they're shooting Season 8 and I'm not invited. And I get onto the set and then I'm escorted off by security. When you love something a lot, it's bound to hurt you. Some things are just hard to put into words, so I see them in colors and stuff, but that could just be my Asperger's; I don't know. I miss it very much and I wish I hadn't become so cynical."

In a 2019 interview on the *Recover Everything* podcast, Brendon opened up about a childhood rife with trauma, speaking about his twin brother, Kelly, being kidnapped in his childhood, and the stutter he himself developed after being molested. I'm reminded that you never really know a person's interior life, why they move through the world the way they do, with the experiences and possible traumas they've faced along the way.

"I loved working with Joss," Brendon then suddenly says, pivoting without being prompted. "If you don't give Joss what he wants, then that's a problem. He relishes in killing [off] actors who he doesn't like performance-wise." Brendon then recounts a story from behind-the-scenes of Season 1 in which, according to Brendon, he approached a noticeably ticked-off Whedon on set. "I fucked up, Nicky," Brendon recounts Whedon telling him. According to his story, Whedon was dissatisfied with his casting of Dean Butler as Buffy's dad. " 'The problem is I can't kill him because it'll change Buffy's arc.' And what he did was brilliant. He moved him to the opposite end of the world." Problem solved? Buffy's dad, Hank Summers, at least survived.

That wasn't the case for everyone.

It was during the shooting of the Season 5 finale ("The Gift") that Joss Whedon took Amber Benson aside—never typically a good sign. "I have amazing news," he told her excitedly. "We're gonna kill your character. Isn't that great?"

Benson was confused, both by the decision and Whedon's glee in the idea. "He was so excited from a story point of view," she recalls. "He was really interested in the addiction storyline for Willow, and I think he intuitively understood that the only way for an addict to hit bottom is to lose the thing that's most important to them. And so in his mind I know it was never a thought about how her death was going to impact the audience in this very negative way. You want to talk about entitlement? There are just things that people don't think about because it's not in your world purview. And so I think if he would have had some connection to that world, I think he would have done things differently. But because he's a cisgender white man, that never occurred to him."

A bit about Season 6's Big Bad and how it connects to Tara's death: The Trio was comprised of two returning players, Jonathan (Danny Strong), who had been a part of the series off and on since the "Unaired Pilot," and Warren (Adam Busch), who had appeared briefly in Season 5 as the creator of April the Robot and later the Buffybot, along with newbie Andrew (Tom Lenk), the cousin of Tucker Wells, a student at Sunnydale High who appeared for a single episode in Season 3. Over a casual game of Dungeons & Dragons, Warren turns to the other two and meekly asks: "So…you guys wanna team up and take over Sunnydale?"

Largely perceived as a joke of a threat throughout much of the season, Buffy is forced to take them seriously after Warren murders his ex-girlfriend and tries to use magic to make Buffy believe she did it. With a taste for blood, Warren (now operating solo after Jonathan and Andrew are apprehended by the police) quickly assumes the role of supervillain when he shows up at Buffy's house with a gun.

Tara's death, caused by a stray bullet that was actually intended for Buffy, happened without warning and sent shockwaves through the Buffysphere. "A stray fucking bullet? Are you fucking kidding me?" Jenny Owen Youngs said when I asked for her reaction, as a queer person, to the death of Tara.

Willow and Tara had broken up earlier in the season, due to Willow's addiction to magic. In the final moments of Season 6, Episode 18 ("Entropy"), they reunite after a prolonged "will they (they probably will)/won't they?" "I'm sorry, it's just...you know, it takes time... There's just so much to work through. Trust has to be built again, on both sides. You have to learn if we're even the same people we were, if you can fit in each other's lives...It's a long...important process, and...can we just skip it? Can you just be kissing me now?" It was a rare, happy moment in a season rife with grief, depression, addiction, and a general air of melancholy. It would be a brief moment.

In the following episode, Season 6, Episode 19 ("Seeing Red"), things take a turn for the worse. In what would be their final scene together on the show, Willow and Tara are seen getting dressed post-coitus. "Hey! Clothes!" Willow remarks. "Better not get used to 'em," Tara responds. Moments later, the scene is interrupted when Tara discovers red splatters across Willow's white blouse. "Your shirt," she tells Willow, her last line on the series, then collapses to the ground. Willow lets out agonizing sobs, imploring a lifeless Tara to get up. She can't get up, though. She's dead.

Resigned, Willow lifts her head, her face wet with tears, but her eyes completely black. And then, as she stares up, they start to fill with red. In the final three episodes of Season 6, the Big Bad is revealed not to be the Trio, comprised of Warren, Jonathan, and Andrew, but in fact Dark Willow, an evil alter ego that takes over Willow's body to circumvent her grieving process. Dramatically, it provided an adrenaline rush leading into the final episodes of the season. Here we had Willow, the human embodiment of all that is good, being overtaken by the dark side. Similar to Angel's descent to Angelus in Season 2, there wasn't just a new baddie, there was one less good guy/gal to help stop them.

Fan reaction over Tara's death was swift and incensed, especially from the queer community, who felt a connection to the show's implicit *and* explicit queerness. "I'm not sure it handled queerness in the best way," Cynthia Erivo says about the show, zeroing in on

Willow and Tara's relationship specifically. "I was glad that they were given space to be as a couple and that it didn't feel fetishistic, and I feel like that's largely down to the people that played them. But I hated the fact—and this always happens—that they either became really evil or were killed. It's something that consistently happens. And I just really didn't need that. I didn't want Willow to go apeshit and crazy and evil and I didn't want Tara to die. I didn't think she needed to. So, about that reboot, if we're going to have queer characters, have queer characters, great, but let them live."

Fans also felt blindsided by a show that had often felt both aware of, and at times even in conversation with, its own fandom. "This was a queer character who knocked down massive doors in the land of television," says Kristin Russo. "This was not a quick relationship. This was a deep, meaningful, loving, long-lasting relationship. If you're going to fucking kill one of those people, you better at least talk to a couple of queer people before you do it."

We'd faced loss before, most notably Jenny Calendar in Season 2 and Joyce Summers in Season 5. But both of those deaths, though distressing, felt earned from a storytelling perspective—Jenny was killed by evil forces intent on hurting Buffy and those close to her; Joyce was killed by a brain aneurysm. Tara's death, by contrast, felt cruel, yes, but mostly just unnecessary. "A cruel death." *Where have I heard that before?* I wonder as I type this. Ah, yes, a few chapters earlier when discussing Kendra's death.

The "amazing news" Whedon had delivered to Benson, and then the fandom, ended up creating an aftershock that would dictate the show's future in ways even he couldn't control. "I think that killing Tara was—in retrospect, of all the people, did she have to die?" Marti Noxon said in 2018.

I don't think there's any bigger fan ire within the series than this. "It's a very good question, and one I've spent twenty years thinking about," writer Drew Z. Greenberg says when I ask if the fan reaction, specifically from queer people, affected his perception of Tara's death.

It was Greenberg, after all, the only openly gay writer, who wrote the above reconciliation scene between Willow and Tara, one of Tara's last scenes on the show. "I absolutely understand people's reaction to it—and I had the same reaction," he says. "We didn't have that many queer characters on TV, and certainly not many queer relationships on TV. So to shoot one of them in the back felt violent. I get that."

"Man, people just can't wait to kill the queers on TV," says Jenny Owen Youngs. "Just pump them up and ship them out. Diversity points achieved. Maximum emotional heart wrenching achieved. And then they're gone and we can just ride the wave of sorrow. I don't love it. Are there other ways you can get the most bang out of your story buck?"

But according to Greenberg, citing the dead lesbian cliché or "bury your gays" here is not quite what this death was doing. "The roots of that cliché come from seeing queer people as a problem and not knowing how to deal with us, that we're a problem to be solved," he explains. "And so often in cinema, TV, and other works of fiction, the way that you deal with it is to either have us kill ourselves or to murder us and then the problem is solved. Tara was not a problem. Tara was the moral center of the show. She was love and she was kindness and she was something good in a group of people who were, especially during Season 6, kind of floundering a little bit and needed some sort of center. I think that when Joss made the decision to kill the character it was because he wanted you to miss her. And in that way I don't think there was an intention to tread on unpleasant ground. Obviously it's not great to kill her, but the intention was to set her up as the paradigm of greatness, not 'Phew, we got rid of the gay character.' That said, of course, especially in hindsight, it would have been better to keep her around. And I think that if Joss would have made the show today, he probably wouldn't have killed her off. I have to assume, right?"

He's right, and we can prove it. Whedon, sensing that he'd made a mistake, tried to bring Benson back several times. The first attempt

was during Season 7, Episode 7 ("Conversations with Dead People"), where Tara was to appear in corporeal form through the vessel of the First, the season's Big Bad, which assumed the body of dead people (ergo the episode title). Plan A didn't pan out. Neither did Plan B.

"I did have a secret plan to bring her back that never came to fruition, sadly," Whedon told a panel at Comic-Con in 2007. "In Season 7, my original intent was to do an episode in which Buffy was basically granted a wish. She got one get-out-of-jail-free card, anything you want in the whole world, no restrictions, and she couldn't decide for the entire episode what to get and finally came to Willow and said, 'You know those shoes that I always really wanted but they're really expensive? I got them.' And Willow's like 'You used your wish on shoes?' And Buffy says, 'Of course not,' and walks out of the room and Willow turns around and Tara is standing there." (Rumors have persisted that Whedon made up this story to mollify the fanbase, but Drew Z. Greenberg, in our interview, corroborated that Whedon had every intention to bring Tara back.)

Fans began clapping and aw-ing. According to Whedon, it was going to be the third- or fourth-to-last episode. "But we couldn't work it out," he told the crowd. "The deal didn't happen for various and ridiculous reasons."

Various and ridiculous reasons? What does that mean? At the time, Benson cited scheduling issues. In a 2003 interview Benson gave this cryptic response when asked about why she chose not to return: "There were a lot of other reasons [I didn't go back], but one was that I didn't want [Tara] to go bad. As an actor, of course, it appeals to me to play kind of evil and bitchy and sexy, but, as a human being who gets letters that say, 'I didn't kill myself because of what you and Alyson did,' that part of me goes, 'You're not just an actor any more; you're making a social commentary now, baby. You've got to be responsible.'"

In a 2007 interview, she again called it a scheduling issue. "The timing just didn't work out. I was getting ready to go to London to direct the animated version of *The Ghosts of Albion*, so it just wasn't to be."

I had a hard time believing that, then and now. Without even knowing Benson, I recognized how much this character meant to her and how much she knew the character meant to the fandom. Surely schedules could have been shifted to make this work. Plus, I was stuck on the unexplored "other reasons" she first cited. As it turns out, as is often the case with this show, there's a *there* there.

"This is the first time I'm talking about this," she prefaces before taking a big breath. "I had had some issues with somebody on the show, and it had kind of come to a head as I was getting ready to leave. Leaving the show was sad because there are some of the crew and the writers and some of the cast that I just adore, but I had made my peace with that person and the show and I was done: 'I'm leaving everything in a good place. I don't need to come back.' And then all the shit hit the fan and Joss realized he had messed up. I mean, this is a time when people are, like, sending faxes to that production office, like this was a big, horrible thing, and it was devastating to a lot of people. And I think it hit Joss that he had made a mistake, that he had been short-sighted. I truly, for all of his faults and for all of the things about him that are frustrating, I don't think he ever meant to hurt the LGBTQ+ community. He just wasn't thinking. I can truly, from the bottom of my heart, say [that] this was nothing intentional. This was a thoughtless error. But I didn't want to come back. He really wanted me to come back and we just couldn't come to an agreement on it. And most of that was my schedule. I was gonna miss going to England, not being able to direct *The Ghosts of Albion* if I had said yes."

Benson also had lost trust in feeling like Tara, who meant a great deal to a great many fans, would be granted grace—something her character had not been afforded in her unceremonious death. "I didn't really trust what was going to happen to the character. I think that's something if you've talked to some other cast, people are like 'Yeah, I came back...and then he just did what he wanted. Even though he told me that he wasn't going to kill me in this way, he killed me in that way.' I just didn't feel super trusting of the situation. And I felt like

people had already been really hurt by this. And I'm not the writer. I can't decide what's going to happen to this character. I don't have the reins. And so between the schedule, and not really having a hundred percent trust in what was going to happen and some other things, it just didn't work out."

Again, "some other things." I decided not to pry further, grateful to have gotten as much new insight as Benson felt comfortable disclosing. That's the thing in situations as nuanced as these, striking the delicate balance of asking the important questions while respecting that some people's experiences aren't meant for public consumption. "I'm sad for people who loved the character and wanted to have her back. But I also think when you make a decision like Joss made and kill this character and not understand what was going to happen, sometimes you have to let the error lie so that people can learn from it."

One other point of contention I bring up with Benson is her credit—or lack thereof—in the show's opening title sequence. Benson appeared in forty-seven episodes altogether (twelve in Season 4, eighteen in Season 5, and seventeen in Season 6) but only appears in the show's title sequence once, during her final appearance on the show. This is especially odd when contrasted against two of the show's big love interests. Seth Green, who appeared in thirty-nine episodes across three seasons, was added to the main title sequence after ten appearances. Marc Blucas, who appeared in thirty-one episodes across three seasons, was added to the main title sequence after eight appearances. I mentioned this disparity to her.

"I am not very good at standing up for myself, and I've never had people manage my career: the agents and the lawyers and the managers," she says. "I never really had anybody that was able to really stand up for me. So I always sort of took it with like, 'Oh, it's just me. I suck at negotiations. I suck at getting people to pay me a fair wage. There's just something about me that says 'sucker,' you know?"

She laughs. "But it's interesting now when you say that, 'cause

I'm like, 'Oh yeah…' " She pauses for an extended amount of time and then: "Oh gosh. Every other love interest." Her realization lingers for a moment before she presses on. "It was tough for me. It definitely made me feel lesser. There were things that felt unfair, but I always took that as something that was just my personal inability to do the things that you need to do. I've never been very good at making demands on other people or asking to be treated equitably. I was like, 'Oh, it's okay.' And it's bad. It is a bad thing. It's a lack of care for oneself. And it's something that I personally have to work on because it's always my feeling to give over to other people and let them have the thing that makes them happy. And I think standing up to Joss and not coming back was a real moment for me to stand up for myself. Something that I hadn't really done before. I realized that my mental health was not worth going back and being in a situation that wasn't safe for me emotionally. And I've been quiet about it for a really long time because the fans love [Tara] so much. I didn't want to tarnish any of it. But we're twenty-five years down the line, you know? Ray Fisher just stood up and talked about how he was treated on a set that Joss was on. And I think I feel a lot of guilt for a situation that I was in where things were not positive and I didn't stand up and make a stink about it. And now other people have had to deal with situations that were similar because I didn't say something."

The Ray Fisher allegations Benson is referring to are complex, and therefore I implore you to express your right to google it. But here's an abridged version of what he alleges happened (allegations, it need be noted, that have not, as of this writing, been proven): On June 29, 2020, actor Ray Fisher tweeted that he'd like to "forcefully retract every bit of this statement," which was a video clip of him in attendance at Comic-Con International 2017 calling Whedon a "great guy." Fisher had played the role of Victor Stone/Cyborg in *Justice League*, a film that Whedon had been brought in to take over post-production on after director Zack Snyder stepped down in the wake of his daughter's death. Whedon would commence two months of reshoots with the

cast, which included Ben Affleck as Bruce Wayne/Batman; Henry Cavill as Clark Kent/Superman; Gal Gadot as Diana Prince/Wonder Woman; and Jason Momoa as Arthur Curry/Aquaman.

Two days after Fisher's tweet came more from the actor. "Whedon's on-set treatment of the cast and crew of *Justice League* was gross, abusive, unprofessional, and completely unacceptable," he wrote on Twitter. "He was enabled, in many ways, by [then president and chief creative officer of DC Entertainment] Geoff Johns and [former Warner Bros. co-president of production] Jon Berg. Accountability>Entertainment." (Berg told *Variety* that it was "categorically untrue that we enabled any unprofessional behavior.")

Less than two months later, in late August, WarnerMedia launched an investigation into the production of *Justice League*, an investigation that Charisma Carpenter says she participated in.

In September, Jason Momoa became the first *Justice League* co-star to come out in support of Fisher. "This shit has to stop and needs to be looked at," he wrote on Instagram. "Ray Fisher and everyone else who experienced what happen[ed] under the watch of Warner Bros. Pictures needs proper investigation. I just think it's fucked up that people released a fake *Frosty* announcement without my permission to try to distract from Ray Fisher speaking up about the shitty way we were treated on *Justice League* reshoots." (The *Frosty* he's alluding to is a live-action *Frosty the Snowman* adaptation that remains nothing more than an announcement.)

"Serious stuff went down," Momoa concluded. "It needs to be investigated and people need to be held accountable."

"I'm happy for Ray to go out and speak his truth," Gal Gadot told the *Los Angeles Times* that December. "I wasn't there with the guys when they shot with Joss Whedon—I had my own experience with [him], which wasn't the best one, but I took care of it there and when it happened I took it to the higher-ups and they took care of it. But I'm happy for Ray to go up and say his truth."

Fisher's story had been fleshed out in greater detail in an October

interview Fisher did with *Forbes* in which he alleged (in a quote that was later deemed to be "primarily based on third-person information" and was thus removed) that Whedon attempted to digitally change the skin tone of an actor during post-production. "What set my soul on fire and forced me to speak out about Joss Whedon this summer was my becoming informed that Joss had ordered that the complexion of an actor of color be changed in post-production because he didn't like the color of their skin tone."

"As is standard on almost all films, there were numerous people involved with mixing the final product, including the editor, special effects person, composer, etc. with the senior colorist responsible for the final version's tone, colors, and mood," a rep for Whedon told *Forbes*. "This process was further complicated on this project by the fact that Zack shot on film, while Joss shot on digital, which required the team, led by the same senior colorist who has worked on previous films for Zack, to reconcile the two."

"Race was just one of the issues with the reshoot process. There were massive blowups, threats, coercion, taunting, unsafe work conditions, belittling, and gaslighting like you wouldn't believe," Fisher commented when asked for details. (Note: These allegations have not, as of this writing, been proven.)

On November 25, Whedon exited the HBO series that was set to be his big return to television.

"This year of unprecedented challenges has impacted my life and perspective in ways I could never have imagined, and while developing and producing *The Nevers* has been a joyful experience, I realize that the level of commitment required moving forward, combined with the physical challenges of making such a huge show during a global pandemic, is more than I can handle without the work beginning to suffer," he says in a statement. "I am genuinely exhausted, and am stepping back to martial [*sic*] my energy towards my own life, which is also at the brink of exciting change." He did not detail what change he was referring to.

On December 11, Warner Media released a statement to *Variety* confirming that the investigation into the *Justice League* movie had concluded and that "remedial action" had been taken. There is no further explanation of what that remedial action is or was.

In an April 2021 story in the *Hollywood Reporter*, a "knowledgeable source" told the media outlet that Gal Gadot had multiple concerns with Whedon's revised version of the film, including issues about her character being more aggressive than her character in *Wonder Woman*. A witness on-set at the time told *THR*: "Joss was bragging that he's had it out with Gal. He told her he's the writer and she's going to shut up and say the lines and he can make her look incredibly stupid in this movie." (Note: Whedon has not admitted this behavior.)

In May 2021 Gadot was asked about this specific incident during an interview. She responded: "[Joss] basically kind of threatened my career and said if I did something, he would make my career miserable. I handled it on the spot."

"My issues with [Joss] are how he handled [the *Buffy*] set," says Benson. "And I've spoken to him about this recently." (My interview with Benson was conducted in December 2020.) "I told him that there were painful things for me on that set, and I feel like he mishandled things and allowed behaviors that were not positive on that set. And those were behaviors that were for me mentally not good. Now when I'm looking at a job, if I get a feeling like someone's going to be difficult or not fun to work with, I'm not going to do it. It's just not worth it. It's really not. All the money in the world is not worth going to work and feeling bad."

I ask what compelled Benson to reach out to Whedon decades later. "I'm getting ready to do a project that is *Buffy*-related, and I just wanted to reach out to him and get his thumbs-up, his 'Go for it.' And I think because it's been so long, I thought it was a good time to talk about some of the things that I had issues with and just say my piece. And he was very kind and very thoughtful about it. But it wasn't about him. It was about me saying the things that I needed to say."

There's another anecdote from Season 6 that I can't quite shake, centered on one of Buffy's goofiest costumes, her uniform during her stint at the Doublemeat Palace: red-and-white pinstripes with a base-ball hat that had a half-chicken, half-cow. "She hated that uniform," costume designer Cynthia Bergstrom says about Gellar. "And that was something that I think was done to her purposefully. I think he wanted her to look ridiculous."

There's what people perceived as that signature Whedon brand of cruelty once again. Killing off Kendra so mercilessly in Season 2. Belittling Sarah Michelle Gellar's film work in the press. Telling Marc Blucas that the audience was going to hate him. Backing James Marsters up against a wall. Gleefully telling Amber Benson she was being killed off the show. "I'm a very gentle man, not unlike Gandhi," Whedon joked in an interview between Seasons 5 and 6 when asked if he threatened actors against revealing secret plot points. "I don't ever threaten them. There is, sort of hanging over their head, the thing that I could kill them at any moment. But that's really just if they annoy me."

He'd tell you he was joking. Not everybody saw it that way. But that's just scratching the surface. More on that soon.

There are two other touch points that are central to Season 6: The musical episode, "Once More, With Feeling" (which I implore you to stop reading this book immediately and watch and/or listen to the soundtrack), which we'll further explore in a later chapter, and a moment at the tail end of Season 6 that we'll discuss right now, in which Spike sexually assaults Buffy. "I'm glad you're asking about this," Marsters says when I ask him if we can discuss this moment. First, let's set up the moment and then let's unpack it.

Early on in Season 5, Spike starts to realize that he has some type of feelings for Buffy. Episode 4 ("Out of My Mind") concludes with Spike's dream in which Buffy comes to his crypt attempting to kill him and instead they end up kissing. By the next episode ("No Place Like Home"), Buffy finds Spike lingering outside her home.

He claims he's out for a walk, but Buffy discovers a pile of discarded cigarette butts, implying he's been there for a while, watching her. In Episode 7 ("Fool for Love") he comes to her home with the attempt to murder her with a rifle, only to change his mind after discovering Buffy in tears on her back porch having learned the news of her mother's deteriorating health. He gently pats her on the back.

About Joyce's health: in Episode 4, Joyce faints out of the blue. The nurse says she'll be fine, but they're not sure what caused it. Headaches persist. "The Joyce stuff is some of the most disarming material they've had on the show thus far," my friend Sean texted me while watching the series for the first time. "The way that the show is presenting it is very true to life—despite the fact that there's demons. There's just so much time spent on Buffy and Dawn in the hospital waiting on their mom or bringing their mom home and caring for her and wanting the best for her but also not knowing when, at any moment, something is going to be triggered in her brain. They could have done it in one or two scenes but I appreciate them doing it over many episodes and giving it weight and a sense of looming." By Episode 7, Joyce reveals to her daughter that she needs to go back into the hospital for some additional tests, ergo crying Buffy.

By the next episode ("Shadow"), Spike has trespassed into Buffy's home, where Riley finds him sniffing her clothing. Before he's thrown out, he grabs a pair of her underwear. In the next episode ("Listening to Fear"), Buffy discovers that Spike has been stealing pictures of her. By Episode 10 ("Into the Woods"), Spike admits to having feelings for Buffy. "You actually think you've got a shot with her?" Riley asks. "No, I don't. Fella's gotta try, though. Gotta do what he can."

Buffy, it should be noted, is having none of this. "You want credit for not feeding on bleeding disaster victims?" she asks him in Episode 11 ("Triangle") after he attempts to earn her praise. "You're disgusting," she tells him. Things come to a head in Episode 14 ("Crush") when Spike attempts to admit his feelings to a less-than-amenable Buffy.

Spike: You can't deny it. There's something between us.

Buffy: Loathing. Disgust.

Spike: Heat. Desire.

Buffy: Please! Spike, you're a vampire.

Spike: Angel was a vampire.

Buffy: Angel was good!

Spike: And I can be too. I've changed, Buffy.

Buffy: What, that chip in your head? That's not change. That's just...holding you back. You're like a serial killer in prison!

Spike: Women marry 'em all the time!

Buffy: Uhh!

Spike: *[Realizing that's not what he meant]* But I'm not...like that. Something's happening to me. I can't stop thinking about you. And if that means turning my back on the whole evil thing...

Buffy: You don't know what you mean! You don't know what feelings are!

Spike: I damn well do! I lie awake every night!

Buffy: You sleep during the day!

Spike: Yeah, but...You are missing the point. This is real here. I love—

Buffy: Don't! *[She puts up a hand to stop him. He sighs.]* Don't say it.

By that episode's conclusion, Buffy does not mince words about her feelings for Spike: "I want you out. I want you out of this town, I want you off this planet! You don't come near me, my friends, or my family again ever! Understand?" He doesn't understand. Not even close.

In Episode 17 ("Forever"), following the death of Buffy's mother, Spike attempts to drop off flowers at the Summers residence but is intercepted by Xander. "He didn't leave a card," Willow notes, implying that he was not giving condolences to seek points with Buffy but out of genuine regard for her mother, who he says never treated him like "a freak."

But by Episode 18 ("Intervention") Spike does the inconceivable and has a robot version of Buffy made that he can have sex with. The real Buffy, of course, finds out about this, is appropriately skeeved, and confronts him at his lair. But it just so happens that Spike was able to play the savior to a damsel in distress earlier in the episode—not Buffy, but the person Buffy cares most about in this world: Dawn. When he could have enacted the ultimate betrayal, he ultimately proved his love through loyalty. And so Buffy visits him, pretending to be the robot version of herself. She does this to seek confirmation that Spike has not betrayed her or her sister, who is being mercilessly sought after by a hell beast—same old, same old. She kisses him as an act of gratitude. Mid-kiss he begins to realize that it's the real Buffy and not the robot he created. "The robot was gross and obscene," she tells him as she starts to walk out. "What you did, for me, and Dawn...that was real. I won't forget it."

In Season 6, following Buffy's death, Spike takes on a parental role over Dawn, partially out of his affection for her and mostly due to his love for Buffy. Torn out of heaven unwittingly by her friends, Buffy returns to Sunnydale despondent, isolated, and worn down. She seeks solace in Spike. It eventually leads to a kiss, this one born out of passion. This leads to sex...a lot of sex. And it eventually morphs into some kind of relationship.

"The show is different, depending on where you are at in your life when you watch it," says Ian Carlos Crawford. "You relate to different things. You maybe think something is good at one point in your life and rewatch it and decide it's not. When I watched the show live I loved Spike and Buffy. I was all the way in, thinking Spike was her one. Watching it as an adult, I'm like, 'Mmm...I don't know about that.' That's not to say I don't enjoy Spike as a character. I am who I am, which means the guy wearing black nail polish and a leather jacket is a dreamboat, but I look at Spike differently now than I did as a teen first watching it."

As mentioned earlier, less diehard *Buffy* fans will view the show's

most basic, unyielding question as: Are you Team Angel or Team Spike? "Angel was the right boyfriend for Buffy coming into her power. Spike was the right man to be with as she became the power," Stacey Abrams tweeted in November 2020. But Spike was never a man. "I know that I'm a monster, but you treat me like a man," he famously told Buffy in the lead-up to the final battle before her second death. Even still, many fans feel an affection for Spuffy, maybe because he was with her until the end, maybe because he was on the show longer than Angel, or maybe, just maybe, because he was right for her—whatever that means. I'm not convinced.

"God love Stacey Abrams, and she could almost make me change my opinion just because I think she's so awesome, but I do believe in the love of Buffy and Angel," says Gellar. "And I always thought that was her true soul mate. There was something magical about Buffy and Angel. That relationship on every level worked: the writing, the casting, the chemistry, whatever those things are, those are those magic-in-a-bottle situations that just happened. And I got lucky that I really liked working with [Boreanaz] on top of it. Like, that was just the cherry on top."

But for some, me included, Buffy *without* a man was just fine. "Honestly, neither," says Professor Lowery Woodall when I asked him which team he's on. "One of my favorite things about the show is that Buffy ends up alone. I appreciated that she found a sense of connectedness internally instead of externally."

Still, many people, including former cast members, are adamant about choosing one. "If anyone says that it's not Bangel, you're fooling yourself," says Nicholas Brendon. "Spike and Buffy were more entertaining to watch. But if we're talking about angst, if we're talking about that romance, that unrequited love, it's hands-down Buffy and Angel. Also, I mean, Spike tried to rape her."

"I have not seen that scene again," James Marsters says. "I've watched it one time. I don't do well with scenes like that. If I come across it on television, I have to turn it off. I just have a really fiery

reaction to that kind of material for personal reasons. So when that script came down the pipe, it was really problematic for me. And I fell into anger and depression and resentment, thinking, My God, I have to do whatever I'm told to do. If I was doing a movie, I could have passed on this script, but I am legally bound to do whatever they think of. In a normal TV show, when you're filming the pilot, you know what you're going to be asked to do every week. And that's why a lot of television is less than completely exciting. It's the same fucking thing over and over again. But it's safe for an actor. You can count on it. When you do movies, you might be doing more dramatic things, but you can decide, 'Do I want to give that? Do I want to show that? Do I want to put myself through that?' But when you work for Joss Whedon, all bets are off."

He continued: "I remember saying to the writer who wrote the script on my way onto the soundstage, 'You don't realize what you were putting us through.' It was the hardest day of my professional career. I remember in between takes curling up in the fetal position on the floor. Just kind of thinking about the fact that if I just dove into the concrete headfirst hard enough I could fly through the floor and fly away and get the hell outta here. I don't think I was in true danger of hurting myself, but that thought was coming to me. It was bad."

"I remember not being happy about it and not feeling like she would ever let that happen," recalls Gellar. "She was a superhero. So why...? He's not stronger than her. So she obviously had to let part of that happen because she wanted to self-punish, which I understand wanting to self-punish, but would that be the choice? The whole season each choice seemed more for shock value to me than authenticity."

"I think that my tension in my reaction, my panicked pain about having to do a scene like that, especially to Sarah, created a scene that was in fact much more fiery than they intended," says Marsters. "On the one hand, Buffy is a superhero and she absolutely physically has enough power to push Spike through a wall to protect herself. But storytelling is vicarious. Everyone who watches *Buffy* is Buffy. So I was

in effect doing that to everyone who was watching the show, and they are not superheroes. And it ended up being really hard to watch."

"You can't unsee it once you see it," says Jenny Owen Youngs. "It's a terrible scene to watch—and then a terrible scene to have watched. I think it was a bad choice of the show to take that route. I feel like they needed to create circumstances that would push Spike in a certain direction, and they chose this path. I think it's a really big mess and I'm glad that I'm not a television writer of any kind. I guess what it does for us, the viewer, is it forces us to reconcile the fact that this hot guy who's funny and who we're shipping with Buffy is also still, at his core, not really a man, not really a person, doesn't have a soul."

"I didn't watch it in 2002, but I watched it in 2012 and it was very different then than watching it now," says Kristin Russo. "Even that span of less than a decade [had an impact] for me as a woman understanding my relationship to desire and what had been taught to me by the television shows that I watched and how that informed how I took in the character of Spike. There's a list as long as you could possibly make of these men that were given to us in the '90s and early 2000s. Jordan Catalano from *My So-Called Life*. Sawyer from *Lost*. And when you're fifteen to thirty and you are seeing again and again that the hottest sex is with the shittiest guy? I'm queer and I still took that message in and wanted to forgive all of the faults and wanted to understand the beating heart of the bad boy. And I think that that's what is so complicated about unpacking the arc of Spike."

Some fans try to forget it, suppressing this as a dark turn in the character's path to redemption. Others can't forget it. But as Joss's outburst at Marsters conveyed seasons earlier, fan love for Spike was and remains very high. Beyond lovability, he's one of the most recognized characters from the show even for non-viewers. Even Marsters has tried to reconcile his own complex feelings on the scene that really sent Spike down a torturous path.

"In defense of the scene," he says before taking a long pause. "Joss was very frustrated because he was trying to remind the audience

that Spike was evil in his universe. Evil is not cool. Evil is not something that you feel for. Evil is pathetic. Evil is laughable. Evil is not someone, something, you want to be kissing. And I really respect him for holding that line, for fighting for that one. I think that a real problem in Hollywood is making evil look good. Because in real life, it doesn't really look very good. Because it's not good. So he was pushing it further and further, trying to get the audience to realize that Spike is a bad boyfriend and Spike is not healthy. He's a soulless vampire. He's a mass murderer. And the audience kept coming back like, 'Oh yeah, but he's so cute. Can you please have him kiss Buffy?' And [Joss] would be like, 'What the fuck?' And so he kept going farther and farther to try to get the audience to realize this."

I can't not counter him here. "But did it go too far?" I ask him, understanding his point but adamant on it needing to devolve to attempted rape. "Well, I mean, how far would you go to make that point? I don't know if he went too far. I don't know. If the audience wants to be mad about that—about that scene—just remember your part in it, which is that you were fighting for Buffy to kiss a mass murderer." He laughs. "And again, no blame to anybody, but really. Joss was trying to make a point here. He's not giving the audience what they want. He's giving what he thinks they need. Or what he thinks is important. And he's willing to piss people off, which is one of the reasons that the show is so good."

The scene is, of course, troubling. Equally troubling is the lack of dealing with the aftermath. In the next episode, Xander, who walked in on a bruised Buffy on the bathroom floor, calls it "attempted rape." Two episodes later, in the season finale ("Grave"), it's spoken about again.

Dawn: You know, if Spike were here, he'd go back and fight.
Xander: Sure, if he wasn't too busy trying to rape your sister.
[Dawn stops walking and stares.]
Dawn: What?!

Buffy (Sarah Michelle Gellar) wields her crossbow in the sewers of Sunnydale, in her prom dress, while hunting for the Master (Mark Metcalf). Gellar still owns the dress. And yes, it still fits. Buffy the Vampire Slayer © 1997 *Twentieth Century Fox Television.*

Xander (Nicholas Brendon), Giles (Anthony Stewart Head), and Willow (Alyson Hannigan) are on the run from a killer clown that's haunting their collective nightmare. Willow in this geisha getup? Look, not everything about the show holds up. Buffy the Vampire Slayer © 1997 *Twentieth Century Fox Television.*

Clare Kramer, Amber Benson, James Marsters, Christian Kane, Michelle Trachtenberg, Anthony Stewart Head, Alexis Denisof, J. August Richards, Joss Whedon, Danny Strong, and Marti Noxon pose for a photo during the fifth annual *Buffy the Vampire Slayer* Posting Board Party. This is a place for legends. *Photo by Albert L. Ortega/WireImage*

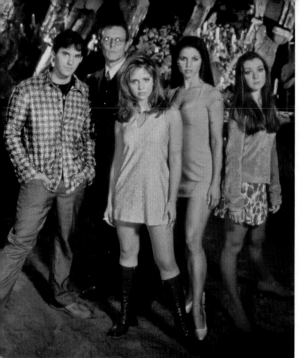

Promotional portrait of the Season 3 cast. The equilibrium of this quintet truly is unmatched. You could tell me this was an Annie Leibovitz editorial and I'd believe you. *Photo by Fotos International/Courtesy of Getty Images*

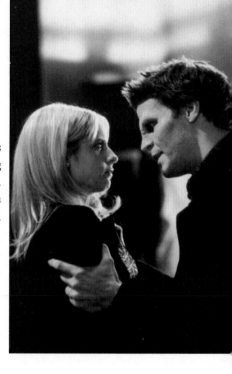

Angelus (David Boreanaz) squeezes Buffy's (Sarah Michelle Gellar) arms, having once again turned evil (or so we thought). Buffy the Vampire Slayer © *1997 Twentieth Century Fox Television. All rights reserved.*

David Boreanaz attends the 1999 WB Upfront All-Star Party. *bites lower lip* *Photo by Robin Platzer/Twin Images/ Online USA, Inc.*

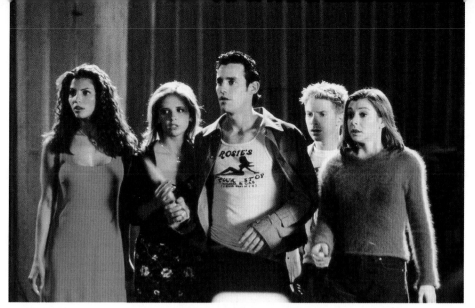

Cordelia (Charisma Carpenter), Buffy (Sarah Michelle Gellar), Xander (Nicholas Brendon), Oz (Seth Green), and Willow (Alyson Hannigan) stand with shocked faces outside the Bronze after encountering Faith the Vampire Slayer (Eliza Dushku) for the first time. The entrance of my favorite character of all time? Ah, that's herstory. Buffy the Vampire Slayer © 1997 *Twentieth Century Fox Television. All rights reserved.*

Eliza Dushku shows off Faith's signature knife while in attendance at the celebrity Q&A session at the 2014 Vancouver Fan Expo. That knife is second only to the scythe as my favorite weapon on the series. Rocket launcher is a close third. *Photo by Phillip Chin/ WireImage*

Sarah Michelle Gellar and David Boreanaz shoot a scene together from the Season 3 premiere. I remember first seeing this still prior to the episode coming out and being like, "Wait a goddamn minute. Ain't he dead?" *Photo by James Aylott/Getty Images*

Sarah Michelle Gellar, Alyson Hannigan, and Seth Green shoot a scene at the UCLA campus from the Season 4 premiere. Welcome to Sunnydale University. *John Fagerness/Online USA, Inc.*

Buffy (Sarah Michelle Gellar), under a powerful love spell, stares longingly at Xander (Nicholas Brendon) off-screen. Is this my favorite Buffy hair moment in the entirety of the series? Not no! *Buffy the Vampire Slayer © 1997 Twentieth Century Fox Television. All rights reserved.*

Sarah Michelle Gellar and Alyson Hannigan shoot a scene at the UCLA campus from the Season 4 premiere. New year, new hair lengths for both of our leading ladies. *John Fagerness/Online USA, Inc.*

Costume designer Cynthia Bergstrom and Sarah Michelle Gellar. Hair game strong. Very strong. *Cynthia Bergstrom*

Michelle Trachtenberg, Joss Whedon, and Amber Benson at the *Once More, with Feeling* CD release event. Not owning this CD in the early aughts meant you were seriously disturbed. *Photo by Albert L. Ortega/WireImage*

James Marsters signing autographs at ATAS Presents: Behind the Scenes of *Buffy the Vampire Slayer* in 2002. The Beatles whomst? *Photo by Albert L. Ortega/WireImage*

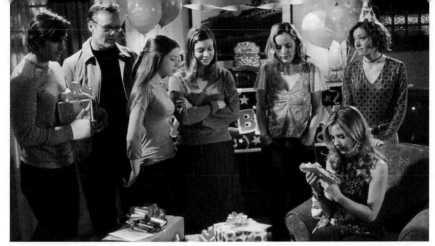

Xander (Nicholas Brendon), Giles (Anthony Stewart Head), Dawn (Michelle Trachtenberg), Tara (Amber Benson), Anya (Emma Caulfield), and Willow (Alyson Hannigan) join Buffy (Sarah Michelle Gellar) to celebrate her birthday at the Summers's home. It was a short-lived celebration after the Scoobies found out they were under a spell that wielded them incapable of leaving the house. *Buffy the Vampire Slayer © 1997 Twentieth Century Fox Television. All rights reserved.*

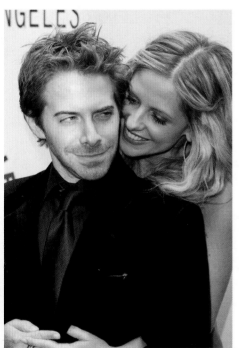

Seth Green and Sarah Michelle Gellar at the Paley Center for Media's 25th annual Paley Television Festival in 2008. They look like they really don't get along, don't they? *Photo by Neilson Barnard/Getty Images*

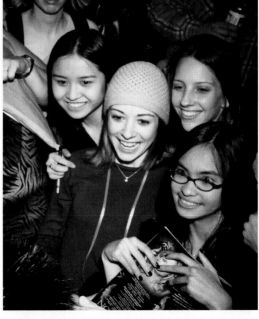

Alyson Hannigan signing autographs for fans during the fifth annual *Buffy the Vampire Slayer* Posting Board Party. Jealous I can't be them. *Photo by Albert L. Ortega/WireImage*

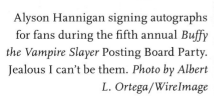

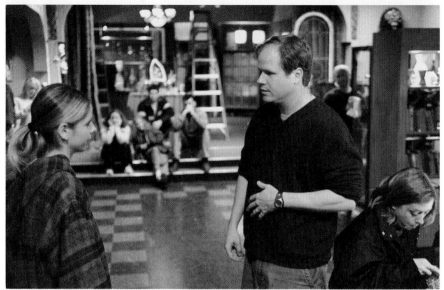

Joss Whedon talks to Sarah Michelle Gellar on set during Season 5. Looks serious.
Photo by Robert Gauthier/Los Angeles Times *via Getty Images*

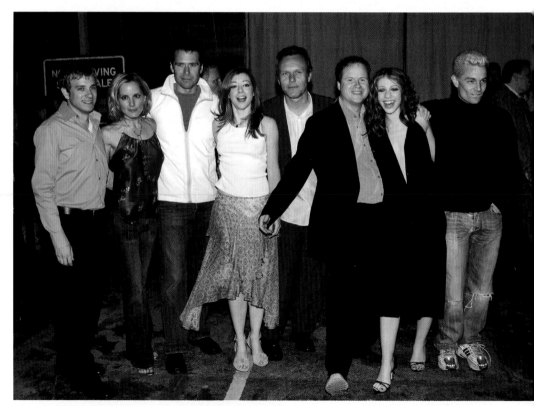

Tom Lenk, Emma Caulfield, Alexis Denisof, Alyson Hannigan, Anthony Stewart Head, Joss Whedon, Michelle Trachtenberg, and James Marsters attend the series wrap party in 2003. Gang's all here...well, most of them. *Photo by Albert L. Ortega/ WireImage*

Xander: Forget it.

Dawn: I don't believe you.

Xander: Fine.

Dawn: He wouldn't do that.

Xander: Is this blind spot like a genetic trait with the Summers women? The only useful thing Spike ever did was finally leave town.

"I think there needed to be a beat," says Ian Carlos Crawford. "There needed to be some kind of reconciliation. Of course, the person that's assaulted is very much allowed to handle it however they want, right? But I think that for a show that has an audience of young, impressionable fans, something seemed off."

The only other time it's mentioned happens two episodes later, in Season 7, Episode 2 ("Beneath You").

Buffy: Look, this...us working together—it's not a way for us to get back together, if that's what you want.

Spike: It's not. Look, I can't blame you for being all skittish.

Buffy: Skittish? That's not a word I would use for it. You tried to rape me. I don't have the words.

Spike: Neither do I. I can't say "sorry." Can't use "forgive me." All I can say is: Buffy, I've changed.

Buffy: I believe you.

And then? Never mentioned again in the series. The fandom's memory proved more unforgiving. "I was seventeen when I watched that episode, and it was traumatic," says writer DW McKinney. "I wrestled myself out of a breakdown while watching that scene. I can't explain why I had such a significant reaction to it, but I began to mentally shut down watching it. It felt like something was being torn away from Buffy and I think from the viewer in a way."

Did the show jump the shark in its sixth season? "No," says Drew

Z. Greenberg. "It changed. It evolved. It became something else. And sometimes that's hard to process. If it had been a show about high school for seven years, that would have felt silly. And so the show had to take on different themes and do some different things. And so, as a result, it was always experimenting. No one is going to accuse *Buffy* of being afraid to try something different. Sometimes it worked and sometimes it was 'okay, well, we tried it' and that's what happens. But I'm proud of everything that we did."

"I get tweeted at and I read things occasionally and I've heard some people refer to Season 6 as 'The bad season,'" says Danny Strong. "But then I've heard other people defending it. I remember at the time thinking it was terrific." Has he gone back to watch it since? Like the great majority of the cast members I've interviewed, he hasn't. Many, in fact, have never even seen the show.

"Revisiting Season 6 on the podcast I liked it less," says Ian Carlos Crawford, whose podcast does episode-by-episode recaps. "I think the writing is a little relentless for a show that was never—even with Buffy's mom dying, the world about to end, and Buffy dying—as relentlessly sad as this season was. But if I had to defend it, I would say that that's depression. Depression is relentless. A lot of others, too, have come to defend Season 6 in that way. But I think my biggest issue is that tonally it just feels like a different show. But I still don't think it's bad."

Still, Season 6 was ripped apart by many fans for a number of reasons beyond just Tara's death and Spike's attempted rape. It wasn't just that the show was darker; it felt downright nihilistic in its treatment of its female characters, none of whom seemed to be able to catch a break. To review: Buffy was traumatized and therefore despondent, Willow turned evil, Anya was left at the altar and reverted back to her vengeance demon ways, Tara is murdered (as was Katrina, Warren's ex-girlfriend, brought back for a second appearance for the sole purpose of, well, being murdered), and Dawn feels directionless and often ignored both by Buffy and the writers. All this on top of

the death of Joyce one season earlier, one of the show's most beloved female characters.

Marti Noxon, who had assumed the day-to-day responsibility of showrunner with Whedon now dividing his time between *Buffy*, *Angel*, and developing *Firefly*, shouldered most of the criticism. How convenient for Whedon.

"With season six, there was this announcement that I was running the show and Joss was going to take a backseat, but in reality, anybody who knows Joss knows that his idea of taking a backseat is not every single thing, you know?" Noxon said. "But I did have way more input over that season and some real muscular influence on the direction of that season in part because I was really vocal about wanting Buffy to make some bad mistakes. My argument was that, when we become young women, especially if we're troubled or haunted by something, that can lead us to make some bad choices, especially in the area of romance. And people really took me to task online. I finally just disengaged and didn't participate in that conversation at all."

Whedon chose a more caustic approach, writing directly to fans on "The Bronze," a discussion board at the time, now defunct: "Say not that I'm not into it, Marti's not getting it done, anything of that sort... Fact is, I'm in this show up to my neck always. Same with *Angel* and yup, *Firefly* too... Marti (She of the great brain and great beauty) and I shaped this year very carefully, and while we made mistakes (as we do every year), we made our show. We explored what we wanted to, said what we meant. You don't have to like it, but don't think it comes from neglect."

Noxon, meanwhile, is content admitting that there were parts of the season that she feels went too far. "We pushed into some categories that almost felt sadistic and that Buffy was volunteering for things that were beyond just 'bad choices' and were almost irresponsible for the character," she said in 2017. Do I find it odd that a writer as adept and perceptive as Noxon wouldn't be able to steer clear of such self-professed irresponsibility? I do. About as odd as her refusing to

answer a single email request (and there were many) to engage in an interview for this book. Read into that what you will.

"I love [Season 6]," says writer Drew Z. Greenberg. "I'm a fan of exploring those sides of ourselves that aren't pretty. Even as I heard and saw some of the reaction from people at the time I remember thinking, It's not your cup of tea, it's mine. I dig this. And I had enough people around me who were enjoying what was happening— or at least telling me they were enjoying what was happening. Are there things that I feel like you look back at now and say, 'Well, that pushed the limit'? For sure. There are a couple of things where you can look back and say, 'Too much.' But it was an attempt at trying something and telling a story that wasn't being told on other shows at that time. We tried. And some of it worked and some of it could have been done better."

I ask Greenberg if he was aware of any on-set tensions as the new guy in town. "I walked into a show that was running really well. With every show, it's a lot of people working in a very tight space for a lot of hours for a lot of months. Every show has things that flare up, and you deal with them, grown-ups deal with them, and move on. I was not aware of a great deal of tension throughout the course of the season... except for a couple of things." If those ellipses could talk.

What's clear is that Season 6 was as disharmonious behind the scenes as it was on-screen. "Season 6 was a very tough time for every-body," says Gellar. "*Buffy* wasn't a business to any of us; *Buffy* was our lives. It was our passion. It was everything to us. And so when deci-sions were made for other reasons...I don't think any of us had the capacity to understand at the time. Had *Buffy* been on now I would probably understand things differently that I couldn't comprehend at that time. But was that a golden time for us? No. I don't think it was just me that felt the story was off track on Season 6. We love these characters and it affects you."

CHAPTER 11

It's About Power

"I remember Joss sitting down with us when we did our State of the 'Onion' discussion where we kind of looked at where we were as the season was ending and what we wanted to look forward to in the next season," recalls Drew Z. Greenberg. "And I remember him saying 'Okay, that got dark. It got dark for everybody. I think I'd like to maybe give a little hope now.'"

The big question became, as *Buffy* went into its home stretch, what does *Buffy* mean to people? The character *and* the show. And that, as articulated before, was hope—particularly for women who have been discounted or written off, but not just them. It was about anyone who felt they had been sidelined. "And to that end," Greenberg says, "you feel a certain amount of responsibility to say this story, when you step up and own your power, it can end well."

"The story was back on track," Gellar says about the transition out of Season 6's darkness and into the light of Season 7—*Buffy*'s final act. Buffy would have a new job and a new love interest—and a human one, at that. *Quelle surprise!* And then more romantic tension with Spike. I know, you're shocked. Willow, returning from a healing journey in London with Giles, would put the pieces of her life back together in the wake of Tara's death. And speaking of Giles, he returns to Sunnydale. As does Faith. As does Angel. Dawn starts her sophomore year of high school. Anya is still a vengeance demon. Xander, meanwhile, well...not much happens outside of losing his left eyeball. "Didn't anyone tell you about playing with pointy sticks?"

Buffy asks Xander in Season 3, Episode 2 ("Dead Man's Party"). "It's all fun and games until someone loses an eye," he responds in signature Buffyverse foreshadowing.

But overall, the vibe improves significantly.

"We had a few things in mind with season seven," said Whedon. "One, everybody was tired of being depressed, including us. Two, this was the last season." (That much seems to have been decided in the interim between Season 6 and Season 7. The announcement would come between the sixteenth and seventeenth episodes of the season with a splashy *Entertainment Weekly* cover featuring Sarah Michelle Gellar and the forever burned in my brain words: "Buffy quits.") "Three, let's get back to where we started. Let's go back to the beginning. Not the word, not the bang, but the real beginning. And the real beginning is girl power. The real beginning is what does it mean to be a Slayer? And not to feel guilty about the power, but having seen the dark side of it, to find the light again. To explore the idea of the Slayer fully and perhaps to see a very grown up and romantic and confusing relationship that isn't about power, but is actually genuinely beautiful between two people in the form of Buffy and Spike."

"It tied up the bow of a lot of the trauma of these characters," says writer Gabe Bergado, who wrote the *Vogue* essay "How Instagram Is Keeping Buffy the Vampire Slayer Alive, One '90s Look at a Time," (featuring yours truly). Bergado is an adamant defender of Season 7 despite my efforts to get him to point out a flaw.

"I think the best part of Season 7 was that we all knew it was the last season," says Doug Petrie. "Unlike the end of Season 5, where it was like 'Is this story over? Is it not over?' You could make a case for either. This was like, 'We've told the story.'" According to Jane Espenson, the writing team was generally ready to move on as the series ramped up to the finish line. "I remember that, although I felt that way, I was a bit less ready than some of the others. I remember talking about how we'd all look back on these as happy and satisfying years and that we should all appreciate what we were in the middle of before it was gone."

According to Nicholas Brendon, *Buffy* is four shows. There's the high school years, college, post-college, and Season 7. "Season 7 is its own entity. It was maudlin," he says. Season 7 felt like it was trying to do many things and ended up succeeding at only a few. It felt like a course correction tonally from Season 6, while also trying to recapture the glory days and also trying to sprint to the finish line. Whereas Season 6 took creative risks to varying degrees of success, Season 7 felt safe.

I think no other moment better encapsulates the missed opportunity of Season 7 than the final scene in the premiere episode. In it, Spike is in the basement of the newly rebuilt Sunnydale High. It appears he's talking to himself but then the camera angles and we see Warren, one of the Big Bads of Season 6, who then morphs into Glory, the Big Bad of Season 5, then Adam, the Big Bad of Season 4 (you see what's happening, right?), then the Mayor, then Drusilla, then the Master, and finally Buffy. We later learn that this is the First Evil, shape-shifting between Buffy's former foes only then to "be" Buffy herself. It was an electric moment, seeing all of the Big Bads in succession. You wanted it to lead to something bigger, but alas it did not.

Even the actors were disappointed with the outcome. Clare Kramer says she spent weeks prepping for the opportunity to revisit the character after two years, trying the best she could to reassess the character at home. Then the script arrived. She had but a few sentences of dialogue and then she, along with most of the other actors who were brought back, was never to be seen or heard from again. "It was a little bit of a heartbreak, I'm not gonna lie," she says. And that to me is the crux of Season 7: potential. We get this in the form of the literal Potential Slayers, but also in watching the show try to acknowledge its legacy while sometimes struggling to reconcile that the legacy was still being written.

In my most recent Season 7 rewatch, I was struck by what seemed like a disintegrating chemistry between the cast. Maybe I was seeing the characters grow apart, as is wont to happen with enduring

relationships, but when peppered with an oft-repeated refrain of actor exhaustion that I only learned about having conducted interviews with the cast, it reads to me as apathy. Apathy not for *Buffy*, the show, but for *Buffy* the job.

"I remembered talking to guest stars and [I'd be] like, 'Hey, you see the barbed wire? I bet you think it's to keep people out, huh? That's to keep me in.' So that's where we were. That's what it had come to," says a melancholic Nicholas Brendon.

"I got some frustrated energy from [Brendon] on Season 7," says actor Tom Lenk, who joined the cast in a recurring capacity as Andrew Wells in Season 6 and stuck around until the (bitter) end, about Brendon's demeanor during the show's final lap. "Sometimes I felt bad because my character got very funny things to say and his character was very serious in that season." It's true, after Xander left Anya at the altar midway through Season 6, his character's arc began to peter out. Sure, he helped save the day in the Season 6 finale, convincing Dark Willow to not destroy the world—pretty honorable if we're keeping score. But in Season 7, Xander was relegated to an especially backseat role, kinda pining still for Anya but not doing much else. Those frustrations in feeling left out of the fold were not something Brendon kept quiet about, now or then.

Some actors speak freely about tensions coming to a boil during Season 7, while others are more cagey, but full of insinuations. "I have a friend of mine who is a Vietnam War veteran, and he will tell me certain things that happened to him in the jungle and then there are certain things that he will not discuss...because I wouldn't understand the context," says James Marsters. "I would take away from his story an entirely different idea than he was trying to tell me. I don't get it on a certain level. I'm a civilian. And there are things that I don't want to talk about, about what we went through on *Buffy*, because you weren't there. It's disrespectful to my fellow cast members to lift that curtain. What I will say is that I came to know the best and the worst in all of the cast and crew. And I came to love them and respect

them deeply for their whole selves. And I think that no one really went crazier than me."

According to Marsters, he had been using method acting, a technique developed by Russian actor and director Konstantin Stanislavski, in which an actor makes use of experiences from their own lives in an effort to bring them closer to the experience of their characters. Some method actors, like Daniel Day-Lewis, go as far as to remain in character off-camera as a way to fully embody the lived experience of another person as opposed to having to turn it off or on. "It's playing house," Marsters describes. "It's what we do as kids. I'll be Daddy and you'll be Mommy. But if you fill in all the details of the house you're playing in, and spend time imagining all of those details and filling in all of the minutiae for yourself, you can really lose yourself in that fantasy. It becomes easy to enter that other world and then just believe that you're there and act accordingly."

Marsters, in turn, discovered that the method made him a lot safer psychologically for film roles because he would be in it for months, versus years. "I found that because *Buffy* went on for that long it really drove me crazy." He laughs in a way that could be perceived as either menacing or self-deprecating, depending on your ear. "Because with Spike I was playing on all of my darker aspects of my personality: My loneliness, my sense of isolation, my sense of being an outcast, all of my anger and resentment, all of the things that generally drive me to dark places is where I was living as Spike. And I was kind on the set, but I suspect I was a bit strange at the same time. I was very quiet and I didn't hang out with the others. I sat by myself a lot."

Marsters shares with me a particularly painful anecdote that took place during the filming of Season 7. His girlfriend had just broken up with him, his cat had died, and he was filming scenes in which Spike, having gotten his soul restored, was being revisited by the souls of his victims. "I was beating myself up with any experiences that I had that I still felt guilty about. I would dredge that up and tell myself I was worthless and a horrible person for having done that.

That went on for a few months. And by the end of that I was in a clinical depression and had to go on an antidepressant. Luckily, I was a professional. I was able to show up on time and know my lines and not cause any bonfires at work. I didn't get in any fights. I don't think there's any stories of 'James wouldn't shower for a season' or anything like that. But I know what happened inside my head and I can forgive what may have been happening inside of other people's heads as they were trying to climb the mountain too."

The Buffy of Season 7 was grappling with the mirror being held up to her major, long-brewing superiority complex. "I guess I'm starting to understand why there's no ancient prophecy about a Chosen One and her friends," she told the Scoobies in Season 4. It's a theme that would be exacerbated by her growing alienation from the group, particularly Xander and Willow.

Xander: You think we haven't seen all this before? The part where you just cut us all out. Just step away from everything human and act like you're the law. If you knew what I felt—

Buffy: I killed Angel! Do you even remember that? I would have given up everything I had to be with—I loved him more than I will ever love anything in this life. And I put a sword through his heart because I had to.

Willow: And that all worked out okay.

Buffy: Do you remember cheering me on? Both of you. Do you remember giving me Willow's message: Kick his ass.

Willow: I never said that—

Xander: This is different—

Buffy: It is always different! It's always complicated. And at some point, someone has to draw the line, and that is always going to be me. You get down on me for cutting myself off, but in the end the Slayer is always cut off. There's no mystical guidebook. No all-knowing council. Human rules don't apply. There's only me. I am the law.

But as would soon be proven: there wasn't *only* her.

Season 7 centered on the First Evil, the personification of the concept of evil itself, manifested from all evil in existence, which—shocker!—wants Buffy dead. And not Season 1 or Season 5 dead, but dead-dead, like never-to-be-seen-again dead. The First Evil is an incorporeal presence that can take the form of any person who has died. As a result, the First Evil appears as all of the show's former Big Bads as well as Buffy and her mother, among others.

So how does one fight an undefeatable evil mega-force? Slayers, lots of 'em. Mystical forces choose lots of young girls and deem them Potential Slayers who are waiting to be activated if and when the Slayer is killed in battle. Kendra, for instance, had been assigned a Watcher from the time she was an infant to prepare her for the day she would assume her birthright. With the exception of Sineya, the First Slayer, all Slayers had once been Potential Slayers. Although, not all Potentials become a Slayer. At least, that was then. This was now.

These Potentials came from all over the world, and as a result, invited and embraced multiculturalism into the Buffyverse. "That's probably the first time that I saw women up on the screen from all walks of life with different faces and skin tones, all of that, and realized how vast the Potentials could be in where they could come from," says Cynthia Erivo. "And at the same time, part of me wished I could have seen that all the way through the series, the idea that a me or my sister or a friend of mine could be the next Slayer or could be a Slayer at the same time, and that we all have the potential within us to fight evil." That evil would prove nearly insurmountable.

Frustrated by Buffy's resurrection a year earlier, the First decided to dispatch its army of Harbingers of Death to kill as many Potentials around the world as possible, and their Watchers too. As a result, Giles began to call as many Slayers as he could and had them come to Sunnydale so that he and Buffy could train them for a final battle. The final arc of the series was centered on these new Potentials preparing for battle, and Buffy instilling in them the myriad lessons

she'd learned from life as a Slayer, tasked with fighting evil, and life as a human being trying to survive in this world.

"I'm beyond tired," she told the group in the tenth episode of the season ("Bring on the Night"). "I'm beyond scared. I'm standing on the mouth of hell and it is gonna swallow me whole. And it'll choke on me. We're not ready? They're not ready. They think we're gonna wait for the end to come, like we always do. I'm done waiting. They want an apocalypse? Well, we'll give 'em one. Anyone else who wants to run, do it now, 'cause we just became an army. We just declared war. From now on we won't just face our worst fears, we will seek them out. We will find them and cut out their hearts one by one until the First shows itself for what it really is. And I'll kill it myself. There is only one thing on this earth more powerful than evil, and that's us. Any questions?"

But within the lighter tone of Season 7 there was still some darkness, specifically in the tail end of the season, which sees the Scooby Gang, including Dawn, Willow, Xander, and Giles, kick Buffy out of her own home, fearing she no longer has their best interests at heart. In the pantheon of bizarro, unearned, and unintelligible moments on the series, this ranks very high.

Buffy: Look, I wish this could be a democracy, I really do, but democracies don't win battles. It's a hard truth, but there has to be a single voice. You need someone to issue orders and be reckless sometimes and not take your feelings into account. You need someone to lead you.

Anya: And it's automatically you. You really do think you're better than we are.

Buffy: No, I—

Anya: But we don't know. We don't know if you're actually better. I mean, you came into the world with certain advantages, sure. I mean, that's the legacy.

Buffy: I—

Anya: But you didn't earn it. You didn't work for it. You've never had anybody come up to you and say you deserve these things more than anyone else—They were just handed to you. So, that doesn't make you better than us. It makes you luckier than us.

Years earlier, when Faith told Buffy the same thing—"You think you're better than me"—she responded by saying, "I am. Always have been."

It's in these final scenes that Buffy's hero status starts to tick toward antihero. "I feel like Season 7 showed Buffy more obviously as a somewhat unlikeable character, which adds to the incredible power of the show," says makeup artist and *Buffy* superfan Max Artemis. "It really poses the question, 'How would a young woman react being brought back from the dead, something she has clearly no desire for, and being forced to confront everything that made her want to end it all from the beginning?' Though it could have been more subtle and less repetitive and convoluted, I personally feel like no other TV show was ever able to replicate this kind of hero/antihero dynamic in their main female character. This is also why I feel the show's firm position in post-feminist media study is so fundamental."

Artemis argues that Buffy as the hero/antihero is one of the most important examples of duality in postmodern feminism when it comes to pop culture: "Of course, she is this shining knight that helps, but she also hurts; she reflects on her life that she had no say in; she ponders on the absolutism of separating the world into good and bad. To build sympathy for somebody that holds the mirror up to the viewer and shows them that not everything is a simple problem with a simple solution. Maybe there is no solution at all. I think this is one of the strongest points the series made right up to the end and something which, in my eyes, no series after it was able to replicate, this kind of heightened realism and deeply human behavior study mixed with an abstract fantasy world that then again reflects on real-life issues is just a spectacular piece of history."

During a Q&A between Stacey Abrams and Sarah Michelle Gellar, I submitted a question asking what lessons Abrams learned from the show that she takes into the work she does today. She, without a moment's hesitation, cited the Potentials. "What was so lovely about the last season was this notion that anyone could be called, that anyone could draw upon this power and that you don't have to be anointed: it's already in you, this notion of shared power, but individual responsibility. But what drew me to the show from the very beginning was the decision to act. Not that you can't decide to walk away—Buffy *did* decide to walk away at one point—but it's the constant decision to do right, not because you don't have a choice but to affirmatively lean into challenge, the push-back against wrong, to act when inaction is more comfortable and safer. That is what I love about *Buffy the Vampire Slayer*. It's who I hope I can be. And on a much smaller scale, what I've always loved about the show is that it allows you to be fearful, to be reticent, to walk away, but to never abandon your responsibilities. There's always a chance to come back and do more."

In the end, good conquered evil. Using the power of the Scythe (my third favorite weapon introduced on the series, after the rocket launcher in Season 2 and Faith's Jackal knife in Season 3), a weapon forged by a group of powerful mystic women who called themselves the Guardians, Willow is able to activate all of the Potential Slayers around the world at once. "The idea of using the power of the Scythe to then empower every girl that has the potential? I was gooped," says Gabe Bergado. In an almost-too-overt-but-it's-*Buffy*-so-somehow-it-works moment of climax, Willow's hair turns white, underscoring that the black hair born out of the emergence of Dark Willow had found a counterpoint in Willow discovering how to wield her powers for good.

"When that screen pulls back and you see hundreds of these women, it's just incredible, especially to know that we give the duty to women in this moment, and to understand that we, women, can be a part of huge change," says Cynthia Erivo, who like many tuned in on May 20, 2003, to see how it would all end.

And how it would end would hinge on one of the show's onetime Big Bads, Spike, who would sacrifice his status as the living dead, fulfilling his desire to atone for his sins.

> [*Buffy and Spike are the only ones left in the hellmouth. Spike is still glowing from the amulet, sending rays of light out into the hellmouth. Buffy stands in front of him, staring, still holding her scythe.*]
>
> **Spike:** Go on, then.
>
> **Buffy:** No. No, you've done enough. You could still—
>
> **Spike:** No, you've beat them back. It's for me to do the cleanup.
>
> [*The walls are crumbling around them.*]
>
> **Faith:** [*Calling down to Buffy*] Buffy, come on!
>
> **Spike:** Gotta move, lamb. I think it's fair to say school's out for bloody summer.
>
> **Buffy:** Spike!
>
> **Spike:** I mean it! I gotta do this.
>
> [*He holds out his hand to stop Buffy. She laces her fingers through Spike's, and his hands burst into flame as she holds on tight.*]
>
> **Buffy:** [*Softly, looks into his eyes*] I love you.
>
> **Spike:** No, you don't. But thanks for saying it. [*Another earthquake; Buffy lets go of his hand*] Now, go! [*Buffy runs up the stairs*] I wanna see how it ends.

Buffy doesn't end up with Angel, Spike, Riley, or Robin Wood (the son of former Slayer Nikki Wood and the Sunnydale principal whom Buffy briefly dates). She does not require the love of a man. She's survived. So have her friends—well, most of them. Dawn is safe. She is happy. Big smile. She defeated the bad guy.

About most of her friends surviving: "I, like many fans, was devastated by the unfathomable decision to kill [Anya] off in the finale," I tell Emma Caulfield during our interview. "Beyond feeling cruel, it was narratively unnecessary. It's particularly strange, given the pushback just a year earlier to the killing of Tara. I know you've called the

death 'lame,' but also once said that you asked for it to happen. I'm curious as to why. Something tells me there's more to this story."

"I did ask to die," she confirms. "I could be wrong about this, but from what I do remember the show was on the bubble as to whether the whole creative team wanted to do another season. I think if it was this collective, 'Yes, let's do one more,' that would have happened, but everything was sort of up in the air at that point and I knew that I didn't want to do another season regardless. I just felt like I had tapped into everything I was going to tap into and I was ready to spread my wings elsewhere and Joss took note of that. So when it was decided that the show would end, Joss came to me and told me that I was going to die, and I thought, Okay, that's pretty cool. And then I read the script, and I remember thinking, There's no real mourning for her. And that felt personal. And I know it was. And my response to it over the many years now has just been like, 'Well, you know, it happened,' or 'Death, it's sudden.' 'They avoided the apocalypse and I'm sure they cried about me later.' But at least for what was shot, they didn't. And that is . . . that is definitely a creative choice for sure. I can't look at that any other way other than 'Go fuck yourself.' That's how I took it. That's how it will always remain, because there really was no story reason for there to be a lack of emotion about it."

I ask if she feels more compelled to speak her truth, given the recent accusations around Whedon (which we'll get to in the next chapter). "This is a lifetime ago, right? Well, it's a lifetime for me. It's not a lifetime for those who love the show, who were with it from the beginning, or who have come to the show later, throughout the years, even as early as last week. The show continues to find its place every year that it passes. I mean, it will never die, which is hilarious, 'cause it's about mortality and whatever, but it literally will never die. And nor should it. I think it should stand up there as one of the greats. And I think it was. I think it was a wonderful show all the way around for what it attempted to tackle. And maybe it stumbled along the way, but that's just because that's life and we're human and whatever. So

I'm not harboring any like, 'Uh, if I could just speak the truth and get it off my chest, this has just been weighing down on me.' It's so not in my life, it's not at all on my radar. It becomes on my radar when fans will ask questions about that, especially in light of recent events, and it's like, 'Do you share these moments and this or that?' My relationship with Joss was … we had a professional relationship. I always did my job. But on a personal level, there's nothing there. And I'm perfectly fine with that."

I deploy the Oprah pause. She continued: "What he would choose to say, I don't know. I don't even know the extent of how he's weathered all of the things that have been said. I don't know if it's just a blanket denial or if he's just stayed quiet or if he has a different version of events. I don't care, because he doesn't matter to me. I don't say that in any kind of way other than to mean 'You just don't affect me.' I'm just glad it's in the past and it's done. I just say things start from the top down. I was never put in any sort of sexually inappropriate situation. He never promised me something and didn't deliver. He was just sort of this creator who wrote really great dialogue—so did every other writer—and I was lucky to play that role for as long as I did. But yeah, there's no great love lost there."

Again, she continued: "It's hard, man. And I'm obviously choosing my words carefully, and then at times I don't choose my words. But I mean, I think between everything I'm saying and not saying you, you know…"

Yeah, I know.

Not everyone was happy with the show's ending, both then and now. "I wanted the show to end like it started, with the core four," says Nicholas Brendon. "Maybe bring [Cordelia] back, maybe even Angel [for more]. I had a really hard time with all the Potentials. A lot of it was selfishly, because I was mourning. And so we have all these girls here now and I'm just wanting to be with people I love."

Brendon called Season 7 a bummer of a season. "Oh my fucking God," he says. "We had so many actors that wanted to do the show and

Joss was always 'I don't do cameos.' Then Ashanti shows up because she's thinking she might want to act and she's put with me? Great. I got Ja Rule over here and they've got six buses. I'm like 'What the fuck is going on right now?' I was so confused by that."

He's not wrong, in a sense. We first meet the main group of Potential Slayers in the episode "Bring on the Night." Whether intended or not, this shifted the dynamics from a show about a core group of friends to an ensemble show. You have the main cast of six, and then you add Giles, Principal Wood, Andrew, Faith, and the Potentials, and suddenly the number of named characters grows to twenty plus. As a result, screen time and storylines began to condense and, in some instances, dissolve. Some cast members were excluded from episodes entirely. For a season that Whedon prefaced with an aim of "Let's get back to where we started," there was a lot of new and, to be frank, underdeveloped story that felt distinctly incongruous to the goal he laid out.

The pressure to carve out a space within an ecosystem that was slowly coming to an end was only amplified by a set teeming with newbies among the show's veteran cast. "I looked up to all these actors who had far more experience working on TV than I did," says Tom Lenk, whose character, Andrew, was only on his second season yet was practically a vet among a sea of actors playing Potential Slayers. "I wanted to be liked and to make them laugh, so looking back, I may have let myself fall into the role of court jester. And on a show where your character can be murdered at any time, I definitely wanted to make the most of every episode, in case it was my last." In the end, Andrew would survive the series and play a big role in the comic books that followed.

As for the core four? There's a moment at the end of the pilot episode that is re-created in the finale nearly verbatim. It's a beat that helps outline the full-circle nature of the series finale, and helps underscore the growth of the characters, and by proxy, the show. Growth, but familiarity all the same.

In the pilot:

Giles: We've prevented the Master from freeing himself and opening the Mouth of Hell. That's not to say he's going to stop trying. I'd say the fun is just beginning.

Willow: More vampires?

Giles: Not just vampires. The next threat we face may be something quite different.

Buffy: I can hardly wait!

Giles: We're at the center of a mystical convergence here. We may, in fact, stand between the Earth and its total destruction.

Buffy: Well, I gotta look on the bright side. Maybe I can still get kicked out of school!

[The three students continue to class. Giles stays behind and watches them go.]

Xander: Oh, yeah, that's a plan. 'Cause lots of schools aren't on Hellmouths.

Willow: Maybe you could blow something up. They're really strict about that.

Buffy: I was thinking of a more subtle approach, y'know, like excessive not studying.

[Giles turns to go back to his library.]

Giles: The Earth is doomed!

In the finale:

Buffy: So, what do you guys want to do tomorrow?

Willow: Nothing strenuous.

Xander: Well, mini golf is always the first thing that comes to mind.

Giles: I think we can do better than that.

Buffy: I was thinking about shopping. As per usual.

Willow: Oh! There's an Arden B. in the new mall!

Xander: I could use a few items.

Giles: Well, now aren't we gonna discuss this? Save the world to go to the mall?

Buffy: I'm having a wicked shoe craving.

Xander: Aren't you on the patch?

Willow: Those never work.

Giles: Here I am, invisible to the eye ...

[Xander, Willow and Buffy walk down the hall together away from Giles.]

Xander: See, I need a new look. It's this whole eye-patch thing.

Buffy: Oh, you could go with full black secret-agent look.

Willow: Or the puffy shirt, pirate sash—

Giles: The Earth is *definitely* doomed.

"Not since the Von Trapp family saying goodbye to the Nazis have I cried so hard," recalls Douglas Petrie of that moment.

"I feel that I wrote the perfect ending for the show and wrapped everything up exactly the way it should be," said Whedon. "We wanted to hit the final chord of a beautiful symphony. That, unfortunately, was in season five. So with season seven, I sort of had to shut the door on the idea that this was the last episode a little bit, because the weight of that was crushing me. I was terrified. But I so very specifically knew what I needed to say and what I needed to have happen. That was all in there. But when you get into actually writing it, you're just, like, 'Oh, God, it's not good enough.' Then you're, like, 'Dude, you've got to chill,' because it's unbearable pressure. You want the last episode to mean something that no other episode has. And it is large. It was so hard to shoot. So we went out with a bang and hopefully an emotional one."

Was the finale universally beloved? Not by all. "Yes, satisfying, hooray, everything's going to be okay," says Jenny Owen Youngs of the episode. Also: "How fucking dare they kill my girl Anya? And yet they dared." For as much as the show is dissected, the seventh

season—and in particular the series finale—get little attention, let alone scrutiny.

I mention this very point to Claire Saffitz, who is a staunch defender of not only the series finale, but the season leading up to it. "I think the way the show ended was so flawed, but also so perfect," she says. "I don't think I could've imagined another ending. In fact, I almost like the flaws for it. I have so much respect for the way that the show ended, and for the finale message about sharing power and empowering other people, and about an escape for Buffy, a freedom for her that she could then enjoy for the rest of her life. She sort of unburdened herself at the same time, and I really loved the message in that. I think there is a real unraveling that you feel in the final season of things getting really chaotic and desperate that I really like, actually. And I just have so much respect for the showrunners and its writers wrapping up this show in a way that I feel acknowledged all of the previous seasons and that I never feel like I see in finales. I watched *Lost*; what a waste of time. They were like, 'Don't worry, we're going to wrap it up and tie up all these threads and loose ends,' and they never did and I was so mad. So I really appreciate that in *Buffy* they worked really hard to honor the entire history of the show and I think they did a good job."

Still, she acknowledges the inconsistencies of the finale season. "Like all of a sudden the ubervamps are very easy to kill. Like, why is Dawn killing one of them?"

For me—and I'm going to be *honest*-honest, as we're this deep in now and if we (you, reader, me, whatever) haven't established some level of trust then we're doomed—the show never quite felt like its whole self after the WB years. To para-quote the great columnist/ keeper of shoes in her oven Carrie Bradshaw: "After all, [seasons] change, so do [characters and story arcs]." And I get that. But the later seasons of *Buffy*, for me, feel like a different show. One I still enjoyed, but without the same depth of reverence. While I can acknowledge the creative leaps the show took in dealing with more adult themes such as loss, addiction, trauma, and more, the buoyancy of the first

two-thirds of the series seemed entirely gone. "But what about...?" I can hear you saying. Sure, yes! But *for me* it's a different kind of love that I have for the show once our hero sacrifices her life to save the world. We had a landing that was stuck with expert precision, not so much a hint of wobble, so why even attempt another go?

But others—and this is what I live for—disagree. "I'm a really big fan of the later seasons, and I think a reason why is because my dad passed away when I was twelve, and I really connected with Buffy surviving through this grief and having to carry on, to be her family's protector and take care of her younger sister (I have a younger sister)," says writer Gabe Bergado. "So when I think of the pop culture that helped save and heal me, it's really *Buffy* that comes top of mind."

Did the show ever jump the shark? "No, I think that's why we went out when we did," says Doug Petrie. "Joss and I had a lot of talks. I know there was that whole famous *Entertainment Weekly* cover [that read] 'Buffy quits.' I don't write headlines. This was something that Joss and I had talked at length about. I was exhausted. I think that creating the power for the other Slayers and that 'every girl in the world should have the power...' to me wraps up what the show was about: empowering women and empowering men to support empowered women, which I think also goes overlooked."

Gellar describes filming the finale as bittersweet. "I finished on the soundstage on a Friday night at like five in the morning. People weren't even there, they had gone home 'cause it was so late. And then I had one day on location left and that was kind of it. Everyone else went back to the soundstage to finish filming, but I had to leave because I was contractually obligated to *Scooby-Doo 2*. It was weird because all of the sudden it was just over. And you have to process things. But overall I was happy with the direction of the finale. I loved the idea that any girl who has the power, who wants the power, can have it. That's the ultimate message of the show. And so I'm very proud of it. I think bittersweet is the right word."

"I remember it was the series finale and I was walking the

locations with Joss," recalls Petrie. "We were literally on the school bus [that the surviving cast flees in] and he was like, 'We'll do this and do that with the camera,' and 'This is what the actors will do.' And I remember getting very emotional being on this school bus. It was a deep, deep sadness of 'I don't want to leave.' It felt like leaving school... again. And I joke, but it's not a joke: When people ask, 'What was it like writing for *Buffy*?' That's like saying, 'What was it like graduating from Hogwarts?'"

I ask Gellar if there's any part of her that wishes the show had wrapped after Season 5, being that the show felt, in so many senses, complete at the hundred-episode mark. "That would have been out of my hands because we were all contractually obligated for seven years, so I don't know that it ever crossed my mind, you know? I think I've been vocal that Season 6 is not my favorite. I think that a lot of Season 7 was pulling the trajectory back to where it should be. But if I had to rank seasons, I wouldn't put 6 and 7 up as my top two. I don't think anybody would. Even if you love Buffy and Spike together, I still don't think you would put it at the top."

I tell her that for me, the show skewed too far away from its original "high school is hell" premise in the later years. "I always say it's a metaphor for the horrors of growing up, so it's not necessarily the horrors of high school." And then, without warning, in what I know to be a signature SMG pivot: "More importantly, was Kim Cattrall asking you if she had blocked you or was she asking if you were blocked by Joe Biden?" (She was asking about me, for the record. Cattrall blocked me in 2017 for incessantly asking her about *Sex and the City 3*.)

Gellar's response—people not putting Season 7 in the top, not the Cattrall snafu—got me curious. I decided, keeping with Whedon's Season 7 theme of "let's get back to where we started," to poll fans of the series once more to gather their thoughts on *Buffy*'s least-talked-about season.

"There's a smattering of good ideas, but it doesn't work and a lot of it pisses me the fuck off."

"#JusticeForAnya."

" 'Him' and 'Conversations with Dead People' remain some of my favorite episodes."

"The way they turn on Buffy felt like it came out of nowhere and never worked for me."

"Struggled to like any of the Potentials and wanted more Willow therapy than a UK trip."

"One of my top seasons. Unpopular opinion, but I love every episode leading to the final Big Bad."

"Not my favorite. Muddled storylines, plus Anya's death shook me."

"7 was the flop era."

"Justice for 7! Class Protector, but the employed version? Yes, please."

"Felt like some missed opportunities in terms of the Slayer lore."

"A little rushed, but not nearly as bad as some say. I loved it. And some of the most iconic looks!!"

"While a great season arc, it has less one-off episodes that usually provide talking points."

"Emotional journey and a good conclusion to a complex story."

"Not as bad as I remember but still not great."

"Big ideas, many didn't stick the landing."

"Meh 😐"

"Loved it! Faith coming back!! Jonathan redemption!!"

"Way more serious vibe, and with good reason, since Buffy had gone through serious shit."

"Very satisfying series finale. And the callback to Season 2's 'kick his ass' moment was epic."

"Great hair, love that she chose to wear a white shirt and beige jacket for the final battle. Brave."

" 'Twas a noble attempt."

"Some of SMG's best, but the Potentials were weak."

"Season 7 was meh except that time in Episode 1 when all the bad guys came back. 'It's about power.' "

"Great as a direct continuation of Season 6 but stumbled in world-building."

"Loved Andrew as the comedic note among all the darkness."

"I have so many thoughts but my biggest takeaway has always been: cookie dough."

"Dawn's best season (mostly). I loved the path they put her on."

"Loved how the Core 4 became generals in the army. All their shared experiences paying off."

"It has moments that definitely felt like fan service and that not everyone's head was in it."

"Better than Season 6."

"Horrible, awful, makes my eyes bleed."

"Not as concise as other seasons, especially from *Buffy*, but had many gems and finally an Anya-centric episode."

"It gave/gives me anxiety knowing the end was/is coming."

"Not enough Giles, but I don't hate Season 7. But I would love to hear you tear it apart."

"We can continue to not talk about it."

"Ultimately my least favorite season. I'd say 6 and 4 have lower lows but 7 has so few highs."

"Weird, rushed, and kicking her out of her own fucking house? You get the fuck out."

"I just don't care for it. The storyline is uneven. Too many new characters. I don't like it."

"Amazing overall, but underwhelming villain."

"We pretend that season doesn't exist . . . apart from Andrew."

"Should have been a tight 12-episode season."

"People don't like the storyline, but I don't understand why. It resolves everything so satisfactorily."

"Season 7 is arguably one of the best seasons."

"Season 7 is by far the best final season of any TV series that has ever existed. Period."

"Kennedy was not bad, she just wasn't Tara."

"It got better with age."

"Pales in comparison to Season 6, but it's still *Buffy*."

"Seeing Buffy in the high school hallways again will never not be emotional for me."

"Top-3 season in my opinion."

"Great start, great end, but such a slump in the middle."

"Spike's storyline was a bit volatile with his soul. And Willow? Detoxing from being a fierce witch? Sigh."

"The speeches were too much. It lost its way but had some shining moments."

"I loooove Season 7. It really cemented the idea that we can all slay and that women are just better."

"There's no bad season of Buffy, but Season 7 is the 'least good.' It has some brilliant moments though."

"In short, I think you come into it with an emotional hangover from Season 6."

"Mostly boring, but an amazing and iconic finale."

"I loved it thematically. The scale is properly epic. But I can't stand how the characters treat her. Like, she's saved your lives so many times, you owe her everything. Get a grip."

"Amazing first half, dismal second half trapped in Buffy's beige-ass house."

"Andrew is a gay icon."

"We should talk about it more."

"Buffy is *not* the enemy and everyone is an ingrate for not realizing."

"There wasn't a Season 7."

"It's crazy that Season 6 is the controversial one when 7 just gave up."

"We might not talk about it, but we still think about it. How many shows can say that?"

"Wish it ended at Season 5."

"I respect it, but I don't always love it."

"It wasn't the season I wanted, but it was the closure I needed."

"It was POOOOOOOOP."

That marks the conclusion of the run of our show. Now can begin the other half of our story.

The Joss of It All

"Joss always talked to me about how the show was about a young girl becoming an empowered woman and how—and this is what really gets me—how he didn't want to see the pretty blonde victimized, how he wanted to see her as the hero of the story," recalls costume designer Cynthia Bergstrom. "And now in light of everything that's come out, I'm just thinking, Then why the fuck did you victimize everybody? Why did you traumatize? What is wrong with you?"

In 2017, Lowery Woodall gave a keynote address at the Whedon Studies Association conference. The topic of his talk was the way that the organization needed to brace for the fallout of Whedon's alleged behavior following his ex-wife's letter detailing the torment she suffered as a result of the implosion of their marriage. "I saw this as the first domino to fall in a long list of allegations that would come out about Joss that cast doubt on the kind of person he was and how his personal behavior impacted the legacy of his work," Woodall says. "I cautioned the organization to take proactive steps to distance itself from the man and instead focus on the content of the shows/films/et cetera. I believe that Mr. [Ray] Fisher's comments as well as those from Charisma Carpenter and Gal Gadot have borne out my initial concerns."

Let's rewind the tape.

In March 2017, on *Buffy the Vampire Slayer*'s twentieth anniversary, Joss Whedon was riding high. He had directed *The Avengers* and *Avengers: Age of Ultron* for Marvel and was about to take over DC Extended Universe's *Justice League* after the sudden death of director

Zack Snyder's daughter. In the years since *Buffy*, Whedon had found great success in Hollywood, even picking up an Emmy for co-writing and directing the Internet miniseries *Dr. Horrible's Sing-Along Blog*.

Five months after shooting commenced on *Justice League*, the facade would begin to slowly...no, not slowly...rapidly crumble. But not *just* yet. At this point, Whedon was doing a round of press in celebration of *Buffy*'s latest milestone, and looking back fondly on the show's cultural impact.

"I want *Buffy* to be remembered as a consistently intelligent, funny, emotionally involving show that subtly changed the entire world...or a small portion of pop culture," he told *Empire*, in what would turn out to be one of his last interviews about the series to date. "You know, enlightenment is the slowest process this side of evolution. It's very hard to have come up in the 1970s, to be raised by a feminist and then through the Reagan era and then, God help us, two Bush eras. Feminism, which hopefully will become an obsolete term by the time I'm dead, is a really important thing. Changing the way people think about women and the way they think about themselves is what I want to do with my life."

If this were a documentary film, we'd echo the audio of that last sentence, allowing it to reverberate before bringing in the headlines that would soon follow.

"If cancel culture is real, why do we have to cancel Joss Whedon every year?" a viral tweet read on February 10, 2020. "It's time to let go of the idea that one iconic creator is responsible for everything we love about a property they're involved with," wrote *io9*'s Courtney Enlow over a year later in February 2021. "Because with that much power comes individuals who will wield it for evil."

There's a certain kind of mythologizing of Joss Whedon and other male auteurs that can often protect them and make them appear exempt from scrutiny. And Whedon was a unique brand of auteur, one who seemed to enjoy, even depend on and feed off of, fan adoration. People loved him and he loved to be loved in return, which

created the artifice of a symbiosis. He'd regularly page through *Buffy* message boards throughout the show's run, eager to gaze upon and even engage with the fandom. That changed in August 2017. "15 years is a long time and a lot of water has flowed under the bridge," read a post from "Whedonesque," a popular message board dedicated to all things Joss Whedon. "But now it's time to say goodbye. No more threads after this one, we're closing down."

There had always been rumors, as is sadly common for powerful figureheads in Hollywood. But in August 2017, Joss Whedon's ex-wife, Kai Cole, made the decision to publish a guest blog in *The Wrap* that would, in time, prove to be the first strike. The headline did not mince words. "Joss Whedon Is a Hypocrite Preaching Feminist Ideals," it read.

"I've been asked some questions by the press recently about my divorce from Joss Whedon, to whom I was married for 16 years," she began. "There is misinformation out there and I feel the best way to clear up the situation is to tell my truth." When she states several lines later that she doesn't think it is fair to her or other women to remain silent any longer, it is unclear who the "other women" are. Maybe she meant other victims of alleged abuse, or maybe she more pointedly meant other victims of her alleged abuser. We can do nothing more than speculate, but I imagine this ambiguity of word choice was not an oversight.

She continued: "There were times in our relationship that I was uncomfortable with the attention Joss paid other women. He always had a lot of female friends, but he told me it was because his mother raised him as a feminist, so he just liked women better. He said he admired and respected females, he didn't lust after them. I believed him and trusted him. On the set of *Buffy*, Joss decided to have his first secret affair." (Note: Whedon has never admitted to having any affairs.)

She did not name a name, then alleging that Whedon later admitted to her that over the course of fifteen years of their marriage he had had multiple affairs and a number of "inappropriate emotional ones" with his female actors, coworkers, friends, and even fans.

"I believed, everyone believed, that he was one of the good guys, committed to fighting for women's rights, committed to our marriage, and to the women he worked with. But I now see how he used his relationship with me as a shield, both during and after our marriage, so no one would question his relationships with other women or scrutinize his writing as anything other than feminist."

Her allegations of Whedon engaging in workplace affairs would be corroborated by three independent sources in a 2021 *Variety* investigation.

Cole went on to detail how her entire reality changed upon Whedon's admission of his series of affairs, writing that she went from being a strong, confident woman to a confused, frightened mess, eventually being diagnosed with Complex PTSD.

Whedon, in what would become his default mode, chose not to respond, only offering this quote, through a rep, to *The Wrap*: "While this account includes inaccuracies and misrepresentations which can be harmful to their family, Joss is not commenting, out of concern for his children and out of respect for his ex-wife."

"Is anyone really surprised that Joss is Xander?" writer Louis Peitzman tweeted in 2017. Four years later, I reached out and asked him for his thoughts on that tweet, given the new information that has emerged (we'll get to that very shortly). He shared this: "I actually got banned from Facebook temporarily for writing this, because saying 'men are trash' is considered hate speech. In retrospect, I would have worded it differently, not because I care about getting banned from Facebook, but because I don't ever want it to seem like I'm excusing bad behavior with a blanket 'men are trash' statement."

"I find any man who makes feminism a part of his brand identity while his shows have noxious racial and sexual politics suspect," essayist Angelica Jade Bastién tweeted. And then there was this tweet from writer Molly Lambert: "Also Joss fired Charisma Carpenter from *Angel* for getting pregnant sooo..."

About that. On February 10, 2021, actress Charisma Carpenter came forward with her own allegations against Whedon, saying that

the "disturbing incidents"—which included allegations of harassment, ongoing passive-aggressive threats to fire her, and verbal abuse, including calling her fat to her colleagues when she was four months pregnant—triggered a "chronic physical condition" that she still lives with.

Here is her statement, with permission to print in full, from Carpenter herself, as it deserves to be read unabridged:

For nearly two decades, I have held my tongue and even made excuses for certain events that traumatize me to this day.

Joss Whedon abused his power on numerous occasions while working together on the sets of *Buffy the Vampire Slayer* and *Angel*. While he found his misconduct amusing, it only served to intensify my performance anxiety, disempower me, and alienate me from my peers. The disturbing incidents triggered a chronic physical condition from which I still suffer. It is with a beating, heavy heart that I say I coped in isolation and, at times, destructively.

Last summer, when Ray Fisher publicly accused Joss of abusive and unprofessional behavior toward the cast and crew during reshoots on the *Justice League* set in 2017, it gutted me. Joss has a history of being casually cruel. He has created hostile and toxic work environments since his early career. I know because I experienced it first-hand. Repeatedly.

Like his ongoing, passive-aggressive threats to fire me, which wreaks havoc on a young actor's self-esteem. And callously calling me "fat" to colleagues when I was 4 months pregnant, weighing 126 lbs. He was mean and biting, disparaging about others openly, and often played favorites, pitting people against one another to compete and vie for his attention and approval.

He called me in for a sit-down meeting to interrogate and berate me regarding a rosary tattoo I got to help me feel more

spiritually grounded in an increasingly volatile work climate that affected me physically.

Joss intentionally refused multiple calls from my agents making it impossible to connect with him to tell him the news that I was pregnant. Finally, once Joss was apprised of the situation, he requested a meeting with me. In that closed-door meeting, he asked me if I was "going to keep it" and manipulatively weaponized my womanhood and faith against me. He proceeded to attack my character, mock my religious beliefs, accuse me of sabotaging the show, and then unceremoniously fired me the following season once I gave birth.

At six months pregnant, I was asked to report to work at 1:00 AM after my doctor recommended shortening my work hours. Due to long and physically demanding days and the emotional stress of having to defend my needs as a working pregnant woman, I began to experience Braxton Hicks contractions. It was clear to me the 1:00 AM call was retaliatory.

Back then, I felt powerless and alone. With no other option, I swallowed the mistreatment and carried on. After all, I had a baby on the way, and I was the primary breadwinner of my growing family. Unfortunately, all this was happening during one of the most wonderful times in new motherhood. All that promise and joy sucked right out. And Joss was the vampire.

Despite the harassment, a part of me still sought his validation. I made excuses for his behavior and repressed my own pain. I have even stated publicly at conventions that I'd work with him again. Only recently, after years of therapy and a wakeup call from the Time's Up movement, do I understand the complexities of this demoralized thinking. It is impossible to understand the psyche without enduring the abuse. Our society and industry vilify the victims and glorify the abusers for their accomplishments. The onus is on the abused with an expectation to accept and adapt to be employable. No

accountability on the transgressor who sails on unscathed. Unrepentant. Remorseless.

These memories and more have weighed on my soul like bricks for nearly half of my life. I wish I said something sooner. I wish I had the composure and courage all those years ago. But I muted myself in shame and conditioned silence.

With tears welling, I feel an overwhelming sense of responsibility to Ray and others for remaining private about my experience with Joss and the suffering it has caused me. It is abundantly evident that Joss has persisted in his harmful actions, continuing to create wreckage in his wake. My hope now, by finally coming forward about these experiences, is to create space for the healing of others who I know have experienced similar serialized abuses of power.

Recently, I participated in WarnerMedia's Justice League investigation because I believe Ray to be a person of integrity who is telling the truth. His firing as Cyborg in *The Flash* was the last straw for me. Although I am not shocked, I am deeply pained by it. It troubles and saddens me that in 2021 professionals STILL have to choose between whistleblowing in the workplace and job security.

It has taken me so long to muster the courage to make this statement publicly. The gravity of it is not lost on me. As a single mother whose family's livelihood is dependent on my craft, I'm scared. Despite my fear about its impact on my future, I can no longer remain silent. This is overdue and necessary. It is time.

Why are we talking about *Buffy the Vampire Slayer* twenty-five years after the show first aired? To celebrate the legacy, yes, but also to correct the record. Some will question the timing. "What took so long?" is a refrain too often expressed to and about victims of abuse in all walks of life when they choose to tell their story. Why and

when a survivor comes forward isn't for any of us to know or to challenge. Imagine, if you can, being associated with something that so profoundly changed people's lives—and continues to do so decades later—that for you is rooted in trauma. Might you have complex feelings?

In Marilyn Frye's essay on sexism from her 1983 book *The Politics of Reality: Essays in Feminist Theory*, she begins with a discussion of how oppression requires that you show signs of being happy within your given situation. "It is often a requirement upon oppressed people that we smile and be cheerful. If we comply, we signify our docility and our acquiescence in our situation," Frye writes. But Carpenter had been speaking out, in her own way, for years to those who were keen to listen, and at times read between the lines. "If you've seen anything Charisma has ever done, she has not been shy about the fact that fucked-up shit happened on the set," says Kristin Russo.

The first public utterance about her unceremonious exit from *Angel* came at the DragonCon 2009 convention. A fan got up and asked: "I actually watched all of *Buffy* and loved Willow and thought Willow was my favorite character until I rewatched *Buffy* and *Angel* together and then I realized that Cordelia was my favorite character... I really felt that in the fifth season of *Angel* when they decided to do what they did with Cordelia, the energy changed and it didn't change in a positive way."

"I know," Carpenter responded, to uproarious cheers and laughter from the room. "It was canceled." She let out a big laugh and then appeared slightly embarrassed by the enthusiasm of the response. She looked to Julie Benz on her left, laughed, and Benz put her hand on Carpenter's back. The fan continued: "I'm curious what you felt about what happened with Cordelia." At this point, Benz looked over at Carpenter. Then Carpenter back at Benz. And an all-knowing expression came across both of their faces. "I just feel like the way Cordelia was cut out was really just weak," the fan concluded.

"That's a loaded question," she started off. "I think what happened,

you know, my relationship with Joss became strained...I was going through my stuff and then I became pregnant and you know, I guess in his mind, he had had a different way of seeing the season go...I think Joss was really, honestly mad. He was really mad at me and I say that in a loving way, which is...it's a very complicated dynamic working for somebody for so many years...And also as you've been on a show for eight years, you've got to live your life. And sometimes living your life gets in the way of what the creator's vision is for the future. And in that becomes conflict. And that was my experience."

She then went on to say that she thought they, her and Joss, had put that stuff aside and were in a "better space," even going so far as to acquiesce and say she'd work with him again.

She concluded by letting the attendees know that she did not want to return for the hundredth episode in Season 5 of *Angel,* but did so because "you needed closure as fans of the show." She did so on one condition: "I don't want to die. I'm not going to go back to die." In the end, she would go back to die. Carpenter had already signed on the dotted line to return, and was heartbroken when she got the news that her fear would be a fictional reality. "Well, let me hear the story," Carpenter said, recalling a conversation with *Angel* executive producer Jeffrey Bell when he gave her the news. "And when I heard it I said, 'That's good. Joss is good.' And it sucked that I died. But I really thought it was a hell of a way to go." The audience laughed, because Carpenter gave them permission to by creating a happy ending for them to digest.

"Those looks were about me encouraging and letting her know that if that's her truth, it's okay to speak it," says Julie Benz, who herself knows the experience of the untimely death of a character well. Her character Rita on the hit series *Dexter* was killed off after four seasons in a twist that even Benz didn't see coming. "It just might go down as one of the most shocking deaths *ever* on television," one critic wrote. Benz tells me that it took her some time to feel like she had permission to speak her truth without fear of recourse. "Not everything has to be glossed over as though it was rosy," Benz says.

Carpenter would remain quiet about her exit for nearly a decade until, in 2019, *ScreenRant* wrote a listicle of TV/movie pregnancies that were real: "During season four of *Angel*, Cordelia became inexplicably possessed by an evil demon," they wrote. "This storyline was implemented because of Charisma Carpenter's pregnancy. The storyline was wildly unpopular amongst fans, and ultimately was Carpenter's last with the series. At least that provides some explanation for how bad the storyline was."

"Hey, *ScreenRant*, If you'd like to know the facts of my pregnancy and exit from *Angel*, maybe call for a comment instead of printing lies," Carpenter tweeted in response. "I NEVER HID my pregnancy from production. CLEAR?"

After a fan tweeted in response, commenting that "it felt like the show was punishing you for being pregnant and all this article does is perpetuate the idea that you deserved it," Carpenter responded, saying: "There's so much to this tweet. Man! Finding out I was not invited back for Season 5 will always be a deep wound."

Finally, in 2021, galvanized by Ray Fisher's allegations, Carpenter decided to rewrite a history she herself had at one time mistold out of a sense of protection she no longer felt beholden to keep. In the 2021 documentary *Tina*, a look at the life and career of musical icon Tina Turner, journalist Carl Arrington gives the following observation as to why Turner came to him in 1981, finally ready to tell the world about what she described as the harrowing events that led to her split from husband Ike Turner. "People choose to tell their stories for lots of different reasons," he remarks. "I think she told me so much because she wanted to tell it and forget it." I try to be mindful of this throughout my myriad conversations with Carpenter, which began in 2019, recognizing that her story is hers to tell, *when* and *if* and *how* she wants to. Not every detail requires a follow-up question, even if it bubbles in my mind. Not because I'm not curious, but out of respect.

"Reading about the extent of Fisher's allegations made me feel

incredibly guilty about how I, as a *Buffy* fan, viewed the character of Cordelia Chase," says writer DW McKinney. "I wasn't initially a fan of Cordy on *Buffy*, but I understood that she was an archetype that was counter to Buffy and counter to who I was as a Black teen watching the show. I tentatively enjoyed her growth on *Angel,* and just when I was starting to really like her, the Connor-Cordelia storyline happened and I despised her character. In *Buffy*-speak, I was wiggin'. I stopped watching the show."

(The who-whating how with huh? Basically, for those not *Angel* initiated, Angel and Darla, for complex and mostly unexplainable reasons, have a child name Connor, who is taken to a hell dimension and ages at an accelerated rate before returning to Earth, and not too long later winds up in the arms of Cordelia before the two have sex.)

"I came back to it because my feelings were starting to affect how I saw Charisma Carpenter," says McKinney. "And who she is as an actress is so far beyond Cordelia. When I watched the reruns, I asked myself why Cordelia was going through these odd changes and why that storyline was allowed to happen. It wasn't until years later that I learned that Whedon may have been abusing Carpenter behind the scenes and that storyline was basically punishment for her pregnancy. I was undone by that. In a way, I felt complicit because [Carpenter's allegations] skewed my viewpoint and I'm sure that happened with other viewers too. And I know how difficult it is to get coworkers to value you and respect you while you're doing your job while pregnant."

I spoke to Carpenter prior to her issuing a public statement about much of what that statement crystalized, in particular the longstanding rumor that she was fired from *Angel* during the show's fourth season because of her pregnancy.

"I only know from my point of view," she said. "I don't know what happened in the writers' room. Recently I've learned that the writers didn't know how to facilitate Cordelia, they didn't know how to make it work where you now have [Angel *and* Cordelia] working for redemption. She's a higher being and da-da-da... I think that they felt

unclear. And for me, I felt like Cordelia is truly the voice of a middle-aged white man named [executive producer] David Greenwalt. He embodied her, he championed her, and he went over and show-ran *Angel*. Then he didn't feel valued by the network or by the studio, so he left. Then Tim Minear stepped in and he was show-running. We were still hanging in, still doing great, and then *Firefly* happened. The shows were growing and growing and the talent pool was being stretched and put in other places. So then the redheaded stepchild that was *Angel* got sort of forgotten. I don't mean to insult the people that were there, because I know they tried their best and I know that they put blood, sweat, and tears into the job as well, but Cordelia suffered. She suffered without David Greenwalt, she suffered without Tim Minear, and those were the two people that understood her best."

Notice: She does not mention Joss's name here, the man who created Cordelia on the page.

"It was 100 percent not expected," she says of her untimely dismissal from the show, which was met with fervent backlash from the fandom (a theme, eh?), many of whom had come to see Cordelia as the co-lead of the series. "When you're a thirty-year-old woman and you've been on a show for seven years, and you've been with the same partner for like five years, you do have sex. It's plausible a person could get pregnant, and it shouldn't be something that could [get you fired]."

Carpenter says she tried to reach out to "the powers that be" (read: Whedon and co.) to inform them of her pregnancy. She heard nothing back. Finally, once Whedon had learned the news via a third party, he requested a meeting with her. "I was let know how it was fucking everything up for the season," she says.

What's so odd about hearing that story, I tell her, is that if something like that were to ever happen today—a showrunner allegedly firing his lead for getting pregnant—there would be immediate and swift action *against* the showrunner. "It wasn't supposed to be

accepted then," she says. "To be honest with you, I was so afraid to say the truth for fear of those things that we fear. I had a little baby to feed and I was a primary caretaker of my family. I couldn't afford to say my truth. I couldn't afford to talk about the way that I was treated."

"I imagine it had to be so difficult," I tell her.

"Beyond. I don't know that my career has ever really overcome it, to be honest. In the end, I found out later—and listen, it's not lost on me how well an actor is paid—that I was the lowest-paid actress in prime-time television. I don't know if that's bad agenting or just the machine that is 'You're not enough,' 'You're not good enough,' 'You create these issues,' 'You have anxiety.' And I'm not disagreeing on this, I was challenging in those areas, but I was always made to feel that I was also very worth it. So it was always sort of like this 'Oh my God, you're this huge talent,' 'We want to do everything to make it possible for you to be your best,' and 'America loves you' and 'You're awesome.' Then at the same time when it came time to talk about my paycheck, it was, 'You're a problem,' 'You cost us this.' It was always this building up to knock you down. It was always something like that going on, and it was very disruptive to me as an artist. It was disruptive to me as a person, and as a new mother I had a lot to traverse and navigate as skillfully as possible. However, back in the '90s you didn't necessarily have a lot of voice."

With the rise of movements like Me Too and Time's Up, and increased attention, scrutiny, and consequence for those in power who abuse their position, the times, thankfully, are changing. "There's been tremendous exposure of the undermining that takes place by men in powerful positions where they make you feel like you're 'extra.' Men can be a handful also and [can] be fucking 'extra.' I feel there's been progress, but we're not there yet. It was a lot to manage at the time. I have done my best to look at my part and all of that, to see things from a production point of view, and I was not perfect. I was doing my best to cope under a tremendous amount of duress. Having a baby should not equate to not having a job the following year.

I knew what I was sitting on could be potentially explosive. I felt like I had no agency. There was just nothing I could do about it. I think no matter what job you have, in the workplace, every woman faces that unspoken reality that you're going to pay. You're going to pay for intrinsically just being a woman. Just having a reproductive system and to be able to have a baby is a problem. I am a very talented person, but I also have a very strong work ethic. Somehow that wasn't enough to sustain my job."

Carpenter's comments lit the match. Within hours, her co-stars began weighing in—well, most of them. "*Buffy* was a toxic environment and it starts at the top. [Charisma] is speaking truth and I support her 100%," Amber Benson tweeted. "There was a lot of damage done during that time and many of us are still processing it twenty plus years later."

Benson elaborated on this more in our interview. "It starts at the top—and I'm not talking about Sarah, I'm talking about Joss. And it creates the tone of the set. And I worked on shows where the producers are very aware of this, and they work really hard to make everybody feel like they are important and that they have a place in the show. And I think because this was Joss's first show, there were things that got dropped. I think sometimes it made the set feel tense because people were like, 'I don't know that I'm important. Like, I know Sarah is important because she's the name of the show, but am I important?' And I think that that made it hard. And I think it puts a lot of pressure on relationships with Sarah and other actors and then other actors with each other. I think there was a lot of tension in that way."

She continued: "I came in in the fourth season, so all that stuff had already been concretized. And so it was a little bit of navigating and being aware that there were sort of alliances and tensions and some people got on really well and other people were okay...nobody was flat-out fighting or anything, but you could just feel like people weren't sure of their place. And I think it is the boss's job to make everybody understand where they are in the hierarchy and how they

fit in and that they are necessary, you know? 'Cause if you make every-body feel like they're a part of it and that they're necessary and that they're not worried about their job, then there's this comfortability. And I think when that wasn't happening, there was some uncomfort-ability on-set."

James Marsters too spoke about this tension during our interview. "We were at war, the enemy was time, and time won every battle. And when you're in a war and you lose every battle it's hard. It can take the wind out of your sails. If we didn't care, it wouldn't have been so frus-trating. I don't know if everyone frames it in their mind the way I do, but I attribute some of the tension on the set by just that: that we were trying to summit a mountain and always couldn't get to the top really. Although we got very high, I mean...look, we did very well. We did our best. But we lost it. We lost the war."

Hours after Carpenter's and Benson's statements on social media, Sarah Michelle Gellar released a statement on her own Ins-tagram. "While I am proud to have my name associated with Buffy Summers, I don't want to be forever associated with the name Joss Whedon. I am more focused on raising my family and surviving a pandemic currently, so I will not be making any further statements at this time. But I stand with all survivors of abuse and am proud of them for speaking out."

"Thank you [Sarah Michelle Gellar] for saying this," wrote Michelle Trachtenberg in her own Instagram post hours later. "I am brave enough now as a 35 year old woman....To repost this. Because. This must. Be known. As a teenager. With his not appropriate behav-ior....very. Not. Appropriate. So now. People know. What Joss. Did. The last. Comment I will make on this. Was. There was a rule. Say-ing. He's not allowed in a room alone with Michelle again."

"What he did was very bad. But we win. By surviving!" she wrote in the comments section of her own post. Carpenter weighed in, in her comments, writing: "This is very troubling and disturbing to read. I'm so so sorry Michelle. You should have been protected!!! You

have given rise to the mama bear in me. Here to support you in any way you need. Sending all my love."

According to a report published by *Variety* weeks later, "While several high-placed sources who worked on *Buffy* say they were not aware of this rule, a person with direct knowledge of the production at the time confirms that an effort was made by those around Trachtenberg to ensure the young actor was never alone with Whedon. According to this person, it was due to an improper verbal exchange between Whedon and Trachtenberg."

I'm both struck and concerned that a set could have such a rule. All attempts I made to gather more information about this were hastily red-taped. "If that was something that was out there, that should have been a huge flipping deal and should have spurred an investigation," says Danny Strong. Trachtenberg was in discussions to be interviewed for this book prior to this information coming to light. Once it did, her team declined her involvement despite persistent efforts, even with the promise of no Whedon discussion.

Some (read: men on the Internet) were quick to critique Gellar's statement, seeing it as not saying enough. "When people make statements online you cannot contain in those kind of spaces the nuance that is required to have conversations about trauma," says Kristin Russo, when I ask her if she shared in my annoyance at seeing Gellar become the subject of critique and not Whedon. "I am so holistically frustrated with the expectation that is put upon people to show up the way that 'we' want them to when they are the people that walked through the experience. What is Sarah Michelle Gellar obligated to do in this space? She obviously stood with Charisma, Amber, and Michelle. But what has *she* walked through? I don't know. You don't know. No one knows. And we don't have a right to that information. The retraumatization of so many people because of that expectation is harmful. And I thought she said a lot in a very small space. I thought she said a fucking lot. Her statement was clearly 'Love *Buffy*. Fuck this guy.' Like she told us, 'Don't let go of all of the work and heart

and tears and love that we breathed into this character . . . but fuck that guy.'"

The statements kept on coming.

Emma Caulfield, too, reposted Gellar's message, adding: "In the wise words of my friend Sarah Michelle Gellar," ostensibly co-signing her solidarity. I asked Caulfield about this during our interview months later. "My first thought was 'Well that's out finally.' It wasn't like 'Whaaaaat?!' I don't know why it took people so long to have an understanding that this person who fanboys put on a pedestal and think can do no wrong finally got dethroned."

"For what it's worth, I believe and stand with [Charisma Carpenter], [Ray Fisher], [Amber Benson], and others who have the strength to come forward with their truth," wrote Clare Kramer. "A lot of this industry needs a reset."

The following day, on February 11, 2021, Eliza Dushku released a lengthy statement on Instagram directed at Carpenter. "CC"—a name several of her co-stars had used when describing Carpenter to me in our interview—"My heart aches for you and I'm so sorry you have held this for so long. Your post was powerful, painful, and painted a picture we'll collectively never unsee or un-know. I frequently think of the saying, 'we are as sick as our secrets.' Our secrets indeed make and keep us sick . . . May you and countless others feel the solidarity and connection you have likely missed for too long. From courage, come change and hope. It starts and will end because of courageous truth-tellers like you. I admire, respect, and love you."

Dushku, it should be noted, came forward in 2018 with her own allegations of sexual molestation against a stunt coordinator, who she worked with at the age of twelve (the alleged was thirty-five) on the set of *True Lies*. "Whereas he was supposed to be my protector, he was my abuser," she wrote in a lengthy Facebook post. (Note: The stunt coordinator has denied the allegations made against him.)

"I owe you an apology," Carpenter wrote in the comments of Dushku's post. "I never lent my voice to you privately nor publicly

when you shared your truth after suffering sexual misconduct in the workplace. As I wrote to you privately, this makes your statement of support sweeter. And as I said to [J. August Richards, who portrayed Gunn on *Angel*], your loving embrace empowers others to feel safe to share their stories. Thank you for being who you are. Thank you for your inspiring words of support. I will never forget how you have made me feel."

I reached out through various channels, including cast members themselves, in an effort to speak with Dushku. However, she ultimately declined.

That same day, Anthony Stewart Head said he was "gutted" by the allegations when asked about it during an appearance on the British daytime television show *This Morning*. "You can probably see that I've been up most of the night," he said, indicating his sleepless face. "Just running through my memories, thinking, What did I miss? This is not a man saying, 'I didn't see it so it didn't happen.' It's just...I can't...I am gutted. I'm seriously gutted. One of my memories—my fondest memory, in fact—was that he was so empowering, not just in the words in the script but in the family feel of the show. I'm really sad if people went through these experiences that they didn't...I was sort of like a father figure. I would hope that someone would come to me and say, 'I'm struggling, I just had a horrible conversation.' Admittedly, the first post by Charisma was when she was working on *Angel* and I was long gone but there are other posts subsequently that are making me think, How on Earth did I not know this was going on? There were always ups and downs and highs and lows."

(The record must be reflected to note that Carpenter made it explicitly clear in her statement that this alleged behavior took place on both sets: "Joss Whedon abused his power on numerous occasions while working together on the sets of *Buffy the Vampire Slayer* and *Angel*," she wrote unambiguously.)

I ask Head during our interview (which took place three months after Carpenter's allegations came to light and after an ongoing

back-and-forth in an effort to secure the interview) if his thoughts have changed at all now that he's had time to process. "I actually do still say exactly what I said then: it was a family. I was kind of a person that people would—because I was older, because I was actually a father, people would come to me. So I'm sad that no one talked to me, at the time, about concerns that have come to light. I'm glad people are still fond of *Buffy*; the show was a remarkable piece of television, ahead of its game. It paved the way for so much of what we now see."

I press him to say more on the subject of Whedon. "The difficulty with the whole Joss situation is that it's very difficult to…ah, never mind. I have to say I was very nervous [about this interview], and then when our initial time didn't work out I thought, Oh well, but then when you came back around I thought, Oh well, bite the bullet. It's difficult because you don't want to see someone's work shot down. But as far as what Charisma has said, yes, there was a lot of strain on-set but I can't say that that's an excuse if the behavior is true."

The statements kept coming. Carpenter's *Angel* co-star J. August Richards tweeted his support of Carpenter, writing: "Sending you my love, [Charisma]. I know the feelings of vulnerability and fear that come with speaking your truth. As I said to you yesterday, I am here for you, however you need me." Carpenter responded, writing: "As I said on our call, many people are watching how my truth statement is received. When they see a positive, loving embrace from [people] like you, it creates space for their own stories to be heard. Thank you. [Please] know I am inspired by you for speaking your heart too." (She is referencing Richards coming out publicly as gay in April 2020.)

There was also a tweet that day from Nell Sovell, writer and creator of the television series *Sabrina the Teenage Witch*. "I met Joss once when I interviewed to be a writer on *Buffy*. I was pregnant at the time. First thing he said to me: 'Boy, are you fat.' I laughed because it was an interview. But when I read Charisma Carpenter's post, I realized it was a pattern. And I didn't get the job."

On February 12, James Marsters released a statement on social

media. "While I will always be honored to have played the character of Spike, the *Buffy* set was not without challenges," he wrote. "I do not support abuse of any kind and am heartbroken to learn of the experiences of some of the cast. I send my love and support to all involved."

That same day, former *Firefly* writer Jose Molina shared an experience he witnessed while working with Whedon on the series. " 'Casually cruel' is a perfect way of describing Joss," he wrote. "He thought being mean was funny. Making female writers cry during a notes session was especially hysterical. He actually liked to boast about the time he made one writer cry twice in one meeting."

Executive producer Marti Noxon, who was showrunner for the final two seasons of *Buffy* and worked more closely with Whedon than anyone else associated with the show, had very little to say in her statement released on Twitter that same day. "I would like to validate what the women of *Buffy* are saying and support them in telling their story. They deserve to be heard. I understand where Charisma, Amber, Michelle, and all the women who have spoken out are coming from." A week later she was tweeting about smelling Tupperware. (Am I frustrated to have not had even a response to my multiple requests for an interview? One could accurately infer that.) "I think what I found really strange was that I didn't really get a sense that she supported not only women, but more specifically the women on her crew," said costume designer Cynthia Bergstrom when I asked about working with Noxon. "It was odd."

Bergstrom would work on *Angel* with Carpenter for the pilot episode. She was, in her words, manipulated by the production manager to do the episode for free. It would be her only episode. "One of my costumers went on to be the costume designer on *Angel*, which was interesting because Joss actually asked me to design both shows. And I was really excited. And the next thing I know they're taking my set costumer, who had very little experience, and they're making her the costume designer. And I was just like, 'Well, it's just one less headache for me,' but I was looking forward to that and I just thought,

'Wow, what game are you playing here? First you offer me a show, then you take it away and then you take my set costumer anyway.' I would hear stories from my friend who worked on *Angel*, and it was brutal. It was clear that Charisma was going through something. And just bless her heart. I ran into her years later and I just hugged her."

On February 13, Tom Lenk took to Twitter: "So as not to center myself in the narrative, I thought it was important to leave space for the women and series regulars of *BTVS* to speak. But while I am here listening, I wanted to take a moment to send my love and support to the women of *Buffy*."

That same day, Danny Strong tweeted as well: "Sending love and support to Charisma Carpenter, Amber Benson, Michelle Trachten-berg, Sarah Michelle Gellar, and all who have gone public about their toxic experiences on *Buffy*. I truly admire your bravery in speaking out."

Days later, and weeks after our initial interview, Strong suggested we have a follow-up interview. "It was far beyond what I knew, as far as how much people had felt personally damaged and traumatized by the situation," he started off by telling me. "Look, my experience on the set was a very positive experience, including my interactions with Joss. And so I wasn't aware of how toxic the set was for some. And it seems like who it was toxic for was the really attractive women. That was who he was creating really unpleasant working experiences for. And it's not in your typical sexual-harasser way, even. These stories, they're sort of atypical in creating this petty, almost high-school-like environment in pitting the pretty girls all against each other. I'm sure there's a lot of psychological depth about what that says about Joss."

Strong corroborates the existence of rumors at the time, the same rumors mentioned in Kai Cole's column in *The Wrap*, alluding to Whedon having sexual relationships with various actors. "It certainly wasn't a secret," he says. "I assumed it was well known that there were certain actresses that he was having... I don't know if they were relationships, one-night stands, or what, but there was always that

little talk of, 'Oh, Joss hooked up with her.' But with what's come out, clearly there was a lot more bubbling under the surface that I wasn't aware of and it seems other people weren't as well."

Strong says he waited two days to publicly comment because he wanted to call several cast members and talk to them. Through these calls Strong gained some perspective on the experiences others had on-set that he was either not present for, unaware of at the time, or both. I think it's important here that we underline several things he's getting at. There's been a fair amount of criticism lobbed at former cast members who have not publicly spoken out. This implies two things that might very well be categorically false: that no communication has happened outside of the public eye and that it's incumbent upon cast members to make public statements, and if they do not, they are somehow complicit. None of this is true. (And I can confirm that conversations have been happening outside of the public arena.)

"It's truly up to people to decide what they want to say and what they don't want to say," says Strong, adding: "I feel like because I am now a showrunner and a director, it was important for me personally to speak up because I want to make it very clear that as a person who is in a position of authority on a set I do not condone this type of behavior."

The statements from former cast members kept on coming. On February 14, David Boreanaz tweeted a reply to Carpenter's statement that read: "I am here for you to listen and support you. Proud of your strength." Carpenter responded hours later, writing: "I know you're there for me, David. I appreciate all you've done to demonstrate that support privately as well. Especially since Wednesday. Thank you so much."

That same day, Julie Benz tweeted: "My heart goes out to all victims of abuse. Sending love to my fellow *Buffy* and *Angel* survivors. I stand with you and support you."

Clearly there were some goings-on behind the scenes as well. Sarah Michelle Gellar shortly thereafter followed Charisma Carpenter

and Julie Benz on Instagram. They both did the same. Benz also followed Michelle Trachtenberg. It's unclear what conversations were had amongst the cast in private. I could ask them, I suppose. But it's not my business, or yours. I'd like to believe in the strength of solidarity. I've always gotten the sense that this cast wasn't the closest, but now I realize that even if that were true (and again, who's to really know besides them?), there were perhaps forces at work leading them to mistakenly believe each other were the enemy. As Carpenter's statement reads: "[Joss] pitt[ed] people against one another to compete and vie for his attention and approval."

I asked Benz about this specifically. "I would say the vibe when we were working on the show...it wasn't supportive," she said, corroborating the words of so many—too many. "We were all young, we were all fighting for our place in the sun. There was a lot of...tension. I think everyone was feeling a lot of pressure. It was all kinda high school. That was the vibe. But I would say conventions brought us closer together. And obviously what happened recently...it's a great way to put your arms around the women in the show and just be like 'I'm sorry. I'm sorry I wasn't there. I'm sorry I wasn't aware. I don't even know if I could have done anything had I known, but I'm sorry. And I'm here now. And I support you now.'"

Benz notes how she sees a different generation coming up, younger actors entering Hollywood with a different mindset about how this business can and should operate. "But you gotta remember in the '90s and 2000s it was cutthroat. But that's starting to change. The whole Me Too movement and Time's Up helped bring that about. You walk on-set now and there's way more of a sisterhood with the other actresses you're working with than ever I've experienced in the past."

I ask her, to the extent that she's comfortable talking about it, if she ever had any experiences similar to the ones that have been alleged. "I didn't experience it," she says. "But I wasn't there twenty-two episodes a year. When I was on-set, I was treated very well. So this

is like finding out that your best friend's family are abusive alcoholics behind closed doors. You don't know that, because when you're over there everyone is so kind and so wonderful. That's how I view it. I was a guest in the house. And I didn't know the family secrets.... It's hard, let's just be honest. It breaks my heart. I do believe that we have to start believing women when they speak up. There is no win, absolutely no win, in speaking out. There's no win in Charisma coming forward. And by the way, obviously, she wasn't keeping this story a secret, even in 2009 she was saying it. It's really about addressing male toxicity on-set."

On February 15, Carpenter's *Angel* co-star Amy Acker expressed solidarity with Carpenter and other accusers, writing: "I will always be proud of the work we all did on *Angel*. While I personally had a good and professional experience, it is heartbreaking to hear that not everyone did. I do not condone any actions that made anyone feel hurt or uncomfortable, and I offer love and support to everyone who is speaking out to tell their truths."

Alyson Hannigan, who worked with Carpenter for three seasons on *Buffy*, did not make any public statement. Not that she had to. Hannigan's interview for this book was locked and meant to take place the day after Carpenter's statement was released on social media. It was canceled and not rescheduled.

As for Nicholas Brendon, who has his own legal issues, quite a few in fact that we'll take a look at in detail later, nothing intelligible was gleaned. On February 16, the *Daily Mail* wrote the following headline: "*Buffy the Vampire Slayer*'s Nicholas Brendon Is 'Not Ready to Discuss' Joss Whedon Abuse Allegations as He Undergoes Emergency Spinal Surgery After Suffering from a 'Paralysed Penis.'"

He did offer this up during a Facebook Live: "Out of this I just hope that growth comes, and healing, and then being a better person and a better people...I mean, were there transgressions? Yeah, there were. To me as well, you know what I mean? It's like, I had my relationship with Joss as well. And I love him...I took the bad...but

that's not everybody...I love and support [Carpenter] very much and I know that story, and it's not a kind story...I know my relationship with Joss and...there's a lot of kindness. But also not, you know? So it's kinda hard to give a statement when things are like that."

I had asked Brendon about Whedon during our interview, which took place weeks before the reckoning spurred into motion by Carpenter's public account. But the Ray Fisher and Kai Cole stories had long been public knowledge. "Hearing the stories about Joss, I'm like, 'Jesus Christ, fucking people. Like, grow a pair of fucking testicles.' It's okay if he raises his voice, you know what I mean? It's okay if he has a passion. If he's fingering your pussy like Donald Trump, then we have a problem here. But it's just bullshit. It's this cancel culture. Fucking political correctness, good God. It kills me."

I let Brendon know that I'm not attempting to cast Whedon in a bad light so much as shine a light on his, how shall we say, complexities. "But he's not bad, though," Brendon counters. I can't help but think there's some subliminal self-preservation wrapped up in his response, especially considering their similarities, best underlined by the fact that Joss was casting himself when he cast Xander. "Me and Joss have a special relationship. We always will. Joss is a walking conundrum. He's like that Levi Strauss ad with the two horses pulling the jeans in opposite directions. He's got such a confidence and an ability and an ego because of his immense talent. But he's also so very insecure when it comes to girls or anything like that."

For a man that Brendon calls his onetime mentor and speaks of so highly, I'm curious why the two aren't in touch anymore. "You know, it's funny," he starts, then: "You always say 'it's funny' when it's not funny." According to Brendon, during the 2017 *Entertainment Weekly* reunion, Whedon and Brendon went for a walk in which Whedon apologized for not being there for Brendon over the years through, as Brendon described it, his "stuff." (Again, we'll get to that.)

"I said, 'It's okay.' The thing that I wasn't okay with was that he was holding another secret, and that was that I was not invited to

the photoshoot. So when I found that out, there was an anger that kind of boiled up a little bit inside of me." Does he hold a grudge? It's hard to determine, as Brendon's feelings tend to waffle throughout our interview—sometimes angry, sometimes sad, often sentimental, mostly pained. "I think about Joss every day. It's probably why I cried earlier. I was hurt by Joss, by him not being there and then also having this other secret."

Actor Laura Donnelly, star of the Whedon-created show *The Nevers*, gave what I perceived as a bizarre response in a March 2021 interview about that show when asked about her experiences with Whedon prior to his exit. "From my personal experience, it was the best screen, film or TV, experience that I've had on any set," she began. "From my point of view, he always felt very supportive and protective of the artistic integrity and what we as actors needed in order to be able to do our job." Her co-star, Ann Skelly, weighed in too, adding: "Everyone would show up to work happy to be there, ready to go. That is a very contagious feeling. It was a very positive energy." This is all well and good and diplomatic.

And then Donnelly says this, completely unprompted: "One of the first talks that we got from HBO, and I think this speaks to the culture as it has been learned about over the years and the progress that we've managed to make within the industry, was an HR talk about what you can do if you do ever feel uncomfortable on a set in any capacity at all. So we all knew that there were very clear lines of communication there if we ever felt that we were in any way uncomfortable. Certainly, from my point of view, I always felt like I was being very looked after in that capacity. I'd like to think that everybody else on set did too." What a bizarre comment to offer up to the question "What was your personal experience of working with Joss?"

Still, there are those who recognize the good that Whedon has done for them, which is not to say they are dismissing the allegations lobbed against him. "I owe my career to him," says *Buffy* writer Drew Z. Greenberg. "He took a chance by hiring me, because I had almost

no experience. And I'm grateful to him for that. I think what he did was revolutionary. He created a show about putting women at the center of their story. That wasn't common. Especially in genre. Especially in teen genre. And I think that's remarkable. I think the good that he did is remarkable. He taught me how to do what I do. How to be discerning about dialogue and themes and visuals and how to say we can have something that speaks to the audience but does it in a way that's artistic and means something. And I wish that everybody treated TV that way. He did something. Every time that he put an episode on air he was trying to do something. We started every episode with the question of 'What's the *Buffy* of it?' Meaning, what's the emotional journey of *Buffy* this week? And when you add up those emotional journeys over the course of weeks and months and seasons and series, you're telling the story of these characters. And every time he put something on the air he was trying to say something about what it's like to have an emotional experience about something."

It's easy to look at Whedon's rise without context, and marvel. He was the invisible kid in high school who became not only hyper-visible but hyper-beloved, and created a space for other invisibles to feel more seen. "I was one of those kids who no one pays attention to, so he makes a lot of noise and is wacky," he told *Rolling Stone* in 2000. "But I was funny; I wasn't totally annoying. I decided early on that my function in life was to walk into a group of people, say something funny and leave while they were still laughing. Which is pretty much what I did, only now I get paid for it." It's a remarkable trajectory... out of context.

"I think that this mentality that we're seeing in him is kind of like this high school nerd who's angry that the pretty girls didn't like him and he gets older and he's gonna lash out at the pretty girls or hook up with some of the pretty girls, and the pretty girls that don't want to hook up with him he's going to lash out at them in some way or turn other girls against them," surmises Danny Strong, who mentions an oft-repeated refrain from Whedon (repeated again here in this book)

about his own experiences of being an outcast in high school who couldn't get the girl. "I just want to say if you're in your mid-thirties, fuck you. That's not an excuse. You should know better by then. You're very rich. You're very successful. Give me a fucking break that you're still talking about being the high school nerd that didn't get the girls. It's not an excuse to mistreat people."

"I think that acting like these cases are aberrations—and I know this word is super overused—feels like gaslighting," says actor and writer Tavi Gevinson. "Because even if these kind of allegations in Hollywood have only been reported on in more recent years, there have been whisper networks for years. People have tried to talk about topics like these before. To suddenly act shocked or to act like these are individual bad actors who somehow came up with the idea to abuse women all on their own and were enabled all on their own I think absolves the workplace itself or the system that protects them or tries to silence victims. In effect, it lets these other things off the hook. I think you can hold all of it. I think you can say of course this person is responsible for their own actions, of course, and also we're just going to keep hearing more of these stories unless we can talk about why abusing people is harmful to them and to oneself as opposed to this is no longer socially acceptable."

Is Joss Whedon canceled, as some might wonder or conclude? We have, after all, heard nothing from the man in years. Not even a peep. He's also got no future work on his docket, according to IMDB .com, as of this writing. But perhaps the real question is, Will Joss Whedon continue to be given immunity for his alleged actions? "A lot of people don't want cancellation and other people do," says Gevinson, speaking in the more general sense about Whedon-like figures who mill about Hollywood. "I think that...not to be that guy, but Mariame Kaba, a transformative justice advocate, facilitator of transformative justice processes, and abolitionist organizer, she said something once—I'm sure she says it a lot—in an interview I listened to. She said, 'Consequences and punishment are not the same thing.' I

believe in consequences and I believe a consequence could be public accountability, but I simply don't know enough to know what consequences should be in terms of what happens to a TV show. But that's not cancellation. That's not punishment. That's consequences for actions. If you commit workplace abuse, you probably shouldn't be a boss."

"I think that he's a man that very much wants to be a good man and is trying very hard to become that," James Marsters says when I ask him about his former boss. "I think that Joss is a very, very passionate artist. I love passionate artists. Dude, we are *weird*. It is bracing sometimes. It's not always pleasant to hang out with us. There's something exciting and dangerous and inspirational about watching someone so passionately try to say something that is vulnerable and illuminating. I saw him as a grand wizard and also a little boy. I asked him once, 'What's it like to wind up the universe and just watch us all dance around to the tune that you wound up?' And he was like, 'Oh, it's great, James. It's great. It's just that I have to keep winding.'"

Thank God We're Hot Chicks
with Superpowers

"The word 'feminist,' it doesn't sit with me; it doesn't add up," Joss Whedon told a crowd at Equality Now's "Make Equality Reality" event in November 2013. "First of all, on a very base level, just to listen to it. We start with 'fem,' which is good. I think that's promising, you know, 'fem.' It's nice, but it's strong; *f* is a very porous letter, very inclusive. It's not too wimpy. We go to 'in.' Fem-in. Okay, not as impressive, but they can't all be 'Rose's Turn.' Sometimes you gotta get from A to B. 'Ist.' I hate it. I hate it. Fail on 'ist.' It's just this little dark, black little . . . it must be hissed. 'Ist'! It's Germanic, but not in the romantic way. It's just this terrible ending with this wonderful beginning. This word for me is so unbalanced." Throughout all of this, the audience is laughing, maybe because they find this and him genuinely funny. Maybe out of discomfort. I wasn't there, so it's hard to interpret.

He, of course, continued: "My problem with 'feminist' is not the word, it's the question: 'Are you now, or have you ever been, a feminist?' The great Katy Perry once said—I'm paraphrasing—'I'm not a feminist but I like it when women are strong.' I don't know why she feels the need to say the first part, but listening to the word and thinking about it, I realize I do understand. This question that lies before us is one that should lie behind us."

Is Joss Whedon a feminist? The Tumblr page "Joss Whedon Is Not a Feminist" would argue not. So, too, would his ex-wife, Kai

Cole, whose essay that we discussed earlier stated au contraire in its headline: "Joss Whedon Is a Hypocrite Preaching Feminist Ideals." Whedon, himself, has always skirted the term. "I've said before, when you declare yourself politically, you destroy yourself artistically," he told *BuzzFeed* in 2015. "Because suddenly that's the litmus test for everything you do—for example, in my case, feminism. If you don't live up to the litmus test of feminism in this one instance, then you're a misogynist. It circles directly back upon you."

He was less reticent to use the term with regard to the series, calling it a "feminist show that didn't make people feel like they were being lectured to" in 2017.

There are a number of quotes about the series from Whedon that, when revisited with rose-colored spectacles smashed and obliterated, read very differently. "The idea was, let's have a feminist role model for kids," he said in a 1999 interview. "What's interesting is you end up subverting that. If she's just an ironclad hero—'I am woman, hear me constantly roar'—it gets dull. Finding the weakness and the vanity and the foibles makes it fun." And then he adds this: "From the beginning, I was interested in showing a woman who was [take-charge] and men who not only didn't have a problem with that but were kind of attracted to it." There's not only this equal weight given to the male gaze on the character but this idea that the men in Buffy's life couldn't appreciate her in a non-romantic or non-sexual way.

A year later, in a 2000 interview with *Rolling Stone*, Whedon said this: "I definitely think a woman kicking ass is extraordinarily sexy, always. If I wasn't compelled on a very base level by that archetype I wouldn't have created that character. I mean, yes, I have a feminist agenda, but it's not like I made a chart."

Whedon has long credited his feminism to, of course, his mother. "She was an extraordinary inspiration," Whedon said of his mother in a 2005 interview. "[She was] a radical feminist, a history teacher and just one hell of a woman. What she did was provide a role model of someone who is completely in control of her life. It was only when I

got to college that I realized that the rest of the world didn't run the way my world was run and that there was a need for feminism. I'd thought it was all solved. There are people like my mom, clearly everyone is equal and it's all fine. Then I get into the world and I hear the things people are saying. Then I get to Hollywood and hear the very casual, almost insidious misogyny that just runs through so much of the fiction. It was just staggering to me."

This was, throughout much of his career, one of Whedon's key selling points. He was outspoken in distancing himself from a faction of "geek culture" that view(ed) women as being in servitude to men. He was "other" to the "othered," or so he sought to position himself. But even his beloved Slayer lore was rife with contradiction.

Consider this: The first Slayer, as it exists within the *Buffy* lore, was taken, against her will, by a group of men who chained her to the floor of a cave and, using powerful magic, imbued her with the heart, soul, and spirit of a powerful shadow demon. Slayers are trained and overseen by Watchers, who are predominantly men. When we do finally meet a female Watcher, she is promptly revealed to be evil and is subsequently killed off. In fact, women are constantly killed off on the show: Darla, Jenny Calendar, Kendra, Harmony, Maggie Walsh, Xin Rong, Nikki Wood, Joyce Summers, Katrina, Tara, Halfrek, and Anya—just to name a dozen. Men, more often than not, get to leave the universe of the show unscathed: Angel, Wesley, Oz, Riley, Giles.

A great example of the grace afforded to male characters often at the expense of female characters happens in Riley's exit. I could explain the circumstance, but *The Mary Sue*'s Natasha Simons explains it far better in her 2011 essay, "Reconsidering the Feminism of Joss Whedon": "Riley sexually undermines his girlfriend of over a year with a vampire, then delivers her an ultimatum that she must essentially get over it, or he's leaving on a jet plane, don't know when he'll be back again (never come back, Riley). She reacts with the appropriate level of scorn, before Xander, the Chronicler of Buffy's Failures, lectures her on her failure as a girlfriend to Riley, her lack of

adequate emotional support, her once-in-a-lifetime chance with this hulking cornfed sad sack—and she goes running after the helicopter like a dog in heat! It's truly infuriating."

This was, both sadly and obviously, in line with the television (and film) landscape of the time, and the belief often perpetuated throughout media that women were subservient to men, and to not be subservient was some sort of act of defiance. "This might be the male perspective on a female-driven show, but it was surprising to me and sad and infuriating that people were saying, 'Oh my God, the woman is competent in this show,'" says writer Doug Petrie. "It was like, 'Wait, that's the big surprise? Really?' And sadly, the answer is yes, that's one of the big surprises. As much as it was a feminist show, I don't remember ever approaching it as such. I remember approaching it as 'Buffy is an awesome hero. And she manages to cope with her own emotional pain while preserving and fighting for something greater than herself.' So I'm super proud to have my contribution to having moved that cultural needle a little bit for girls and women and boys and men everywhere."

The impact of the character's presence on young women, who for seven years watched Buffy contend with, fight, conquer, and sometimes come up short against demons both corporeal and internal, cannot be denied. I ask food writer, chef, and YouTube personality Claire Saffitz if the character had any impact on her own sense of female power or female empowerment. "I think yes, but in much more of a delayed kind of way," she says. "I think as a teen I looked at Buffy as someone who was like, 'Well, I'm never going to be like that.' But I do think it got me interested in being more physical as a person. I remember learning very early on that Sarah Michelle Gellar was a black belt, and that she did a lot of her own stunts and fight scenes, and I remember thinking, Wow, here is this little, tiny young woman. Her character is kicking ass, but *she* is also kind of kicking ass. Not that I ever took martial arts or learned self-defense, but I remember thinking, Oh this is something that I admire and want to emulate.

And I still feel that way as someone who feels fully embodied and in control of their body physically. I think that had a big impact—even as I was watching it for the first time."

Buffy's feminism, both the series and the character, is undoubtedly complex. Prove it? Okay. In Patricia Pender's essay " 'Kicking Ass Is Comfort Food': Buffy as Third Wave Feminist Icon," she argues that the show's final season features collective feminist activism unparalleled in mainstream television up to that time. "At the same time," she writes, "the series's emphasis on individual empowerment, its celebration of the exceptional woman, and its problematic politics of racial representation remain important concerns for feminist analysis. Focusing primarily on the final season of the series, I argue that Season 7 of *Buffy* offers a more straightforward and decisive feminist message than the show has previously attempted, and that in doing so it paints a compelling picture of the promises and predicaments that attend third wave feminism as it negotiates both its second wave antecedents and its traditional patriarchal nemeses."

For many of us who first discovered *Buffy* in our preteens or early teens, the series was a great entry point to feminism. Such was the case for writer Gabe Bergado, who notes his love of the idea that a woman was using the phallic symbol of a stake to take down vampiric men. "As I got older and read a lot of the forums and criticism I started to understand that, yes, this show is very much white feminism. Yet I think many of the protagonists on TV that we see now wouldn't exist without *Buffy*. So we can be thankful for everything that *Buffy* introduced us to while also still being critical. Women of color, for the most part, were treated so poorly on the show. I think with the Potentials it was kind of fun because you got to see the spectrum of femininity, but for the most part, beyond white feminism the show was pretty...not great."

Let's dig into that "white feminism," shall we? "Maybe twenty-five years ago, when the show was first airing, we could call *Buffy* a feminist show at its base level because it undoes the Final Girl trope—but

even then, the feminism is white; it doesn't serve Black or brown char-
acters," says writer DW McKinney, adding she would be hard-pressed
to call the show feminist today. "The way it treats its female-identified
characters, the way that queer characters are treated—I mean, Tara,
my God, everything involving Warren. No. The women on the show
had to be abused and mistreated to be empowered. It's built into the
lore: Slayers arise from the death of another Slayer. The power for
all of the women in the show, maybe with the exception of Joyce,
came from trauma. Buffy, Faith, Tara, Willow, Darla, Drusilla, Dawn,
Anya—they had to be brutally hurt to become the women that they
were. That reads more misogynistic than feminist to me. Is Buffy a
feminist character? I don't know. Whenever I think about her being a
feminist, I first think about her mocking and belittling Kendra."

> **Giles:** And you are called...?
> **Kendra:** I am de Vampire Slayer.
> **Buffy:** We got that part, hon. He means your name.
> **Kendra:** Oh. Dey call me Kendra. I have no last name, sir.
> **Buffy:** *[Haughty]* Can you say "stuck in the '80s"?

"I could certainly see a reading of the show that viewed Buffy's
ability to transcend the perpetual torrent of danger that inflicts the
lives of slayers where so many POC slayers had failed as highly prob-
lematic," says Professor Lowery Woodall. "There is a white savior/
white exceptionalism narrative that seems to be mummering under
the surface of that history."

And yet this was a show that featured a number of strong,
empowered women outside of the character of just Buffy herself,
from her friends to her colleagues to her enemies all the same. So
perhaps *Buffy* is less a feminist masterpiece so much as it is a show
that widened the scope of possibility for the television landscape that
came in its wake. Actor, writer, and former *Rookie* editor in chief Tavi
Gevinson was born a year before *Buffy* first aired and discovered the

show in high school at the behest of a colleague. "I was really into it because it was when I was also having a teen witch phase and there was so much good '90s supernatural pop culture," she says. "But I didn't stick with it because genre-wise it's not what I gravitate towards most." Still, she gravitated toward the show's overarching themes, even after she stopped watching episodically in the show's second season. "I was very into the idea of the thing that makes you unique or the thing that gives you unique insight can also be something that is isolating, or can be a source of distress."

Though she's not a completist of the series (not *yet*, I remind her), I'm curious as both a pop-culture consumer and a pop-culture creator herself, how or where she sees *Buffy* within the landscape of great feminist pieces of art. "I don't think of TV shows as art," Gevinson starts by telling me. "I think some TV shows are art, I think some movies are art, but I think of them as a whole as art hyphen products because ultimately—and I say this as someone who is starring on one—even if you are the showrunner and it's your vision, you're answering to executives who are answering to advertisers. and I think that makes it more commerce than art."

That doesn't mean that it's not a creative expression, she stresses. "I point this out because I think to some extent, because we're ultimately talking about pop culture and commerce, there are ways in which shows like *Buffy* are really influential and ahead of the curve, or ahead of the rest of Hollywood, but can still be behind in terms of reflecting the world around them." In other words, it could be viewed as equally ahead of its time and behind the curve. It's not that some people view it one way and others view it another way, but rather that some of those people hold space for both truths.

Buffy, as I imagine you've concluded by now, is one of those shows that was both. "It made so many young women feel seen and at the same time, as we know, being able to make something with powerful female characters doesn't preclude the ability to commit workplace abuse," says Gevinson. "You can kind of take any figure like Joss

Whedon and look at their art and look for clues into their psyche and their personal politics. I generally am not a fan of that exercise, as I think it undermines the experiences of the people that were subject to that alleged abuse. I think their testimony should be enough. I'm excited that increasingly it seems that the idea of making a feminist show goes beyond just quote-unquote empowering or empowered female characters. It can entail a whole vision that is feminist that's beyond just inclusion." Still, Gevinson cites *Buffy* and its performers broadening the scope of how women could be onscreen as one of the reasons why these shows like *I May Destroy You* or *Pen15* can exist today.

What Gevinson seems to question in looking at *Buffy* as a springboard for today is whether a feminist show, or a queer show even, can be more about the vision and the actual storytelling than just representation. In other words, do they convey visionary change as opposed to cosmetic change? It's the difference between Buffy *kicking* butt and Buffy *being* a butt-kicker. Subtle, but distinct.

There's the textual feminism implicit from the outset of a young girl "taking back the night," and then there's what allegedly happened behind the scenes that was made public in 2021. Those public accusations by Charisma Carpenter, Amber Benson, and Michelle Trachtenberg, along with those of Kai Cole in 2017, can be viewed as a form of these women's own self-empowerment. "Is *Buffy* a feminist show?" can almost be seen as the wrong question to ask, since yes *and* no are correct answers. Perhaps the better question to ask is in what ways did this show reshape the way we think about and the conversations we are having about female empowerment?

Gay Now, Gay Then

"I am watching *Buffy the Vampire Slayer* again," *RuPaul's Drag Race UK* Season 2 runner-up Bimini Bon-Boulash declared on an Instagram Q&A in June 2021. "That's one of my faves just because it made me queer I think."

Buffy, the show not the character (although maybe the character, we'll get to that), was queer before queer was cool. It explored queerness through its characters and their relationships as well as implicitly through themes of outsiderness and secrecy. There were nuanced queer characters and queer relationships, and ones that just *felt* queer.

> **Cordelia:** So, are you dating somebody or not?
> **Buffy:** I wouldn't use the word "dating," but I am going out with
> somebody. Tonight, as a matter of fact.
> **Willow:** Really? Who?
> **Faith:** *[Appearing out of nowhere]* Yo, what's up? Hey, time to motorvate.
> **Buffy:** Really, we're just good friends.

"As a whole, *Buffy* is an immensely complex text with content that truly caused people to reconsider what is and isn't queer," writes Nicole Grafanakis in her essay "The Queer Influence of *Buffy the Vampire Slayer*." "The show challenged people to redefine the socially constructed notions of acceptable gender and sexual performance." It's in statements like this that I can't help but be reminded of that familiar refrain, the minimization of *Buffy* as a teen show about

vampires. Sure, it's that—and there's nothing wrong with that. Sure *and* it's so much more, as Grafanakis shrewdly argues.

As my friend Johnny Atorino notes, himself a thirtysomething gay *Buffy* devotee (we're everywhere!), the show came out at a time when there wasn't another show that portrayed the misfits/outcasts in high school in such a specific and nuanced way. "*The Craft* comes to mind, but that was a movie and has such a different spin on the misfits. In *Buffy*, they depicted high school as *literal* hell for the Scoobies. There wasn't a show at the time that allowed the misfit so much agency while also depicting such a lack of agency in the eyes of their peers. The show has lasted so long because no superhero show, no show about witches (like *Charmed*, which is often rudely compared with *Buffy*—look, *Charmed* is great, period; *Buffy* is great, exclamation point, and that's a nuanced but important difference)...no high school queer/misfit show has done what *Buffy* did and continues to do: allow the adolescent queers to not only find one another and empower one another but then to fight their demons inside the halls, outside the halls, and under the halls of their high school."

For many of us, myself included, the show helped us to visualize our future selves, allowing us to see queerness in all of its nuances, and existed in a world in which queerness was not othered. "It was the first time I saw a show where the queer characters were fully developed," says writer Gabe Bergado. "I knew of gay celebrities—there were headlines like 'Is Ricky Martin gay?' and I remember the original *Queer Eye* cast—but it was exciting to see characters like Willow and Tara change over the seasons, have their heroic moments along with their mistakes, and of course, cast spells to take down demons."

The actors, too, recognized the significance of this moment. "I knew it was important to have a lead character who was gay because so often, at that time, it was the forced friend," says Gellar. "Not to us—I don't want to say it wasn't a big deal, it's always a big deal when you're breaking ground, but it wasn't a big deal in that sense that it was more, 'Oh she's gay? Great.' I think we were proud to tell the story,

but even more proud in people's reactions to it. And I'm proud of the show for helping to normalize something that should be so normal as opposed to so often on television shows where it's like the 'special episode' and everyone discusses it. That's not the world that *we* live in, meaning those of us who worked on the show. We were living in a world where someone comes out and says they're gay, it's just 'Okay, great.' All anyone should ever care about is that the person that you're in love with is a good person and that they take care of you. That, and Oz cheated on her. Tara was good to her."

I didn't yet know I was gay when I started tuning in to *Buffy*. I didn't know much at all, really. It was all very "fire bad; tree pretty" in terms of my slow-burgeoning worldview. But I remember, so vividly it's somewhat jarring, watching Willow and Tara clasp hands in the very first episode in which Tara is introduced. It's so obvious watching it now exactly what that moment tells and foreshadows. But like Willow, I didn't know that there were parts of me that were being repressed or maybe were just still developing. With the show, I was able to live in a paradigm so apart from the world around me, one in which queer was powerful, that I felt immediately aware of and emboldened by the many signs of otherness that had presented themselves throughout my life.

"It was my favorite show," says writer Drew Z. Greenberg, who started watching *Buffy* while he was attending law school in the Bay Area. "*Buffy* was my relief from having to deal with that craziness. Five years later, he would meet with Joss Whedon and Marti Noxon the morning after the Season 5 finale aired. "I had literally watched the show the night before, watched Buffy die, and then I walked into the meeting for this potential job and I was like, 'What are you guys doing? What's happening? How is she going to come back?'" It was a full-circle moment for Greenberg, sitting in a room with his heroes, talking about his favorite show.

Like Noxon, who he could not believe was sitting before him, it was his first job. And as such, he felt the pressure. "Joss's standards are

high and you want to make him proud and do right by the show." They took a chance and hired him to write Season 6, Episode 9 ("Smash"). It went well. They asked for another. "I remember after I turned in my second episode we had been nominated for some award, so we went to this thing—and we didn't win, I'm sure, that was our story on that show—and we were all sitting around in our tuxedos and Joss pulled me over to the side of the room and says, 'By the way, I read your script. Welcome to the family.' And I gulped. It could not have been more perfect. It was a scene out of a movie. I had made him proud."

Greenberg would become the first and only out LGBTQ+ writer on the series. ("Television writer Jane Espenson isn't gay, she just writes that way," read the opening line of a 2011 Espenson profile in *The Advocate*.) That would end up playing a significant role in his approach to the writing. "To place it all in context, 2001, 2002… slightly different time than it is now and yet not that long ago," he says. "I knew that the whole Willow/Tara relationship was ground-breaking and that the kiss in 'The Body' was a first in so many ways. And so I knew that I was a part of a show that hadn't been done before and was continuing to do something that hadn't been done before, so yes, I felt a certain sense of responsibility."

I assumed it must have been challenging at times, watching a room full of heterosexual writers crafting a nuanced gay love story. I thought wrong. "I could have stood up and screamed, 'I know best,'" he says. But he didn't. Because he didn't need to. "It wasn't that kind of environment because Joss was really interested in doing the right thing, and that was the sense that I got while I was there. Joss and Marti were very in tune and very good allies, especially in terms of where we were as a culture back then."

I ask for an example. Greenberg cites his first episode, wherein Willow goes to a bar with fellow witch and longtime recurring character (sometimes a rat) Amy Madison, and they get drunk on magic power. About Amy: played by actor Elizabeth Ann Allen, she appears

on every season of *Buffy*, with the exception of Season 5. We meet her in Season 1, Episode 3 ("Witch") as an outcast Wiccan at Sunnydale High who befriends Buffy and Willow. She pops up briefly in Season 2 before returning in Season 3 and, trying to escape a group attempting to burn the town's witches at the stake, turns herself into a rat. But then, being a rat and all, is unable to remove her own spell. She cameos briefly in Season 4 when Willow turns her human without realizing before reversing the spell, and she returns to her full human form when Willow, a witch powerful enough to take on a hell god, finally figures out the spell. *Huh?* Let's just leave it there. Newly human, Amy wants to go out, and so she and Willow head to the Bronze.

Shortly after arriving, Willow gets harassed by a pair of drunk heteros for being gay. "In my first draft that I wrote, Willow waves her hand and the two guys that are bullying her can't stop making out with each other," says Greenberg. "I was like, 'Grrr, gay avenger, grrr.' And Joss said, 'I see what you're doing here with that. I understand it. And I don't want to do it. Here's why. There are two reasons: One, I don't want to ever say that a person's orientation can be changed with the wave of someone's hand. You are who you are. And two, I don't ever want two guys making out to be seen as a punishment.' And I was like, 'That's pretty good.'" He laughs. "In that moment I was like, 'You're a better gay man than I am...even though you're not.'" It would prove to be a pivotal moment of understanding for Greenberg, the realization that though he was an outlier in the writers' room, he was amongst storytellers who were thinking about others' lived experiences with care.

But Willow and Tara were hardly the token gays of Sunnydale. There were a number of other LGBTQ+ characters introduced into the Buffyverse. First up, in Season 2 we meet Larry. In Episode 15 ("Phases"), he comes out for the first time when approached by Xander in the locker room, who thinks Larry is hiding the fact that he's a werewolf. The ensuing tête-à-tête is *Buffy* at its Buffiest.

Xander: I know your secret, big guy. I know what you've been doing at night.

Larry: You know, Harris, that nosey little nose of yours is going to get you into trouble someday ... *[He grabs Xander by the shirt.]* Like today.

Xander: Hurting me isn't gonna make this go away. People are still gonna find out.

Larry: *[Lets go]* All right. What do you want? Hush money? Is that what you're after?

Xander: I don't want anything! I just wanna help!

Larry: What, you think you have a cure?

Xander: No, it's just ... I know what you're going through because I've been there. That's why I know you should talk about it.

Larry: Yeah, that's easy for you to say. I mean, you're nobody. I've got a reputation here.

Xander: Larry, please, before someone else gets hurt.

Larry: Look, if this gets out, it's over for me. I mean, forget about playing football. They'll run me outta this town. I mean, come on! How are people going to look at me after they find out I'm gay?

[Xander looks at him in astonishment. Larry looks like a heavy burden has just been lifted and smiles.]

Larry: Oh, wow. I said it. And it felt ... okay. *[Whispers to self]* I'm gay. *[Louder]* I am gay.

In Season 3 we meet Scott Hope, a potential rebound for Buffy after she put a sword through her lover, Angel, and sent him to a hell dimension. Buffy and Scott's fling quickly fizzles, but in Season 7 we learn that their failed connection might have been for reasons out of Buffy's control.

Holden: I heard a lot of rumors about you back then. You were all mysterious.

Buffy: I was?

Holden: Well, you were never around. A lot of kids thought you were dating some really old guy, or that you were just heavy religious. Scott Hope said you were gay.

Buffy: What? I dated that ringworm.

Holden: He says that about every girl he breaks up with. And then last year, big surprise, he comes out.

And in Season 7 we meet Kennedy, Willow's girlfriend following the untimely death of Tara.

So those are the five major LGTBQ+ characters on the series. Sort of. We need to talk about Andrew. Andrew Wells is introduced at the beginning of Season 6 as a member of the Trio. There's a small Easter Egg moment in his second appearance.

Jonathan: I need you to hold hands.

[Warren holds out his hand to Andrew, who recoils.]

Andrew: With each other?

Warren: Well, you know what homophobia really means about you, don't you?

Later that season, in Episode 18 ("Entropy"), Andrew lets off another indicator by accident. The Trio has placed cameras in the occult shop run by Giles and Anya, the Magic Box, to keep an eye on the Scooby Gang and end up catching Spike and Anya having sex.

Jonathan: Oh my God.

Andrew: What are they...ohh.

Warren: Is that—

Jonathan: Spike.

Andrew: *[Riveted]* He is so cool. *[Glances at the others, self-consciously.]* And, I mean, the girl is hot too.

In Season 6, Episode 19 ("Seeing Red") after Warren kills a demon, Andrew says it was "so hot." More small but pointed moments follow, like in Season 7, Episode 14 ("First Date").

Xander: I'm going gay. I've decided I'm turning gay. Willow, gay me up. Come on, let's gay.
Willow: What?
Xander: You heard me. Just tell me what to do. I'm mentally undressing Scott Bakula right now. That's a start, isn't it?
Andrew: *[Wistfully]* Captain Archer... *[He nods]*

Andrew is what *Gender and Sexuality in Star Trek* author David Greven calls a "quasi-allegorical gay male character," in that he's never explicitly identified (self- or otherwise) as gay, but is implicitly gay. Even Tom Lenk, who would play Andrew for twenty-eight episodes, making him one of the most frequently recurring characters on the series, still to this day isn't 100 percent clear on Andrew's orientation.

"When I auditioned for the role, Andrew was not written as a gay character," says Lenk, who is himself openly gay. "Back then, and frustratingly even for the most part today, characters are all straight unless otherwise specifically labeled gay." Upon starting work on the show, Lenk assumed he was playing a straight, comic-book-obsessed, evil-ish nerd, like his other two cohorts, Warren and Jonathan. For Lenk, Andrew's infatuation with Warren and then later Xander seemed like it lived in a very fanboy idolization zone. "But then when I think about straight-guy fanboy/comic book culture— grown adult hetero bros obsessing over very hot, ripped superheroes, in form-fitting spandex unitards—it all seems very gay to me now," he says.

You could also theorize that the character didn't know he was gay, says Lenk. "But also if he *was* gay... make him *gay*. There's so many layers to it and I think that's why I've gone through so many various relationships with the fandom. I have many seemingly important

theoretical ideas that I could sum up in a queer studies program master's thesis paper in and around this topic, and also the other part of me says, 'You want my character to be gay? He's gay.' It doesn't matter what my internal acting 'process' was or what I imagined my 'motivations' to be. The fun part about watching TV is getting to project thoughts, feelings, and emotions onto the characters you are watching. I am constantly projecting gayness onto all sorts of characters. Hello, *Bridgerton*?! Also, I only watched the episodes once in order to see if my hair was okay (YES I KNOW, SOMETIMES IT WAS NOT!), so my ideas about the character are all based on what I read and thought and felt while we were filming it, and not necessarily reflective of how the average viewer sees it as the end product."

Andrew, as it turns out, is canonically gay, as the character comes out in the comic books that continued the series. For Lenk, the varying relationships with the fandom he references come from years of waffling between leaning into the character's queer legacy and wanting to distance himself. Why? "At that time it was, 'You play one gay character and you will now very likely play gay characters for the rest of your career.' And why is that frustrating? There's less opportunity because there's less gay characters. So at that point in my career I think it was frustrating to be dealing with that because as an actor you just want as much opportunity as you can get."

Perhaps my favorite queer moment on *Buffy* is not, in fact, a queer one, but rather one wrapped in metaphor. "One of the scenes that meant the most to me as a young gay watching the series was when Buffy 'comes out' to Joyce about being a Slayer," one fan, Richard Curcio, wrote to me when I was looking around for fan-favorite moments. "Did you feel that scene mirrored coming out to parents as LGBTQ+ the way I did?"

Raises hand emphatically.

As Patricia Pender writes in *I'm Buffy and You're History: Buffy the Vampire Slayer and Contemporary Feminism*, "There is reason to suggest that the series is most queer when it is not directly addressing

explicitly homosexual content." Such is the case in the finale of Season 2, in the scene Curcio referenced. Up to this point, Buffy has kept her identity as the Slayer a secret from her mother. Worried about Joyce's safety, Buffy comes out to her stunned mother. "Honey, a-are you sure you're a vampire slayer?...I-I mean, have you tried *not* being a Slayer?" All that I, who watched this with my knees clenched to my chest in my childhood bedroom, could hear was, "Honey, a-are you sure you're gay?...I-I mean, have you tried *not* being gay?"

Trying to make sense of it, Joyce concludes: "It's because you didn't have a strong father figure, isn't it?" Buffy counters: "It's just fate, Mom. I'm the Slayer. Accept it."

Joyce refuses. She's angry. She's confused. She's unsure. Buffy, meanwhile, is trying to save the goddamn world...again. And so mother and daughter have it out.

> **Buffy:** I'm sorry, Mom, but I don't have time for this.
>
> **Joyce:** No! I am tired of "I don't have time" or-or "you wouldn't understand." I am your mother, and you will *make* time to explain yourself.
>
> **Buffy:** I told you. I'm a vampire slayer.
>
> **Joyce:** Well, I just don't accept that!
>
> **Buffy:** *[Steps closer]* Open your eyes, Mom. What do you think has been going on for the past two years? The fights, the weird occurrences. How many times have you washed blood out of my clothing, and you still haven't figured it out?
>
> **Joyce:** Well, it stops now!
>
> **Buffy:** No, it doesn't stop! It *never* stops! Do-do you think I chose to be like this? Do you have any idea how lonely it is, how dangerous? I would *love* to be upstairs watching TV or gossiping about boys or...God, even studying! But I have to save the world...again.
>
> **Joyce:** No. This is insane. *[She takes Buffy by the shoulders]* Buffy, you need help.

Buffy: *[Throws off her mom's arms]* I'm *not* crazy! What I need is for you to chill. I *have* to go!

Joyce: No. I am not letting you out of this house.

Buffy: You can't stop me.

I was nine years old. Unaware of my homosexuality, but deeply aware of an innate but unconscious knowing of what could not yet be known. "I, too, had a response and mine was not unconscious," says writer Drew. Z Greenberg, who had not yet joined the show. "It was 1998 and I was at that point out, but kinda newly out, and I saw that and thought, 'Oh these guys are clever.' It was obviously not trying to hide what the conversation was. And I hadn't seen that before. We always felt on some level as queer people that Buffy represented us—at least, I did. There was this thing of having to hide who you are from your classmates but also the idea that *you* know that who you are isn't bad. You know that who you are actually makes you special. That's what you hope all queer people feel. We don't. But you hope that's what we feel. For them to take that then and have that conversation with her mom where they use the language against her? Yeah, I had a reaction to it. It felt like somebody saw me. It felt like this show belongs to us."

It would happen again, in Season 3, in even less coded language when Joyce learned that her daughter had died the previous year.

Joyce: When did you die? You never told me you died.

Buffy: No, it was just for a few minutes.

Joyce: *[Starts to pace nervously]* Oh, I hate this. I hate your life.

Joyce: *[Faces Buffy]* Look, I know you didn't choose this, I know it chose you. *[Takes a breath]* I have tried to march in the Slayer Pride parade, but I don't want you to die.

"Buffy's arc as the Slayer and the concept of having a relationship as the Slayer with a vampire and the vampire has a soul...it's all so

queer," says Kristin Russo. Russo and her *Buffering the Vampire Slayer* co-host, Jenny Owen Youngs, asked Kristine Sutherland (who played Joyce) about this very moment when they had her on the podcast, asking what the conversation on-set was like about this being a parallel to queerness. "She didn't recall that being a part of the conversation, but it is so blatantly that. And I think it's brilliant. Any show that's rooted in a fantasy-horror space gets that incredible power to do that. And obviously we're two queer women watching the show, so we're gonna be like, 'Hell yeah!' But I think that a lot of people who might not be able to understand the experience or who maybe wouldn't sit down to watch a story about a queer girl coming out to her mom might be able to digest that moment in a way that's more relatable and maybe they have a bit more vulnerability going into it to learn some things on the way through."

"Sure, the 'coming out' moment with Buffy's mom is great, but have you ever seen Buffy and Faith running around the Bronze together?" Owen Youngs quips. "After that, no doubt they were running right to the queer bars," Russo adds. I don't doubt it. And many a lesbian fan fiction would corroborate that and more.

Herein lies an example of Whedon educating himself and admitting his cultural blind spots. When Whedon first learned of fans picking up on a lesbian subtext between Buffy and Faith, he was irritated. In his mind, he had written it one way and for fans to perceive it another way could only mean one thing: They were wrong. "I was like, 'You guys see lesbian subtext behind every corner, you just want to see girls kissing—get over it,'" he recalled during a 2009 NPR interview. But after a fan directed Whedon to their website in which they dissected Buffy and Faith's relationship, "I went on it, and came back and apologized. It was like, 'Everything you said is true. It's all right there.'"

Funnily enough, Buffy, the character, would have a real-life coming-out of sorts five years after the show concluded. "Buffy Summers is all confidence in fighting the forces of darkness," reads a 2008 *New*

York Times story. "But she's often shakier in her intimate relationships...Her liaisons include Angel, a vampire who is arguably her true love; Riley, a military operative who combats the supernatural; Spike, another vampire; and Parker, a fellow college student and one-night stand. In a new issue of the *Buffy the Vampire Slayer* comic book series, being released Wednesday, Buffy sleeps with a fellow slayer. And, oh yeah, she's a woman." Satsu, one of the Potential Slayers activated (but not seen) in the series finale, shares an intimate moment with Buffy.

Is Buffy gay now? Bisexual? Pansexual? Prefers not to label herself? "We're not going to make her gay," Whedon told the *Times*, "nor are we going to take the next 50 issues explaining that she's not. She's young and experimenting, and did I mention open-minded?...I wouldn't even call it a phase...It's just something that happens."

His seemingly progressive statement got derailed by his follow-up, in which he trivialized Satsu's life in an attempt to poke fun at the way the show/comic constantly kills off beloved characters. "We're not going to dump her off the face of the earth, unless we kill her, because we love to kill characters. If we do, don't worry, she'll probably come back as a ghost. She's in the rotation...For as long as she can live."

When asked about any fear of a similar backlash to the death of Tara that he could face if he chooses to kill off Satsu, Whedon was characteristically cavalier: "It's something you have to factor in," he said, noting that he discovered the "bury your gays" trope only after Tara's death. "You do have to be careful about the message you're sending out. It's a double-edged sword. You have to be responsible, but you also have to be irresponsible or you're not telling the best stories."

Was *Buffy* a groundbreaking show for queer visibility and representation? Inarguably. "In context, in that time, it was indeed," says one of the most prominent casting directors within the fashion industry, James Scully. "Most young gay people look back now at that time and rag on *Will & Grace* and shows like that, but you have to

understand the context of that time. People hated us. This was the Bush years. We weren't out the way we are now. And especially kids of that age, who were really watching *Buffy*. You could identify with her because she was an outsider and a loner. Even though she had friends, it was a group of outsiders. And then when Willow came out years later, that was a real blockbuster. I couldn't believe they were doing this. It all seems so normal now, but at the time it wasn't."

He continued: "I grew up with a generation of men and women who fought for us and then died. And I remember growing up thinking you would never have any representation, that media would not be something in which I would see myself. And the fact that I was already into my thirties when this show came out thinking, Wow, I cannot believe that teenage kids are getting to watch this, and that's *normal*. Whereas when I was a kid, the only character that was gay that was on television that I can think of was the drag queen Beverly LaSalle on [*All in the Family*], who they never knew whether she was a drag queen or trans or male or female and ultimately gets murdered in a fag-bashing, and the other was Billy from *Soap*. And *Soap* was broadcast after midnight, so that was all you got. So those storylines on *Buffy* seemed like a real push. It wasn't just a kid coming out and going away. They made it a part of the storyline until the end, which I think was really important."

And lest we forget the many of us of all genders and sexualities who wanted to *be* Buffy, Buffy in her crop tops, her tight pencil skirts, her seemingly never-ending bounty of patent leather jackets. She was and is and always will be the ultimate. "In my experience growing up gay, I was conditioned to hate the feminine qualities in myself, from the way I talk to the way I walk and everything in between," says Matías Franco, a *Buffy* superfan known on Twitter for his supercuts of the series. "So just to watch women simply be able to fully embrace their femininity has always resonated with me. And on *Buffy*, they were able to do all of that and then some."

"I do remember when costuming for Alyson [Hannigan] and

Iyari [Limon]'s characters, I wanted it to be, for lack of a better word, normal," says costume designer Matt Van Dyne, echoing a similar sentiment from Gellar. (Limon, it should be noted, played Kennedy, a Potential Slayer and love interest to Willow in the show's final season.) "It's funny when you talk about me being a gay man working on the show. I never—and it might have been to my detriment—[I] was very blind to the homophobia in the industry over the years. Not because I was naïve. To me it was always 'Being gay? What's the big deal?' To me it wasn't. I'm just me. And I would bring that to the work that I did, especially with gay characters. They're just who they are. Celebrate that."

I ask Emma Caulfield what she feels is her greatest accomplishment on the show. She immediately mentions her gay fandom, which I proudly count myself among. "Somebody had recently said, 'You're kind of like a gay icon and I was like 'Am I?'" As Caulfield imitates their adamant yes response, our voices overlap as I let out my own affirmative yes that happens to sync with hers. "Oh my gosh. Well, thank you. Like, that is like the best compliment. Then they actually explain, like, 'Well this is why: you checked these boxes, which puts you in this distinguished category.' And I'm like, of all the categories this is by far my favorite one. So that just fills me with great joy."

Buffy hits differently for LGBTQ+ people; it just does. And I'm not talking about just gay men, as can often be the case with certain pop-culture relics. I really mean the whole of our beautiful community. Why is that? I ask my friend Johnny:

"It's important to not shrug off the 'queer person has a secret' trope that's in *Buffy* that speaks so loudly to many in our community. 'The queer has a secret power' is so special for kids and is revisited time and time again in YA novels and in shows. I watched this show when I was in the closet and then out of the closet. I was able to have a *Buffy* poster above my bed, have the 'Bite Me' book out on display, or ask my mom to tape *Buffy* on TV for me when I was at choir practice late and I could 'pass.' My secret was still safe 'cause it was a pretty

girl from TV. But us queers all knew what we were watching. We were watching a queer with a secret slay her demons throughout high school and growing up, hiding and dodging danger almost daily, all the while her mother was just hoping she was adjusting well to a new town. We watched the queer Scoobies navigate a landscape that was vicious and fun at the same time: high school and hell on Earth. We were watching *us* in so many ways. We knew, Mary. No high school show was doing that. At least, not starring the misfits, the weirdos... the ones that are sometimes popular and sometimes not. Sometimes invisible and sometimes the center of conflict and drama."

We knew, Mary. We knew.

The Caucasian Persuasion

"It's kind of upsetting," Amber Benson says when I bring up the topic of *Buffy* and race. "I feel like that's consistent with the times, but it's a failure. It is an absolute failure." While the show is often considered quite progressive in its views on gender roles or sexuality, when it comes to race, ethnicity, and nationality, the show is at best ignorant and at worst harmful in its depiction (or lack of depiction) of people of color.

"You asked has the show aged well, and I thought to myself, 'Not color-wise,'" says Clare Kramer. "There were barely any minorities on this show." Among the show's twelve official cast members, there were no people of color. The writers' room, too, consisted of all white people. It's not to say the Buffyverse was entirely devoid of POC, but it's worth meditating on how few there were—and the stymied roles they played.

Here are the Black characters on *Buffy* in order of first appearance, and with a parenthetical around the number of episodes they appear in: Absalom (1); Kendra Young (3); Mr. Trick (5); Olivia Williams (3); Forrest Gates (12); Sineya (3); Nikki Wood (3); Sweet (1); Robin Wood (14); and Rona (9). Other POC characters that recurred on the show in order of first appearance, and with a parenthetical around the number of episodes they appear in include: Ampata Gutierrez (1); Xin Rong (1); Carlos (1); Kennedy (13); Chao-Ahn (7); Lissa (1); and Caridad (3).

"There was a lack of humanity, grace, and complexity shown to non-white characters on *Buffy*," remarks author and columnist DW

McKinney. "When Slayers weren't blatantly exoticized like Kendra or the one Asian Slayer who shows up in—surprise!—China of all places, they were reduced to gross stereotypes. The First Slayer was a Black woman who was enslaved by the first Watchers Council who moved around creeping and skittering like a creature. She embodied basic primitivism. Kendra came from Jamaica, which, given all the places she could've come from, Jamaica in this case represents a superficial understanding of Blackness. Whedon appealed to a capitalist and consumerist understanding of Blackness. The Slayer came from a country that is readily identifiable to white Americans, a country where Blackness is palatable and easily accessible as much as it is exoticized. I can't even say it's an accomplishment that most of the non-potential Slayers were Black because it shows a lack of creativity, an inability to imagine Slayers beyond a racist duality."

And speaking of representations of Blackness in the show overall, we saw these stereotypes in the villains, too, she says, mentioning Forrest, Mr. Trick, and Sweet as prime examples. "These reductive ideas of Black characters, and of characters of color, show a general disinterest in depicting their complexities. They weren't given the same humanity and relatability as the other main, white characters. Each member of the Scooby Gang could have been substituted with a non-white actor. In some ways, if that were the case, the storylines and revelations would have been more significant."

According to Danny Strong, who won an NAACP Image Award for writing and producing *Empire*, the lack of diversity on *Buffy* is a symptom of the lack of diversity that existed all over television at that time—and continues to happen today. "Joss not having diverse content and not having a diverse writing staff comes from that not being a priority in the storytelling. That's an assumption I'm making, but, you know, you look at the staff and everyone's white, right? That happens when you make no or very little effort to have an inclusive staff." Just how white was the *Buffy* writing staff? There are twenty-five writers who receive credits throughout the show's 144 episodes.

Twenty-four of them are white. Diego Gutierrez, the only writer of color to write for the series, wrote only a single episode ("Normal Again") and was not a part of the writers' room.

Cynthia Erivo agrees that the past-tense conversation about *Buffy* and race still exists in the present tense across aspects of the industry. Even still, the conversations and advancements in prioritizing diverse storytelling were in no way where they've progressed to today.

"There was something weird happening in that late-'90s, early-2000s time where shows just really didn't know what to do with Black characters," says Erivo. "It was like there was an *idea* of what Black people were like as opposed to 'Hey, come and have an experience with us and maybe talk us through what we could possibly do with your character.' Or 'Can we have an understanding of what your experience is like as a person?' No questions were being asked. A lot of these shows were being made by straight white guys; they are clearly going to struggle with white women's roles, and then you give them the task of trying to figure out anything for Black women and it's often coming up short, or feeling one-dimensional, like they are either good or they're bad. And if they're bad, they're really bad. Mostly, they're really bad. There was no time taken to really dig into the stories of young *Black* women, and I'm always so confused as to why, especially on a show like *Buffy*, because it's a fantasy, it's make-believe, so you really can do anything. Where the possibilities are endless, why wouldn't you seize that opportunity?"

I decided to seek out K. Todd Freeman, who played Mr. Trick in Season 3 and was the first recurring Black actor to be featured on the show. "I was relieved that I thought I fit in with the whole world and the milieu," says Freeman about watching back his very first appearance on the show. Freeman was a stage veteran who appeared as Belize in a production of Tony Kushner's *Angels in America* and was Tony nominated for the 1993 production of *The Song of Jacob Zulu* on Broadway prior to coming on *Buffy* in a recurring capacity. "I didn't stick out like a sore thumb, which is one of the things that you're always worried about."

In Mary Ellen Iatropoulos and Lowery A. Woodall's book *Joss Whedon and Race* they successfully attempt to unpack why conversations reflecting on the show's overwhelming whiteness are so important. Throughout the book, which examines Whedon's work from *Buffy* to *The Avengers*, they demonstrate how critical race theory can be a viewer's tool for social justice. "We hope to turn the conversation away from individual blame and back onto the issue of race and representation, onto the larger cultural patterns of oppression in which our beloved characters inadvertently participate, even when they don't mean to, especially when they don't mean to. Because…in the unintentional we can see the institutional."

This lens is critical, which is to say *Buffy* had a race problem, *but* it's a problem the creators likely weren't aware of, actively thinking about, or trying to combat, *and* that's a problem.

"Are there aspects of the show that you watch now, some twenty-plus years later, and cringe?" I asked Jane Espenson, who wrote or co-wrote twenty-three episodes of the series. "The whiteness," she responds. It's a whiteness not just felt in the absence of characters and writers of color, but one that permeates the series. Race, ethnicity, and nationality exists within the universe of the series, albeit at the margins, and it is through the relative lack of characters of color in Sunnydale (again, meant to embody Everytown, America, according to Whedon) that the show must be examined.

Let's take, for instance, a throwaway moment late in Season 2. Willow is discussing the pressure being put on her by Principal Snyder to raise the grade of one of the swim team members. (Willow is subbing in as a computer science teacher in the wake of Ms. Calendar's death—why the district couldn't hire an actual substitute teacher is a conversation for another day.) "I'm interested in why, when this school is on the brink of winning its first state championship in fifteen years, you slap a crucial member of that team with a failing mark that would force his removal. Is that how you show your school spirit?" Snyder asks her.

Later, Willow is discussing this not-so-veiled threat to her friends. "That is wrong, a big, fat, spanking wrong," Xander tells her. "It's a slap in the face to every one of us who studied hard and worked long hours to earn our D's." And then Cordelia, never the Rhodes scholar, interjects. "Xander, I know you take pride in being the voice of the common wuss, but the truth is, certain people are entitled to special privileges. They're called winners. That's the way the world works." Xander pushes back. "And what about the nutty 'all men are created equal' thing?" he asks. "Propaganda spouted by the ugly and less deserving," she counters. "I think that was Lincoln," Xander says, attempting to get the last word. "Disgusting mole and stupid hat," she responds. Willow well-actuallys the situation by letting them know it was, in fact, Thomas Jefferson. "Kept slaves, remember?" Cordelia adds, this time successfully getting the last word.

"Here Cordelia connects the episode's narrative (Season 2, Episode 19, "Go Fish") to larger systems of institutionally condoned oppression, linking the racist selectiveness of the founding fathers to the 'special' treatment received by the swim team at Sunnydale High," write Iatropoulos and Woodall. It's an apt comparison, but one that's immediately steamrolled by more "pressing" matters—that is, how this affects Xander. "You know what really grates my cheese? That Buffy's not here to share my moral outrage about swim team perks."

Ethnicity is mentioned much later in the series, in the waning stages of Season 5. After a fight with Tara, Willow abruptly announces that she's taking off and will not attend the college's multicultural fair as planned. "I don't feel real multicultural right now," she says in a huff, showing in very direct terms that multiculturalism is something she can opt out of. What she's not directly addressing in this statement is her white privilege and her ability to choose whether to be conscious of her racial identity.

And then of course there's the show's treatment of its characters of color—or rather, mistreatment. The show's first Black multi-episode character arrives in the form of Kendra in the middle of Season 2.

She's given no last name. "I was an avid fan of *Buffy the Vampire Slayer* until November 17, 1998, and then, it happened," writes media studies professor Lynne Edwards in her essay "The Black Chick Always Gets It First: Black Slayer in Sunnydale." She goes on to describe the "it" as "the betrayal that Black fans dread, yet have come to expect— the moment we are painfully reminded that we are Other." Edwards goes on to describe Kendra's entrance on the series, which sees her emerging from the cargo hold of an airplane over tribal drum beats and a flute. "I knew three things the moment I saw her. She was different. She was dangerous. And she was dead."

Her instincts were correct. Kendra would stick around for two episodes before leaving town. She'd return unexpectedly in the season finale only to have her throat slit by Drusilla's sharp nails. We see her collapse. When Buffy visits the hospital shortly thereafter, she checks on all of her friends (all of whom are alive)...except Kendra. Could Kendra have been pronounced dead on the scene and therefore not been sent to the hospital? Perhaps. Is there a deleted scene in which a despondent Buffy mourns the loss of the only other Chosen One? Doubtful, but I like the thought. Still, death by fingernails? Something seems off. She'd be mentioned one other time, only in reference to the Slayer lineage, not in any kind of meaningful way. It felt like an unnecessary death. Was it a necessary death? It could be argued. Without Kendra, we'd never have gotten Faith, an indelible imprint on the show. But to lose Kendra so quickly felt deliberately callous.

"I knew she wasn't going to be a series regular, but I thought she could continue on the show in some capacity," says author and columnist DW McKinney. "It wasn't going to be *Buffy and Kendra the Vampire Slayers*, but Kendra could have returned home and fought vampires there. She could have been a reserve Slayer that Buffy called on when she needed help fighting the countless Big Bads drawn to the Hellmouth. There was no reason for Kendra to be killed except to generate an emotional rise out of Buffy and fast-track her hero's journey for that story arc. I am still very pissed about Kendra's death."

She's not alone. "I felt short-changed when they took Kendra away, because there was so much potential, and for someone like me, for the little Black girls watching, Kendra was the shining light, and the character we could really relate with," says Cynthia Erivo. "There was so much space to have seen what the partnership could have been like between Buffy and Kendra and what that could have grown into. We lost something really cool in that. I'm not even entirely sure why they had to kill her off."

I think it's a testament to both the character and to Bianca Lawson's performance that despite appearing in only three episodes of the series, she remains a necessary and often-referenced part of the show's legacy.

We would meet three other Black Slayers throughout the series: Sineya, referred to as the First Slayer, or the Primitive; Nikki Wood; and Rona. In Edwards's essay, she identifies how each fulfills a trope within a longstanding cinematic stereotype for Africanized characters: Kendra as the tragic mulatta figure, Sineya as a savage, Nikki Wood as the Blaxploitation Jezebel figure, and Rona as the Sapphire figure. "She wasn't at first," Bianca Lawson, who played Kendra, tells me, when I mention Edwards's essay and how she draws a parallel between Kendra and the tragic mulatta figure. "There was a complexity to her that unfortunately didn't get to blossom as intended. It became a different arc than I'd signed on for."

The first overt acknowledgment of race within the world of the show comes thirty-seven episodes in when Mr. Trick arrives in Sunnydale. "Admittedly it's not a haven for the brothers, strictly the Caucasian persuasion here in the 'Dale," he surmises, before moving on to praising the town's death rate. "A relative lack of characters of color doesn't mean that race doesn't exist," write Iatropoulos and Woodall. "It just means the effects of race and racism are harder to see and understand, and that what may be presented as 'normal' and 'neutral' is actually socially constructed, often in harmful ways that are invisible to those with the power to define what 'normal' and 'neutral' are."

"I grew up in an era, going through school and whatnot, where I was often the only Black person in the room," says actor K. Todd Freeman, who played Trick. "And this show was what, the late '90s? I knew that I was one of the first Black characters on the show. And for me at that time, that was not an unusual position to be in, because it had happened quite often in life for me. But I was also glad and proud to be one of the first ones. It did not bother me. I thought: good. Not that I was blazing a trail, but good that I got that designation."

Sharon Ferguson, who played Sineya, the First Slayer, felt similarly. "Being on a set that is non-diverse is not unusual—especially within that time frame. Usually [at that time] we were the only people of color on a set. But at the same time, it was a great honor to be a woman of color on-set representing a powerful character. Although it wasn't unusual to be the only person of color—Black person, might as well say it—on-set, for me it's a high honor always. I'm grateful for when I have the opportunity, because I feel like if I'm in the room, I can represent myself and my training and everything that I bring to that room that now creates space for people who maybe have never even before thought about a woman of color doing other things. Now it's in their presence and you are saying to them, 'Hey, I deserve to be in this room. I deserve to have a chance. And I'm going to show it to you right now.' And most anyone like me, that's how we look at the opportunity. You are creating space for the person who may come after you and potentially for more opportunities for yourself."

I ask Freeman if he had any problem having lines addressing the lack of people of color in Sunnydale being written by a middle-aged white man on a show comprised of a writers' room that did not feature a single person of color throughout its 144-episode run. "I don't have a problem with white people writing that for me. I'm not so caught up in that *thing*, though I know the world is today. I don't think that Black people have to write for Black people or that you can't be of one race and write for someone of another race. I think an artist is supposed to be able to tap into the universality of the human condition."

But something did stick out to him about the line. "Once it was acknowledged, they didn't do anything more to alter that, that there weren't more people of color put into the show once the show itself acknowledged that. It's like, okay, you've acknowledged it, now do something about it."

The show would eventually do something about it (albeit arguably not enough) in its final season, when it introduced the Potential Slayers, many of whom were POC, and the character of Robin Wood, the new school principal at Sunnydale High, who is later revealed to be the son of former Slayer Nikki Wood. He's brought on as a late-stage potential love interest for Buffy, but her heart is never in it. Of the few Black characters on the show, D. B. Woodside's character, Robin, is in an even rarer category of Black characters who survive. And the reason why, it turns out, is a little disturbing, given the context.

Woodside revealed a conversation he had with Whedon, whom he called "probably the most intelligent person I've worked with," in a 2016 interview with the *AV Club*. "Joss cracked a joke when we were shooting the finale, where he came over to me and he said, 'You know, I've got to be honest with you. When I was writing this, I was going, "Does he die? Does he live? Does he die? Does he live?" And you caught me on the day that I said, "He lives."'" In that interview, Woodside recalls that story by ending it with a laugh. But there's something inherently sinister about that careless approach to storytelling.

For Sharon Ferguson, getting the call from the parking lot on the way out of her audition letting her know that she got the part was huge. She'd been a fan of the series and was particularly excited, given her dance background, at the physicality being asked to do the role of Sineya. She would be playing a Slayer and get to go blow-to-blow with Sarah Michelle Gellar. Does it get any bigger than that? When she finally got the script, she was given eight words. "No friends! Just the kill. We...are...alone!" But her character has many more lines, lines that were given to Amber Benson's Tara. "Someone has to speak for her," Tara explains to Buffy, telling her that the First Slayer has

no speech and no name. No speech, and yet she speaks her one line without any trouble.

"I just figured it was a creative choice for [Joss]," says Ferguson, appearing genuinely unbothered. "I had a background in voiceovers and had hoped that they would have used the uniqueness of [my voice], but at the end of the day the final cut is theirs. It's . . . interesting that they made that choice." Then, after a pregnant pause, "It would have been nice."

I ask Benson about her cognizance of the lack of Black actors on the show, but also the lack of Black crewmembers. "We just live in such an entitled space as white people. I think back to that time, and I remember being cognizant, but I think I was just happy to have a job that I didn't talk about those things. Now I'm embarrassed that I never said anything or that that wasn't something that I felt that I needed to spotlight. Once we got into the LGBTQ stuff that was happening with Willow and Tara, that was such a big part of it for me. And we were doing so much good work there that I think the ball got dropped when it comes to race."

I mention Edwards's essay in conversation with Ferguson, and how Edwards refers to Sineya as a savage. "Well, it makes sense that the first Slayer would be someone from Africa," she says. "I just wish we were able to expand on it more." This seems like a through line: It's not just the lack of Black characters on the show; it's also the care (or lack thereof) taken with the few who were given a life on the show.

But despite the writers' shortcomings, the impact of the Black Slayers on the legacy of the series cannot be denied. "At the time, my father was always nagging me and my sister about the shows we watched," says DW McKinney. "If the casts were too white, he would basically dismiss the show. I watched a lot of Black sitcoms, but the supernatural genre was one space where I didn't see myself. And I often saw Bianca Lawson on some of these Black sitcoms. So, when Bianca Lawson as Kendra beat the snot out of Buffy in their first scene together, I screamed at the television. It was like all my worlds merged

together. I was hyped! Because then it clicked. It was possible for there to be a universe with a Black Slayer and an all-Black Scooby Gang. All that flipping around I did in my room while I watched Buffy *wasn't* so unrealistic when Kendra was doing it onscreen too."

I ask Lawson if she was aware of McKinney's essay *"Buffy the Vampire Slayer's* Kendra Young Showed Me Black Girls Could Be Heroes, Too" and the character's overarching and enduring impact—particularly amongst the show's Black female fans. "I had no idea at the time. It was just a job. A character that I got to inhabit for a moment. This is really one of the highest honors as an artist. That your work lives beyond you and helps others on their journey somehow."

The lack of characters of color on the show is an example of a criticism that was less hurled at the show twenty-plus years ago. *Buffy* was seen not only as a critical darling but forward-thinking, for lack of a better term, in its worldviews of women as leaders and queer people as powerful. It's not that people of color weren't looking at the show then and noticing their own lack of representation but rather that others (many, not all) have caught up to the conversation. This expands beyond just *Buffy* and has to do with the way time, space, and societal evolution changes our perceptions of the past. "I was online back when it first started and people would say, 'Oh, these characters, they're all so relatable,'" says Jacqui Kramer, an agent who works with alumni of the show on convention appearances. "Now it's interesting watching this generation watch it and people are like, 'Oh my God, Xander was such an incel,' as well as the comments on race, the Trio and how they treated the females, and the overall gender dynamics and how an eighteen-year-old is viewing it now as opposed to an eighteen-year-old in 1998."

I start my interview off with a beaming Sharon Ferguson by asking when the last time was that she thought about *Buffy*. "I always think about *Buffy,* because ever since I knew what my character's history was, I have prayed for a spin-off. From day one. There's so much that could have gone into it. And there really hasn't been many people

of color, and especially a dark-skinned girl with dreads, in the super-hero space. I've always wished and prayed for it to come true. It keeps me hanging on. It gets me to the gym. It keeps me motivated, because I'm like, *You gotta be ready.* I'm still hoping."

The fire in her eyes makes it clear Ferguson sought joy in an experience in which she was playing a character that may have been tokenized, exoticized, or both. She chose that joy because she saw the mark she could leave on the show's legacy.

"We can't deny the power of women. And I think it's interesting that they gave young women, as well, a voice at that time, which can only lead to stronger grown women. And I think it laid down a leg-acy that we should follow up on, especially in this day and time. And we should take advantage of all the Slayers of color. Why isn't there a whole thing with all of the Slayers of color? Because we've been slay-ing it politically, in life, on TV, but most of the time we are slaying it in the background. It's time to come forward now. I do believe that work is left undone here with *Buffy* and I do think that's why people are still holding on to it. We ignited something in the population, but not everybody got to fully realize it."

Stylish, Yet Affordable Boots

Buffy is a style icon, plain and simple. Prada. Haider Ackermann. Vera Wang. I mean, the way Sarah Michelle Gellar wears a coat alone deserves a dissertation. "Considering for that moment of the '90s, which in fashion was represented by Kate Moss, Shalom Harlow, and Amber Valetta (really the last model cultural moment), Sarah Michelle Gellar's TV wardrobe really did represent just that," says James Scully. "The slip dress and the cardigan, those things that were such hallmarks of that time. She was the anti-Catwoman because, in the end, she just kicked ass in her high school clothes. You didn't have to have a uniform to define who you were."

But Buffy wasn't just practical; she was stylish. "Occasionally, when I'm watching the TV, I'll notice something that one of the characters is wearing and think, 'Oh, that's really cute,' or 'I guess that's in style because Buffy's wearing it,'" said writer Jane Espenson, echoing a sentiment felt by many of us. It's a show, as she noted, that's particularly adept at reflecting what teenagers are wearing while simultaneously influencing them.

I ask Gellar what it's like, all these years later, seeing Buffy still remaining pop-culturally relevant, mentioning that on the whole the show doesn't feel very dated. "It doesn't feel dated because all of the wardrobe choices came back...otherwise it would feel dated. It's just that everyone's wearing the chokers and the T-shirts and the dresses."

"I think I was thinking about it a lot," Cynthia Erivo says when I ask her about *Buffy* being one of the first, if not the first, shows to have

a butt-kicking female protagonist who was not a prototypical super-hero (at least, not in the usual sense of the word). Instead, she was an ordinary girl *with* superpowers. There was no Wonder Woman/Diana Prince or Catwoman/Selina Kyle duality. Instead, Buffy had to modulate moving through the world, whether kicking ass or trying not to flunk out of history, as one unified self. "I think that's why I was so drawn to it, because Buffy felt like she was an everyday girl, a woman who is trying to get through school, who was close to my age, who was able to live these two different lives but didn't have to dress differently for either one of them. It wasn't like, 'Now I'm going to put on my superhero costume and go and fight evil.' It was just that evil was wherever she was, and sometimes that would be on her way home from school, and she had to defeat the bad guy while being a daughter, a sister, a friend, and all that. That's what I was really drawn to even if I wasn't conscious of it; subconsciously I was seeing something I hadn't seen before."

And yet, Buffy did have a uniform of sorts. "Obviously it's not a superhero uniform in the traditional sense (which works with the entire allegory of how real life is hell that runs through the show), but the black pants/leather jacket/tank top that she often wore to go patrolling to me basically does feel like a uniform of sorts," argues Jessica Morgan, writer and co-founder of the fashion blog *Go Fug Yourself.* "This is more a uniform in the way that a lot of people have their own uniform consisting of a basic outfit they wear a lot, but I do think it was uniform...ish. It's just not a *costume.* But of course, yes, I think this works to reinforce the show's sense of the natural, even though so much of what happened on it was supernatural."

Stylist and costume designer Samantha McMillen, whose clients include Michelle Pfeiffer and Elle Fanning, says she was watching the show in real time from the jump. "I recorded the episodes if I wasn't home to see. I remember coveting her wardrobe and/or feeling really cool that I had some of the same pieces she had. She was wearing things I'd seen at Fred Segal or Curve or American Rag or our beloved

Barneys. She was a strong, powerful woman who had a very specific sense of style and a determination to save the world and her friends over and over despite having a broken heart or grieving over one loss after another or coming back from the dead more than once. She had the perfect little '90s dresses for hanging out at the Bronze. A multitude of cool pants with stretch in them for high kicks and running. Coats for patrolling. Her wardrobe was fashionable and utilitarian where possible. I also didn't mind if she was fighting in miniskirts; it went along with the overall tone of the show."

When I ask McMillen if she had a favorite outfit, she attaches what looks like a dossier to her email—my kinda fan. "The obvious favorites that everyone loves are the Vera Wang wedding dress from Angel's dream, the red Homecoming dress, the leopard minidress with leather coat and knee-high black boots. But in general her sleeveless tops and leather/vinyl pants with the perfect coat or oversized jacket were the quintessential Buffy uniform. I loved her layered slip dresses, sheer tops over camisoles, and a multitude of cute camisole-and-cardigan combos. She had a white long-sleeve sheer top over a tank top that was so good. I loved her love of lilac and various pastels mixed with green, burgundy, or brown. Neck scarves. She was layering cute small earrings before that was a thing. I loved her thin black headbands. Her perfect coats. I said that. But how did she afford all those coats?! Her lilac prom dress in the Prom episode. It could have fit better…but it was beautiful. A favorite outfit that stood out was in Season 6 when she first pounced on Spike: Pale lilac lace low V-neck layered top with a black leather long skirt and knee-high black flat boots. I'd wear it now."

"Sarah was and is very astute when it comes to fashion," says Matt Van Dyne, who costumed the last ten episodes of the series after a prolific career in television, including stints at *The Merv Griffin Show*, *Cheers*, and *Murphy Brown*. But this isn't going to be a chapter all about clothes so much as it will be about the woman responsible for many of those iconic fashion moments: Cynthia Bergstrom.

I first met Cynthia in 2019 when I interviewed her for a story

about the show's costumes. She was warm, her memory was sharp, and I recall us both laughing a lot throughout the interview. I did not plan on reinterviewing her for this book, thinking I had everything I needed from that previous hour-long interview. And then a funny thing happened. Funny? Not really funny at all.

During my interview with Matt Van Dyne (who took over for Terry Dresbach, the costumer for the first twelve episodes of Season 7), I mentioned that I thought it was odd that a costume designer who had been with a show for the majority of its run (Bergstrom joined at the start of Season 2) would depart so late in the game. I asked if he was privy to why she was departing just ahead of the home stretch. "I'll just answer that yes," he responded. "That's all you'll get."

Immediately my hazy-but-not-entirely-deficient memory went to the 2019 interview I did with Bergstrom. I recalled how she had mentioned that the heaviness of Season 6 had an emotional impact on her that left her wanting out. But something about her tone left me wondering if there was more to the story, or a different story from the one she'd presented to me earlier.

So I reinterviewed her. And this time, and for reasons we'll get into, she gave me the real story.

"*Buffy* never dies, you know?" she says when I ask her how she feels about talking about this show, once again, nearly twenty-five years later. "It's *Buffy* and it's *Scream*. Those are the two things that I'm asked to talk about. Nothing else." She laughs. I'm reminded of an earlier conversation I had with Charisma Carpenter in which she mused about the double-edged sword of being a part of something like *Buffy*. On the one hand, you're proud, even flattered, that people still are talking about it. On the other, you might want people to consider the many places you've been since.

"I'll be honest, for several years I didn't want to talk about *Buffy*," Bergstrom tells me. "And then I noticed that it just didn't stop. Interview requests were coming in all the time, fans were asking questions, and I started to really see the love that people had for the show.

And then the letters, the emails, the DMs got really personal and people were saying how this show—oh my gosh, I get a little emotional thinking about it—how this show saved their lives. A lot of trans people, gay people, people that were living in homes where they didn't have a lot of support or encouragement for their creative outlets, people that wanted to be designers but didn't think that they possibly could. And I saw that this is a really powerful opportunity to come forward as the woman that I've always wanted to present: somebody that helps empower others to be the best that they can be to live their dreams, to know that they matter."

So now that she is talking about *Buffy*, leaning into what she once avoided, how does it feel? "Right now, in 2021, I can honestly say that I'm really proud to be associated with the show. I'm proud of what the show has done in terms of helping others to feel empowered. That's not taking into consideration the recent accusations against Joss. That, I think, needs to be discussed separately." And we will.

I mention my conversation with Van Dyne and his (perhaps unintended) implication that there was more to why she left the show. She asks if he told me anything more. I say no, telling her that I didn't ask, feeling it was her story—if there even was a story—to tell.

"It was a tough show. It got tougher as time went on. And I saw a grand lack of consideration for the effort, the heart and soul, that people were putting into the project. And it was with a heavy heart that I left. I'll be really honest: I saw a lot of game playing. I saw a lot of pitting against one another amongst those above the line. And my crew, they meant everything to me—I mean, it was because of them that I was able to crank out the work that I did and the costumes on a weekly basis—and they were fed up. They had had enough and they wanted to leave the show, but they didn't want to leave me. And my right-hand person, she was like, 'Cynthia, the subject matter is so dark. This isn't fun anymore.' I mean, Season 6 was dark. Did I do 6? Or did I leave on 5?" She laughs. I laugh too. And then the laughter dissipates. "It was really dark. And it was hard to watch the actors

transition, especially Alyson. I mean, Alyson really grew up on the show. So that's the reason."

It occurs to me that Bergstrom must have gone to Whedon to issue her resignation. I ask if she remembers that conversation. She breathes in deeply and pauses for a moment. "Yes," she says as her gaze shifts from me to somewhere off in the distance. She stares off in silence, awaiting my next question. I don't ask. She takes another deep breath.

"I told Joss that I was leaving, and he said, 'I'm surprised you stayed as long as you did. I was thinking of firing you anyway, because you're too close to Sarah.' That was a gut punch. And I think at times Sarah might've thought I was too close to Joss because I was right in the middle of the two of them. And the two of them had some... *thing* going on. And my allegiance was always with Sarah. I think Sarah and I had a really great relationship up until the end. She was fun. I enjoy dressing her. We had our moments, but we'd actually laugh about them. This type of environment is really like living with your nuclear family all over again. And we spent a lot of hours together and there's a lot of emotions, a lot of stress, a lot of highs, and a lot of lows. Joss, though he was brilliant, I didn't know what was going on. I heard things and I really thought it couldn't possibly be true, because what I heard was worse than what Charisma has stated, but it didn't involve Charisma, though."

She continues: "The pitting against one another, from what I was told, it sounds like there was a lot of forethought given to these actions. It was planned. It was manipulated. And it was created for sheer amusement and control and power. I mean, it was... it's evil. It's just not okay."

Immediately, I'm transported back to my May 2020 interview with Charisma Carpenter, and her uttering the exact same words. We were discussing my own experiences with being bullied on the playground and how I'd found solace in the strength of characters like Buffy and Cordelia. "You are doing your purpose and you are inspiring people to listen to themselves and to be true and authentic and not

be allowed to be stepped on and made to feel small and insignificant. Like, that's not okay. It's just *not* fucking okay."

This behavior from Whedon wasn't just something Bergstrom heard about; it was something she witnessed firsthand. "I knew Joss was difficult. There were times where he would get so angry—and I don't care if this is on the record—he would get so angry at something that Sarah said or wanted. And I was like, 'Just give it to her, for God's sakes.'" Two sources familiar with the production told *Variety* that "fairly early into the show's run, Gellar had a severed relationship with Whedon, to the extent that she did not want his name spoken around her."

"I remember this one time in the middle of the wardrobe department he grabbed my arm and he dug his fingers in...I mean, I had marks 'cause he was so angry and I was just like, 'What are you doing?'" Bergstrom pauses, looks down. "I forgot about that."

Bergstrom would go on to work on *CSI: Miami* and *Private Practice*, where she met and befriended actor Kate Walsh. "I was Face-Timing with Kate and a mutual friend of ours a couple months ago and I was getting ready to do an interview. And I said, 'Okay, you guys, I gotta get ready for this interview.' And she said, 'Have fun, kill it.' And I said, 'You know, I really wish I could tell the truth.' And then our friend, who isn't in the business, said, 'What does that mean? What does it mean to tell the truth?' And I just looked at Kate and I said, 'Kate knows.' And she smiled. And that was it."

"I don't want to keep other people's secrets," she adds. I mention my conversation with Amber Benson, and how she expressed a reticence to share her less-than-favorable experiences on-set out of not wanting to let down the fandom. "I'm too right-there, protective of the audience. But I think if we don't tell the truth, it's an injustice to the fans because they need to decide for themselves."

She continues: "There was a lot that went on, and part of me wants to just share everything because I've had to be the keeper of these secrets for so many years and there's a part of me that just doesn't want to hurt anybody else. Which is, like, really fucked up. Like, if

some man was beating me up and I needed to protect myself, so I grab a cast-iron skillet and I put it in front of my face, the face that he's hitting, am I going to feel bad that he broke his hand? I hope not... but that's sort of what it feels like. It's the same with psychological, emotional, verbal, and sexual abuse. When we remain silent and keep their secrets, we are protecting the perpetrator. We need to grab the skillet. We need to use our voices and speak truth to the injustices that have silenced us. We need to protect ourselves and others from further abuse. Charisma bravely picked up the frying pan."

Now more on the costumes: It's a scientific fact that clothes just look good on Sarah Michelle Gellar. "The great aspect of Sarah is that she could carry overalls and a T-shirt and look fabulous—I still get requests as to who made the overalls—and then she could also step into Prada or Dolce & Gabbana or any designer garment out there. She's a tiny little thing in stature, but she just really wears clothes well." But when Bergstrom signed on, Buffy's look was far less sleek and far more retro.

The show's costume designer at the time, Susanna Puisto, exited the series and Bergstrom was officially hired to take the reins. "I think they just wanted fresh eyes, and I do remember [the producers] sharing that they wanted less of a vintage look and wanted everything to look a little bit more hip and a little bit more cool," Bergstrom recalls of her hiring. Buffy had quite literally been reborn and resurrected in the Season 1 finale and was now taking ownership of her status as the Chosen One, and so her style needed to reflect this. She describes the look she was going for as a sort of "badassery, hot look."

Bergstrom put Gellar in high fashion, outfitting her in mostly contemporary designers and emerging designers found at Barneys and Fred Segal and specialty boutiques throughout Los Angeles. Miu Miu. Marni. Blumarine. Pamela Dennis. Burberry. Milly. Trina Turk. Folley. Katayone Adeli. Rozae Nichols. Philosophy by Alberta Ferretti. Willow, meanwhile, was outfitted in Fuzzi, Custo Barcelona, People's Liberation, Tree, and Rozae Nichols. Cordelia would wear Maria Bianca Nero, Tommy Hilfiger, and J.Crew.

"It was this gorgeous Prada dress, probably the most expensive thing I'd ever touched at that point in my life," Clare Kramer says of the unforgettable red dress her character was introduced in. "I couldn't believe that they were entrusting me to wear it. I loved that dress, though. And it did add to the feeling of who the character was for me as an actor." I mean, put me in Prada and I, too, would begin to feel things. But seriously, a regard for the quality of the costumes was shared by many of the actors I spoke with.

"The thing I think about the most when I think back upon my time on *Buffy* was my great costumes," says actor K. Todd Freeman. "I was always in designer things. I remember thinking, Oh my God, my shoes are Ferragamo, the suit is Gucci. This is the best. And I remember that my mother used to love the fact that I was dressed so well. I also remember my cousin was very upset because I ate a Blow Pop and I ate popcorn and she said, 'Vampires only consume blood.'"

"The best way I can put it is that they were *very* of-the-time," says Jessica Morgan, who pushes back at my argument that Buffy is an enduring style icon. "You don't really realize how much leather folks were wearing at the turn of the century until you look back at events from that time period and we were *all* wearing leather pants and skirts and jackets and knee-high leather boots. As a matter of fact, I don't know if this was widespread or just something that some of my friends and I did, but we called leather, knee-high zip-up boots 'Buffy boots.' Buffy was *very* leather-forward."

Bergstrom seized on the opportunity to use costumes as a story-telling device throughout the series. As characters evolved, so too did their wardrobe. "God, why do all my shirts have such stupid things on them?" Willow says in Season 5. "Why can't I just dress like a grown-up? Can't I be a grown-up?" "Take Willow, for instance," says art director Joshua Liebman. "Her looks transform as she does: Nerdy computer geek whose mom dresses her to groupie/girlfriend/I'm with the band to Stevie Nicks/white witch vibe. I think of how fashion became part of the narrative to the point of being inseparable from

that narrative. Even when Faith inhabits Buffy's body...her clothing is used as part of telling that story, and not only the story, but part of the inside, knowing what we know as an audience while watching the understanding unfold on the rest of the characters."

Unlike shows like *Sex and the City, Gossip Girl,* or *The Marvelous Mrs. Maisel,* which sought a fashion-forward lens in the sense of almost making the clothing characters in themselves, *Buffy* created looks that were unique to the world of Sunnydale, and not clothing that could be found on a runway—despite the fact that some of it could. Buffy didn't look like the average American teen, but she also didn't look like a glamour gal. She existed somewhere in the space between. And it's because of that, that although the show feels very of its time, it doesn't feel dated. Sure there are looks that read as '90s fashion artifacts—I'm talking to you, Season 1—but mostly the clothing of *Buffy* feels less like costume and more like clothing, the real hallmark of great costume design.

I'd be remiss to leave out Buffy's hair in a chapter as important as this. In March of 2017 I wrote "A Necessary and Important Guide to Sarah Michelle Gellar's Many Iconic 'Buffy' Hair Styles" for Mic.com. "Um...I see a lot of hair DON'TS!!" Gellar tweeted in response at the time. I remind her of this article during our second interview, pressing her to recognize the iconic-ness of her coif throughout the series. "Not the year I had the skunk stripe," she says, avoiding the prompt. "The skunk stripe was pretty horrible." "Anything else?" I ask. "And then there was the time I cut my hair and hated it. That didn't go over very well for me." C'mon, SMG! "I think her early college years were some of her best hair." (I love the idea of Gellar referring to Buffy in third person.) "What about her Season 2 hair?" I ask, mentioning my favorite era. "The network didn't like it when I was very, very blond. I kept getting notes on it." Curious, dear reader, what's *your* favorite hair era?

"I was at Armani in the '90s and I met Cynthia Bergstrom," recalls Samantha McMillen. "[Bergstrom] found out I was a fan of the show and she gave me a set of the Sunnydale High gym clothes and one of Buffy's

stakes. I keep the stake in a case. I lived for *Buffy* and *Angel*. I rewatched 'The Prom' episode before the interview and the show holds up. It always feels like visiting old friends and you pick up right where you left off."

For Bergstrom, the memories are more wrought. She beams with pride when I list some of my favorite fashion moments from the show that she architected, but her smile quickly dissolves when we talk about most things production-related. She's clearly proud of the work, but it came at a cost to her mental health.

Bergstrom left the industry in 2016 and went back to school to earn her master's in spiritual psychology. In the subsequent years she's been working as a life coach. As we wrap up our interview, I ask her how she's feeling, recognizing the emotional labor of sharing information she's long held on to in secrecy.

"I just want to really acknowledge Charisma for coming forward," she says. "I don't care if she had waited ten more years. She came forward when she was ready to come forward. When you get tools that help you get a little altitude, you can see with a different perspective. The industry can be a weird place where rules don't apply, but they should be applied. The abusive nature of the industry has been talked about for years, yet rarely has there ever been anything done about it. Hands are only slapped, but those victimized are left traumatized. The behavior that we see on film sets would never be accepted at any other workplace. Emotions run amok. Chaos runs rampant. Not all shows are abusive. I worked on several other projects before and after *Buffy* that were wonderful experiences. All in all, though, after twenty-seven years in film, I had had enough and left the industry. I'm glad I did. Life is nice on the other side. Being the costume designer of *Buffy* was one of the highlights of my career. I was honored. I could have left it anytime and I stayed…until I didn't. But I think it's a marvelous show and…y'know…sometimes the mighty fall. Sometimes you have to take the message, and maybe leave the messenger behind."

You Talk Funny

"The slanguage of *Buffy*, is that what you called it?" Clare Kramer says with a laugh. "That's *funny*." I certainly didn't coin the term. It's one that's been used by the fandom for years in discussing the dialogue and speech patterns unique to the world of the show. "There's certain playwrights like this, Christopher Durang is a great example, someone who when you start saying the dialogue it's like you're on a fun roller coaster," says Kramer. "And that's what the dialogue was like on *Buffy*."

Perhaps one of the most lasting influences of the series is its contributions to the lexicon, or, as it's most often referred to: *Buffy*-speak. But don't take my word for it. There are, of course, entire books dedicated to the very subject. "One of the most distinguishing features of the show is the innovative way its writers play with language—fabricating new words, morphing existing ones, and throwing usage on its head. The result has been a strikingly resonant lexicon that reflects the power of both youth culture and television in the evolution of American slang," writes linguist Michael Adams in his book *Slayer Slang: A Buffy the Vampire Slayer Lexicon*.

Buffy-speak came from how Joss Whedon himself spoke and, according to the writers, was absorbed and adopted by all of them by proxy. "I'll think of the straight line to say, the line that gets the intent across, and then I'll figure out what's the flippy way to say that," explained writer David Fury. It really became as much a part of building out a full and textured world as the sets and costumes.

So how does one define *Buffy*-speak? "The characters had a distinct way of speaking that didn't reflect actual observed teenage language," says writer Jane Espenson. "It was more like the way a group of people in a communal living situation all start developing their own slang. I'd define it as creative embroidery of language. We built on each other and tried to create something creative and coherent and plausible."

I ask her for an example. "I just started re-reading a script at random to find one," she says. "I picked 'First Date.' There are some very Buffified lines in there, but the one that struck me the most is actually not a line of dialogue but a stage direction. Andrew, confronted by the First in the guise of Jonathan, threatens to scream. Then the stage direction says, 'Andrew draws a big breath for screaming with.' That's a perfect example of a sentence that has been made amusing through a purposeful awkwardness. 'Andrew prepares to scream' would've been more usual, but it doesn't suggest the sort of hearty, humorous inhale I wanted to inspire."

There's, of course, the references, a trademark of the show from the outset. In the pilot episode, upon meeting Cordelia, Buffy is given a coolness test:

Cordelia: You'll be okay here. If you hang with me and mine you'll be accepted in no time. Of course, we do have to test your coolness factor. You're from L.A., so you can skip the written, but, let's see. Vamp nail polish?
Buffy: Uh, over.
Cordelia: So over. James Spader.
Buffy: He needs to call me.
Cordelia: Frappuccinos?
Buffy: Trendy but tasty.
Cordelia: John Tesh?
Buffy: The devil?
Cordelia: Well, that was pretty much a gimme, but you passed.
Buffy: Oh, good.

"I can't believe you, of all people, are trying to Scully me!" Buffy says to Giles in Season 1, Episode 6 ("The Pack"), of course referencing *The X-Files* when he tries to deny the possibility of supernatural forces being behind a bizarre event. A few episodes later, in Episode 9 ("The Puppet Show"), Xander asks: "Does anyone else feel like they've been Keyser Sözed?," a reference to the film *The Usual Suspects* in which one of the characters assumes multiple false identities.

Other references throughout the first season would include Neiman Marcus, the 1980s band DeBarge, *The Thing*, the 1969 western *The Wild Bunch, Mommie Dearest, Gidget, Hocus Pocus*, Yanni, Oedipus, Helen Keller, and Laura Ashley, to name just a few. Some people caught every one. For others, it was in one ear, out the other. And for others still, *Buffy* served as a culture dictionary. I remember asking my mother who Gustav Klimt was at twelve years old because of a *Buffy* reference. (Fun fact: The first use of "to google" as a verb on television? *Buffy the Vampire Slayer*, of course.)

The series could reference *The Real World* in one sentence and then *Death of a Salesman*'s Willy Loman a few seconds later, proving time and time again a cultural dexterity unlike anything else on television.

But *Buffy*-speak is far more complex than simple referencing. You take regular phrases and twist them just a bit. So instead of "love makes you do things," it's converted to *Buffy*-speak as "Love makes you do the." When something makes you happy, it "gives [you] a happy." When you want to be handed a book: "Book me." Unclear about something? "Can you vague that up for me?"

"Wig" in *Buffy*-speak is not what goes atop your head. It's a feeling of unease. As in: "They gave me the wig ever since I was little," Buffy says in Season 1, Episode 9 ("The Puppet Show"), when asked if she thinks dummies are cute. There's also variants: "wiggy," "wigged," and the "wiggins." When something really sucks, it "ubersucks," which is not a precursor to the ride-sharing app, I regret to inform you.

"The bar was set so high," says writer Doug Petrie. "It's gotta be

this level of meaningful and smart and specific and you can't rest for a second and every syllable has to count. The thing that Joss did that I love the most, that I'd never seen a showrunner do before is this: There's the writers' room and then what we put on air. And the writers' room is hilarious and profane and filthy and beautiful and wrong and all of these things. But then you have to give your stuff a shave and a haircut when you put it on air. And there were a couple of times when we'd be in the writers' room and we'd just start making the craziest jokes and then Joss would say, 'Let's do that.' And I remember once or twice saying, 'Can we do that?' and him laughing and saying, 'Why not?'"

I ask Espenson for her favorite memory of working on the series. "Walking past the Magic Box exterior on the walk from my parking space. Hanging out and laughing with Doug [Petrie] in his office, which he'd covered in movie posters. Watching Seth Green eating lunch with his werewolf makeup on. Watching the episodes in big groups at Joss's house on Tuesday nights when they aired. But I really think the best moments were when I was alone at my keyboard and I realized I had the perfect line for some scene. That really feels like magic. You get why the root word of 'inspiration' is about breathing—you feel as if someone just blew the idea into your head, like it came entirely from outside you."

It was this environment that not only allowed for, but encouraged, language variants to thrive. Weird was good. Weird was celebrated. Weirder? Better. Weirdest? Now we're talking. "What was wonderful about our little community was that the way you cleared the bar was by being your goofy self," Petrie says. "Be as true to yourself as possible, and say the weird thing that you think nobody wants to hear, and then all of a sudden you feel like you're in the club."

Was there room for improvisation? Not at all. "*Buffy* was a word-perfect show," recalls Clare Kramer. "If you said, 'He's going down the hall' and the line was 'He is going down the hall' you'd need to redo the take."

"There were times where I said 'I'm,' and they're like, 'Yeah, it says, 'I am' in the script," recalls Marc Blucas. "There was no leeway. There was no improv. There was no missing a word. So as someone new, it was phenomenal training because I had to have every line word-perfect. Because you had to. There was no not saying a word for Joss. That said, I don't want to ever do a show like that again."

Close Your Eyes

One of the key set pieces throughout *Buffy*'s seven-season run was the Bronze, a nightclub located in the "bad part" of town (by the shipping docks and railroad tracks) that, for whatever reason, allowed teenagers to swarm the place on the regular. It became a hub for hangouts, make-outs, fumigation parties, death, and destruction, but most of all: good music. "I fell in love with so many bands because I had discovered them on *Buffy*," said drag legend Trixie Mattel in a 2019 interview on *SlayerFest '98*.

With performances by Michelle Branch, Cibo Matto, the Breeders, Aimee Mann, Biff Naked, '90s alt-rock band Sprung Monkey, Belgian band K's Choice, Manhattan-based indie band Lotion, plus performances by Superfine, Velvet Chain, Nickel, and Bellylove, the Bronze was a breeding ground and incubator for a ton of alternative music throughout *Buffy*'s run.

Buffy the Vampire Slayer: The Album was released in 1999 and featured music by Garbage, the Sundays, and Alison Krauss and Union Station among the bands featured on the show. It was succeeded by *Buffy the Vampire Slayer: Radio Sunnydale—Music from the TV Series,* which featured Sarah McLachlan, the Dandy Warhols, and the Breeders.

But the music of *Buffy* extends far beyond the walls of the Bronze and can be largely credited to Christophe Beck. "Every episode we treat as a movie, and we try to make it as dramatic as big, orchestral movie scores are," he explained. Beck had worked with *Buffy* producer

David Greenwalt on a show called *Spy Game,* and Greenwalt called him up in the interim between Seasons 1 and 2 to see if he might be interested in joining the series in a regular capacity. "I was indeed familiar with the show and was already a fan, and remember thinking how enticing the combination of high school and the supernatural would be for a composer," he says. "So naturally, I was super excited to be considered." He met with the production team and got hired shortly thereafter, working on a little over half of the second season and all of Season 3 before continuing on in a recurring capacity from that point on.

"Joss Whedon loves big, symphonic music, and so do I, and while the show is set in high school, the themes and emotional arcs are big: love, life and death, the end of the world, just to name a few. So, I saw it as an opportunity to flex my orchestral muscles, and write cinematic music that makes great use of recurring musical motifs. It was truly an awesome compositional opportunity."

Beck would receive a nearly complete cut of an episode, write the score in three to five days, and then present it to Whedon for feedback. He'd then spend another day or two rewriting and recording a live instrument or two ("to sweeten my virtual orchestra") and turn it in to be mixed into the show. "Lather, rinse, repeat!"

One of his biggest moments—and please understand that if I was there with you now I'd be forcing us to listen and cry—happened in the climax of the Season 2 finale, in which Buffy must send her lover to a hell dimension in order to save the world. The musical underscore, known as "Close Your Eyes," helps to cement Buffy and Angel's complex love as the real deal, doomed and eternal. "Buffy and Angel's romance has a certain duality to it," Beck says. "On the one hand, there is the innocence and uncomplicated excitement that comes with a teenager in love. On the other, theirs is a doomed romance, tragic and profound, and let's not forget, while Buffy is a teenager, Angel most certainly is not, having been alive for hundreds of years! I tried to imbue their theme with a certain sadness and

tragic destiny while also keeping it musically simple enough to evoke the feeling of young love." Beck would pick up an Emmy for his work on this episode, winning for Outstanding Music Composition for a Series (Dramatic Underscore).

Beck left the show in his full-time capacity after Season 4 concluded, but returned twice: once for the Season 5 finale ("The Gift") and again, several months later, for the behemoth musical episode "Once More, With Feeling." Ask many Buffy fans for their favorite episode, or ask a more passive fan of the series for their favorite episode, and every time, without fail, the musical is the one.

"I remember, we were waiting for a setup, about to shoot a scene in the library during the pilot. It was Joss, myself, and Sarah Michelle, we were in this little area behind the scenery and I said how much I loved musicals," recalls Anthony Stewart Head, who had just done *Rocky Horror* at the Piccadilly Theatre in London. "And Joss said, 'You know, it would be quite fun, somewhere down the line, if the show goes, to have a musical.' And I went, 'What? How? That would be—that would be great. That doesn't usually work, but, you know, yeah, that would be fun.' And so every season, I'd say, 'Are we going to do the musical?' and he'd say, 'No.' And then it appeared, one summer, the CD came through in the post. I was in England, we were on hiatus, and it was Joss playing the piano with his [then wife] Kai and you could hear the essence of it, you could hear the songs and I thought, 'Wow. Wow! What? Oh my God!'"

Musical episodes of TV series have become the norm, if not antiquated, thanks to shows like *Grey's Anatomy, Community, It's Always Sunny in Philadelphia, Riverdale, Scrubs,* and *How I Met Your Mother.* But back in 2001 there had only been two big musical episodes of a television series: *Xena: Warrior Princess* in 1998 and *Ally McBeal* in 2000. Both were quite successful but much more compact in scale.

"[Joss] had mentioned, 'I want to do a musical,' and our reaction was 'Sure, sure, sure, sure, sure, yes, yes, yes, abso—oh, whatever you want, yeah, yeah, yeah, yeah,'" recalled producer Gareth Davies. "Then

we came back off hiatus [between Season 5 and Season 6] and Joss walked into my office and put a script on my desk and also a CD. And I said, 'What's that?' And he said, 'Oh, this is the musical.'" Whedon had written the script, written *and* orchestrated the music, and even sung through the entirety of the score with his wife at the time, Kai Cole.

According to Davies, the actors spent evenings and weekends learning their vocals and choreography. "This is the best part of rehearsal...the part where we finally get air conditioning," Gellar remarks, looking up from the rehearsal-room floor in behind-the-scenes footage on the DVD release of Season 6.

"It was grueling and intense, but deeply rewarding," Beck, who composed the overture, coda, and "Dawn's Ballet," recalls. "I grew up a huge fan of musicals, and wrote two full-length productions with my brother while we were in college, so it was great to revisit that territory after almost ten years doing other things. Joss, [guitarist] Jesse Tobias, and I all worked together over a period of months putting together the songs, recording the cast doing their singing, and all the mixing and post-production that that entails, prior to shooting. Then of course, after the episode was shot, I still had my little scoring part to do. I'm getting tired just thinking about it, but for sure it's one of the highlights of my career."

The result was a fully realized musical, comprised of nineteen tracks, both sung and danced, rehearsed by the cast for three months (in addition to their regular shooting schedule, mind you). It is easily regarded as one of the pinnacle achievements of the series, if not the best episode of the series of all time. It was a spectacular free fall that was able to elegantly stick its landing. "What could have been, at best, an eccentric diversion and, at worst, a shuddering embarrassment, succeeded on every level," wrote Jonathan Bernstein in his review for *The Observer*. "It provided a startling demonstration that creator Joss Whedon has a facility with lyrics and melody equal to the one he's demonstrated for the past six seasons with dialogue, character, and plot twists. Rather than adopt the 'Hey, wouldn't it be wacky if we suddenly

burst into song?' approach practiced by *Ally McBeal*, the *Buffy* musical was entirely organic to the series' labyrinthine progression."

It wasn't just that they attempted it, that they pulled it off, or that they did so with flying colors; it was the way in which the episode managed to use music as the vehicle and not the destination. "I can't think of anything else where you break six major storylines in song," says Anthony Stewart Head. "Including the fact that Buffy was in heaven, not hell, including Giles leaving, including the breakup of Amber and Aly...Insane!"

Though *TV Guide* picked it as the fifth best episode of the twenty-first century, the National Academy of Television Arts and Sciences neglected to include it on the ballots for Emmy nominations in 2002. They called this an "accident" and sent out a belated postcard to its members listing the episode as an added entry for Outstanding Writing in a Drama Series. It was too little, too late. "Once more, one of the best shows on television isn't getting the respect it deserves," read a 2002 *Washington Post* article dedicated to *Buffy*'s unsung status. "[It's] another example of the lack of industry respect afforded to one of television's most consistently clever shows."

Still, fans remember it as a high point of the series, especially coming so late in the show's run. *Buffy* had taken great risks in its storytelling before, with great success, so this really felt like a victory lap. "I was obsessed with it," says Cynthia Erivo. "I recorded it on my VCR and everything. Do you remember those?" "Do I ever," I reply, reminiscing about the seriousness with which I would take my recordings of the show, when a tape allotted you six hours and I'd have to work meticulously to make sure the final episode didn't get cut off. "It was the first time that we really got insight into the minds of the characters, which is often what musicals do. Music happens when speaking isn't enough anymore, and they really landed that. And they were all really good!" (I've begged Erivo to give us a cover of "Under Your Spell" one day, so let's collectively form a prayer circle in the hope of making that happen.)

It's hard for Beck to be too bitter about the Emmy snub, considering he picked up a win years earlier. In fact, he seems nothing if not grateful for his time on the show and his experiences with Whedon. "Joss loves music and how it can help tell his stories, and his passion and thoughtfulness shone through throughout our time working together. In those days, when I finished with my first pass at an episode, I would send a messenger across town with a VHS tape with all the music synced to picture for his review. He would then watch it and fax me his notes. I remember many anxious moments watching the fax slowly come in, to see how much work I was in for over the next day or two. It seems quite archaic in today's world of instant digital communication, especially the way we have all adapted to working from home over the last year or so. But it worked."

And speaking of awards...

Class Protector

"I just want to say, *Buffy the Vampire Slayer* only went for seven seasons and we're about to pass that whore up at some point. Eat shit, Sarah Michelle," joked Trixie Mattel on an episode of her web series *UNHhhh*. Then, not joking: "She should have an Emmy for *Buffy*." "Is it past due?" her co-star Katya asks. "It's a little late," Trixie responds.

It is too late, yes. But it's never too late to lay some respect on Gellar's performance. We'll do a lot more of that in the next chapter. But why not a little bit here too? "Let's talk about Sarah Michelle Gellar's performance," I prompt Cynthia Erivo during our discussion about the series in which I have to periodically pinch myself to remind myself that one of my favorite performers is taking the time out of their busy schedule to talk with me about our shared love of *Buffy*. "I think it's one of the greatest ever captured on camera," I tell her. "I think so too," she says. "And I learned from you that she was never nominated for an Emmy, which really surprises me because I never realized that. For a show that ran for so long and covered so much area, it's so strange that she wasn't recognized that way."

Buffy and awards? Two very unmixable things. It's a testament to the velocity with which the television landscape has changed, but also the culture writ large, to see both teen shows and genre shows morph into awards bait. Tatiana Maslany's 2016 Emmy win for *Orphan Black* would never have happened in the late '90s/early 2000s, nor would Zendaya's 2020 win for *Euphoria*. It's not that these aren't

award-worthy performances (they are)—it's that the audiences for these shows were once perceived to be too niche to warrant the show receiving such prestige recognition.

Buffy had a lot working against it in terms of being taken seriously by those with the power to bestow awards, the most obvious of which was its name. I get it. I'm reminded of the opening line of Jerry Bock and Sheldon Harnick's *Fiddler on the Roof,* when Tevye looks out to the audience and muses, "A fiddler on the roof. Sounds crazy, no?"

It also came with the association to its film predecessor, largely perceived as a flop. You'd think after the show's first season, and with the critical praise it earned from the outset, award-show governing bodies might bend. You would be wrong.

Another factor was its unconventional approach to genre, a defining factor in many people's love for the show but something that award shows, particularly the Golden Globes, frowned upon. It seemed more comfortable in the drama category, yet stacked next to *The Sopranos* and *The West Wing, Buffy* felt downright vaudevillian.

But it didn't totally get shut out by way of awards recognition. The series picked up two Emmy wins in its second season: Outstanding Makeup for a Series and Outstanding Music Composition for a Series (Christophe Beck's award mentioned in the last chapter). It also picked up a Television Critics Association Award in 2003 and was a favorite at the Saturn Awards, where the show picked up three wins for Best Network TV Series and acting trophies for Sarah Michelle Gellar, Alyson Hannigan, and James Marsters. Additionally, the show received eight other Emmy nominations, including Outstanding Writing for a Drama Series, Outstanding Hairstyling, and Outstanding Makeup; three Television Critics Association Awards nominations; and, perhaps most notably, a Golden Globe nomination for Gellar in the category of Best Actress in a TV Series-Drama in 2001. (She lost to Sela Ward for *Once and Again.* Am I still bitter? I'm fuming.)

But Gellar has no regrets. "People always ask me, 'Are you mad

that *Buffy* didn't win Emmys or Golden Globes?' and I'm always like, 'But why? We won all the important things,'" says Gellar. "We won the hearts of the audience, and that's who I made *Buffy* for. I didn't make it for a bunch of foreign journalists that choose the Golden Globe. Like, sure, I had fun at the party. It was great. I got to wear a dress. But that's not why I made the show. I made the show to mean something to people. And in my mind, I'm extremely successful because of that, because I made a show that meant something and still means something to people. And it's all gravy now."

I push back, telling Gellar I remain distressed at what I think is a grave oversight. "But what does that mean, really?" she counters. "There's plenty of people that I could tell you won awards those years and you'd be like, 'What? Who?' If you give me my choice of being a part of this legacy or having a trophy, like, it's not even a conversation."

And she's not just being diplomatic. She has a previous Emmy win to prove it. "I learned that lesson, luckily, really early on. I won an Emmy for *All My Children*. And when I was on soaps, everything was about the Emmys. Every episode is just 'Is this my Emmy performance? Is this what I'm gonna submit?' And I'll never forget that night, winning. And when it was done I thought, Wait, that's it? I don't feel any better about myself. It doesn't mean I'm a better actor. It just meant that those people thought favorably about this performance, and that's just their opinion. And I just...I don't know if art ever needs to really be judged that way. I want to be judged by the people I make it for."

Plus, at the end of the day, Buffy, the character, won a Class Protector Award at her prom. "I wish I still had the trophy," Gellar says. "That makes me sad that I don't have that anymore."

Do I wake up from time to time in a rage à la Joy Behar throughout the Tr*mp presidency? Not no. But then I look at the oversights that come every year around award shows and the ensuing beguilement at a system that's never been nor claimed to be democratic.

Every year, like clockwork, we are surprised to find out that awards are bad. But you know what isn't bad? An enduring legacy, "which," to quote Mariah Carey shading Nicki Minaj in 2013, "is difficult to get. Not everybody has that to their credit."

Agree, Mimi. They really don't.

Popular Culture Reference, Sorry

Pharrell: Do you guys follow any TV shows?
Willow Smith: *Buffy the Vampire Slayer* forever! I will forever be
following that TV show until the day that I die. I love *Buffy*.
Jaden Smith: Yes! *Buffy the Vampire Slayer*!

—*Interview Magazine*, 2016

Part of *Buffy*'s ongoing cultural ubiquity has to do with how often refer-
enced the show was during its original run in addition to its relevance
within the zeitgeist of popular culture. Both the title of the show and
the heroine's name are specific and memorable, and thus the series
has remained a talking point for decades since the Buffster slayed her
last vampire. "*Buffy the Vampire Slayer* is my favorite show ever and I
truly just have it on as background noise because I've seen every epi-
sode several times," food world celebrity Claire Saffitz revealed in an
April 2020 video for *Bon Appétit*. "I just love it so much."

From the show's outset, the parodies began. In 1997, there was
"Buffy the Umpire Slayer" on *Mad TV*. A year later, in 1998, Sarah
Michelle Gellar appeared in a *Saturday Night Live* sketch in which
Buffy was relocated to the *Seinfeld* universe and had adopted an Elaine
Benes affectation and Jerry, George, and Kramer were all vampires.

When Prue (Shannen Doherty) exclaims that there might be
zombies or vampires present in a 1999 episode of *Charmed*, Phoebe
(Alyssa Milano) jokes, "Where's Buffy when you need her?"

"So, what is it you do?" Jack (Sean Hayes) asks Matt (Patrick Dempsey) during a 2000 episode of *Will & Grace*. "I work in television," Matt responds. "Oh my God, I love TV," Jack responds. "*Buffy* is my life." That same year, *Friends* parodied the series when Phoebe's twin Ursula (both Lisa Kudrow) starred in *Buffay the Vampire Layer*.

In a 2001 episode of *Spaced*, Tim (Simon Pegg) gets on his knees to pray to get a job at Darkstar Comics. "I'm not really a praying man, and I never really ask you for much, so if you can just see your way clear to helping me today I would be really, really grateful. Thank you very much. Amen." The camera then pans up to what he was praying over, as angelic music plays. It's a Buffy poster.

She really is the name on everybody's lips. "WWBD: What would Buffy do?" Kenneth (Austin Basis) tells his fellow Ghostfacer in a 2006 episode of *Supernatural*. "You know what I really wish would come to Marthaville? Buffy," Sam Merlotte (Sam Trammell) declared in a 2008 episode of *True Blood*.

In a 2009 episode of *The Simpsons*, Lisa is using a parody Wikipedia site called "Wiccapedia." If you zoom into the bottom right of her screen, one of the search options is: "*Buffy the Vampire Slayer*. The greatest show in history. 2,500,000,000+ articles." In a 2013 episode of *The Big Bang Theory*, Leonard (Johnny Galecki) knocks on Penny (Kaley Cuoco)'s door at six thirty in the morning to tell her: "You need to watch *Buffy the Vampire Slayer*. It's the perfect show for the two of us. It's got action and jokes and hot vampires and romance."

Beyond *Friends*, the show would be parodied often. There was a reference to Buffus the Bacchae Slayer in a 1999 episode of *Xena: Warrior Princess*. The film *Scary Movie* named one of its lead characters Buffy Gilmore, an homage to Sarah Michelle Gellar, whose role in *I Know What You Did Last Summer* was being spoofed. A 2001 *Disney's House of Mouse* episode features Donald Duck watching *Goofy the Vampire Slayer*. A 2002 *Arthur* special introduced the fictitious Muffy the Vampire Slayer. The 2004 film *White Chicks* has Marcus (Marlon Wayans) referring to Lattrall (Terry Crews) as "Buffy the

White Girl Slayer." And in 2006, Graham Norton recruited Anthony Stewart Head for a sketch titled "Poofy the Vampire Slayer" on *V Graham Norton*.

But that's just scratching the surface. Other shows to reference *Buffy* through the years include *Daria* (1999), *Dawson's Creek* (2000), *Malcolm in the Middle* (2000), *Just Shoot Me!* (2001), *The New Adventures of Old Christine* (2002), *South Park* (2002), *Everwood* (2003), *Farscape* (2000), *Gilmore Girls* (2004), *CSI* (2005), *Smallville* (2005), *Veronica Mars* (2006), *Yu-Gi-Oh!* (2006), *Robot Chicken* (2008), *Bones* (2009), *Castle* (2009), *Reaper* (2009), *The Cleveland Show* (2009), *Family Guy* (2011), and *The Vampire Diaries* (2011), just to name twenty.

And then there's the celebrity love for the show. Jaden Smith, as mentioned above, is one of the show's most vocal celeb fans. "Rewatching *Buffy the Vampire Slayer* from the beginning," he tweeted in April 2020. Five years earlier, in July 2015, Smith called into Beats 1 radio on the day of the launch of Apple Music to request the *Buffy* theme song to be played worldwide. And it was—three times, in fact. "Buffy is life. Thank you guys," he tweeted in response to Nerf Herder, who wrote and performed the show's theme song, after they reposted a story about it.

"I was very inspired by *Buffy*, mainly because it felt very fresh and new and like something that hadn't been on television before," *Grey's Anatomy* creator Shonda Rhimes told the *Hollywood Reporter* in 2014. "I felt like I rediscovered television again by binge watching the first—I think it was the first five or six seasons of it—in a row when I was a new mother trapped at home."

Even those who haven't seen the show are aware of its towering presence within the culture. "I know you'll hate me for this but I've never seen it," actor and singer Mandy Moore tells me over Instagram DM. "I know I'm an outlier. Everyone lives for that show." (Holding out hope she'll one day find her way to the series. It's never too late.)

"Bit random but I think my all-time favourite season finale might be 'Restless,' *Buffy* Season 4," tweeted actor, screenwriter, and

producer Simon Pegg that same year. "Quite a convention breaker." Seven years earlier, he referenced the show in an interview with *The Independent* about his experience filming the HBO miniseries *Band of Brothers*. "I spent a lot of time lying in my trailer off-set wearing full-army parachute gear, watching *Buffy the Vampire Slayer* between takes."

Can you blame him?

Love Is Forever

"Happy International Women's Day to cis women, trans women, non-binary, and intersex people who continue to suffer discrimination, violence and inequality," tweeted actor Mae Martin in March 2020. "We've come a long way but still far to go, and crucial to be united in our parallel struggles, not divided! Now here is Buffy." Included with the tweet was a picture of Sarah Michelle Gellar, stake in hand, during a promo shoot for Season 1.

Many shows have fans, some even have fandoms, but few are as big, as vocal, or as committed as fans of *Buffy*. And as fans, we continue to be fed, even some twenty-five years later. Take the United Kingdom, for instance, which saw a big uptick in viewers in 2021 when the series was added to Channel 4's streaming service All4 and Disney+'s Star expansion. When Grammy-winning singer/songwriter Ed Sheeran was promoting the accompanying video for his single "Bad Habits" in June 2021, he explained that the video was not only based on *Buffy* but that he had "blitzed" the entire series with his wife throughout quarantine. When Gellar posted a video from the interview on her social media, captioning it "Next time instead of being inspired by, just put me in your video...please...thank you," Sheeran responded saying "If you're serious we have to make that happen. I'm sure a huge fan." Then, proving his *Buffy* knowledge predated his most recent binge, he added this: "My song 'Afire Love' samples 'Remembering Jenny' from Season 2. Proper fanboy over here."

And he's far from alone.

"*Buffy* did a great service to a lot of people over the last two and a half decades," says Clare Kramer. "When the show first launched, we didn't have the technology that we have today. If I was a person struggling with gender identity or depression, I couldn't go online and find a group of like-minded people or reach out and call a sponsor on Zoom if I was struggling with addiction. The show gave a community to groups that were looking for community. That is a service that the show provided. Back in the day, in the late '90s and early 2000s, that community was something people were looking for and the show provided the catalyst for people to have a human interaction. When they got together to celebrate *Buffy*, they actually got together to celebrate each other and to support each other."

It's true. When I put out a call to fans of the show to share their stories, I received hundreds of emails and direct messages. "I was thirteen, closeted with a bad haircut, when I went to Wizard World Chicago specifically to meet Amber Benson," wrote a fan named Alex Warheit. "We waited patiently in a line for her booth that wrapped around and around for at least an hour or more. Eventually, someone came through and said 'Amber will be done at five, so we're cutting off the line here' before my spot and I was...devastated. Crushed. Trying not to cry. I waited anyway just to see if maybe the line would move faster. Ultimately, they came out and said Amber agreed to stay until everyone got through. Like many young gays, we sublimate by becoming a loudmouth class clown (my AIM name was Alarmingly-Loud, okay?), so when I tell you I was at a loss for words upon getting to Amber, know what a rare thing that was for me. She might as well have been the most famous person on the planet to me. She could not have been sweeter. I think she sensed my fear and that I couldn't communicate. I mustered a 'We didn't think we were going to meet you, thank you so much for staying,' and she instantly gave me a hug and I felt blessed by Tara Maclay herself. She signed my Willow/Tara comic and took a picture and it was the coolest thing that had ever happened to me."

"I can't summarize how much I love *Buffy*, or how long I've loved it," wrote another fan named Alan Barwel. "It started in the UK when I first came out at eleven years old. I'm now thirty-three and it's still ongoing. I never realized there was a real reason for loving it, I just thought, I love it, and that was it. Being an adult and understanding it more, I guess I loved it because I am gay and didn't realize. *Buffy* is the biggest metaphor for feeling alone and still being strong. Growing up and realizing you're not alone and you can change that made me feel connected, and I know why now."

No, I'm not crying. You're crying. (I'm, meanwhile, weeping.)

"I don't think I have ever told anyone this story and it still feels hard to write even if it has been more than a decade since these events took place," wrote a fan named Vasileios, who asked that I not publish his last name. "I was having a hard time due to a serious illness in the family and I was not dealing with it as well as I expected. I was always a happy and positive person, but at the time I was not feeling like either, and it was a very unexpected sensation. I was spending a lot of time at home and decided to binge watch *Buffy* for the first time. The show was not broadcast in my country, Greece, when it first aired and around that time. The DVD box sets were made available and as I was a huge Sarah Michelle Gellar fan this was one of the first few things that made me excited after a long time. It wasn't until I reached Season 6 that I fully related to Buffy and [it] helped me realize that I was experiencing depression-like symptoms. Never before in my life had I experienced emotions like that so it was very hard for me to understand what was happening, especially as there were very few mental health resources at the time. It was while I was watching 'Once More, With Feeling' (and after bawling during the final number) that it really hit me and I realized I needed to seek help. I can never express how much *Buffy* means to me because of this."

"I've been watching *Buffy* for a very long time and I cannot get over this one Xander quote," writes another fan, named Alia Ahmed. " 'Let me tell you something, when it is dark and I'm all alone and I'm

scared or freaked out or whatever...I always think..."What would Buffy do?" You're my hero.' There are many fantastic moments in the show but this quote was so raw and in the moment. This is how I feel when I watch the show, because *Buffy* and SMG are my heroes. No matter what situation I was stuck in, I knew in my heart that at the end of the day I would come home to watch *BTVS* and my distraught feelings would disappear. *Buffy the Vampire Slayer* is my home. It's a show that I can relate to on so many levels and it's a show where I can cry, laugh, and let out my inner rage with those incredible fight scenes. Knowing the amount of power this show has for everyone makes me feel like I have that power too."

Emma Caulfield says she never gets sick of hearing the oft-repeated "you saved my life." "It never gets old. It never gets anything less than sort of shocking to me and elicits this very...I am trying to find the word, but it's like...it's just deep, deep I guess empathy. Like, 'Oh God, really? Like, really?' 'Cause for me, I just was essentially, especially in later seasons, bringing a lot of the levity. I never consciously at any point thought this is definitely going to impact somebody on a really profound level and it's going to save their life. I just thought that's just this ridiculous human being fumbling through stuff. So to hear that the show, or me specifically, being awkward, trying to figure out how to be human had a direct correlation to someone's time in high school when they wanted to kill themselves, I'm like, 'Whaaaaaat?' I sort of have the Bambi eyes, that dumbstruck look on my face. What does somebody do except listen, and just like... be glad it helped."

It's a fandom that has dedicated both hours and dollars to keeping this show and its legacy alive through conventions, events, appearances, message board parties, and more. There's no fans without *Buffy the Vampire Slayer* (1997–2003), sure, but there's no *Buffy the Vampire Slayer* (2004–now) without the fans. "The conventions changed my life," says Clare Kramer. "Playing the character, that is one part of the lottery that is getting to be Glory. The other part is the

human interaction. There's something about *Buffy* that is reaching out and connecting with people who are feeling like they are a minority, whether it's a gender association, a sexual identity, a race issue, a physical disability, what have you . . . something about this show is the great equalizer. And when you go to an event around *Buffy*, it doesn't matter your creed or your skin color or your sexual preference or gender identity, everyone is welcome. And that is what these gatherings are about."

These gatherings have a life three times as long as the series and bring fans old and new, old and young, and from all stretches of the world together to celebrate *Buffy*. I imagine it can be overwhelming to be in a room full of people, most of whom adore you and perhaps at times in their lives obsessed over you. I ask Emma Caulfield if it's different being a woman at a convention, particularly if there's any difference between female fan attention and male. "If there's a line that's going to be crossed, it comes from the men, straight men, not gay men ever, *straight men*," she says, this time souring the pronunciation. "I find that they get very . . . there's a through line there with being kind of like not necessarily connected to reality in a way that makes me comfortable in person."

I ask her to elaborate. "Women are typically very respectful. I mean, you have your occasional 'I'm feeling really uncomfortable, I need security right now' kind of situation. That's happened a few times. But typically it's with some men where I start to feel like 'You have a hidden knife somewhere and you're just going to cut my throat.' Like their eyes kind of go crazy on me. And I haven't experienced that with any other show. Sometimes you feel like you're walking into the basement of a horror movie. It feels like that sometimes. And I don't know what that is, because the show certainly never promoted anything like that. I don't know where that crossover comes into play. But there's a vibe I get from some of the straight men sometimes, an 'I don't feel comfortable right now' kind of vibe."

Still, the conventions on the whole allow the fans to not only

connect with the cast but to connect with one another. But before the convention circuit became popularized, there were the online forums. It was there that fans could connect, share their thoughts, theories, predictions, and, of course, bitch. Jacqui Kramer, who now works as Clare Kramer's publicist, used to post on the message boards that were first popularized during the initial run of the show, back before social media platforms like Twitter and Reddit became the primary forums of fan discourse. "I started posting during the third season when I was between employment opportunities," Kramer says. "I had moved to Massachusetts and I was bored. And I remember we would post and we always knew that they could be watching, the actors, the writers, and Joss, but we also prided ourselves on not caring."

As it turns out, about half of the cast and creatives I interviewed would check out, if not frequent, the message boards. Some admitted this proudly, while others spoke of it more like a guilty pleasure. "Oh, yes, I definitely read what the fans were saying," recalls writer Jane Espenson. "Now, that's commonplace, you can't avoid it, but at the time it was new. It did affect the show sometimes; if we saw that a lot of people had guessed where we were headed, we could change it."

"I checked it out a few times, and then the insecure actor in me kicked in," says Emma Caulfield. "Like, 'I don't think I like what you're saying.' 'Oh, I do like what you're saying! Why aren't you saying more?' 'Wait, am I popular?' And I just ducked out. I can't do this. I figured someone will just tell me if I'm failing or if I'm liked. And if not, I'll know when I get fired I guess."

It was in these message boards that the seeds were planted for a love of the show that grew much deeper and wide-ranging than the show itself. *Buffy* is about 100 hours in total if you were to mainline the entire series (highly recommend). You'd need just over four days without sleep to complete it all (though I don't recommend *this*). But the legacy isn't hours, even years. The legacy will outlive us all.

"Any one of us could cure cancer and on our tombstone it will still say 'Oh, they wrote for *Buffy*,'" jokes Douglas Petrie. But there's,

of course, shards of truth in that. *Buffy* lives on even today at conventions, in academia, in podcasts, in comic books, and more. "It was the subtext, but it was also the text of the jocks being like, 'What are you going to do, little girl?' And then her kicking the shit out of them," says Ian Carlos Crawford, the host of *SlayerFest '98*, "your friendly neighborhood queer Latinx-run *Buffy the Vampire Slayer* podcast." "A lot of us wish we could have done that to some dumb jock in high school. So there's a wish fulfillment and a reliability and then the fact that she'd kick your ass and look good doing it."

"I was an avid fan," says Cynthia Erivo. "I would be watching every week. I was in the last year of primary school heading to secondary school and it was on at nighttime, I probably shouldn't have been up at that point, but I was and I was immediately addicted. I've always been into action and sci-fi and horror and thriller and things like that and this was everything in one. And then to top it all off that the person at the center was a woman who had the most power felt really cool. It was something I had never really seen before. I was immediately sold."

I ask Erivo if she has any favorite moments that come to mind from the series and cite my love of the rocket launcher moment in "Consequences." Then I immediately regret asking such a broad question. This is a show where the most recent episode aired eighteen years ago, not to mention not everyone is rewatching it on the regular, as is my preferred modality. "Is that the episode where Angel becomes Angelus? Yeah, that was heartbreaking." I'm immediately vibing by the indication that I am *clearly* in the presence of a real fan.

Erivo, like many other fans of the show, was keyed into the layers of storytelling at play. "Yes, fantastical things would happen, but often they would boil down to 'How can we be good to one another?' The Angel/Buffy relationship was less about good and evil and more about fighting for a love that you believe in. And I think that when you can filter themes that we as humans are constantly relearning through something that requires you to use your imagination, I think

you have a winner and a show that you can't help but keep going back to watch it and seeing the impossible be possible."

"I was definitely into the general fantasy genre, but I don't think I had the tools at the time to sort of understand why I was so drawn to it," says Claire Saffitz, who throughout her tenure at *Bon Appétit* would sprinkle *Buffy* references throughout many of her videos. "I wanted to be Buffy. So fashionable and funny and quippy and quick with the retorts and athletic."

But Saffitz contended with something that many early adopters of the show had to deal with: a lot of eye rolling. Whereas today, genre shows like *Game of Thrones* have been elevated to appointment viewing, just twenty-five years ago, a show like *Buffy* was easily scoffable. "I think part of the reason is that my viewing of the show was always a little bit closeted," she says. "I couldn't celebrate it as I was watching it. No one I knew watched it while it was on TV. It was something that was only mine. My sisters and I would watch TV, but they didn't watch *Buffy*. In fact, they made fun of it a little bit because I think there was such a poor understanding of what the show really was at the time that it came out. I am actually really proud of my teenage self that I recognized how incredible this show was."

But, as is often the case, Saffitz later found and then helped grow the fandom. "I had a group of friends, all women, who discovered the show not too much later, when we were maybe in college. Two of my good friends who were both women's and gender studies majors took a class on it in college even. Then it became something that I could share with my closest friends, and now with my husband. But I had to wait a long time to be able to share my real love for this show with people around me."

Saffitz argues that that judgment still exists to this day. "I still think people don't understand what the show is, have never seen it and don't really care to. As a viewer and as a fan I've become a lot more vocal and proud about my fandom around this show, because as an adult I have more perspective. I look back on the show and am

like...this show is incredible. And I'm also proud that I was an early adopter. I'm not an early adopter of literally *anything* else. But I still encounter people who are like, 'Oh, my God, *Buffy*? Isn't that like a teenybopper show or something?' And I'm like, 'Actually, it's not.' But I do feel like after this last decade of really premium television it has been receiving much more of the recognition I always thought it deserved."

For Gellar, part of watching with her kids for the first time is seeing the show through their eyes. And lucky for her, they seem rapt. "It's certainly an interesting lesson in 'Women are from Mars, men are from Venus,' because my daughter just loves the love stories and she's like, 'I ship Buffy and Angel. No, wait, I love Riley.' And Rocky's like, 'When is the next demon coming? When's the next fight scene?'"

Gellar, from my vantage point, had at one point a long-standing reluctance to discuss the show in its wake. It makes sense. As an actor, you want people to be able to see you as many roles and not stay stuck on one. Whereas *Buffy* lived on through fan conventions that attracted much of the show's cast, Gellar participated in only one: the 2008 PaleyFest ten-year reunion. She would not participate in any formal *Buffy*-related anything until almost a decade later, when *Entertainment Weekly* gathered the cast for the twenty-year reunion. And that's when things started to shift. Gellar began posting memes about the show, referencing *Buffy* in her Instagram captions and even went so far as to try on her prom dress from the very first season of the show in honor of the show's twenty-three-year anniversary in 2020.

"People always say to me, 'Does it bother you all these years later to still be called Buffy?' And I'm always like, 'Are you joking? That's the biggest honor you can ever have that you made a piece of art that is still important to people.'"

• I think, again from my vantage point, she's grown to understand and appreciate the legacy in all its complexities. I'm reminded of a Tony Kushner quote from a 2018 *New York Times* profile. "Look, I understand that the first line of my *New York Times* obituary is going

to be 'author of *Angels in America.*' " He paused and smiled. "But I also know that I'm going to get a *New York Times* obituary."

"For a while, it wasn't cool to be into the thing that you used to be on," Tom Lenk notes. "Now, rewatch culture is its own thing. And because podcasts, for instance, can be monetized, you start to see lots of actors from shows they were on start a rewatch and embrace what they once may have avoided." This is true with *Office Ladies*, a podcast co-hosted by former *Office* co-stars Jenna Fischer and Angela Kinsey, in which they rewatch the series, and *Showmance: Glee Recap Edition*, in which former *Glee* co-stars Kevin McHale and Jenna Ushkowitz do the same.

For many of the actors I spoke to, there was a sense of not wanting to let the fandom down with some cold, hard truths: that this was a job that many don't hold the same attachments to as the fans. And the fans can often take on a twisted sense of pride in feeling like they can one-up the actors with their knowledge of the show. I put a segment of a 2020 interview I did with Charisma Carpenter on YouTube in which she talks about her unceremonious firing from *Angel* and subsequently learning that she was the lowest-paid actress in prime-time television at the time. One commenter ignores this and every other word she utters, and instead comments: "Pylea was Season 2 not 3, Charisma," trying to correct her for not remembering the season in which her character was sent to an alternate dimension.

"We are getting to the point where sometimes the fans remember things better than I do," says Douglas Petrie. "Which I could never understand growing up. I remember the first show where I was aware that there were writers was *Star Trek*. At conventions the writers would say, 'Well you guys remember that better than we do,' and I thought they were lying."

(William Shatner, who portrayed Captain James T. Kirk on *Star Trek*, famously poked fun at this very phenomenon in a 1986 *SNL* sketch. "Before I answer any more questions, there's something I

wanted to say," he announces from a podium. "Having received all your letters over the years, and I've spoken to many of you, and some of you have traveled, you know, hundreds of miles to be here, I'd just like to say...get a life, will you, people?! I mean, for crying out loud, it's just a TV show!")

I think there's a truth many fans of anything, really, must accept in understanding that their attachments to a certain person by way of a certain entity are not necessarily the same attachments that the person themselves holds to the entity. As a result, stars can disassociate themselves from a certain body of work to avoid the toxicity of a fandom. It's particularly tricky with a show like *Buffy*. A Jennifer Aniston fan might approach her and tell her, "I loved you on *Friends*," whereas a *Buffy* fan might approach Amber Benson and say, "You saved my life." It's what stopped Amber Benson from coming forward with her own negative experiences on-set: a fear of biting the hand that feeds you. That hand up until 2003 might have been Joss Whedon, but in the eighteen years since, it's the fans. But forgotten in that is the symbiosis that should exist: The work does not exist without the audience, sure. But the audience does not exist without the work.

"I'm not as scared of the fandom," Gellar admits. "And I think that the one thing—and you know me personally, so you can attest— social media is not made for someone like me. I am a very private person. But what I have come to understand is that with social media, I get to be the architect of my own story. I determine what I share and what I don't, and it comes directly from me. And so I think for that reason, it makes me more comfortable sharing stuff because I am in control of that." It's also, she adds, that she simply doesn't remember this stuff. This has been a common refrain in many of my interviews: less a reluctance to discuss the show so much as a genuine lack of memory. It makes sense. Can you recall in great detail the job you had twenty-five years ago? "Like, I didn't know [January 19] was Buffy's birthday. And if I hadn't gone on Instagram that day, I probably

wouldn't have known, so thus I would've missed it. It would not have been an intentional slight. It would have been just the genuine fact that I didn't know."*

"I'm more a fan of the fans than I am of *Buffy*," says *Buffy* costume designer Matt Van Dyne. "They are just the kindest, sweetest people." It's a fandom that was vocal on the message boards during the show's run and continues to be on social media today, especially as a new generation discovers the show. In many senses, it's the fans who drive the legacy, with those who created it in the passenger seat.

So how do we, the fandom, consider this show twenty-five years after it premiered and with five years' worth of allegations stacking up against Joss Whedon? That part is not so easy. Three years before Kai Cole went public with her essay calling her ex-husband a "hypocrite preaching feminist ideals," Dylan Farrow confronted fans of her father with a provocative thought pattern: "What's your favorite Woody Allen movie? Before you answer, you should know: when I was seven years old, Woody Allen took me by the hand and led me into a dim, closet-like attic on the second floor of our house. He told me to lay on my stomach and play with my brother's electric train set. Then he sexually assaulted me." (Note: Woody Allen has vehemently denied Dylan Farrow's allegations.)

"I think we came into the podcast, and speaking about *Buffy* in a public way, already knowing that Joss was not a perfect feminist," says *Buffering the Vampire Slayer* co-host Kristin Russo. They had started the podcast a year before Kai Cole's letter. But even before that, the

* Fun fact: Buffy's birth date is listed as October 24, 1980, on a computer screen in Season 1, Episode 8, "I Robot, You Jane." Later in that same episode, when examining the same file, her birthday then reads as May 6, 1979. However, in Season 4, Episode 11, "Doomed," she says that she's a "Capricorn, on the cusp of Aquarius," which would corroborate the January 19 birthdate that is canonically believed to be her birthday. Plus, Season 2's "Surprise" and Season 3's "Helpless" are both Buffy birthday episodes and both aired on January 19. As for her birth year, in Season 5, Episode 22, "The Gift," the year changes once again, now reading as 1981.

pair had operated knowing that Joss was a "problematic figurehead," as the pair articulated. "It's quite a dichotomy to have this thing that we're like, 'Hey, smash the patriarchy! Hey, feminist hero!' And to also then reconcile that one of the creators of the show (I know he's billed as *the* creator, but one of the things that we talk about is that there are many creators) has caused so much harm."

And yet that is what we, the fans, must face. "I think about the fact that for actors like Charisma, the show is forever a trigger in their lives," says James Scully. "And I'm not the only one, as are many people, who have suffered that kind of trauma or some form of trauma. It's sad that they had to work within a framework where they had to wait all of these years to finally say something. Most people just want to put that stuff to bed. In my industry, when people say, 'I can't believe that this stylist did that,' I'm like, 'Well, they did.' It's very difficult for me to look at someone like Bruce Weber's work, even though that is someone who totally formed my idea of fashion. I would have no career without Bruce Weber. It's a difficult question to answer: Can we view the show now without foregrounding the Whedon allegations? But I have to say I empathize with the victims *and* it was such a formative show, the beginning of a different kind of golden age of television. I'm having a difficult time with so many of these things, separating the art from the artist. But if these actresses came out and said, 'Please don't watch this anymore,' then it would make the choice much easier emotionally."

"I think it's different now if you are watching it for the first time," says Gabe Bergado, echoing a sentiment felt by many, including me. "Everything that *Buffy* was going to provide me with, I've gotten. I'm thankful to have watched it and been able to grow with it in my formative years without having known this. It doesn't change what I've taken away from it, but it makes me sad for all of these actresses and people who worked really hard on the show and had to go through that, because I owe them so much. But I've never given full thanks to Joss Whedon. There's so many people beyond just him who worked

on the show. I'm thankful for what I've been able to take away from it, but it's definitely soured things."

Still, some simply won't or can't rewatch the series given all that is known now. "I can't separate Whedon from the series," says author and columnist DW McKinney. "It's not possible anymore. I rewatched the show in 2019, and even then, there were more problematic issues that popped up for me than in years previous. With the full lens open on Whedon now, with all the stories of his alleged abuse, it's impossible to detangle him from the show, because now I—we—can see how his behavior is intrinsically woven into the show. It makes you rethink many of the characters. The ones that were already questionable come off as being hyper-perverse, misogynistic, and abusive. I can't see myself doing a complete rewatch in the near future, maybe just my favorite episodes."

Lowery Woodall agrees. "The writing will always be solid—each character—well, each main character—has a distinct voice that rarely seems to waver throughout the course of the show. But there are a few parts of the show that do not age as well. The feminism of the show, while admirable for all it tries to accomplish, now feels overshadowed by the personal demons of Joss and his failures as a human being. It is impossible for me to imagine watching the show without thinking of the hypocrisy between the message he is preaching and the way he lives his life."

This conversation—the separating the art from the artist—is one Tavi Gevinson and I have had on several occasions, and not just about Joss Whedon. "As much as I'd like to have hard-and-fast rules that can apply to every case that is lacking accountability, whether it's of assault or abuse or bigotry, I think it's hard to generalize because I think there are different kinds of harm. So in some cases I can separate the art from the artist, and in other cases I can't, and then in other cases it just depends on the kind of day I'm having. I would say overall I have no illusions over what kind of difference it makes in the world if I listen to a song or not. I know that sounds glib. I know that sounds

nihilistic. I actually come at this from a place of believing that there could be radical transformation of society that is in part a result of the Internet and journalism and all of these avenues of pursuing justice often outside of law enforcement that have become more present in the last few years. The way I feel today is that I would defer to what the actresses on the show want. But at the same time, that's a tremendous burden to put on victims and survivors. At times I've been really grateful for people to ask me that sort of thing, and at other times I don't want that power, like, you figure it out. If you're uncomfortable, if you can't separate the art from the artist, that's on you."

Ultimately, Gevinson says the reason that questions like these continue to stay at a boil is because fandom becomes a big part of our lives and our identities long beyond the timeline of the art itself. As she says this, I stare at a mug that a friend made me featuring my image alongside Sarah Michelle Gellar's that I keep on my desk. "I think the question of 'Can I still like this person's art?' can be a solipsistic exercise, because I think it's more 'How do I reconcile my fandom with my values? And how do I deal with this part of my identity?' And honestly I think 'Can I still like this person's art?' is a really childish response to learning about apparent abuse and violence. I would in fact argue that that obsession with taste is part of why artists or showrunners or whomever have been able to act with impunity for so long."

At the same time, and Gevinson acknowledges just this, life is hard, and for many of us, these shows are lifeboats at a time when we are drowning or *feel* like we're drowning. All the more reason then, she says, to not treat these figures as outliers and to understand that exploitation, abuse, and different forms of violence are integrated into the power structures of Hollywood and beyond. "At this point it shouldn't be surprising that Joss allegedly did any of this stuff, because we know now that men with feminist personas can be abusive. Where I am at now personally, if you agree that we are shaped by systems and various forms of oppression and if you have a basic grasp

on cyclical abuse or trauma, you can see why it is not surprising that we are learning that so many people are abusive or have been violent towards other people."

For many people, the question is less whether they can still watch *Buffy* so much as it is whether they can still engage in the culture of loving *Buffy*. Is it socially acceptable? Will liking this get me shit on the Internet? "I think those questions fly in the face about what is so great about art and pop culture, which is that you don't get to decide how you feel about it," Gevinson says. "You have an involuntary reaction the same way a laugh in response to a joke is involuntary, the same way what you find erotic can be involuntary. It's not really up to you to mediate it or understand it. I think it takes away some of that mystery and turns art into a political forum that I really don't think it is or should be when what you like and what you don't like is your primary mode of political expression. I don't know how productive that is, and I also think it's bad for art and for artists."

She leaves me with this: "I don't mean to sound like such a raging bitch about what people do with their fandom. I understand that it is a big part of people's identities. I also think that it's really painful when the thing that helps you cope with life's struggles, especially in an instance like this when they are specific to sexism, when you find out that the creator was also a perpetrator of the same kind of issues that their work was helping you cope with. That is really painful, and I have no answer to it besides the thing that I repeatedly come back to in my own life which is, *Well, yes, did you think you'd go through life unscathed?* There is no version of me that exists somewhere else without having had those experiences. There's no version of my favorite artists who were also abusive where they didn't also abuse people. There's no alternate timeline where my assailants didn't commit any violence. I think letting go of these fantasies of purity is one kind of path toward moral clarity. And I think being able to extend compassion to yourself, as a fan, for having these concerns doesn't

preclude the ability to decenter yourself and care about justice and accountability."

Joss Whedon created *Buffy*, but it is no longer his, and one could argue that it was never his to begin with. "The idea that Buffy the concept, the heroine, the flawed human, the woman trying to make her way in a world against insurmountable odds, could ever belong really to one person [just doesn't work]," says Jenny Owen Youngs. "The way that stories work is that a bunch of people collaborate on them and then they go into the world and are immediately no longer the property of the people who even all worked together to put them [out there]. They become a part of the popular culture, and with a show like *Buffy*, the collective consciousness, and every single person who watches the show, projects and intakes what they most want to."

Some don't agree. "Joss is the series and the series is Joss," argues Lowery Woodall. "He has his fingerprints all over every episode of the series. Even the ones he did not write or direct often had his direct influence pervading over them." I'm reminded of the Season 3 DVD special feature "Buffy Speak" in which the writers explain that *Buffy*-speak is essentially just them all picking up on how Whedon, himself, speaks. Jane Espenson even notes that most times people compliment a line that she wrote for an episode, it's more often than not a Whedon rewrite.

Still, *Buffy* remains a powerful connective thread, a shared language that can bond strangers. "When I meet someone who loves this show, it's like an instant connection," says Claire Saffitz. "And that's not something that comes easily to me, or that I find very often. My acupuncturist heard me talking about *Buffy* in a video and was like, 'I like *Buffy* too!' And that's when I realized why we'd had a great connection from the beginning. I think that it tells you something about a person when you learn that they also love this show. I think it tells you that, possibly, I don't want to generalize, but maybe they're a little weird, maybe they experienced some alienation as a teen, as a high

school student, and I love sharing that. For me, when I meet someone else that watched this show, I get really excited."

And so we can watch the show with love and adoration while pointing out plot points and lines of dialogue that were passable in 1997 and are no longer passable today. Or one can choose to leave *Buffy* with Whedon in the past. But still, "the beating heart of this show remains intact and continues to be a light for anyone that wants to look at it," says Owen Youngs. Its light flickers, but never goes out.

"One of the many magical pieces of the show is that we really do see a lot of the characters from so many angles," adds Kristin Russo. "We don't see just the best parts of them. We see the worst parts of them and we don't only see the best and the worst, we see the shit in between. And that's uncommon. I think the gray area that the show is always exploring, always, sets it apart from so many other stories. And because of it, it's a show that people watch again and again. Because when you're twenty-one and someone just broke your heart, you're pulling from a particular place. When you watch it and you're forty, guess what? You're gonna have so many feelings, including, 'Holy fuck, I didn't know that *this* piece was here for me.' It's just so nuanced and rich. Like Cordelia, it has many layers."

SMG, and the Weight of the World on Her Shoulders

"I'm a huge fan of yours, as you know," Stacey Abrams said during a May 2021 conversation in promotion of her book *While Justice Sleeps*, which was moderated by Sarah Michelle Gellar. "In fact, it's in every one of my romance novels that I was a *Buffy the Vampire Slayer* fan from way back. But I also used to love you when you were Kendall on *All My Children*. I say that because not only are good storytellers in writing, good storytellers as actors make you believe that you know what's possible and you can situate yourself in the creation of this new world."

Abrams, like me and many others, is tapped into the dynamism of Gellar's performance as a central reason for the show's success, both then and now. "I'm not just saying this because you're interviewing me: It matters who plays the role; it matters who imbues the story. I got a question once, would I watch a reboot of *Buffy*, and my answer is probably not. You can call her something else, she can be one of the Potentials who comes into power, but there are some characters that are so iconic because of how they are portrayed that it's not just the words on the page, it's how those words are lived."

"Where's her Emmy?" Jenny Owen Youngs shouts when I asked if she thinks an appropriate amount of respect has been put on Sarah Michelle Gellar's name for this performance. "In my closet right now, I have a whole bag of pins that just say 'An Emmy for Sarah,'" says

Kristin Russo. "We say it so often that it had to go on a pin. I'll send you one."

"I think when you think about actors who are able to slip seamlessly into their character, people talk about James Gandolfini as Tony Soprano, and I think we should also be talking about Sarah Michelle Gellar as Buffy," says Claire Saffitz. "She became Buffy, and I think that might be part of the reason why it doesn't get seen, people thinking, Oh that's just her personality. But that's very disrespectful and I think doesn't recognize her for her craft."

Her castmates agree. "She's on a level that a lot of people don't get where she can get there, wherever it is, so subtly and truly that she barely needs to say or do anything for you to feel it," says Seth Green.

"She's just so ridiculous," Emma Caulfield says, whose interior vocal intonation changes at the mere mention of Gellar's name. "I'm saying it with love. She is so professional, right? Like, humblingly professional, like, 'Damn, you didn't mess up one single line and you just spoke for like four pages...how do you do that?' She's got this intense work ethic, really, like, unmatched by anyone I've worked with before or since and then just, like, drops right out. There's no 'Let me ease out of that scene for a second' or 'Let me just kinda ease back into being Buffy for a minute.' She just switches. And she just makes me laugh. She's such a powerhouse. There's literally nothing that girl can't do. She's fiercely loyal. She's been a celebrity for forever, and there's celebrity Sarah—very, very well thought out—and then there's this person that's, like, right *there*, if you can access her. She's the best time."

"When we met through the *Cruel Intentions* audition process and became friends, I naturally tuned in to everything she did," says actor Selma Blair, one of Gellar's best friends. "She was different. She was just SMG. Very in-charge. Very capable and sexy. And crazy smart and clued-in to all. A nurturer. A boss. A friend. A Disneyland girl, a loyal comrade. Fun. Blond. Tan. White teeth. Great skin. That glint in the eye. A really hard worker. You know all this as soon as you

meet her. Even at the age she was, I was always impressed by Sarah and understood her star power without any weirdness. Sarah always felt very sure of her internal compass. I learned to feel very safe with Sarah. No small feat. I always marveled at her ability to multitask and delegate and care for people, all while really knowing this business. And she is an incredible talent. Incredible in her connection with the public. The respect. And her skills. She is extremely, easily funny."

Obviously to most, the proof is in the pudding. Just watch the show! She's unbelievable! Go back and listen to any DVD commentary for the show and you'll undoubtedly come to a moment when whoever is providing the commentary—writer, director, cast member, you name it—will utter something to the effect of, "And here's Sarah Michelle Gellar doing that *thing* that she does." For me, there's Meryl Streep and Sarah Michelle Gellar; without them the craft of acting would be a lesser art form.

"If I had to make a list of the top three most professional actors I've ever worked with, I think she'd have two of those three slots," says Doug Petrie. "But she made it look effortless." "Could there have been a better Buffy?" Jane Espenson rhetorically muses. "Her face is a marvel of expressiveness."

"That performance is flawless," says Danny Strong. "It's a fantastic piece of acting, and it was very effortless. I remember watching her on-set and just being like, 'This actress is just fantastic.'"

"We always got on; we had a good connection," says Anthony Stewart Head, who says Gellar was like a big sister to his two young daughters who would visit the set periodically from their home in England. "You hear about actresses—and actors too—who sort of do their take, their close-up, and then leave, and their scene partner has to do the scene with someone else standing in. Sarah Michelle never, ever did that. She always, always gave me a full-on performance even when the camera wasn't on her. I have to take my hat off to her, because we went overtime quite a lot and she had to work so much. Also, a lot of actors and actresses just let their stunt double do all the fights, but she

would always do so much active work on them, rehearsing with the stunt coordinator if she had a break. She did a remarkable job, and it's lovely to still be friends."

"I really learned a lot from her," says Clare Kramer. "Sarah never once, in any of my scenes with her, missed a line, missed a cue, missed anything. I remember one time we had one of [Glory's] minions come and they were literally having to feed them the lines. [A script supervisor] would say the line, and then he'd repeat it. It was a scene with Sarah and I remember thinking, I never want that in my career to be me. I never want to be the person who doesn't know their names, who hasn't prepared, who doesn't know what's going on. And to this day I am that way, and a lot of that is what I learned from working with Sarah. She was extremely professional in all the right ways, in all the best ways. She was kind to me. I basically kept my mouth shut and tried to absorb and tried to listen and understand as much as I could. I learned a great deal from her, more than I could ever learn in acting class."

"She represented something," says Drew Z. Greenberg. "And she encapsulated all of that in her performance. I didn't know about process or anything, I just knew that this show that I was watching, this young woman that was up onscreen, was funny and dramatic and emotional and hit all of these notes. And once I was there I soon learned that I could write anything, *anything*, and she'll handle it. Sarah could quip, she could do an emotional heart-to-heart. Whatever I put on the page was gonna be safe. And that says something. I don't think most people have all of those arrows in their quiver."

It's clear from just about anyone you talk to, colleague, journalist, or fan: before there was something about Mary, there was something about SMG. "She has a beauty contestant's smile and the hyper-vigilant manner of a person who doesn't trust anyone who hasn't earned it but who nevertheless needs your vote," read a 2000 *Rolling Stone* story. "She has a physical charisma that in itself borders on a superpower."

"There's just nothing she can't do," Jenny Owen Youngs succinctly puts it. She's right. Since she made her acting debut at the age of five in a nationally televised commercial for Burger King, Gellar has possessed the chops. A year after that, in 1983, she made her film debut playing Valerie Harper's daughter in the made-for-television movie *An Invasion of Privacy*. Minor film and television appearances followed, including *Spencer: For Hire* and *Crossbow*, before she landed the role of a teenage Jacqueline Bouvier in the television miniseries *A Woman Named Jackie*. A year later, in 1992, she landed her first regular role on the short-lived teen drama *Swans Crossing*. That show failed to gain traction. Fortunately her next role, as a series regular on *All My Children*, would earn her a Daytime Emmy.

"She's been doing this a long, long time," said Brad Turell, then the executive vice president of network communications at the WB, during a July 1999 interview with the *Vancouver Sun*. "And she's not surrounded by managers and agents and all the others. She calls you directly. She talks to you. She talks about the issues. She knows what's going on. She likes to be involved in her career, rather than have her career just happen. It would be neat if that class, that maturity, that professionalism, was emulated across the industry, but..."

At that point, Gellar, who asked to be present for the interview, cut in, shielding her eyes to stop the embarrassment. "I'm sorry. I just couldn't listen to talk about myself anymore," she interjected.

Gellar has always been a private person. There were never any pictures of her getting tipsy at clubs, no mugshots or explosive bombshell interviews. "I've been in this industry a long time, and I've learned that the most important way to keep sane is to have two separate lives—a work life that's out there for everyone to see, and a life that's your own, so that when you go home at night you can be a regular person," she said at the time.

And it's because of that lack of access to her personal life that many rumors were spun out of thin air about who she was based off of her work ethic. Remember, this was the '90s/early '00s, so

a hardworking woman in Hollywood would often be painted as "unfriendly" or "demanding" or a "bitch."

"It's interesting to compare it then to now, because at the time she took so much shit for taking charge," says Seth Green. "It was in a time where women were easily labeled a 'bitch' or a 'diva,' but Sarah's stuff was never like, 'I need three sugars in my coffee!' It was like, 'Hey, we're thirteen hours in, all of this stunt team that's been in full makeup for fifteen hours haven't had a break. The sun is coming up and we need to get this shot turned the fuck around.' Like, it was that stuff."

I ask Emma Caulfield about these rumors and whether she felt they were steeped in misogyny, seeking her thoughts given her vantage point. "Let me think how I'm gonna answer this one," she says. "I want to make sure I also help you set the record straight. Yes, misogyny, sure. I mean, a hundred percent, without a doubt. Press gets information from sources. The press is only going to record or put out there whatever trickles out from sets. She was the lead on the show. It was an ensemble cast absolutely, but the show lived and died with her. There's a level of power there and a level of voice that needs to be accounted for. And if that isn't received well by certain people who have very large egos and who have no interest in working in that fashion, then yeah, there's going to be conflict. And that conflict will find its way through everywhere. It'll trickle down."

And then, without prompting, Caulfield shares this anecdote with me. "I remember specifically a time—and I'm not talking out of turn because she and I, we've talked about this since then and we laughed about it later. There was this rumor going around on set that we were all supposed to be on the cover of this magazine. And it was a big one. And we were told that Sarah killed it because she wanted to be on a cover by herself. And all of us at the time were like, 'Wait a minute. We should get publicity too.' And then just it...it set me off. I just found that to be incredibly disrespectful and not cool. And I spent the entire day basically talking shit about her to anyone and everyone I could think of. And then...then the correct information came to

light and I was like, 'Oh shit, that's not true at all. Oh my God. She had absolutely nothing to do with that.'"

Caulfield then made a decision. First she approached anyone she'd spread the rumor to in the attempt to dispel it. Then she knocked on Gellar's trailer door and explained, "'Hey, so this is what happened. This is what I heard. And this is what I said about you verbatim. Like, these are all the shitty things I just said about you to anybody I could possibly find to talk shit about you with.' Then I told her that I'd gone to everyone to tell them what had *actually* happened. And she just gave me a big hug and said, 'Thank you. I feel awful. I didn't have anything to—' And I cut her off and told her, 'I know you didn't.' I think that was one of the first times that she and I connected separately from work because I wasn't scared of her. I wasn't going to pull any punches. And I wanted to be ethical and honest."

So where, then, did that rumor begin? It had to have started somewhere. Caulfield takes a heavy breath. "There are so many examples of what happened from the top down of, 'This will really make the girls hate each other. This will make the men angry. This is going to stir some toxic shit.' And…and it did."

"She's a badass," says Amber Benson. "I remember going to do *Supernatural* not long after I had finished *Buffy,* and it was such an interesting set because they only had two leads and then everybody else was ensemble. And I think when you have two leads, it makes things a little easier because one person isn't the figurehead. And I think what was tough on our show is that Sarah had all the pressure. And I think she was put in a lot of situations where she was the face of the show. And I think that was hard for some of the other actors. That was the impression I got. Everyone's like, 'No, this is an ensemble,' when it's kind of like, 'No, it's called *Buffy the Vampire Slayer.*' So I think there was some friction because of that."

"I've always had tremendous respect for Sarah," says Julie Benz. "She's a unicorn. I remember even back when we were shooting the first season watching her work—and she was nineteen when she

started the show—and the level of commitment to her work. She was spending her weekends doing stunt rehearsals and she was always on time and knew her lines. I couldn't have done that at nineteen. I've always stood in awe of her and her professionalism and I learned a lot from her, even with the little bit of time that I worked with her, about what it takes to be the lead of a show. And she got a lot of backlash in the press. I would always hear these rumors about Sarah. And having known Sarah and having worked with her I would always say, 'That girl knows her shit more than anybody else on-set.' It's just that she was a woman, a young woman, and there was a lack of respect towards her with her knowledge and experience because she was female and because she was young."

Marc Blucas was also quick to dispel rumors of Gellar being difficult, portraying her as a leader who set the bar high for herself, and in turn wanted others to rise to the level. "Here's one of the things I'm most proud of with the show," he says. "Even though I was the worst actor on it, there were three times I got a phone call on days that I was not supposed to work with someone saying, 'We're having some problems on-set right now. Sarah is saying the only person she'll work with is you.' And that might have been people not knowing their lines, that might have been drama happening that I wasn't aware of—and still am not. But I can tell you that they were like, 'We'll give you time. You can rehearse, but would you mind coming in today?' And to me that was a huge compliment because it meant she enjoyed working with me. Even though there were a million fucking frustrations, she knew I was going to be prepared. She knew I was going to try. And she knew I was going to be kind. That's the takeaway I hope she has of me."

He continues: "But yeah, her comic timing...she has such a face for it too, because she has such big eyes. She had, at that point, eighteen or so years of training. And it showed. Like, she was so specific when she had to be tough or when she had to be funny or when she had to be emotional. The show gave her a platform to do an awful lot of things and she was able to, each and every time."

"Sarah is a beautiful human being and she's also a perfectionist—and I mean that in the positive sense of the term," costume designer Cynthia Bergstrom says. "She's a brilliant actress and she really expects a lot of others. If she saw something that needed to be corrected, it was because she was making it better."

"We were known as Buffy the Weekend Slayer, and Sarah was in almost every scene," says James Marsters. "They burned her to ashes on that show. I remember she started coming in, I think it was in Season 6 or 7 and it was just getting really bad—I mean, we did twenty-two episodes a year, took three months off, and then climbed back into that machine and it will grind you down. And she made a point to come back to the set to say good night to the director and the cinematographer and show them what she actually looked like. And it was just this person who you could tell was hollowed out by fatigue. And she didn't complain. She just wanted you to see it. 'Good night. Have a good night.' And maybe she was just being polite and saying good night. But the effect on me was just like 'holy crap.' I think that I'm tired and I'm not onscreen an eighth or tenth or twelfth of the time she is. If Sarah hadn't been so good at keeping it together, never flagging, always being ready with that amount of hours and with that kind of pressure, it could have gone sideways. I kind of wonder if I'd have been the lead at that time in my life, doing my method-acting thing, feeling everything like that, I wonder if we would have even been able to go seven years or would the whole thing maybe just have blown up."

This "Buffy the Weekend Slayer" name was repeated by many of the actors throughout my various interviews. "I would say now in hindsight having the career that I've had, that was the most difficult show I've ever worked on as far as hours and what was physically demanded of you," says Julie Benz. "We were all operating on very little sleep, and every episode felt like a season finale. I loved it, I absolutely loved it, I'm glad I was young when I did it, but we were doing eighteen- sometimes twenty-hour days, especially with the prosthetics."

According to Benz, and repeated by just about every inter-view throughout, nobody was asked more of on that set than Sarah Michelle Gellar.

Nicholas Brendon, too, praised Gellar's work with the type of introspection that can only come with time. "It's a great show. And Sarah is an amazing fucking Buffy. And I needed the time to heal a little bit. I needed some . . . some space to really see how magical Sarah was. I did not give her the credit in my head that she deserved. And I wish that I had."

"If you get a chance, remind her of this story because she prob-ably forgot about it ten seconds after it happened, but I'll remember it forever," Doug Petrie starts off when I prompt him to recall a moment with Gellar on-set. "I was directing an episode and I was making a lot of self-deprecating jokes because I was nervous. And Sarah took me aside—which is always scary, because I thought, I'm gonna get my ass kicked—and it really changed everything for me. She said, 'You're a good director. Nine out of ten times the direction you give is exactly what should be given. So my advice to you is, "Give the direction, shut the fuck up, walk off the set, and watch that confidence extend itself to the crew."' And I did kind of feel punched in the mouth, but I was like, 'I'm going to try exactly that,' because ultimately she wasn't punching me in the mouth, she was saying, 'Be confident. Stop putting your-self down.' And so I did exactly what she said. Instantly. I said, 'Try this, this, and this,' and I went off. And it changed everything. And she was right. And I've carried that story with me for twenty years. I would bet a million dollars she doesn't remember that story, but she changed everything for me. It was very generous."

"When was *Buffy* on the air?" *Pushing Daisies*, *The Hobbit*, and *Guardians of the Galaxy* star Lee Pace starts off during our interview. It was 1997 to 2003, I tell him. "Yeah, I went to school in 1997, so I was kind of locked in the vault at Juilliard for much of the time that it was on the air. I don't think I've ever seen it, to be honest." He thinks for a moment. "No, I've definitely seen episodes. I've seen the musical

episode, which I have to agree is very fun. But I never watched the show when it was airing." I kinda love that Lee Pace agreed to do an interview with me for a *Buffy the Vampire Slayer*–themed book having never seen the show. In his defense, I came to him more as one of Sarah Michelle Gellar's BFFs than as a famous fan of the show. They met in 2009 when the pair starred in the little-seen indie flick *Possession*.

"You make a good case for checking it out," he tells me when I argue my points as to why he should drop everything and start watching from the beginning.

"Sarah knows what everyone is doing. I remember her looking at the call sheet and reordering it for the assistant directors because she understands how those days go; she understands what we need to film to make the scene go. She's such a professional. That, and she's a vicious prank player, to be honest. I remember going up to Squamish to spend a weekend hiking and camping [while we were filming *Possession*] and I came back on a Sunday night and she had somehow gotten into my hotel room and had covered it in pictures of herself. There were pictures in the pockets of my clothes, in my shoes, in my books. I was finding pictures of Sarah two years later. I remember putting my hand in a coat pocket and coming out with one of her headshots."

It's a testament to how beloved Gellar is that someone like Pace would take the time to do an interview where the prompt was just "love on Sarah Michelle Gellar with me, please." But that he did, and with great enthusiasm.

"She is good at being a friend. She is so supportive, remembers things, checks in. When I first moved to LA to do *Pushing Daisies* I had this house and I didn't have hardly any furniture in it and she gave me a bed. That's who she is. Every year we try to get each other on April Fool's. And if you were to ask her, she would tell you that I've never been able to trick her yet, but I'm sure I've gotten her once or twice." He stops, thinks, reconsiders. "But no, she's too clever. When I was doing *Angels in America* [on Broadway], I heard 'Lee, Lee' outside

of my dressing-room window and I looked out and there's Sarah from the street below yelling up to me. She's a friend that brings positive energy into your life. All you have to do is look at her *SNL* appearances to see how game she is. She shows up. She shows up with her full self. [In this industry] you run into a lot of assholes, but when you do find someone like Sarah who consistently has your back and consistently shows up with fun invitations, you cling to it immediately. Sarah's not going to waste your evening complaining about stuff. She's the best."

Seth Green, one of Gellar's closest friends, shared similar sentiments. "She's one of the finest examples of a woman that I've met. Especially having known her since she was a child, seeing her intentionally chart this path, but also roll with whatever she received that was unexpected, I remain in awe of her all the time She's one of my how-to-be-a-good-parent inspirations. And she really sets a bar for how to be a good friend. I love her and I hope we're friends until we die...and maybe we'll meet each other in an astral plane, who knows?"

I ask Selma Blair to share with me what it is about Gellar that makes her such a remarkable human being. She had a lot to say. "She always liked changing into a sensible shoe or Ugg boots on set—unlike myself," Blair recalled with a laugh. "I wanted to wear wardrobe all around between takes. So proud was I to be an actress, new to this entire world of Hollywood. I am older, but naturally felt younger than my years because I have always been the student. But Sarah will always point out my strengths. She is a remarkable friend. Sarah does not enable bad behavior, but does not judge. A solid young girl and a solid adult. My appreciation is intense."

Unprompted, she continues, because there's more to offer up: "When I got sicker with MS, Sarah took such incredible care of me. Rallied the world's greatest meal train for me, one where Reese [Witherspoon] as well as Sarah's generous and glamorous and dear friends sent over more food than I ever had the option of having in

my kitchen. It was a huge help financially as well as physically. She came to my house and arranged for me to get this amazing vibrating machine—a power plate—delivered. It was a major aid in my body recovery. Still is. Major. And that is Sarah and her connections and how she maintains such good relationships. It defines her now as much as all her stardom with *Buffy*. Sarah packs a punch. Gets the job done. Gives love. Never complains. I don't know how."

She continued, still: "Sarah arranged my Covid vaccine, for God's sake! Got our kids out to the beach with new wetsuits and masks, with me in tow after a weakening transplant. She's remarkable, really. Of course, it's ingrained in me if a camera is on and she's around, I go in for a kiss. It's a joyous reference always. The delicate, poker-faced beauty who taught me to love Disneyland so fully...who knew she would be my best kiss forever? My gorgeous blond sister best friend SMG did not disappoint. From helping me with my sides on that *Cruel Intentions* audition to now, married to Freddie Prinze Jr., the teen heartthrob who I also kissed onscreen. We don't need to socialize with each other regularly even. It's just there. Sarah always makes sure. I love her so much."

If there's two through lines in just about every interview I did, it's (1): *Buffy* was exhausting, and (2): *Buffy* could not have happened without Gellar's unflappable grit, stamina, and steady hand.

I uncovered a 1999 roundtable with the writers of the series ahead of Season 4 in which Whedon attempts humor in a way that was nothing short of patronizing. "Early on, we saw that Sarah can go to a deep, emotional place—she can be light and cute and all that good stuff, but she can also take you to a very dark place, and the show ended up skewing that way," he explained. "We've put her through so much, and some of our mission statement for [Season 4] is to let the poor girl have some fun. We'll still make her cry and stuff—but in a funny way." It's a heartless way to speak about any actor, let alone your star, but as we know from chapters previous, it's hardly out of character.

"A lot of actors just think their job is to show up and hit a mark,"

says Gellar. "And I've never believed that. My job is to hit that mark *precisely,* because otherwise the focus puller can't pull the right focus and the boom operator is going to make a shadow and not be able to hold. And so at every point in *Buffy,* I tried everybody else's job for at least one scene. I tried to hold the boom for a whole scene and my arms almost broke—and I'm pretty strong. I tried to pull focus and it was a disaster. Like, these jobs are very difficult. Holding a steady cam for that long is extremely difficult. And so it wasn't just about the performance."

I reference Gellar's work in "The Body," asking if there's ever any scene from the show that she can watch with any ounce of awe at her own tour-de-force performance. "I don't think so," she immediately shoots back. I press further, knowing there has to be at least one moment. "When I rewatched the Season 1 finale and Buffy says, 'I'm sixteen, I don't want to die,' I was like, 'Okay! I don't know how to improve on that. I'm okay. I'm good.'"

But she wasn't good. She was never good. She was the best.

Gustav Gustafson was the leadman in the art department for *Buffy* from the start of the show. In 2000, his HIV got worse, he had to go on disability, and he died that year (the show dedicated an episode to his memory in Season 5). His best friend and caregiver John Paschal shared this: "You know, this was back in the day when the rags were really running rampant and I would always read about what a bitch she was or the fit that she threw. And I had an inside source, so I would ask Gustav and he told me, 'I'm on the set every minute and I've never seen anything like that.' I just remember they always painted this girl as being nasty and not nice and demanding and controlling.

"And when Gustav got sick it was devastating, and it was quick. We rang in the year 2000 at Cedars-Sinai in his hospital room. I found it really beautiful that everything I had heard about this show and about the cast not liking each other . . . how they just showed up for a crew member. Sarah would come to the hospital and sit with

him in his room. There was no press. Not one person knew she was there. Although, there was a funny anecdote from when she was sitting at his hospital bed about a month before he died and the bulletin board in his hospital room had a cast photo of *Buffy*. And one time the nurse came in, she's doing her job and stuff, and she looks over at Sarah Michelle sitting there and says, 'I have to tell you, you look just like that girl on *Buffy the Vampire Slayer*.' And Sarah looked up and smiled big and said, 'I get that a lot.'

"And so then in the last nine days of Gustav's life he asked if he could come home. He knew he was going to die within a week. So I cleared out my guest room and we brought in the hospital bed and I have to tell you that in those nine days Joss Whedon sent over lunch and dinner every single day, catered for like fifty people. It was very sweet. And Sarah Michelle came three more times in those last nine days. And I got the chance to have a few really nice conversations with her. When she came out of the room she would be visibly shaken. I'm wondering if this was the first person that she knew, that she saw dying day after day. And she would take me outside and say, 'John, what can we do? I'll do anything. I can write a check. What do you need?' And I said, 'Sarah Michelle, you can't write a check. He's going to die within the next few days. There's nothing that anyone can do.' And I said, 'What you're doing is so much just by being here now.' And she'd listen. I said, 'You have no idea what it means to him that you stopped by. You're a star of a massive TV show and you're stopping by. He's a set director, you know what I mean? He's a prop guy. And you're showing up.'"

Where Do We Go from Here?

"If you were to explain to a group of aliens what it is about *Buffy* that makes it a show so defining and formative, how would you explain it?" I ask my friend Matías. "I'd say here on Earth we have this thing called 'women' and basically since the dawn of time society has viewed them as inferior to 'men,' and our culture, including television programs, heavily reflected that. *Buffy* wasn't the first to shine a light on women, but it was certainly groundbreaking in doing so in such a clever and unique way. Giving power to those who seldom feel they have any is something that can inspire greatly, and because of this, many have found *Buffy* to be a big formative piece in their development."

"As an actor, you want to do something that leaves a mark, that makes a difference, that stands the test of time," says Gellar. "So the fact that twenty-five years later, we're still talking about it means that I did something right. And I think that with time comes appreciation. When you're in a situation like that, and you're turning out twenty-two episodes a year and working nights and you're exhausted and you're nineteen years old, it's hard to even understand what's happening. And that's why they say youth is wasted on the young. So now I get to go back and really have an appreciation. It's almost like you get to relive it from a little bit of a distance."

"Since then I have learned a lot more about direction and about production and I look back now and think it's actually remarkable *Buffy* stayed on track," says Anthony Stewart Head. "And yeah, it had its moments, but it was a big, young cast with ambition and with a

voice. I mean, so many people still say, 'This show saved my life,' and a lot of people say to me, 'Thank you because I lost a parent,' or, 'My father wasn't there and Giles was.'"

"I didn't realize that this would be the case, but it is such a huge honor to have a show with this much life twenty-five years later," says Julie Benz. "You don't go into a show thinking that that's going to happen. The fact that twenty-five years later people are still talking about, people are discovering, and people are still watching it is a real testament to the world that Joss Whedon created."

"I've said it before: I always intended for this to be a cultural phenomenon," Joss Whedon said in 2017. "That's how I wrote it. In the back of my mind, I was always picking up an Oscar or a Saturn Award and everyone was playing with Buffy dolls."

"*Buffy* was available during a cultural and television era when so many of us needed it," says DW McKinney, echoing a sentiment I heard time and time again throughout my interviews with fans of the show. "We needed the supernatural escapism. We needed to see an alpha female lead on television who wasn't helpless and was feared by manifestations of evil and danger. We needed to see a young woman who wasn't overtly reliant on the strength of a man. For those, like myself, who watched *Buffy* during their adolescence, we imprinted on her journey and took away from it what we needed for ourselves." Though it's often filed under supernatural or teen show, the truth is that *Buffy* depicted many aspects of the human condition, many universal, including addiction, abuse, loss, toxic friendships and relationships, acceptance and belonging, and more.

But it's even deeper than that for some. McKinney says that watching it now, there is an aspect of the show that allows us to retroactively reinvent and correct how we see our adolescent selves through the show's characters. "They were geeks, freaks, and misunderstood outcasts—but they were heroes. They saved the world on a weekly basis. That is attractive to people who believe their inner magic is unappreciated by the others around them."

"I really feel like it was one of the first water-cooler shows, that thing that you could not wait to get to work the next morning and be like, 'Did you see *Buffy* last night?'" recalls fashion industry insider James Scully, who was working at Kevin Krier Associates in the Meatpacking District of New York at the time. "It's hard to say now, because often people don't know or remember the context of it, but it was pretty groundbreaking television for its time. It really created the road map for that kind of show."

When I say *Buffy the Vampire Slayer*, what are the first memories that are conjured? "For me, I think it would be images from the credits—namely, Sarah Michelle Gellar tearing around a corner in a good coat, getting ready to stake someone," says *Go Fug Yourself*'s Jessica Morgan. "I certainly remember watching it every week, from the pilot (I'd read a good review of it in the *LA Times*, so I was an early adopter), and occasionally filling my friends in on what had happened if they missed an episode, as the beginning of the show was in the time before Internet recaps were widespread. I remember some episodes and moments very clearly, though I haven't seen them in years: 'Becoming Part I and Part II,' Buffy leaving town on a bus while Sarah McLachlan wails in the background, the time Buffy and Faith swapped bodies, Giles being concerned in a tweed jacket. I also often think of that moment in the pilot where Buffy pauses in the act of slaying to tell a vampire that he looks like DeBarge. It's such a specific fashion reference; it always made me laugh."

"I do think it's important to show a young girl struggling with her teen years, with the dichotomy of her existence, and this is what I think is so good about Sarah's performance is that you saw the strength but you saw the weakness, you saw the joy but you saw the sadness, you saw the weight of the responsibility but also her freer moments," says Clare Kramer. "And if there's anything that I want my daughters to take away from that, it would be that this is someone that just like you struggles but is doing fantastic things while she struggles. It's not always the perfect time, you're not always going to

feel perfect in a moment, but you still push ahead and do what needs to be done, and that's what Buffy did."

"I was a *Star Trek* fan when I was growing up, and I was aware that there was a kind of television that created a world that was so enticing and so interesting and so delightful that I wanted to return to it, even after I knew how the plot was going to play out, even after I'd memorized all the lines," says James Marsters. "I knew what Scotty was about to say. I knew that the *Enterprise* was going to not blow up this week, you know? But I still went back there. And I think that part of the reason I went back there was that they were selling this message: that the human race has a chance not to blow itself up. I kind of suspected that *Buffy* had those elements, that we may be painting a world here that is so delightful, so well crafted, that people may actually be coming back many years from now and watching this over and over again. And I remember telling the cast, especially on late nights, 'Guys, we could be the new *Star Trek*. I know we're tired, but we got to bring it because we may be talking about this scene for the rest of our lives. And if we become the next *Star Trek*, I'm the new Spock.'"

But it wasn't just the glory he sought. Marsters says he saw in the show the first superhero piece that was talking about the dangers of defining oneself as a hero and how moral certainty is actually inherently dangerous and corrupting. "So many scripts that just made me go, 'Wow, I'm glad we're talking about this.' I was a subversive theatre producer. And when you do subversion, people can be uncomfortable. You're not trying to piss people off, but you're divesting them of lies that we get taught in childhood, like 'you can buy happiness,' 'some people are more important than other people,' 'gay people can't be heroes,' or 'women can't fight back.' And I was really aware that this was a deeply subversive show at a time when women fighting back was not seen all the time. I guess that's the one thing that I will brag about, because recognizing it right away gave me the energy to go through the long hours. I've met *Buffy* fans all over the world and we seem to share these three things: We are all smart, funny, and we don't take

ourselves too seriously. And this is a combination for my favorite kind of people. I think if you're taking yourself seriously, you're probably watching a different show than *Buffy the Vampire Slayer.*"

"This whole experience is so implanted in my brain because every part of it was sort of a first for me," says Danny Strong. "Every part of it was so exciting because I wanted to be a part of it so badly from the moment that I didn't get the part that was written for me. And once I was on, I so desperately wanted another episode and wanted to keep going. And I so desperately wanted to be in the Scooby Gang. There's not a part of the experience that's not implanted in my brain. There were just a lot of moments throughout the whole experience that were really wonderful and I've just never forgotten."

"I love this character," says Seth Green. "I can't believe I got to play it. Like, it's one of my favorite things I've ever gotten to do and some of my better work. What a gift, right? These writers, all these performers...Like, I feel so lucky. All I've ever wanted to do with my life is tell great stories and play cool characters, and *Buffy* was an extraordinary opportunity for me to do both of those things."

I ask for Green's reaction to seeing so many young people discovering the show all these years later. "I love that media curation has become such that people can share it infinitely. That's been the most exciting thing, having people who watched it when they were twelve to seventeen, now they've got kids and they're sharing it with them. I think all the messaging in the show is valuable and important. I laugh just thinking back about how cheap we pulled it all off. It's my favorite kind of moviemaking where nobody will see the four people holding a trash bag over these two actors as they're huddled under this, like, smoke gag so that we can comp a green screen to be able to get them out of there. It was all like double-sided tape."

"I reflect fondly back on that time: being able to work with David and Sarah and James and Juliet," says Julie Benz. "But it was a challenging show to work on emotionally and physically. I would say it was abusive in that regard, the hours. Even *Defiance* that I did, which was

a sci-fi show that had prosthetics and special effects and green screen and all of that...we never worked an eighteen-to-twenty-hour day. That was the norm back then. And the writers were running the same marathon. And I remember times we'd be shooting scenes but we wouldn't have a full script. And I think those long hours create toxicity."

Still, some paint a portrait of a close-knit cast. "The thing that was actually lovely about being older on-set was that people would come to me when they were struggling with something and we'd chat," says Anthony Stewart Head. "I loved being the middle-aged actor. I loved being there for all of them. The industry is very different in England, and therefore I was able to be a little more grounded. It was just...we all were like a little family. I'm friends with them all to this day, actually. It's twenty-five years down the line and still chatting to people. It's lovely."

But even Head admits that it could be a family divided back in the day. "I always kept a very open mind about everything. But yeah, there were things I questioned—but as I say, you have to keep an open mind. I mean, I've worked on some extraordinary sets, with much more vociferous people. You learn that people are people are people. People have their good days, they have their bad days."

This is not a cast that on the whole regularly hangs out, however. I first had this inclination during the 2008 ten-year reunion, which Alyson Hannigan, Anthony Stewart Head, and David Boreanaz skipped out on. The group shot of the cast contains some smiles but also some sullen expressions.

There were many rumors of on-set feuds but none more mythologized than one between Gellar and Hannigan. During a 2013 appearance on *Watch What Happens Live*, Hannigan inadvertently corroborated this when asked by host Andy Cohen who was most annoyed to be on the show by the end of the run. "Sarah," Hannigan responded plainly. When the audience began to boo, Hannigan offered an explanation: "Well, she had a big career going. I mean she—yeah, it was a lot of work."

She was asked about this interview weeks later during a sit-down for a *Huffington Post* live chat and responded by saying, "[Sarah] worked her butt off. She worked eighteen-hour days for years." Hannigan called Cohen's question "leading," saying Sarah was "the most tired because she worked the hardest."

A much younger version of myself took to Twitter at the time, writing directly to Hannigan. "[Alyson], not pleased at all about the Sarah Michelle Gellar diss on *WWHL*. Made me sad!" Hannigan responded: "It wasn't a diss! She said that herself! She did an interview saying that is why the show was ending! No diss, just fact."

I'm annoyed at myself for not giving Hannigan the benefit of the doubt and assuming the worst. It's no secret that women on sets—especially in the '90s and '00s—were expected to be best friends off-set. And if they weren't, it was assumed that they hated one another. There was no gradient. See: *Sex and the City*. Meanwhile, nobody was ever asking the men of *The Sopranos* or *Entourage* if they were hanging out when cameras weren't rolling.

"I think that unfortunately the set we were on and the world we were in was pitting us against each other," says Gellar. "I think it would have been different if it was today. It would have been a very different relationship. But we have a great relationship now."

I ask Seth Green about these persistent rumors of on-set dust-ups, particularly from his vantage of being on-set during the show's rise to popularity. "I love acting. I love getting a bunch of people together and putting on a show for an audience. That's what I'm in it for. I've spent my career as a supporting performer and I have all measure of balance and jujitsu with which to help create the best environment to make said thing. So I'm not there for drama. I'm not trying to pick fights with anybody. I can find the good that somebody is doing so that we can do our best work together. And that was me on *Buffy*. I was friends with everybody because I'm not picking fights with anybody. And anytime there was interpersonal drama, I would usually just go, 'Oh, you guys should talk that out.' "

"Look, we worked really hard hours," says Gellar. "We were young, we had ups and downs. Everybody had arguments. There were times where David [Boreanaz] could be a handful. He never really was to me, but I'm sure [he was]. And I'm sure I was the same way to people also, right? It wasn't rosy. Nobody gets along all the time. And Alyson and I had moments. There's no question. But you're young." I ask her if she was aware at the time of the incessant rumors: "I didn't live in the world of 24/7 news media and gossip mags, so I don't know how aware I ever was of the stories, to be honest. But I'd heard them. It's a very tough life and I had a lot on my shoulders. And I'm not excusing myself either. There are times where I wish I could have done things differently, but I didn't know how to handle the stress that I was under. I was really young and I didn't have any outside life. I was the one that was always working and sometimes I would be resentful of the fact that they didn't have to work all the time. It ebbs and flows, and anyone that tells you that they get along with everyone all the time, it's just not true."

That's not to say relationships weren't formed and remain strong to this day. "Conventions have allowed the cast to remain close for two-plus decades," says Clare Kramer. "We're all very close for the most part, with the exception of a few who are either really busy or ... you know, going through their own thing. Julie [Benz]. Charisma [Carpenter]. Amber [Benson]. Emma [Caulfield]. These people are like best, best friends of mine, people I can call in a pinch or in an emergency and they respond and I would respond to them."

There is one feud, though (perhaps an imbalanced one), that seems to have played out less on-set and more in the subsequent years. At the 2017 *Entertainment Weekly* twentieth anniversary that Blucas mentioned he was not invited to, there was another noticeable omission from the group interview: Nicholas Brendon. That wasn't an oversight. "Nick has some demons, and he's obviously actively working on them and that was a pretty tough time for him right around there," Gellar says about Brendon's absence from the reunion. Turns out, there's a bit of a backstory required here.

Nicholas Brendon first entered rehab for alcoholism shortly after *Buffy* ended. Brendon was arrested in 2010 and charged with four misdemeanors (one count of resisting arrest, two counts of battery against a police officer, and one count of vandalism), eventually pleading no contest and being sentenced to probation and community service. He was arrested multiple times again between 2014 and 2015. The last of those arrests was for choking his then-girlfriend in a hotel room. He was charged with felony third-degree robbery, criminal mischief, and obstruction of breathing and subsequently entered a rehab facility in California for treatment. He plead guilty to the criminal mischief charge. He was arrested once again in October 2017 for assaulting his then-girlfriend, a different one than his previous arrest, at a hotel bar. He was charged in April 2019 with felony corporal injury to a spouse, pleading "not guilty," and later struck a plea deal, being sentenced to three years' probation and twenty hours of community service, and requiring him to complete a fifty-two-week domestic violence course. Brendon was arrested again in August of 2021 for allegedly obtaining prescription drugs by fraud.

I had trepidations about interviewing Brendon given his past, but I reconciled that he would not profit from his involvement and the completist in me recognized the potential value of his perspective on the show despite his troubles in ensuing years. That perspective, as it turns out, was unabashed and at times downright disturbing. "I think David [Boreanaz]'s a bad human being," he starts our interview off as I fumble to hit record, unaware we'd be going there at all, let alone from the jump.

"My problem with David Boreanaz is this: There's something called—and it's a disease and dysfunction according to the American Medical Association—mental health disorders. And it's something that I've struggled with my whole life. I'm on top of it now. I did a lot of work and still continue to." (Is he implying that Boreanaz is mentally ill, and Brendon knows because it takes one to know one? I decide against trying to parse it out.)

This feud (perhaps a one-sided one, we'll never know for certain) seems to have really crystallized in 2017 on the day of the planned *Buffy* reunion that was intended to reunite the entire cast of the series, minus only Blucas and Head. I ask Head about his absence during our interview. "The thing that was special about the twentieth anniversary, and I wish the fuck I had been there, because—I don't know how fun it was..." It didn't look fun, I tell him, and we both laugh. "I was so sad I couldn't make the twentieth. Somebody, very sweetly, had suggested having me 'present' by having my portrait on the wall above them, like a portrait on the wall at Hogwarts, but unfortunately, I didn't come to life. Speaking of which, I remember Alyson bringing the first *Harry Potter* book on-set and they all got very excited."

Will he be present at the unlikely thirtieth anniversary reunion, should there be one? I ask him. "I would love to see everybody. One of the reasons I like FanCons is that I love hooking up with cast on those occasions. The idea of seeing everyone together would be fun."

But back to the twentieth. Why did he, too, pick up a vibe check of less-than-fun? "I think the bottom line is, everybody's moved on, they've grown, they've developed their opinions about things, about each other, about the world. Some people have had better careers than others. All of that is going to play into it. So therefore, you've got a bunch of actors together—it's not always fun. The reason why actors love dressing up and becoming someone else is because they have intense insecurities. Insecurity manifests itself in so many ways and it makes—it makes things interesting sometimes. I ramp things up and that's why you get the wonderful emotion and so many things."

"Wasn't awkward for me," says Seth Green with a twinkle in his eye when I mention the tension that day. "I'm Switzerland, man."

According to Brendon, it was David Boreanaz who said, " 'If Nicky is [involved with the reunion], then I won't be a part of it.' " I ask Gellar point-blank if she had heard about this (I mean, she had to have). She responds coyly: "You can ask David and Nicholas about that one,

but I can tell you you are on to something." And so, I put on my best Nancy Drew and ask Brendon to detail what happened.

"What [the people organizing the reunion] did was they put my call time right at the end, when everybody was leaving. There was a whole roundtable where the cast was talking and I wasn't there. And I wasn't aware of this until I saw that press kit. So to say that I'm upset with David, who's a dick, is true, because it's like…you don't kick someone when they're down. Like, I didn't do anything to you. Don't fuck with me and I won't fuck with you. It was devastating to see the press kit and then to see that huge roundtable that I wasn't a part of. If I'm in a room first and David walks into that room, I'll tell his people that he's got two minutes to get out of there. Two. And that's it. I try to find the good in people, I really do. And what David did to me I felt was egregious."

Brendon then brings up a January 2021 tweet that got David Boreanaz into hot water among many of his fans. His former *Bones* co-star John Francis Daley tweeted, "What's the best way to tell a stranger to put on their mask without getting into a fight?" Boreanaz responded, "Mind your own business." According to Brendon, if you mention *Angel*, Boreanaz will block you.

"Something happened with David—I don't know what it is—that made him very unhappy on *Angel* and on *Buffy*. It's not normal behavior: The best show he's ever done, he doesn't talk about. And so there's something." I, of course, can't corroborate this, but can only add that David Boreanaz declined several times to be interviewed for this book. He was the only flat-out "no" that I received from any cast member affiliated with the show. Some didn't respond at all, others decided not to proceed after the most recent allegations against Whedon, but Boreanaz, through his reps, declined to participate in January 2020.

I counter Brendon, asking him to say one nice thing about David Boreanaz. He starts with a shady compliment that's not worth printing. I tell him that we're not moving on until he says a nice thing about Boreanaz. I'm not doing this for any other reason than my

sense that his disdain for him is born of hurt. And then: "David was a very, very sweet soul. When we bonded, we would say things like, 'I love you' and mean it. I don't know what happened, but something did. And as much as I say 'You have two minutes to leave [if we were in the same room],' I would just…" Then he shifts to David's alleged vitriol toward him. I interrupt and ask him to finish the sentence he started. "I would probably be cordial and I would say, 'hello.'"

I want to be forthright with Brendon, and so I tell him point-blank that many people have voiced to me a discomfort with me including him in this book, due to his past transgressions. I want him to know this in an effort to try to have him answer to it. "Unless you were there, you really can't speak to it," he starts off by saying, then immediately makes clear that culpability is not rolling off his tongue anytime soon: "It's amazing to me how quick to believe people are and how it'll be a false seed and it'll grow roots. The story that they think they know they'll embellish in their minds, where they think it's the truth. Have a conversation with me. Ask me questions and I'll answer. But contempt prior to investigation? That's ignorant and I don't have time for that."

He muses, "I apexed on the first thing, you know? It was celestial. It was supposed to happen. And then doing other TV shows, it's kind of like, 'Oh man, I'm never going to have another experience like *Buffy*.' That being said, it was really hard too. But man, I loved every second of it." He pauses and shares with me the treatment he's written for the rumored *Buffy* reboot. In it, Buffy is dead, Willow is evil once more, and Xander becomes a Watcher. "I would gladly don the Hawaiian shirt and an eye patch again," he says. I get the sense that Brendon still sees himself in Whedon even all these years later, flaws and all. Perhaps they deserve each other.

Benz, too, is down for more. "I would have taken any chance to play Darla anywhere," she says when I ask if she wished the character would have returned to the Buffyverse. "I would play her still to this day. She was just such a phenomenal character. She was a real gift

to be given to me at that time in my life as an actor. It was outside of what I had been training to do as an actor. All of a sudden, I was embodying this four-hundred-year-old vampire and having to bring all this history to her. And Joss kind of changed my entire trajectory and changed it for the better."

Gellar has been asked about the possibility of a revival or reboot from the moment she stepped off the set in 2003. Fifteen years after production wrapped, in July 2018, the fandom was stirred when it was announced that writer Monica Owusu-Breen would write, executive-produce and show-run a "new" *Buffy the Vampire Slayer*. Joss Whedon signed on as executive producer as well. "Like our world, it will be richly diverse, and like the original, some aspects of the series could be seen as metaphors for issues facing us all today," the producers of the original stated about the new version, which they'd resume duties on. In a *Deadline* story that ran announcing the news it was noted that "according to sources, the diversity in the show's description reflects the producers' intention for the new Slayer to be African American."

Days later, Owusu-Breen took to Twitter to offer this: "For some genre writers it's *Star Wars*. *Buffy the Vampire Slayer* is my *Star Wars*. Before I became a writer, I was a fan. For seven seasons, I watched Buffy grow up, find love, kill the love. I watched her fight, and struggle and slay. There is only one Buffy. One Xander, one Willow, Giles, Cordelia, Oz, Tara, Kendra, Faith, Spike, Angel...They can't be replaced. Joss Whedon's brilliant and beautiful series can't be replicated. I wouldn't try to. But here we are, twenty years later...And the world seems a lot scarier. So maybe, it could be time to meet a new Slayer..."

Many fans weren't sold. In fact, at New York Comic Con three months after the announcement, the crowd audibly booed when talk turned to a new *Buffy*. Were they booing at the prospect of the series being revived or in response to a Black Buffy? Who's to know for certain? Does it strike me as odd that fans of a show would boo at the news of it coming back? It does, yes.

"Come on, guys," Boreanaz told the crowd. "It's a good thing. Let's just embrace [it]. I'm very happy for them. They want to embrace a new generation, something new...Everybody wants old, they want to go back. Which I can understand: You want to see us back in these roles. It's great, it's cool, [but] things move on, stories evolve, times change. I think it's a great opportunity for a reboot like this to show where we are with society now, what you can do with technology. How you can explore those relationships with the same kinds of metaphors. I'm all for it. I think it's fantastic. Good for them. I hope that it becomes huge and successful, and does what it does."

Boreanaz did, however, make it clear that he had no desire to step back into the role of Angel: "You have to realize, we started it. We're proud of that. If someone can step in my shoes and play my character, fuck, go ahead! I think that's great, because I ain't putting on that makeup anymore!"

As for Gellar? She, too, was a no. "I'm not an adolescent anymore," she told *BuzzFeed* in 2019, joking that she had aged out of her slaying days. But she added: "I'm all for them rebooting it. I think it's an important story. I think there's a way to modernize it and tell a different story now." Still, in the years since, this remains the most asked question of Gellar despite her making it clear that she's, as she says, "too long in the tooth."

I can't not ask Gellar about it, telling her that I'm in favor of reviving the Buffyverse but not keen on seeing a *Buffy the Vampire Slayer* reboot largely because of my disdain for rebooted series and them feeling more like nostalgia plays than advancing stories. Gellar agrees. "Would I be supportive if that's what they choose to do? Totally. Do I think it should [be revived]? No. I think that one of the things that's amazing is that this show still works. There's plenty of shows I've gone back and watched in quarantine that I loved and my kids are like, 'What is this? This is awful.' And even I'm like, 'Okay, yeah, that doesn't really work.' The fact that this still holds up to me says 'Is [a revival] really needed?' And that's a question that's not for

me to answer because it's not my decision to make it or not make it. If they do make it, do I support it? A hundred percent."

Unlike a show like *Friends*, for example, which the creators explicitly wrote in a way so that there was no ambiguity to it being the last time we'd see them all together, *Buffy*'s ending feels tailor-made for more storytelling. "I think they've left the door open in a wonderful way, because I do think it would be interesting to see how someone born with that power does fend in this modern world and what the new demons are," says Gellar. "The way *Buffy* was left—that every girl who wants the power has it—you can still tell the story of a Slayer, but maybe it's not Buffy. Because Buffy's story was of that time. So maybe it's a different Slayer, and in that case I'm all for it, because I'd be certainly interested to see how do you handle being a Chosen One now and what injustices you are fighting and what the demons represent."

Who is her choice to occupy the role of said new Slayer? "I vote Zendaya," she says.

Julie Benz's mouth goes agape when I mention Gellar's casting choice. "That would be amazing!" I ask her, one of my final actor interviews, how she feels about a reboot, given the change in climate surrounding how the show is perceived in the wake of former cast members' allegations against Whedon. "I don't think that this stain should reflect on the show," Benz says. "I had a great work experience on the show. And it's a shame to see the Buffyverse end because of this. I would love to see it live on. I think it's an important show and I'm all for a reboot. I don't think I'd be playing Darla; I think they'd probably recast me. I would love to play her, but I know how Hollywood works. Plus, vampires don't age. Unfortunately, I have. Or, fortunately I have. It's a privilege to age and get older—means I'm still here. But yes, I support a reboot. Maybe not right away, though. Maybe in five years."

"I believe that *Buffy* as a show still has a lot to say to audiences," says Lowery Woodall. "I would welcome a reboot that could properly

extricate that message from its original creator." Cynthia Erivo agrees, noting the need for course correction if the material is revisited. "If there is a reboot, it has to be a very different reboot. The seed of the idea is there, but the actualization, the actual making it happen, has to look and feel different."

Still, some aren't sold on a reboot, even if a Black actor was to occupy the leading role. "The reboots of our favorite shows from the late '90s and early 2000s don't have that same nostalgic draw in the way that we want them to," says DW McKinney. "And while we're overdue for having a Black Buffy and I would love to see a Black Slayer as the main protagonist, I would love to explore a wider diversity in the Slayerverse. We are so far beyond just a Black Slayer. It's possible that will be shown in the reboot and we don't know it yet. The problem is that the entertainment industry seems incapable of featuring the diversity in our real lives without problematic elements making an appearance too. So, I am keeping my expectations low."

What will happen, or even if it will happen at all, remains uncertain, with no update since that July 2018 announcement.

But *Buffy* fever will remain, regardless of a reboot. Even bit characters on the show still receive recognition from fans. "My theatre company, Steppenwolf, got a National Medal for the Arts during the Clinton administration, and we had to go to the White House," recalls K. Todd Freeman. "And they started checking our IDs going into the White House and the Secret Service guy is looking at my ID and then he looks at me and then back at my ID and I thought, What's going to happen? Is he going to arrest me or something? And he says, 'Are you Mr. Trick?' This fuckin' Secret Service guy watches *Buffy*. That's when it sunk into my head that this is really a thing."

"I don't get tired of the show being relevant or it meaning something, or everything, to a person," says Emma Caulfield. Though she does bring up an interesting caveat: The fan attachment to Anya can sometimes lead to an expectation that she will forever be and *only* be Anya. "If I do a press junket, two out of every five interviews all

over the world will reference Anya and the bunnies because someone spoke about it on the Internet and it's, like, trending, and then they have to acknowledge it, and then I'm talking about Anya and bunnies when I'm promoting *WandaVision*—that's when it's really upsetting. I get it. It was cute. It was a weird little quirk from a character from forever ago, but that has nothing to do with right now. So yes, it's infuriating on that level. No, it's not when someone you really admire is like, 'Dude, can I just say from forever ago, like, I was with you on *Buffy*.' To have something that's referenced like this is profound and amazing and I consider myself blessed. But there is no way to separate one from the other. So at once it's really great and then it can become incredibly daunting—people trying to see Anya in everything, like those freaks who see the Virgin Mary in mashed potatoes. It's like... you're stretching right now."

Some cast members know the feelings that they conjure in fans of the show because they, themselves, are that way with the things they love. "I'm a huge fan of *Games of Thrones* and *The Walking Dead*, and when I get to meet Gwendoline Christie or Andrew Lincoln, I'm the one who's freaking out because I'm so excited to talk to them," says Clare Kramer. "So for me I don't find it tedious or cumbersome. I actually enjoy the fan's excitement and feed off of it because we're having a shared experience. We're sharing a passion for something that for me I'm very thankful for, whatever negative parts there were, to me it's still a very positive life experience and I appreciate that it was also a positive life experience for the person I'm speaking with, just in a different way."

"It's just mind-bending to me that people still stand in line and still want to take a picture with me," says Charisma Carpenter. "That they want me to sign something and that they're bringing their kids and are like, 'Oh, this is my kid named Cordelia or this is my kid named Charisma.' I've had so many impactful experiences with engagements with fans where they've shared their experience with people in their lives, like, 'Oh, I married my wife because we bonded over *Buffy*.' Or, 'I

saw this series with my mom, who was ailing in the hospital with cancer, and this was what we watched to forget our reality together. This was our show, and now she's gone, and sometimes when I want to feel my mom's presence, I watch *Buffy*.' Like, come on!"

"What gay that watched *Buffy* didn't love Cordelia Chase?" Ian Carlos Crawford opines.

It's got to be a strange kind of energy exchange when fans come up to you and tell you the enormous impact you've had on their life, and how, in some instances, this show saved them. Carpenter continues: "A lot of times when people are in your presence they're not able to really articulate because it's rushed, it's too overwhelming, or they've planned what they were going to say, but then the moment is there and it's just out of your head or it's just too much to kind of find the words. But then there's people that come up and tell me how this show helped them escape, how it was the one thing they could go to that would make them feel safe or that they didn't have to think about their bad day or being bullied or whatever. So when I go to the conventions, 110 percent it's overwhelming. A hundred and ten percent I go home exhausted. It's not necessarily about getting your ego stroked all day long as much as it's just being able to connect with people and knowing that what you did or your work [affected them]. I wasn't responsible for the writing. I didn't dress myself. I didn't do my hair. I didn't do my makeup. I wasn't responsible for any of those things. I was responsible for saying a line and hitting a mark. And the fact that I got to do those things and the way that I said it or whatever was a way that they heard it and that made a difference in their life suddenly gave meaning to this. Yeah, I'm an actress and you can minimize it and poopoo it, but a lot of people are really affected and touched by that character. And I will always be proud of that. I will always be grateful for that opportunity."

I know this fan sentiment—the "you saved my life"—all too well. Because *Buffy* saved my life. *Buffy* gave me a kind of inner strength that allowed me to go on in the darkest days of my childhood spent on

a playground being mercilessly teased merely for being an effeminate gay boy. "I would be remiss not to tell you *I* am one of those people," I express to Carpenter. "It's funny, because I talk about this energy exchange and how I imagine it must be a lot for you, but as someone on the other side of it, I can't help wanting to give you that energy because this world that you are so much a part of, this world that you helped to build, it saved lives, and in so many tangible ways made people realize that life was not as small as the world they might perhaps have been boxed into."

Carpenter responds by saying a lot of complimentary things that I'm going to omit so as not to get too self-indulgent, but she also said this: "You are doing your purpose and you are inspiring people to listen to themselves and to be true and authentic and not be allowed to be stepped on and made to feel small and insignificant. That's not okay. It's just not fucking okay. And I just love that you had that experience and in the face of that adversity said, 'No, I don't accept that narrative. I don't accept your words as my truth.' It takes a lot of courage." Ten months to the day of this interview, Carpenter would release her statement online and, in doing so, show the true meaning of courage.

One moment that Tom Lenk shared in our interview, an anecdote about Carpenter, underscores who she is as a person. "My friend Sergio had to have LVAD surgery (basically a portable mechanical heart backpack) while waiting for a heart transplant, and I knew he was obsessed with the show and Charisma's character ever since we were at UCLA. Charisma had reached out to get a charity item signed by cast members and I messaged her around the same time and told her what was happening with my pal, and she fully came with me to the ICU at Cedars-Sinai and hung out with me and Sergio and it was just a really, really cool thing for her to do and I am forever grateful. Can you believe it?" I absolutely can.

There's a small moment that happens in Joss Whedon's DVD commentary for Season 1 that I think underscores the paradox that is Joss Whedon. Whedon is talking about the show's theme song

and states: "We had a composer do a credit sequence for us—a song, rather—and it didn't really work out. So we went to a few unknown rock bands to see what they could come up with. And Alyson Hannigan turned me on to Nerf Herder, and we went to them, and they won the prize. They did a great job."

Then, one episode later, as the theme song plays once more: "Having praised Nerf Herder for their beautiful theme and how much fun it was, I do want to point out that if you listen carefully it does sort of go off the beat about halfway through. It loses tempo. They came in and recorded it really quickly, and we had to use it, and it does kind of lose it about halfway through."

If there is one through line that was apparent in just about every interview I conducted with the cast and creative team of this show, it was a desire to please Joss Whedon. Whether he knew his apparent powers of intimidation is uncertain, but just about everyone wanted to satisfy him. As you can imagine, this was seldom achieved. I knew there was a vested interest in mythologizing him within the fandom, but many of the cast members cite a similar feeling. "I just remember everyone wanted Joss's approval," says Danny Strong. "I remember the writers would always be a little jealous of whatever writer he seemed to like most that week. Not that it felt like he was playing big favorites; I found everyone was wound up about Joss."

There's a quote in Whedon's commentary for Season 1, Episode 2 ("The Harvest") that made me cringe when I relistened to it. "One of my favorite kinds of actors to work with is the one we'll see right now: the rat actor," he says. "The rat actor is a good, smart actor; gets it done, knows his lines, hits his mark. We've worked with a lot of rats on this show, and they're always very professional and delightful people to be around." Equating any actor, let alone a day player, with a rat is offensive for all of the obvious reasons. But if you can get past that (and some might not be able to), you'll see that he's actually expressing genuine regard and appreciation for these actors. This became evident throughout several interviews I did, namely

with James Marsters, who recounted on-set experiences that sounded uncomfortable or downright unsafe. But that was my interpretation. And as quick as I was to judge, he was quicker to make clear the fact that he didn't mind Whedon's approach; in fact, he *liked* it.

"He's a really good artist," says Marsters. "That's what I experienced. And that led him to sometimes do things that ... I wanted him to do other things. He was kind to me. He was supportive of me. He seemed to really care if I was getting what I needed in order to perform. He seemed to be excited to collaborate with me." In my mind, as he's saying all of this, I'm getting flashes of the story he himself disclosed about Joss allegedly pushing him up against a wall on-set in a rage. And no sooner do these images appear than Marsters himself adds yet another layer. "He could be brutal. He was uncompromising. And that can hurt feelings. It hurt my feelings."

Kind and brutal. Supportive and uncompromising. Caring and hurtful. Marsters's own words reflected back out of sequence.

I end my time with Emma Caulfield by asking if there's anything else she wants to make sure the record is corrected on or made clear on with this book. She thinks for a long time. "I think enough people have come forward now to demystify certain long-standing images and beliefs around certain people. The truth is always the truth, but I have also left things out. Like, you don't want to kick a Smurf. I don't want to tell people what's *really* up and have their whole world shattered. The truth, though, the stuff I could say that I mean and I've always meant, is that there's a tremendous amount of love for most of us for each other. We grew up a lot during that period of time, and as such it would be tumultuous, but there was also a lot of laughter. And the things that made it hard were always very political and unjust. And I don't necessarily know we could make a blanket statement and say, 'Well, that's because of misogyny.' I don't know about that as much as maybe assholes. And if that's steeped in deep hatred for women on the whole, so be it. I'm no shrink."

She leaves me with this: "When people with power are given more

than they should, and abuse that power, and have insecurities on top of having that power and use *that* against somebody else...I mean, call it whatever you want—misogyny, abuse, whatever you want to call it—it's just never fun to be in that. It's never fun to witness it. It's never fun to be on the other end of it. So what do you do? You just go about your life and move on and take all the good with you, like I have with every single one of those little munchkins that I just want to eat. 'Cause I just love them, from Seth to Sarah to Amber to Tom to Tony. I will always answer their phone calls. I will always be there. You know, like, 'Hey babe, what do you need? Of course.' That makes me think I'm pretty damn lucky."

Weeks after our interview, I get a text message from Caulfield. She had misquoted a Wilco lyric and wanted to make sure I had it correct "and I wanted to make sure I was clear about something," she added, asking if she can see a transcription of everything she said about Joss. I send it to her. "All good, thank you," she responds. Then moments later, "Actually—there's one more thing." She then writes this: "There was a point where my contract was up for renegotiation. I was told to settle for an amount that I felt was not reflective of my worth. I was assured that the studio had no more money and I should close. I did. Another actor on the show whose contract was also up, who was also in the process of renegotiating, was told to push and not settle. In the end he got a big raise and I didn't. I didn't know this until a year or so later, and I was furious. It was personal." Deductive reasoning would lead one to believe she was talking about Nicholas Brendon or James Marsters. I don't press her.

"We were at Universal to film the flashbacks with Spike in 'Fool for Love' and it was just this perfect day," recalls Douglas Petrie. "Joss and I were outside, they were doing a setup, changing the lights, and we were on a lawn watching the *Jaws* ride, off in the distance. And Joss—he wasn't talking about the two of us, he was talking about all of us—turns to me and says, 'We're the kings of the nerds.' That was about as happy a day as a nerd can have."

Greedy, I ask him for another memory. "When we were approaching the end of the series and were gonna leave Bergamot Station (the arts center in Santa Monica which, at the time, included the *Buffy* offices and soundstages) for the last time, Joss said, 'Why don't we get a bunch of horses and just ride out of here on horses?' We didn't do it, but we talked about it. And just to have a boss that suggested that is a lot of fun. And it would have been appropriate. You can say in the book that we did."

Here's a lingering question as we start to wind down: Will we ever hear from Joss Whedon again? "The fact that he hasn't apologized to anyone, the fact that he hasn't made a statement is pretty stunning," says Danny Strong. "I remember when the Ray Fisher allegations came out I thought, Clearly Fisher is very upset about his experience and I don't understand why Joss Whedon is just not publicly apologizing. And had he apologized, that might have gone a long way to alleviate people's anger and frustration. And maybe that wouldn't have been enough for Ray Fisher and Charisma Carpenter—and maybe rightfully so—but it would have been something." TL;DR: "There's just something wrong with this guy," he says.

On April 5, 2021, I was given Whedon's personal email by a cast member on the series who suggested I try reaching out directly. The next day I wrote him with the subject line "A Shot in the Dark":

Hi Joss,

My name is Evan Ross Katz, I'm a longtime fan of yours. It's a funny thing, writing you an email and feeling this intense need to be clever. I'll spare you the clever. I'm working on an upcoming book with Hachette Book Group pegged to the 25th anniversary of Buffy.

I have interviews with the bulk of the cast, many of the writers as well as famous and non-famous fans of the show discussing and dissecting this series that for so many of us was formative. Oh yeah, and you are in it. Quite a bit in fact.

I don't think it's a coincidence that we haven't heard from you in quite some time. I respect your right to privacy. But I'd be remiss not to try and seek out an interview with the creator of this show. This book is missing your voice in its current iteration. I think many are hoping to hear from you. I'm happy to keep the conversation focused on the series itself, or any other stipulations you might want in order to make this happen. I wouldn't feel like I was doing my due diligence as a writer, journalist, or fan of this series without seeking you out. If this comes at a bad time or is an undesirable request, ignore it.

But if it's not...

He never responded. Of course not.

How to land this plane? Easy. "*Buffy* doesn't exist without Joss," Gellar says. "This [series] is all words that came out of his mouth, ideas that came from him. And I am eternally grateful that he saw in me and chose me to be the representative and be the outlet. There were days where we got along better than anyone and spoke a language that only him and I could speak together. And there were days where I was beyond frustrated with him. And there were days he was beyond frustrated with me. But my portrayal wouldn't exist without the support and the encouragement and the lessons that he taught me, hands-down. More often than not, he had more faith in what I can accomplish than I did in myself. He really did." I want to again highlight the fact that this interview was done prior to Carpenter's, Benson's, and Trachtenberg's public allegations against Whedon.

Will we ever get a thirtieth-anniversary reunion, or any others down the line? I telephone Gellar in August 2021, days before this here book is due to be turned in. "That's an interesting question. I mean, it depends on how good your book is, Evan," Gellar says, adding that she's kidding (I know!). "I'm always willing to talk about *Buffy* and very proud of *Buffy*. I'm proud of the work, but it seems like we're hitting a time now where other things are overshadowing that, so it's

hard to say. But in the right circumstances, I'm always ready to talk about it and proud of it, my castmates, and the family I created on it."

I end my time with Gellar by thanking her and letting her know that without her involvement this would be a totally different book—an incomplete one. "Well, Evan, it's not like I can say no when *you're* doing it." "You can," I tell her. "I mean, correct me if I'm wrong, you don't really *love* talking about *Buffy*."

"No, I actually do. I really think that's a misconception about me. I love talking about *Buffy*. I think she's awesome. There's never a day that goes by that someone doesn't tell me that they love *Buffy* and that it means something to them. [The fact] that people have tattoos of the show? That's amazing to me. And if there's one thing I could say it's that I am so grateful for the people that love the show and that keep the show alive today. Thank you for loving her the way I loved her. And thank you for loving her journey the way I loved her journey."

Here Endeth the Lesson.

Acknowledgments

Thank you, Sarah Michelle Gellar, for existing. Thank you, Mom and Dad, for the birth and the unyielding support. Thank you, Jordan, Adam, and Katie, for dealing with my bullshit always. Thank you, Cole Jagger and Sage Sunshine, for being the cutest little beans any guncle could ask for. Thank you, Nana, for being a shining light and teaching me the concept of "it's never too late." Thank you, Billy, for the boyfriendship and for committing to all 144 episodes of the series with me throughout quarantine. Thank you, Kevin, for helping me grow up and see past myself. Thank you, Jake, Alex, Austin, and Michael, for showing me the power of community. Thank you, Tessa, for being my ride or die even when I petered. Thank you, Megan, for being my sister from another mister and missus. Thank you, Robert, for encouraging me to write this and guiding me throughout the process. Thank you, Brant, for always responding to a panicked email. Thank you, Jordan, for making sure I was protected. Thank you, AOC, just because. Thank you to anyone who has conversed with me about *Buffy* through the years or put in the work to keep the legacy alive. And last but not least, thank you to my childhood bullies for making me strong where I once thought I was weak.

Notes

Unless otherwise noted, quotes from individuals in this book are from personal
 interviews:

Stacey Abrams, Zoom, June 2, 2021
Christophe Beck, email, March 25, 2021
Amber Benson, Zoom, December 22, 2020
Julie Benz, Zoom, May 4, 2021
Gabe Bergado, Zoom, April 22, 2021
Cynthia Bergstrom, Zoom, March 17, 2021
Selma Blair, email, April 21, 2021
Marc Blucas, phone, January 5, 2021
Nicholas Brendon, Zoom, January 13, 2021
Charisma Carpenter, Zoom, May 11, 2020
Ian Carlos Crawford, Zoom, January 6, 2021
Emma Caulfield, phone, June 1, 2021
Cynthia Erivo, Zoom, May 20, 2021
Jane Espenson, email, November 12, 2020
Sharon Ferguson, Zoom, March 16, 2021
K. Todd Freeman, phone, March 5, 2021
Sarah Michelle Gellar, Zoom, January 25, 2021
Tavi Gevinson, phone, May 25, 2021
Seth Green, Zoom, August 12, 2021
Drew Z. Greenberg, Zoom, February 2, 2021
Anthony Stewart Head, Zoom, June 30, 2021
Clare Kramer, Zoom, May 11, 2021
Jacqui Kramer, Zoom, May 11, 2021
Bianca Lawson, email, March 8, 2021
Tom Lenk, Zoom, January 22, 2021
James Marsters, Zoom, January 9, 2021
DW McKinney, email, April 19, 2021
Samantha McMillen, email, May 18, 2021

Jessica Morgan, email, April 26, 2021
Lee Pace, phone, May 10, 2021
John Paschal, phone, June 4, 2021
Douglas Petrie, Zoom, January 22, 2021
Kristin Russo, Zoom, February 25, 2021
Claire Saffitz, phone, June 8, 2021
James Scully, phone, April 14, 2021
Danny Strong, Zoom, December 22, 2020
Matthew Van Dyne, phone, February 23, 2021
Lowery A. Woodall III, email, May 5, 2021
Jenny Owen Youngs, Zoom, February 25, 2021

Epigraph

"I designed *Buffy* to be an icon": Tasha Robinson, "Joss Whedon," *AV Club*, September 5, 2005, https://www.avclub.com/joss-whedon-1798208181.

Pre-Prologue

"At base, it's the issue of taking authentic material": June Thomas, "Sarah Schulman: The Lesbian Writer *Rent* Ripped Off," *Slate*, November 23, 2005.
"Insidious but very American": Thomas, "Sarah Schulman."

Chapter 2: The Slayer in Me

"My sister was a real *Buffy* fan": Olivia Wilde, "Olivia Wilde," *Shut Up Evan*, podcast, September 15, 2020.
"I live-tweeted *Buffy*": Retta, "Retta," *Shut Up Evan*, podcast, November 10, 2020.
"Evan, I know that you love her": Anna Faris, "Anna Faris," *Shut Up Evan*, podcast, April 13, 2021.

Chapter 3: Rhonda the Immortal Waitress

"*Buffy the Vampire Slayer* is uh…well, it's about a girl": Kristy Swanson, *The Arsenio Hall Show*, 1992.
"He was a baby": Kristy Swanson and Luke Perry, Calgary Comic & Entertainment Expo, Stampede Park, April 17 to 19, 2015.
"The first thing I ever thought of": Joss Whedon, *Buffy the Vampire Slayer*, Season 1, Episode 1, "Welcome to the Hellmouth," commentary track, DVD.
"that blonde girl": Whedon, Season 1, Episode 1, "Welcome to the Hellmouth," commentary track.
"I thought, It's time she had a chance": Whedon, Season 1, Episode 1, "Welcome to the Hellmouth," commentary track.

"I felt bad for her": Mim Udovitch, "'Buffy the Vampire Slayer': What Makes Buffy Slay?" *Rolling Stone*, May 11, 2000.

"I wanted to make a somewhat, you know, low-key": Joss Whedon, *Buffy the Vampire Slayer: Television with a Bite*, A&E, May 14, 2003.

"The first iteration of *Buffy* occurred in 1992": Robin Burks, "16 Shocking Things You Didn't Know About the Buffy the Vampire Slayer Movie," *ScreenRant*, December 22, 2017.

"Apparently, I am so bad in that movie": Beatrice Verhoeven, "Ben Affleck Says His One Line in 1992 'Buffy the Vampire Slayer' Movie Had to Be Dubbed," *The Wrap*, March 3, 2020.

"I'm holding a basketball": Verhoeven, "Ben Affleck Says."

"You could say she's kind of ditzy": Kristy Swanson, *Big Bad Buffy Interviews*, podcast, Episode 4, January 1, 2017.

"I pretty much eventually threw up my hands": Tasha Robinson, "Joss Whedon," *AV Club*, September 5, 2005, https://www.avclub.com/joss-whedon-1798208181.

"It didn't turn out to be the movie": Robinson, "Joss Whedon."

"A slight, good-humored film": Janet Maslin, "Review/Film; She's Hunting Vampires, and on a School Night," *The New York Times*, July 31, 1992.

"light and diverting romantic comedy": Kenneth Turan, "Movie Reviews: 'Buffy's' Gnarly Date with Destiny," *The Los Angeles Times*, July 31, 1992.

"frenzied mistrust of her material": "Panic at First Bite," *Time*, August 10, 1992.

"never treats its material with much respect": David Kehr, "'Buffy' Is, Like, So Campy, You Know?," *Chicago Tribune*, July 21, 1992.

"You know, honey": David Lavery and Cynthia Burkhead, eds., *Joss Whedon: Conversations* (Jackson: University Press of Mississippi, 2011), page 25.

"Ha ha ha, you little naïve fool": Lavery and Burkhead, *Joss Whedon*, page 25.

Chapter 4: *Buffy Will Patrol Now*

"I think it's not inaccurate to say": Tasha Robinson, "Joss Whedon," *AV Club*, September 5, 2001, https://www.avclub.com/joss-whedon-1798208181.

"I was with him": Kai Cole, "Joss Whedon Is a 'Hypocrite Preaching Feminist Ideals,' Ex-Wife Kai Cole Says" (Guest Blog), *The Wrap*, August 20, 2017, https://www.thewrap.com/joss-whedon-feminist-hypocrite-infidelity-affairs-ex-wife-kai-cole-says/.

"There were no young women on television": Gail Berman, *Buffy the Vampire Slayer: Television with a Bite*, A&E *Biography*, dir. Jack Walworth, original air date May 14, 2003.

"They called me up": Robinson, "Joss Whedon."

"There were lots of sets of rolling eyeballs": Berman, *Television with a Bite*.

"The show had to be designed": Joss Whedon, *Buffy the Vampire Slayer*, Season 1, Episode 1, "Welcome to the Hellmouth," commentary track, DVD.

"I was just tickled": Kristy Swanson, *Big Bad Buffy Interviews*, podcast, Episode 1, March 12, 2017.

"I was already on this Aaron Spelling show": Charisma Carpenter, "*Entertainment Weekly* Cast Reunions: *Buffy the Vampire Slayer*," documentary, March 29, 2017, video available at https://www.youtube.com/watch?v=nQ1nDKsILsM/.

"The thing that's very important about this show": Whedon, Season 1, Episode 2, "The Harvest," commentary track.

"Is the presentation ever going to make it to DVD?": Ken P., "An Interview with Joss Whedon," *IGN FilmForce*, June 23, 2003.

"You must make her more hip": Whedon, Season 1, Episode 1, "Welcome to the Hellmouth," commentary track.

"That was a difficult role to cast": Marcia Shulman, "Casting Buffy," *Buffy the Vampire Slayer*, Season 1, extra, DVD.

"The character threw them": Whedon, Season 1, Episode 1, "Welcome to the Hellmouth," commentary track.

"They described me as a street-smart prizefighter": Berman, *Buffy the Vampire Slayer*.

"The idea that the man Buffy would clearly fall in love with": Whedon, Season 1, Episode 1, "Welcome to the Hellmouth," commentary track.

"They have an energy together that's hard to define": Whedon, Season 1, Episode 2, "The Harvest," commentary track.

"You know, we had people like David": Whedon, Season 1, Episode 2, "The Harvest," commentary track.

Chapter 5: Beep Her

"I don't think you ever get over high school": Joss Whedon, *Buffy the Vampire Slayer*, Season 1, commentary track, DVD.

"The idea of this band of outcasts": Whedon, Season 1, Episode 1, "Welcome to the Hellmouth," commentary track.

"She's a demon!": Cast, *Buffy the Vampire Slayer*, Season 1, Episode 4, "Teacher's Pet," March 24, 1997.

"You'll hear in [the first episode]": Whedon, Season 1, Episode 1, "Welcome to the Hellmouth," commentary track.

"every high school in America": Whedon, Season 1, Episode 1, "Welcome to the Hellmouth," commentary track.

"Some shows, *The X-Files*, for example": Whedon, Season 1, Episode 2, "The Harvest," commentary track.

"Originally she had been supposed to die": Whedon, Season 1, Episode 2, "The Harvest," commentary track.

"The best kinds of villains": David Greenwalt, Season 2 DVD Extra: "A Buffy Bestiary."

"You'll see a great number": Whedon, Season 1, Episode 1, "Welcome to the Hellmouth," commentary track.

"pissy": Whedon, Season 1, Episode 1, "Welcome to the Hellmouth," commentary track.

"This was one of the times": Whedon, Season 1, Episode 1, "Welcome to the Hellmouth," commentary track.

"I like the scene a lot": Whedon, Season 1, Episode 2, "The Harvest," commentary track.

"We picked and chose our vampire lore": Whedon, Season 1, Episode 2, "The Harvest," commentary track.

"That was a very conscious decision": Whedon, Season 1, Episode 1, "Welcome to the Hellmouth," commentary track.

"We spent a long time explaining the rules": Whedon, Season 1, Episode 2, "The Harvest," commentary track.

"There are more than 320 Web sites": Thomas Hine, "Television; TV's Teen-Agers: An Insecure, World-Weary Lot," *The New York Times*, October 26, 1997.

"With the cult suicides in California": John J. O'Connor, "Just the Girl Next Door, but Neighborhood Vampires Beware," *The New York Times*, March 31, 1997.

People **gave the season premiere a B+:** Tom Gliatto, "Picks and Pans Review: Buffy the Vampire Slayer," *People*, March 31, 1997.

"The performances are generally strong": Steve Johnson, "'Buffy the Vampire Slayer': Buy a Way...," *Chicago Tribune*, June 4, 1997.

Chapter 6: You're 16 Years Old. I'm 241.

"I remember I was the last one": Sarah Berger, "This Is What Sarah Michelle Gellar Did with Her First 'Buffy' Paycheck," CNBC, October 25, 2018.

"In season one, we found": Ed Gross, "Buffy the Vampire Slayer Turns 20: Joss Whedon Looks Back," *Empire*, September 3, 2017.

"As assured and well-realized as any": Noel Murray, "*Buffy the Vampire Slayer*: 'Becoming: Part 1 and 2,'" *AV Club*, August 21, 2008, https://www.avclub.com/buffy-the-vampire-slayer-becoming-part-1-and-2-1798204868.

"Don't underestimate Buffy": David Bianculli, "'Buffy': Clever Halloween Treat," *New York Daily News*, October 27, 1997.

"The idea that he was stuck down there": Joss Whedon, *Buffy the Vampire Slayer*, Season 1, Episode 2, "The Harvest," commentary track, DVD.

"I was Sid—and he was Nancy!": Nivair Gabriel, "Villains Have More Fun—Just Ask Spike and Dru," *Daily Dragon Online*, September 4, 2012.

"I think the Angelus arc": Gross, "Buffy the Vampire Slayer Turns 20."

"thought the doors would swing wide open": Interview with Marti Noxon, "Marti Noxon: Reel Life, Real Stories," *MakingOf*, August 16, 2011, video available at https://www.youtube.com/watch?v=SP5JnphofA8.

"At one point he threw chocolate": Interview with Marti Noxon, "Marti Noxon: Reel Life."

" 'I'm sorry, honey' ": "Buffy's Boo! Crew," *Entertainment Weekly*, October 1, 1999.

"After that momentous night": Ira Madison, *"Buffy the Vampire Slayer*, 20 Years Later: Sex and the Vampire City," *MTV News*, March 10, 2017.

"I watched David very emotionally": Ruth Kinane, *"Angel* Cast and Creators Reunite for 20th Anniversary of Beloved Vampire Drama Series," *Entertainment Weekly*, June 20, 2019.

"smart and merciless": Roger Ebert, "Cruel Intentions," *RogerEbert.com*, March 5, 1999.

"faintly ridiculous": Stephen Holden, " 'Cruel Intentions': Back to Their Old Tricks, but a Whole Lot Younger," *The New York Times*, March 5, 1999.

"rarely has a film elicited": Peter Travers, "Cruel Intentions," *Rolling Stone*, March 5, 1999.

"porny": Joss Whedon, press conference, Television Critics Association, 1999.

"I did what I think is my best work": Alana Wulff, "Cruel Intentions," *Premiere*, February 11, 2019.

Chapter 7: Will You Be Slaying? Only If They Give Me Lip.

"The third season got off to a sensational start": Ken Tucker, "Buffy the Vampire Slayer," *Entertainment Weekly*, November 6, 1998.

"Season three was a struggle": Ed Gross, "Buffy the Vampire Slayer Turns 20: Joss Whedon Looks Back," *Empire*, September 3, 2017.

"Given the current climate": Charles Taylor, "The WB's Big Daddy Condescension," *Salon*, May 26, 1999, https://www.salon.com/1999/05/26/buffy_rant/.

"I agreed with the postponement": David Lavery and Cynthia Burkhead, eds., *Joss Whedon: Conversations* (Jackson: University Press of Mississippi, 2011), page 16.

"In the end it was probably a smart move": Anita Gates, "Saving the Graduates from Being Eaten," television review, *The New York Times,* July 13, 1999.

"The episode I tell people to watch": Stacey Abrams, "An Evening with Stacey Abrams and Sarah Michelle Gellar," presented by *BookPeople*, Zoom, May 17, 2021.

Chapter 8: Well, You Were Myth-Taken

"[The show is] about adolescence": Tasha Robinson, "Joss Whedon," *AV Club*, September 5, 2005, https://www.avclub.com/joss-whedon-1798208181.

"In season four, the loss of Angel": Ed Gross, "Buffy the Vampire Slayer Turns 20: Joss Whedon Looks Back," *Empire*, September 3, 2017.

"A Hate Letter to Riley Finn": Lucy Valentine, "A Hate Letter to Riley Finn, Worst Man in the Buffyverse," *Junkee*, February 4, 2019, https://junkee.com/buffy -riley-finn/191659.

"A lot of people were surprised": Joss Whedon, Season 4 DVD Extra: "Season 4 Overview."

"We talked about Willow and her being a witch": David Bianculli, "Joss Whedon," *Fresh Air with Terry Gross*, NPR, February 8, 2002.

"While some people, such as Buffy": Nicole Grafanakis, "The Queer Influence of *Buffy the Vampire Slayer*," *The College of New Jersey Journal of Student Scholarship* 22 (April 2020): np.

"I knew that I was going to have a friend": Thomasina Gibson, "Will Power," *Cult Times*, June 2000.

"Are we forced to cut things": Joss Whedon, "Official Quotes on the Willow/Tara Storyline," *Buffy Guide*, July 2000.

"I had to threaten to quit": Jude Dry, " 'Love, Simon' Director Greg Berlanti Almost Quit 'Dawson's Creek' Job Early in Career over Banned Gay Kiss," *IndieWire*, March 23, 2018.

"The bottom line is": Lynn Elber, "Fox Executive Defends Removal of 'Melrose Place' Gay Kiss," Associated Press, July 15, 1994.

"[The network] called me and said": Brian Ford Sullivan, "Live at the Paley Festival: 'Buffy the Vampire Slayer' Reunion," *The Futon Critic* (Blog), March 21, 2008, http://www.thefutoncritic.com/interviews/2008/03/21/live-at-the-paley -festival-buffy-the-vampire-slayer-reunion-27016/20080320_buffythevampire slayer/.

"Eminently visual": Virginia Heffernan, "It's February. Pucker Up, TV Actresses," *The New York Times*, February 10, 2005.

"The first criticism we got was": Robinson, "Joss Whedon."

"Most people sort of shake their heads": Joss Whedon, "Whedon's Top Ten," BBC, May 6, 2003.

"It was sort of a chaotic season": Joss Whedon, *Buffy the Vampire Slayer*, Season 4 DVD Extra: "Season 4 Overview."

Chapter 9: Who's Going to Take Care of Us?

the most shared opinion: Sarah Hagi, "Hey Buffy Fans, Dawn Was Not the Worst," *Vice*, March 10, 2017. https://www.vice.com/en/article/mg43jb/hey-buffy-fans-dawn-was-not-the-worst.

"I had wanted to go further": Ken P., "An Interview with Joss Whedon," IGN.com, June 23, 2003.

"Our mission statement for season five": Ed Gross, "Buffy the Vampire Slayer Turns 20: Joss Whedon Looks Back," *Empire*, September 3, 2017.

"I wasn't designed to be a romantic character": James Marsters, "James Marsters (2020)," *Inside of You w/ Michael Rosenbaum*, podcast, July 14, 2020.

"'The Body' is one of the most sophisticated analyses": Sophie Gilbert, "'The Body': The Radical Empathy of *Buffy*'s Best Episode," *The Atlantic*, March 9, 2017.

"This episode was one that I did": Joss Whedon, *Buffy the Vampire Slayer*, Season 5 commentary track, DVD.

"People emailed and wrote": Whedon, Season 5 commentary track.

"20th Television has made an inauspicious decision": Jim Rutenberg, "'Buffy,' Moving to UPN, Tried to Be WB Slayer," *The New York Times*, April 21, 2000.

"The most likely place for the program": Rutenberg, "Moving to UPN."

"In all likelihood, where we will come out": Michael Schneider and Josef Adalian, "'Buffy' a Toughie for WB," *Variety*, January 10, 2001.

"I will stay on *Buffy* if": Josh Grossberg, "Gellar: I'm Gone If 'Buffy' Leaves WB," *E! Online*, January 22, 2001.

"Fox has been very good to me": Shauna Snow, "Arts and Entertainment Reports from the Times, News Services and the Nation's Press," *Los Angeles Times*, January 25, 2001.

"I've been dumped by my fat old ex": Josef Adalian, "UPN Sinks Teeth into WB's 'Buffy,'" *Variety*, April 23, 2001.

Chapter 10: Ask Me Again Why I Could Never Love You

"It's crystal clear, in retrospect": Joanna Robinson, "How *Buffy the Vampire Slayer*'s Most Hated Season Became Its Most Important," *Vanity Fair*, March 10, 2017.

"Season six was basically about": Ed Gross, "Buffy the Vampire Slayer Turns 20: Joss Whedon Looks Back," *Empire*, September 3, 2017.

"Change is a mandate on the show": Robinson, "Most Hated Season."

"I think that killing Tara": Lila Shapiro, "Marti Noxon on *Sharp Objects*, Joss Whedon, and Going 'Toe-to-Toe' with Jean-Marc Vallée," *Vulture*, July 3, 2018, https://www.vulture.com/2018/07/marti-noxon-sharp-objects-buffy-feminist-legacy-dietland.html.

"I did have a secret plan": Joss Whedon, San Diego Comic-Con panel, July 26 to 29, 2007.

"There were a lot of other reasons": *Curve*, October 2003.

"The timing just didn't work out": Amber Benson, "Buffy TV Series," *AfterEllen*, August 20, 2007.

"knowledgeable source": Kim Masters, "Ray Fisher Opens Up About 'Justice League,' Joss Whedon and Warners," *The Hollywood Reporter*, April 6, 2021, https://www.hollywoodreporter.com/movies/movie-news/ray-fisher-opens -up-about-justice-league-joss-whedon-and-warners-i-dont-believe-some -of-these-people-are-fit-for-leadership-4161658/.

"[Joss] basically kind of threatened my career": Jenna Amatulli, "Gal Gadot Says Joss Whedon Threatened to 'Make My Career Miserable,'" *Huffington Post*, May 10, 2021, https://www.huffpost.com/entry/gal-gadot-joss-whedon-justice-league _n_609942c6e4b0aead1b86977d.

"With season six, there was this announcement": Shapiro, "Marti Noxon on *Sharp Objects*."

Chapter 11: It's About Power

"We had a few things in mind": Ed Gross, "Buffy the Vampire Slayer Turns 20: Joss Whedon Looks Back," *Empire*, September 3, 2017.

"I feel that I wrote the perfect ending": Gross, "Buffy the Vampire Slayer Turns 20."

Chapter 12: The Joss of It All

"15 years is a long time": Mia Galuppo, "Following Criticism, Joss Whedon Fan Site Shuts Down After 15 Years," *The Hollywood Reporter*, August 21, 2017, https://www.hollywoodreporter.com/movies/movie-news/joss-whedon-fan -site-shuts-down-15-years-1031195/.

"It is often a requirement upon oppressed people": Marilyn Frey, *The Politics of Reality: Essays in Feminist Theory* (Trumansburg, NY: Crossing Press, 1983).

"It just might go down": Kristin Dos Santos, "*Dexter*: Sneak Peeks: Get an Early Look at the Game-Changing Finale," *E! News*, December 10, 2009.

"While several high-placed sources": Adam B. Vary and Elizabeth Wagmeister, "Inside Joss Whedon's 'Cutting' and 'Toxic' World of 'Buffy' and 'Angel'", *Variety*, February 2021.

"*Buffy the Vampire Slayer*'s Nicholas Brendon": Carly Johnson and Adam Levy, "*Buffy the Vampire Slayer*'s Nicholas Brendon Is 'Not Ready to Discuss' Joss Whedon Abuse Allegations as He Undergoes Emergency Spinal Surgery After Suffering from a 'Paralysed Penis,'" *Daily Mail*, February 16, 2021.

"From my personal experience": Samantha Highfill, "*The Nevers* Stars Preview Their Supernatural HBO Series, Discuss Working with Joss Whedon," *Entertainment Weekly*, March 24, 2021.

Chapter 13: Thank God We're Hot Chicks with Superpowers

"The word 'feminist,' it doesn't sit with me": "Joss Whedon: 'I Hate Feminist' (VIDEO)," *The Huffington Post Canada*, November 8, 2013, available at https://www.huffingtonpost.ca/2013/11/08/joss-whedon-feminist_n _4240214.html.

"I've said before": Adam B. Vary, "Joss Whedon Calls 'Horsesh*t' on Reports He Left Twitter Because of Militant Feminists," *BuzzFeed News*, May 6, 2015, https://www.buzzfeednews.com/article/adambvary/joss-whedon-on-leaving -twitter.

"feminist show that didn't make people feel like": Mikey O'Connell, " 'Buffy' at 20: Joss Whedon Talks TV Today, Reboot Fatigue and the Trouble with Binging," *The Hollywood Reporter*, March 10, 2017.

"The idea was, let's have a feminist role model": "Buffy's Boo! Crew," *Entertainment Weekly*, October 1, 1999.

"She was an extraordinary inspiration": "The Ladies' Man," *The Age*, September 25, 2005.

"Riley sexually undermines his girlfriend": Natasha Simons, "Reconsidering the Feminism of Joss Whedon," *The Mary Sue*, April 7, 2011, https://www.themarysue .com/reconsidering-the-feminism-of-joss-whedon/.

"At the same time": Patricia Pender, " 'Kicking Ass Is Comfort Food': Buffy as Third Wave Feminist Icon," 2004, via Stacy Gillis, Gillian Howie, and Rebecca Munford's *Third Wave Feminism: A Critical Exploration*.

Chapter 14: Gay Now, Gay Then

"As a whole, *Buffy* is an immensely complex text": Nicole Grafanakis, "The Queer Influence of *Buffy the Vampire Slayer*," *The College of New Jersey Journal of Student Scholarship* 22 (April 2020): np.

"There is reason to suggest": Patricia Pender, *I'm Buffy and You're History: Buffy the Vampire Slayer and Contemporary Feminism* (London: I. B. Tauris, 2016).

"I was like, 'You guys see' ": Dave Davies, "Joss Whedon: Slayers, Dolls and Singing Villains," podcast, NPR, February 12, 2009, https://www.npr.org /transcripts/100601869.

"Buffy Summers is all confidence": George Gene Gustines, "Experimenting in Bed When Not After Vampires," *The New York Times*, March 5, 2008.

Chapter 15: The Caucasian Persuasion

"We hope to turn the conversation away": Mary Ellen Iatropoulos and Lowery A. Woodall III, "Introduction," in *Joss Whedon and Race*, eds. Mary Ellen Iatropoulos and Lowery A. Woodall III (Jefferson, NC: McFarland & Company, 2016), page 3.

"I was an avid fan": Lynne Edwards, "The Black Chick Always Gets It First: Black Slayer in Sunnydale," in Iatropoulos and Woodall, *Joss Whedon and Race*, page 37.

"A relative lack of characters of color": Iatropoulos and Woodall, "Introduction," page 12.

"probably the most intelligent person": Will Harris, "D. B. Woodside on *Lucifer, Buffy the Vampire Slayer,* and Learning Harsh Lessons from *24*," *AV Club*, December 17, 2016, https://www.avclub.com/d-b-woodside-on-lucifer-buffy -the-vampire-slayer-and-1798255652.

Chapter 16: Stylish, Yet Affordable Boots

"Occasionally, when I'm watching the TV": Jane Espenson, *Buffy the Vampire Slayer,* Season 3 DVD Extra: "Wardrobe."

"fairly early into the show's run": Adam B. Vary and Elizabeth Wagmeister, "Inside Joss Whedon's 'Cutting' and 'Toxic' World of 'Buffy' and 'Angel,'" *Variety*, February 2021.

Chapter 17: You Talk Funny

"I'll think of the straight line to say": David Fury, *Buffy the Vampire Slayer,* Season 3 DVD Extra: "Buffy Speak."

The first use of "to google" as a verb: Robinson Meyer, "The First Use of 'to Google' on Television? *Buffy the Vampire Slayer,*" *The Atlantic*, June 27, 2014.

Chapter 18: Close Your Eyes

"I fell in love with so many bands": Trixie Mattel, *SlayerFest '98 (A Buffy the Vampire Slayer Podcast)*, June 25, 2019.

"[Joss] had mentioned, 'I want to do a musical'": Gareth Davies, *Buffy the Vampire Slayer,* Season 6, commentary track, DVD.

the fifth best episode of the twenty-first century: "*TV Guide*'s 65 Best Episodes of the 21st Century," *TV Guide*, April 2018.

"Once more, one of the best shows": Richard Harrington, "Unsung 'Buffy': Props for a Magical Musical Moment," *The Washington Post*, July 2, 2002.

Chapter 20: Popular Culture Reference, Sorry

"*Buffy the Vampire Slayer* is my favorite show": Claire Saffitz, "Every Show the Test Kitchen Is Watching," *Bon Appétit*, April 24, 2020.

Smith called into Beats 1: Eric Thurm, "Jaden Smith Requested the *Buffy* Theme Song and Maybe Broke Beats 1," *Paper*, July 1, 2015.

"I was very inspired by *Buffy*": "Shonda Rhimes Reveals How 'Buffy' Helped Her Rediscover TV," *The Hollywood Reporter*, October 8, 2014.

"I spent a lot of time": Neil Norman, "Simon Pegg: A Geek Made Good," *Independent*, February 4, 2007.

Chapter 21: Love Is Forever

"Look, I understand that the first line": Charles McGrath, "Tony Kushner, at Peace? Not Exactly. But Close," *The New York Times*, March 7, 2018.

"What's your favorite Woody Allen movie?": Dylan Farrow, "An Open Letter from Dylan Farrow," *The New York Times*, February 1, 2014.

Chapter 22: SMG, and the Weight of the World on Her Shoulders

"She has a beauty contestant's smile": Mim Udovitch, " 'Buffy the Vampire Slayer': What Makes Buffy Slay?" *Rolling Stone*, May 11, 2000.

"Early on, we saw that Sarah can go": "Buffy's Boo! Crew," *Entertainment Weekly*, October 1, 1999.

Chapter 23: Where Do We Go from Here?

"I've said it before: I always intended": Ed Gross, "Buffy the Vampire Slayer Turns 20: Joss Whedon Looks Back," *Empire*, September 3, 2017.

"according to sources, the diversity": Nellie Andreeva, " 'Buffy the Vampire Slayer' Series Reboot with Black Lead in Works from Monica Owusu-Breen & Joss Whedon," *Deadline*, July 20, 2018.

"Come on, guys": Marisa Roffman, "David Boreanaz Dismisses 'Buffy' Reboot Backlash," *The Hollywood Reporter*, October 4, 2018.

"I'm not an adolescent anymore": Michael Blackmon, "Sarah Michelle Gellar on the 'Buffy' Reboot," *BuzzFeed News*, October 16, 2019, https://www.buzzfeednews.com/article/michaelblackmon/sarah-michelle-gellar-buffy-vampire-slayer-reboot.

Index